# Impossible Worlds:

**4 in 1**

## The Magic Mirror of M.C. Escher
BRUNO ERNST

## Adventures with Impossible Objects
BRUNO ERNST

## Optical Illusions
BRUNO ERNST

## The Graphic Work
M. C. ESCHER

EVERGREEN

Front cover:
Reptiles, 1943
Lithograph 33.5 x 38.5 cm

EVERGREEN is an imprint of
TASCHEN GmbH

© 2002 TASCHEN GmbH
Hohenzollernring 53, D–50672 Köln
**www.taschen.com**
© 2002 for all M. C. Escher reproductions: Cordon Art - Baarn - Holland
All M.C. Escher works © Cordon Art B.V.
P.O. Box 101, 3740 AC Baarn, The Netherlands.
M.C. Escher® is a Registered Trademark of Cordon Art B.V.

Cover design: Angelika Taschen, Catinka Keul

Printed in Italy
ISBN 3-8228-2282-5

BRUNO ERNST

# The Magic Mirror of
# M·C·Escher

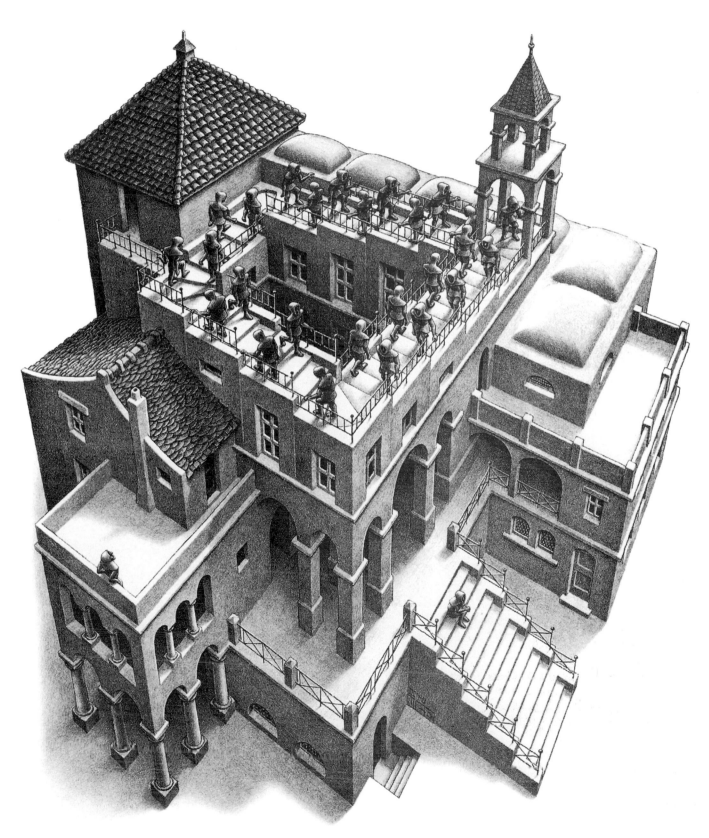

# Bruno Ernst　The Magic Mirror

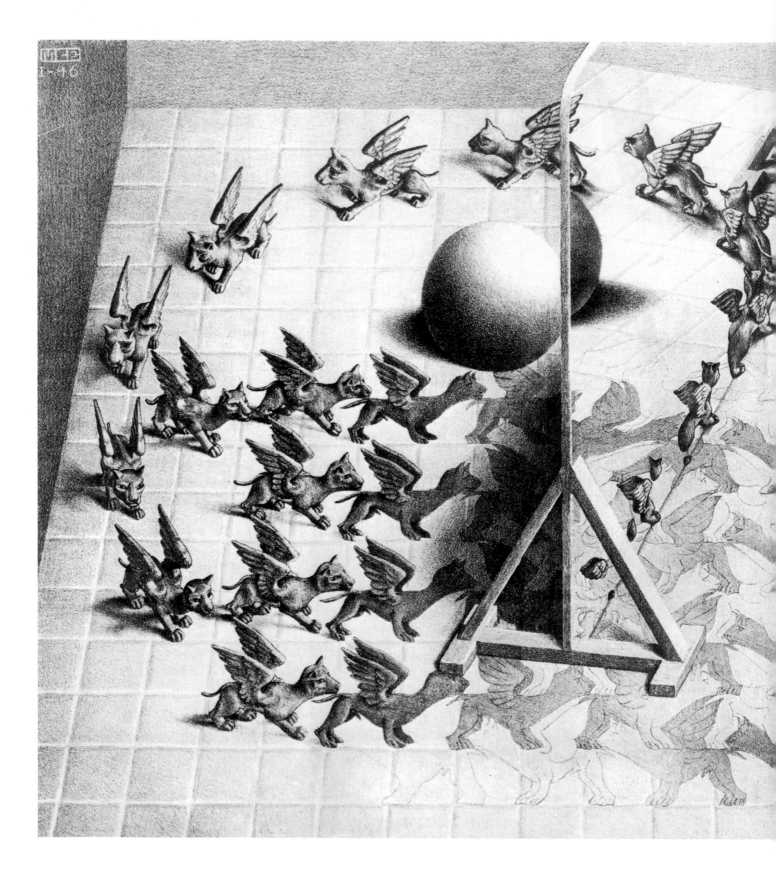

# M.C. Escher

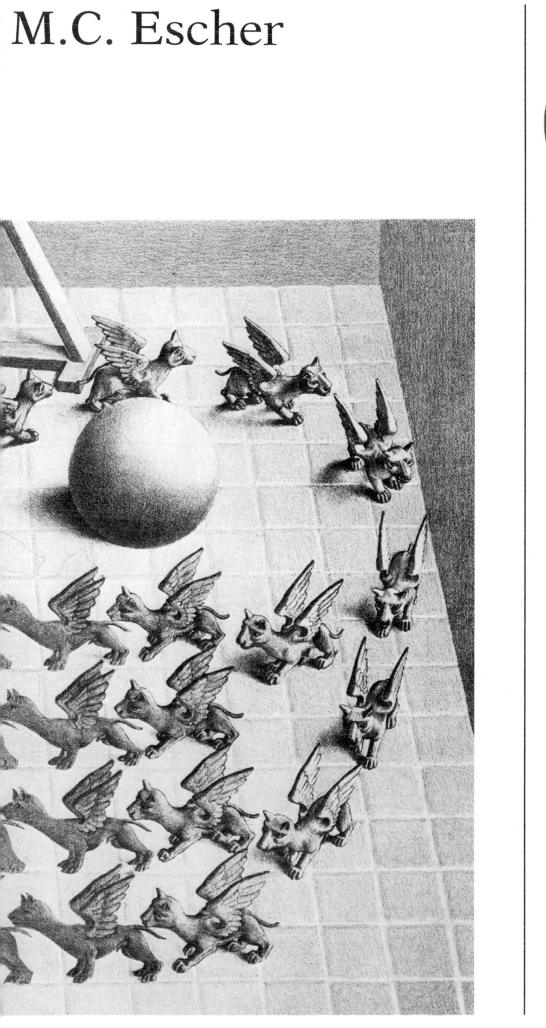

We are grateful to Cordon Art B.V., Baarn, Holland, for permission to
reproduce the pictures and sketches by Escher in this book.

Many diagrams and explanatory drawings were first published in *Pythagoras*,
a journal for mathematics students, and we are grateful to Wolters-Noordhoff
B.V., Groningen, Holland, for permission to reproduce these. We are also
indebted to the Bank of the Netherlands, Amsterdam, for their permission to
reproduce the banknotes designed by Escher.

Translated from the Dutch by John E. Brigham

# Contents

# The magic mirror – a document

This book was written more than 25 years ago and has been translated into ten languages without any change to the text or the images. Yet much has happened in those 25 years to cause the text to be revised. Escher's extensive correspondence and other writings have become available; congresses about Escher have been held (including Rome 1985, Granada 1990); and a number of books have been published about Escher's life and work, together with books that delve deeply into the complexities of his work (e.g. Bruno Ernst, *Adventures with Impossible Objects* and *Optical Illusions*). A number of artists were inspired by Escher's graphic oeuvre and are responsible for a genre that can be termed Escherian.

Is there not a call then for additions and amendments to *The Magic Mirror of M. C. Escher?* No, this cannot be, for it would mar the factual value of this book which is the outcome of a large number of interviews with Escher. I wrote it in 1970 and 1971, and every part of the text was corrected, added to, and where necessary altered by Escher himself. It precisely reflected his own view of his work. This is apparent from the history of how the book came into being.

## The book's genesis

Escher's print *High and Low* hung in the lecture room of the pedagogic institution where I lectured on mathematics. I was constantly fascinated by it: two reproductions of the same view of a town seen from two totally different perspectives, yet forming a harmonious unity with each other. What was the creator of this print communicating? How did he achieve it and what means did he employ?

In 1955, I was at Baarn (in Holland) to help a friend (Ir. A. Bosman) with the editing of a popular mathematics book, for which he had collected a lot of material. Escher came into conversation coincidentally and he told me: "He is a neighbour; he is ideal (for the purpose) and you can contact him quite easily and ask him the questions yourself." It was a little while before I dared to do so, because I not only regarded Escher as a great artist, but also as a wizard. I wrote a letter to him in the summer of 1956 with questions about the print *High and Low*. By return I received the following answer: "...there is much to say about the design and motivation of this lithograph. I do not have sufficient time to do so in writing. If you are able to visit me I will be able to tell you all manner of things by referring to ear-lier and subsequent prints." This was an unforgettable visit. By the end of the afternoon, I had become acquainted with virtually every print Escher had made since 1940 and I came to understand much about Escher's imagination, while being constantly astonished. Later I was to return many times, since this introduction had been rather hasty. I had even criticized the print that he had just completed: *Print Gallery*. Several days after my visit he returned to the subject and made it clear that the changes I had proposed were impossible. Looking back I consider my criticism as outrageous. Imagine it, Escher was about 60 years old and had earned his acclaim as a graphic artist and creator of many exceptional and highly acclaimed prints. I was a 30 years old mathematics teacher. Yet Escher took the criticism of a young man who knew barely anything about his work completely seriously, as though I were a close colleague who had known him for thirty years.

In a letter to his son Arthur, he wrote of this visit: "I want to tell you about a 'brother' with whom I have made acquaintance. This brother," (I was at the time a member of a religious order that was mainly engaged in education), "who I only know as Erich, is a mathematics teacher... A strange character, who just wrote to me all of a sudden to tell me that my prints fascinated him, and the boys he teaches, and that he longed to come to see me in Baarn. This he has done meanwhile. He viewed my jokes with perspective and above all my 'inversion' print *Convex and Concave* (which I believe I sent you, didn't I?), as well as my regular division of planes, with great interest. In connection with the *Convex and Concave* print he gave me a means to invert easily all manner of objects and landscapes that we view. It is so astounding that I will attempt to explain it to you." These were Escher's own words. You can see that there was no reference to my impertinence in passing criticism on his work.

My visit was the beginning of a long lasting friendship. Through the numerous visits and talks that followed, I was slowly guided into the world of Escher's imagination, about which I came to write so many articles over the years. I was very flattered by his reactions, such as "...I don't believe there is anything so authoritative written anywhere about this print (or others)." This was about an analysis of *Print Gallery*, which I had criticized in my first book and which Escher, and later I myself, regarded as his best work.

Early in 1970, Escher was talking about letters from admirers, who sometimes came up with the strangest interpretations of his prints. I had the spontaneous idea of dealing systematically with his work, print by print, so that people would have no uncertainty after his death about his intentions. Escher considered this a good plan and we agreed that I should visit him each week. This lasted for almost two years. On 24 May 1970, he wrote to his sons: "This will be the fourth Sunday afternoon, from four to half past six, that he has come to see me to collect material for a book about my work … It is also enjoyable to see how he attempts so clearly to turn my intuitive way of working into words which I have neither used or known."

During these visits, it was not only the prints and the correlation between them that was discussed, but also the many roughs, alternatives, and early sketches. After each visit I wrote a little about what we had discussed and sent this to Escher, who then immediately wrote back with his comments, sometimes accompanied by encouraging remarks, such as: "Time and again, as I read a fragment once more, I think: what a fine book this is going to be." Or in a later comment: "In general, if I consider the entire work, it seems to me to be an amazingly fascinating book for the reader who is fed up with the drivel of art history."

Sometimes he was very taken with the particular expression in words of what he intended to convey in a print. When I had sent him the piece about his woodcut Spirals and was with him the following Sunday, he went to the drawer where he kept his prints, took out a print of Spirals, and signed it with an inscription to me. While doing so, he remarked: "I have only printed a small number and there is little demand, but your commentary hits the nail on the head. Will you accept this copy from me by way of thanks?"

While we were working on the book, Escher's health deteriorated significantly and I knew that my visits tired him greatly. One Saturday I telephoned to let him know what time I would come the next day. After a short chat, he said to me: "Wait a moment, while I lie down, because I am so tired." I suggested that it would be best to postpone our discussions for a week but he would not hear of it. The book must go on and I will feel better in the morning, was his comment.

Given the manner in which we worked, it was more Escher's book than mine. Of course I was not acting as a ghost writer but it was certainly an authorized translation of his imagination. In 1971, it was ready, and although both a Dutch and an American publisher wanted it, Escher was unable, through all manner of circumstances, to see his book published. This in spite of his looking forward to it as he wrote in a letter to his sons: "It delights me more and more, the appearance of this book."

### The aura

The power of attraction of Escher's prints has grown since his death, together with the popularity of his books and the countless reproductions which are sold every year.

Escher never sought exclusivity. His prints were intended to be disseminated: as many people as possible must share in the enthusiasm and amazement which led to their creation. This is why he never restricted the editions of his prints. Provided there was a demand, he let new editions of his lithographs be printed, and printed new editions of his woodcuts himself. When the demand arose for much larger editions of his prints to be produced by normal commercial printing processes, he gave his permission.

Escher had no pupils; it had never arisen. What might they have learned in any case? At best, the technique of making woodcuts and drawing on lithographic stone. Passing on his ideas did not interest him and would have disturbed him in his constant quest. Besides, his aim was to convey his imagination through his prints. Although no 'Escher school' exists, many artists throughout the world (there are more than fifty that are recognized) have been inspired by his work. In the first instance, this is through the spirit which shines out of his creations. A typical example of this aura, which is not limited to a single print or group of prints, is given by an incident back in 1954. The famous physicist and cosmologist Professor Roger Penrose recounts: "My own involvement in impossible figures dates back to 1954, when I attended the international Congress of Mathematicians in Amsterdam … A lecturer of my acquaintance suggested that I would be interested in an exhibition of work by the Dutch artist M.C. Escher … I was totally fascinated, never having come across Escher's work before. On returning to England, I decided to try my hand at something impossible myself. Finally I came up with the impossible triangle which, in my view, embodied the impossibility I was trying to express, in its purest form. Although, in his exhibition, Escher had had many strange and wonderful things, there was nothing that we would now call an impossible object quite in that sense."

So far as his influence on other artists was concerned, this mainly stemmed from particular objects which Escher had carved out, with the regular division of planes and above all the impossible figures, although Escher only made three of these! This resulted in the view that Escher's work was being distorted and restricted. The public at large had similar preferences, judging from the demand for reproductions of his prints.

The influence on artists did not lead to any continuation of Escher's ideas. This was not really possible, for his journey of exploration was unique; a repetition would be meaningless and I cannot imagine any advancement.

Escher's work is multifaceted in terms of content but behind that plethora lurks a strong unity. After half a lifetime of illustration and reproduction of what especially attracted him to Mediterranean towns, villages, and landscapes, he concentrated after 1940 almost exclusively on the fundamentals and the essentials of his métier: illustration. Questions were posed such as: what is illustration; what potential does a surface provide if we wish to fill it with corresponding figures joined together? Isn't it astonishing that we can illustrate two or more three-dimensional representations on precisely the same piece of two-dimensional paper, without them forming an inextricable image? … and so on.

An idea had to be completely thought out, sometimes over many months, before he would present it to the public. A surprising aspect, to which little consideration has been given, is that he never repeated himself. Look at the roughs of a number of his prints which are reproduced in this book: he could have made an interesting print of virtually every sketch for *Waterfall*, *Convex and Concave*, and *High and Low*. This would be entirely legitimate for an artist and many have established their oeuvre in this way.

But his aim was not the making of a number of fine and interesting prints. In this respect too he was unique: he strove after *the* print which most fully illustrated his idea. Occasionally we see several prints on the same theme, but it is always a matter of an improvement or variation, whereby he considered his idea would be more succinctly conveyed.

In the *Magic Mirror*, you will find not only to a biographical background, but an account of the genesis of Escher's work, resulting from a distillation of the many discussions I had with him, and which he regarded as a faithful description and another manifestation of his intentions.

*Bruno Ernst, 1998*
*(Translation: Stephen Challacombe)*

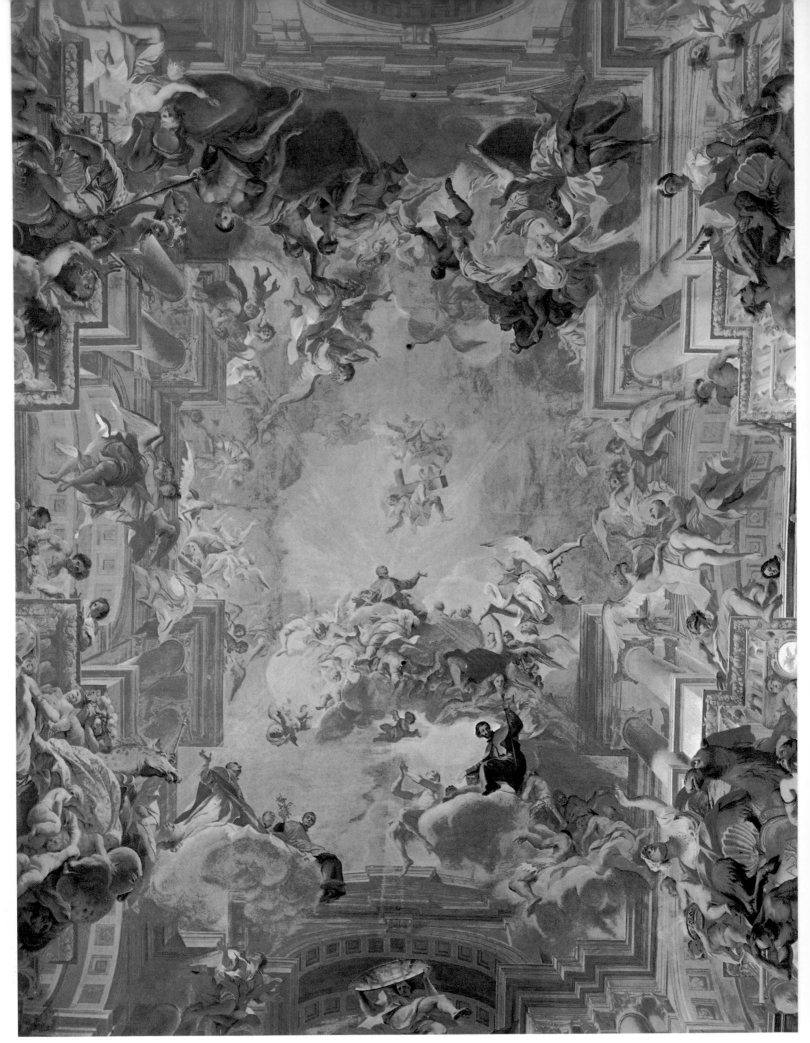

1. Baroque ceiling, St. Ignazio's Chapel, Rome, by Andrea Pozzo. (Photograph by F Fratelli Alinari, Florence)

The Magic Mirror of M.C. Escher

# Part One: Drawing is deception

## 1    The Magic Mirror

*"As the emperor gazed into the mirror his visage became first a blood red blob and then a death's head with slime dripping from it The emperor turned away from it in alarm. 'Your Majesty,' said Shenkua, 'do not turn your head away. Those were just the beginning and the end of your life. Keep on looking, and you shall see everything that is and everything that may be. And when you have reached the highest point of rapture, the mirror will even show you things which cannot possibly be '"*

— *Chin Nung, "All about Mirrors"*

When I was a young man I lived in a seventeenth-century house on the Keizersgracht in Amsterdam. In one of the larger rooms there were *trompe-l'oeil* paintings above the doors. These mural paintings, carried out in many combinations of varying shades of gray, achieved so plastic an impression that one could not escape the conviction that they were marble reliefs—a deception, an illusion that never ceased to astonish. And perhaps even more skillful still are those ceiling paintings in churches in central and southern Europe where two-dimensional paintings and three-dimensional sculpture and architecture pass over from one to the other without any visible joins.

This playful exercise has its roots in the representational methods of the Renaissance. The three-dimensional world had to be reproduced as faithfully as possible on the flat surface, and in such a way that image and reality might be indistinguishable to the eye. The idea was that the painting should conjure up warm, voluminous reality.

In the case of the *trompe-l'oeil* paintings, ceiling paintings, and those portraits which keep on staring at one from whichever point one looks at them, it is a question of playing the game for the game's sake.

It is no longer a matter of representational verisimilitude in the things that are being portrayed, but of downright optical illusion, of superdeception in the service of deceit. The painter takes a delight in this deceit, and the viewer is determined to be deceived willy-nilly, deriving therefrom the same sort of sensation as when he is being taken in by a magician. The spatial suggestion is so strong, so exaggerated, that nothing short of actual touch can

2. Pieter de Wit, "Trompe l'oeil" painting (the Rijksmuseum Amsterdam)

reveal to us that we are dealing with pictures on a flat surface.

A great deal of Escher's work is related to this supersuggestion of the spatial to which we have just referred. However, the suggestion itself is not what he is primarily aiming at. His prints are much rather the reflection of that peculiar tension inherent in any flat representation of a spatial situation. In many of his prints he causes the spatial to emerge from the flat surface. In others he makes a conscious attempt to nip in the bud any spatial suggestion that he may have brought about. In the very highly developed wood engraving *Three Spheres I* (1945), which we shall discuss more fully at a later stage, he carries on a discussion with the viewer: "Now, isn't that one at the top a splendid round globe? Wrong! You are quite mistaken—it is completely flat! Now, just look, in the middle I have drawn the thing folded over. So you see it really must be flat, or I could not have folded it. And at the bottom of the print I have laid the thing down horizontally. And in spite of this, I guess your imagination will go and turn it into a three-dimensional egg. Just satisfy yourself about this with the touch of your fingers over the paper—and feel how flat it really is. Drawing is deception; it suggests three dimensions when there are but two! And no matter how hard I try to convince you about this deception, you persist in seeing three-dimensional objects!"

With Escher, optical illusion is achieved by means of a representational logic that hardly anyone can evade. By his method of drawing, by his composition, he "proves" the genuineness of the suggestion that he has brought into being. And the fascinated viewer, on coming to his senses, realizes that he has been taken in. Escher has literally conjured up something before his eyes. He has held before him a magic mirror whose spell has been cast as a compelling necessity. In this Escher is an absolute master, and unique at that. Let us take the lithograph *Magic Mirror* (1946) to illustrate this. By standards of artistic criticism, perhaps it is not a successful print. It is set before us like some tangled skein. There is certainly something taking place, but what it is is far from clear. There is obviously a story in it, but both beginning and end remain so far unrevealed.

It all begins at a very inconspicuous spot. At the edge of the mirror nearest to the viewer, immediately underneath the sloping bar, we can perceive the tip of a small wing, together with its reflection. As we look further along the mirror, this develops into a complete winged hound and its mirror image. Once we have allowed ourselves to be inveigled into accepting the wing-tip as a possibility, we now have to swallow the compelling plausibility of the whole strange setup. As the real dog turns away from the mirror toward the right so his reflection turns to the left, and this reflection looks so real that it is no surprise whatever to us to see him continue walking away behind the mirror, quite undeterred by the mirror frame. And now winged hounds move off to left and right, doubling themselves twice en route; then they advance upon each other like two armies. However, before an actual confrontation takes place, there is a falling off in their spatial quality and they become flat patterns upon the tiled floor. If we watch closely, we see the black dogs turning into white ones the moment they pass through the mirror, doing this in such a way that they exactly fill up the lighter spaces left between the black dogs. These white gaps disappear and eventually no trace of the dogs remains. They never did exist anyway—for winged dogs do not come to birth in mirrors! And yet the riddle is still there—for in front of the mirror stands a globe, and in the mirror, sloping away at an angle, we can still see just a portion of its reflection. And yet there also stands a globe behind the mirror—a real enough object in the midst of the left-hand mirror-world of the dogs.

Who is this man that possesses this magic mirror? Why does he produce prints like this one, obviously without any consideration of aesthetics? In chapters 2, 3, and 4 we shall discuss his life story and throw some light on his character, insofar as this emerges from his letters and his personal conversations. Chapter 5 gives an analysis of his work as a whole. And the following chapters discuss in detail the inspiration, working methods, and the artistic results of this unique talent.

# 2  The Life of M.C. Escher

## Not Much of a Scholar

Maurits Cornelis Escher was born in Leeuwarden in 1898, the youngest son of a hydraulic engineer, G.A. Escher.

In his thirteenth year he became a pupil of the high school in Arnhem, a town to which the family had moved in 1903. He could hardly be described as a good student. The whole of his school days was a nightmare, the one and only gleam of light being his two hours of art each week. This was when he made linocuts, together with his friend Kist (later to be a children's-court judge). Twice Escher had to repeat a grade. Even so he failed to obtain a diploma on leaving, having achieved only a number of grade fives, a few sixes, and—a seven in art. If anything, this result gave more distress to his art teacher (F. W. van der Haagen) than it did to the candidate himself. Such work as has survived from Escher's school days clearly indicates a more than average talent; but the bird in a cage (the set piece for his examination) was not highly thought of by the examiners.

Escher's father was of the opinion that his son ought to be given a sound scientific training and that the most suitable plan for the boy to aim at—for after all, he was really quite gifted artistically—would be to become an architect. In 1919 he went to Haarlem to study at the School of Architecture and Decorative Arts under the architect Vorrink. However, his architectural training did not last very long. Samuel Jesserun de Mesquita, a man of Portuguese extraction, was lecturing in graphic techniques. It took no more than a few days to show that the young man's talents lay more in the direction of the decorative arts than in that of architecture. With the reluctant agreement of his father (who could not help regarding this as being probably inimical to his son's future success) young Maurits Escher changed courses and de Mesquita became his main teacher.

Work from this period shows that he was swiftly mastering the technique of the woodcut. Yet even in this Escher was by no means regarded as outstanding. He was a keen student and worked well, but as for being a true artist . . . well, no, he was certainly not that. The official college report, signed by both the director (H.C. Verkruysen) and de Mesquita, read: ". . . he is too tight, too literary-philosophical, a young man too lacking in

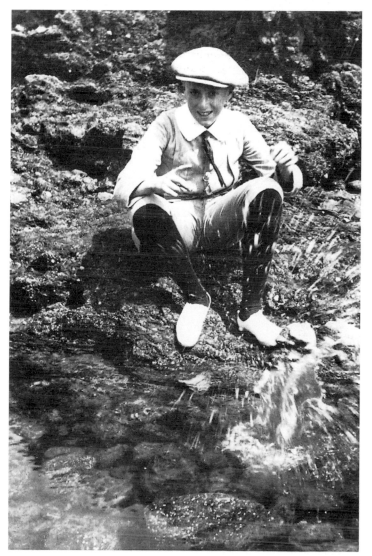

**3. Maurits Escher as a fifteen-year-old boy, spring, 1913**

**4. Escher in Rome, 1930**

to Spain on a cargo boat, and Escher was able to go with them, as "nursemaid" to their children. After a short stay in Spain he boarded another cargo boat at Cadiz, en route for Genoa, and the winter of 1922 and the spring of 1923 were spent in a pension in Siena. It was here that his first woodcuts of Italian landscape were produced.

One of the pension guests, an elderly Dane who had taken note of Escher's interest in landscape and architecture, inspired him with an enthusiasm for southern Italy, and told him in particular, that he would find Ravello (to the north of Amalfi, in Campania) to be bewitchingly beautiful. Escher traveled there and did indeed discover and take to his heart a landscape and an architecture in which Moorish and Saracen elements were attractively interwoven.

In the pension where he was staying he met Jetta Umiker, the girl whom he was to marry in 1924. Jetta's father was Swiss and, prior to the Russian Revolution, had been in charge of a silk-spinning factory on the outskirts of Moscow. Jetta drew and painted, and so did her mother, although neither of them had had the benefit of any training in these arts.

The Escher family came over from Holland for the wedding, which was held in the sacristy and town hall of Viareggio. Jetta's parents set up house in Rome and the young pair went to live with them. They rented a house on the outskirts of the city, on the Monte Verde. When their first son, George, was born, in 1926, they moved to a larger dwelling, where the third floor became their living quarters and the fourth floor was made into a studio. This was the first place in which Escher felt that he could work in peace.

Until 1935 Escher felt quite at home in Italy. Each spring he would set off on a two-month journey in the Abruzzi, Campania, Sicily, Corsica, and Malta, usually in the company of brother artists whom he had come to know in Rome. Giuseppe Haas Trivero, a former house painter turned artist, accompanied him on practically every one of these journeys. This Swiss friend was about ten years older than he and also lived on Monte Verde. Robert Schiess, another Swiss artist, and member of the Papal Guard, sometimes went too. In the month of April, when the Mediterranean climate begins to be at its loveliest, they would set off by train, but mostly they would travel on foot, with rucksacks on their backs. The purpose of these journeys was to collect impressions and make sketches. Two months later they would return home, thin and tired but with hundreds of drawings.

Many an anecdote could be told about this period; a few morsels of traveler's tales must suffice here, to sketch in the atmosphere a little.

A journey through Calabria brought the artists to Pentedattilo, where five rocky peaks rise out of the landscape like giant fingers. The company was more numerous than usual, for a Frenchman called Rousset, who was engaged in historical research in southern Italy, was also with them. They found a lodging in the tiny hamlet—one room with four beds. Meals consisted mainly of hard bread (baked once a month) softened in goat's milk; also honey and goat's-milk cheese. At this period Mussolini had already taken power firmly into his hands. A Pentedattilo woman asked the travelers if they would take a message to Mussolini on behalf of the village. "If you see him, tell him we are so poor here we have not got a well, or even a plot of land where we can bury our dead."

After a stay of three days they tramped the long road back to Melito station on the south coast. A man on horseback came toward them on the narrow, rocky path, and, seizing his enormous camera, Rousset started to film the rider. The man dismounted, and with southern courtesy pressed the travelers to go with him to his home in Melito. He proved to be winegrower and had a very fine cellar. This last was not merely inspected but was so long and so excessively sampled that, a few hours later,

feeling or caprice, too little of an artist."

Escher left in 1922, after two years of study in the art school. He had a good grounding in drawing and, among graphic techniques, he had so mastered the art of the woodcut that de Mesquita had reached the conclusion that the time had come for him to go his own way.

Until early 1944, when de Mesquita, together with his wife and family, was taken away and put to death by the Germans, Escher maintained regular contact with his old teacher. From time to time the former pupil would send the master copies of his latest pieces of work. It was in reference to *Sky and Water I* (1938), which de Mesquita had pinned up on the door of his studio, that the teacher recounted without the slightest tinge of jealousy how a member of his family had exclaimed with admiration, "Samuel, I think that is the most beautiful print you have ever made."

Looking back on his own student days, Escher could see himself as a rather shy young man, not very robust in health but with a passion for making woodcuts.

## Italy

When he left art school in the spring of 1922, Escher spent about two weeks traveling through central Italy with two Dutch friends; and in the autumn of that same year he was to return there on his own. A family with whom he was friendly was going

5. Color sketch of Amalfi, south of Italy

6. Photograph taken by the author of the same spot, March 1973

the travelers arrived in a remarkable state of reckless abandon at the station at Melito. Schiess took his zither from its case and began to play just as the train was due to leave. Out got the passengers and so did the engine driver. Even the stationmaster was so enthusiastic that he started to dance to the music.

Later Rousset recalled the memories of the journey in a letter to Escher and commemorated the incident in this epigram:

*Barbu comme Appollon, et joueur de cithare,*
*Il fit danser les Muses et meme un chef-de-gare.*

Sometimes the zither playing caused astonishment. It seemed to be a better means of communication than eloquent speech or anything else, as instanced in a travel story which Escher himself once published (in the *Groene Amsterdamer*, April 23, 1932).

Usually the only connecting link between the unknown mountain eyries in the inhospitable interior of Calabria and the railroad which runs right along the coast is a mule-path. Anyone wishing to pass this way has to go on foot if he has no mule at his disposal. One warm noontide in the month of May, at the end of a tiring tramp in the blazing sun, the four of us, loaded up with our heavy rucksacks, sweating profusely and pretty well out of breath, came through the city gate of Palazzio. We strode purposefully to the inn. It was a fairly large, cool room, with light streaming in through the open doorway, and smelled of wine and its countless flies. We had long been accustomed to the dourness of the people of Calabria, but never before had we met with such an attitude of antagonism as we sensed on this occasion. Our friendly questions brought forth only gruff and incomprehensible replies. Our light hair, strange clothing, and crazy baggage must have evoked considerable suspicion. I am convinced that they suspected us of

*gettature* and *mal occhio*. They literally turned their backs on us and barely managed to put up with our presence among them.

With a glum expression and without a word spoken, the innkeeper's wife attended to our request for wine. Then, calmly and almost solemnly, Robert Schiess took his zither out of its case and began to strum, very softly at first, as though he were immersed in and carried away by the magic that was coming from the instrument. As we watched him and the men around us, we witnessed the wonderful way in which the evil spell of enmity was broken. With a great deal of creaking a stool was turned around; instead of the back of a head, a face came into view . . . then another and another. Hesitatingly the landlady approached, step by step, and stood there with her mouth open, one hand on her hip and the other smoothing her skirt. When the strings went mute and the zither player raised his eyes, there stood around him a deep rank of onlookers who burst into applause. Tongues were loosed: "Who are you? Where do you come from? What have you come here for? Where are you going next?" We were pressed to accept wine, and we drank much too much of it, which was very pleasant, and our good relationship was even further increased.

The Abruzzi mountains are impressively somber in comparison with other Italian landscapes. In the spring of 1929, Escher went there entirely on his own in order to sketch. He arrived rather late in the evening in Castrovalva, found a lodging, and went straight to sleep. At five in the morning he was awakened by a heavy thumping on his bedroom door. *Carabinieri!* Whatever could they be wanting with him? He was ordered to go to the police station with them. A great deal of argument was required in order to persuade the constable to postpone the hearing until seven o'clock. In any case he impounded Escher's passport. When Escher arrived at the police station at seven o'clock, it appeared

7. Sketch of Jetta

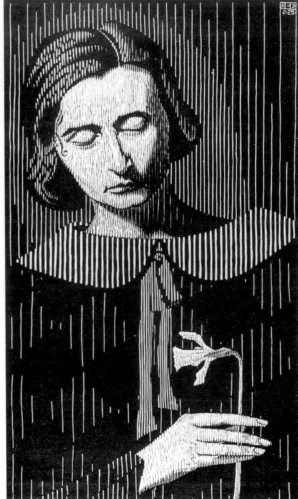

8. *Woman with Flower* (Jetta), woodcut, 1925

that the inspector was not up yet; and it was almost eight before this official put in an appearance. There was certainly a serious accusation; Escher was suspected of having made an attempt on the life of the king of Italy. The incident in question had occurred the previous day in Turin—and Escher was a foreigner, he had arrived late at night, and he had taken no part in the procession that had been held in Castrovalva during the evening. A woman had noted that he had an evil expression *(guardava male)* and had reported this to the police.

Escher was furious about this crazy story and threatened to make a row about it in Rome, with the fortunate result that he was swiftly set at liberty.

What is more, Escher made some sketches for one of his most beautiful landscape lithographs, *Castrovalva* (1930), so impressive in its breadth and height and depth. He himself has said of it, "I spent nearly a whole day sitting drawing beside this narrow little mountain path. Up above me there was a school and I enjoyed listening to the clear voices of the children as they sang their songs." *Castrovalva* is one of the first of his prints to draw high praise from several critics: "In our judgment the view over Castrovalva in the Abruzzi can be regarded as the best work Escher has so far produced. Technically it is quite perfect; as a portrayal of nature it is wonderfully exact; yet at the same time there is about it an air of fantasy. This is Castrovalva viewed from without, but even more so it is Castrovalva from within. For the very essence of this unknown place, of this mountain path, these clouds, that horizon, this valley, the essence of the whole composition is an inner synthesis, a synthesis which came into

being long before this work of art was made . . . it is on this imposing page that Castrovalva has been displayed in all its fearsome unity." (Hoogewerff, 1931)

At this period Escher was not very well known. He had held a few small exhibitions and illustrated one or two books. He hardly sold any work in its own right, and to a great extent he remained dependent on his parents. Not until many years later, in 1951, did a portion of his income derive from the production of his prints. In that year he sold 89 prints for a total of 5,000 guilders. In 1954 he sold 338 prints for about 16,000 guilders— but by this time he had become well known, not for his landscapes and town scenes but for graphic representations of the most appealing concepts that had occurred to his mind up to then.

What a pity it was that his father, the very one who had made it possible for his son to evolve so tranquilly and to reach a stage at which his work bore the stamp of exceptional originality, was never able to appreciate fully the value of this work! Escher senior died in 1939, in his ninety-sixth year. The print *Day and Night* (1938), the first great synthesis of his son's new world of thought, made scarcely any impression on him. It is significant that Escher's own sons also, who had experienced at such close quarters the creation of so many prints, have but little of their father's work hanging in their homes. Escher's comment on this was, "Well, yes, *Ripple* does hang in my son's house in Denmark, and when I see it there, I think it is quite a nice picture, really."

10     The Magic Mirror of M.C. Escher

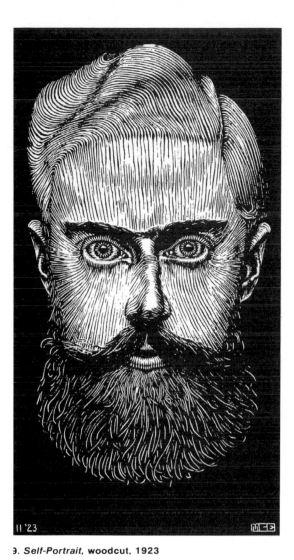

*9. Self-Portrait*, woodcut, 1923

10. Travel snapshots In central Italy

## Switzerland, Belgium, The Netherlands

In 1935, the political climate in Italy became totally unaccept-able to him. He had no interest in politics, finding it impossible to involve himself with any ideals other than the expression of his own concepts through his own particular medium. But he was averse to fanaticism and hypocrisy. When his eldest son, George, was forced, at the age of nine, to wear the Ballila uniform of Fascist Youth in school, the family decided to leave Italy. They settled in Switzerland, at Chateau d'Oex.

Their stay was of short duration. Two winters in that "horrible white misery of snow," as Escher himself described it, were a spiritual torment. The landscape afforded him absolutely no inspiration; the mountains looked like derelict piles of stone without any history, just chunks of lifeless rock. The architecture was clinically neat, functional, and without any flights of fancy. Everything around him was the exact opposite of that southern Italy which so charmed his visual sense. He lived there, even taking ski lessons, but he remained an outsider. His longing to be free from these frigid, angular surroundings became almost an obsession. One night he was awakened by a sound like that of the murmur of the sea    it was Jetta combing her hair. This awoke in him a longing for the sea. "There is nothing more enchanting than the sea, solitude on the foredeck of a little ship, the fishes, the clouds, the ever-changing play of the waves, the constant transformations of the weather." The very next day he wrote a

11. Escher and a colleague at an exhibition both held together in Switzerland

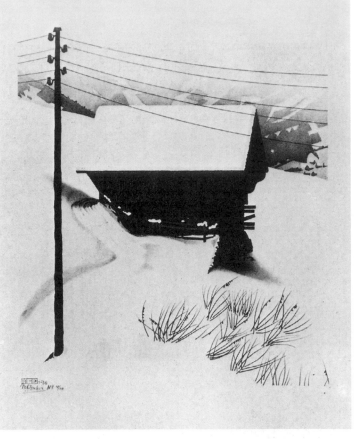

13. *Snow in Switzerland*, lithograph, 1936

12. *Marseilles*, woodcut, 1936

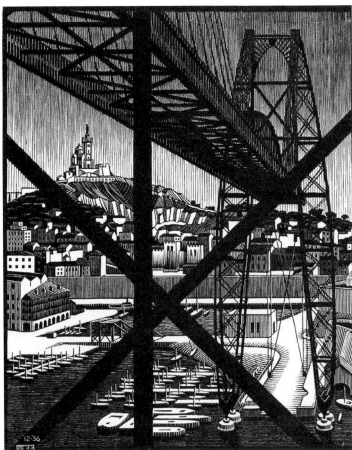

letter to the Compagna Adria in Fiume, a shipping line that arranged voyages in the Mediterranean region on cargo vessels with a limited amount of accommodation for passengers. His proposal is noteworthy: he wanted to pay the price of the cruise, for himself and his wife, with forty-eight prints; that is, four copies each of twelve prints, which he would make from sketches made en route. The shipping company's reply is even more noteworthy. They accepted his offer. Nobody in the company knew Escher, and it is even open to question whether a single member of the management had any interest in lithographs. A year later Escher made this note in his account book:

> 1936. Jetta and I made the following voyages on freighters of the Adria Line:
> I, from April 27, 1936, to May 16, 1936, from Fiume to Valencia.
> I, from June 6, 1936, to June 16, 1936, from Valencia to Fiume.
> Jetta, from May 12, 1936, to May 16, 1936, from Genoa to Valencia.
> Jetta, from June 6, 1936 to June 11, 1936 from Valencia to Genoa in exchange for the following prints which I executed during the winter of '36–'37.

Then follows a list of prints, among which we find *Porthole, Freighter*, and *Marseilles*. These are bracketed together with the figure of 530 guilders, and Escher has added the note: "Value of the voyages received to the tariff charges of the Adria Line, plus an amount of 300 lire which I received to cover expenses."

So there was once a period when the value of a print by Escher could be assessed according to the passenger fares of a cargo boat!

15. *Self-Portrait*, lithograph, 1943

14. *Portrait of G. A. Escher*, the artist's father, in his ninety-second year, lithograph, 1935

This journeying, partly comprising travels in the south of Spain, had a profound influence on Escher's work. He and his wife visited the Alhambra in Granada, where he studied with intense interest the Moorish ornamentations with which the walls and floors were adorned. This was his second visit. This time with his wife, he spent three whole days there studying the designs and copying many of the motifs. Here it was that the foundation was laid for his pioneering work in periodic space-filling.

It was also during the course of this Spanish journey that, because of a misunderstanding, Escher found himself under arrest for a few hours. In Cartagena he was drawing the old walls that straddle the hills there. A policeman regarded this as highly suspicious; here was a foreigner making drawings of Spanish defense works . . . he must surely be a spy. Escher had to accompany him to the police station and his drawings were confiscated. Down in the harbor there sounded the hooter of the cargo boat on which Escher was traveling: the captain was giving warning of departure. Jetta went back and forth as courier between ship and police station. An hour later he was allowed to leave, but he never got his drawings back. It still made him angry when he sat discussing it thirty years later.

In 1937 the family moved to Ukkel, near Brussels, Belgium. The outbreak of war seemed imminent and Escher wanted to be near his homeland. War did come, and residence in Belgium became psychologically difficult for a Netherlander. Many of the Belgians tried to escape to the south of France, and among those who remained behind there grew a tacit resentment of "foreigners" who were eating up the diminishing food supplies.

In January, 1941, Escher moved to Baarn, Holland. The choice of Baarn was determined primarily by the good name of the secondary school there.

In spite of the none-too-friendly climate in Holland, where cold, damp, and cloudy days are dominant and where sun and warmth come as a pleasant bonus, it was in this country that the richest work of the artist quietly flourished.

Outwardly there were no more events or changes of importance. George, Arthur, and Jan grew up, completed their studies, and made their way in the world.

Escher still went on several freighter voyages in the Mediterranean region, but these did not afford any further direct inspiration for his work. However, new prints came into being with clockwork regularity. Only in 1962, when he was ill and had to undergo a serious operation, did production cease for a while.

In 1969 he made yet another print, *Snakes,* and it proved that there was no diminution in his skill; it was a woodcut which still indicated a firm hand and a keen eye.

In 1970 Escher moved to the Rosa-Spier Home in Laren, North Holland, a home where elderly artists can have their own studios and at the same time be cared for. There he died on the 27th of March, 1972.

# 3   An Artist Who Could Not Be Pigeonholed

## Mystics?

> *"A woman once rang me up and said, 'Mr. Escher, I am absolutely crazy about your work. In your print* Reptiles *you have given such a striking illustration of reincarnation.' I replied, 'Madam, if that's the way you see it, so be it.'"*

The most remarkable example of this *hineininterpretieren* (hindsighted interpretation) is surely the following: it has been said that if one studies the lithograph *Balcony* one is immediately struck by the presence of a hemp plant in the center of the print: through the enormous blow-up toward the middle Escher has tried to introduce hashish as a main theme and so point us to the psychedelic meaning of the whole work.

And yet, that stylized plant in the middle of *Balcony* has no connection with a hemp plant, and when Escher made this print, the word hashish was to him no more than a word in a dictionary. As far as any psychedelic meaning to this print is concerned, you can observe it only if you are so color-blind that black looks white and white black.

Hardly any great artist manages to escape from the arbitrary interpretations people give to his work, or from their attachment to meanings that were never, even in the slightest degree, in that artist's mind; indeed, which are diametrically opposed to what the artist had in mind. One of Rembrandt's greatest creations, a group-portrait of the Amsterdam militia, has come to be called "Night Watch"—and not only in popular parlance either, for even many art critics base their interpretations of the picture on a nocturnal event! And yet Rembrandt painted the militia in full daylight—indeed, in bright sunshine, as became obvious when the centuries-old yellowed and browning layers of smoke-stained varnish had been removed.

Quite possibly the titles that Escher gave to some of his prints, or for that matter the very subjects that he used, have given rise to abstruse interpretations quite unconnected with the artist's intentions. For this reason he himself regards the titles *Predestination* and *Path of Life* as being really too dramatic, as is also the death's-head in the pupil of the print *Eye*. As Escher himself

has said, one must certainly not try to read any ulterior meaning into these things. "I have never attempted to depict anything mystic; what some people claim to be mysterious is nothing more than a conscious or unconscious deceit! I have played a lot of tricks, and I have had a fine old time expressing concepts in visual terms, with no other aim than to find out ways of putting them on to paper. All I am doing in my prints is to offer a report of my discoveries."

Even so, it remains a fact that all of Escher's prints do have something strange, if not abnormal, about them, and this intrigues the beholder.

This has been my own experience. Nearly every day for a number of years I have looked at *High and Low*, and the more I have delved into it the more strangely has the lithograph affected me. In his book *Graphic Work*, Escher goes no further than a bald description of what anyone can see for himself. "... if the viewer shifts his gaze upward from the ground, then he can see the tiled floor on which he is standing, as a ceiling repeated in the center of the composition. Yet at the same time its function there is that of a floor for the upper portion of the picture. At the very top the tiled floor is repeated once again, but this time only as a ceiling." Now this description is so obvious and so straightforward that I said to myself, "In that case, how does all this fit together, and why are all the 'vertical' lines curved? What are the basic principles hiding behind this print? Why did Escher make it?" It was just as though I had been vouchsafed a glimpse of the front surface of a complicated carpet pattern, and the very pattern itself had given rise to the query, "What does the reverse side look like? How is the weave put together?" Because the only person who could enlighten me on this point was Escher himself, I wrote and asked him for an explanation. By return mail I received an invitation to come along and talk it over with him. That was in August, 1951, and from then onward I visited him regularly. He was extremely happy to be questioned on the background of his work and about the why and the wherefore; he always showed great interest in the articles which I wrote on the subject. When I was preparing this book in 1970, I had the privilege of spending a few hours with him each week throughout practically the whole year.

At that period he had only just recovered from a serious opera-

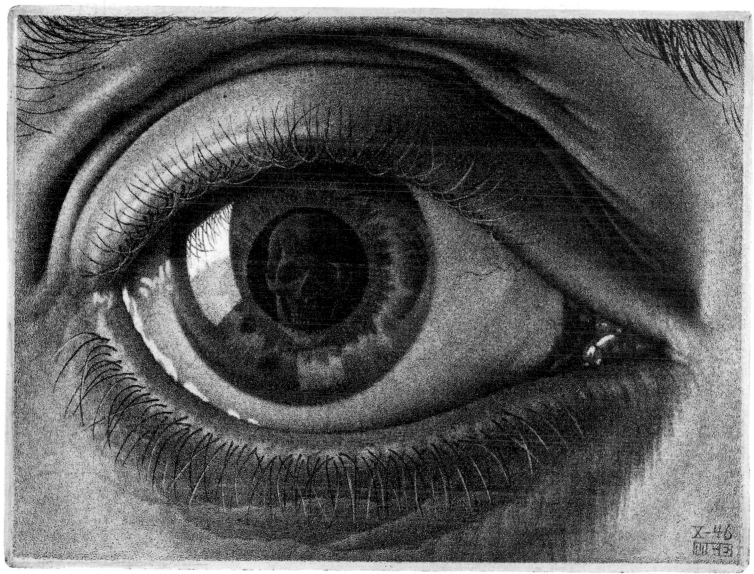

16. *Eye*, mezzotint, 1946

tion and sometimes these conversations were extremely tiring for him. Yet he wanted to go through with them, and he felt a need to explain how it was that he had come to produce his prints, and to expound their origin with the help of the many preparatory studies for them, which he still kept.

## Art Critics

Until recently almost all Dutch print collections had omitted to build up any fair-sized section of Escher's work. He was simply not recognized as an artist. The art critics could not make head or tail of him, so they just ignored his work. It was the mathematicians, crystallographers and physicists who first showed great interest. And yet . . . anyone who is willing to approach his work without preconceived ideas will derive enjoyment from it, whereas those whose only approach is through commentaries

17. "If only you knew the things I have seen in the darkness of night . .

provided by art historians will discover that these latter are no more than a hindrance.

Now that the tide has turned and the public at large seems captivated by Escher's work, official art criticism is bringing up the rear and showing an interest. It really was quite pathetic to see how, on the occasion of the great retrospective exhibition at The Hague, held to commemorate Escher's seventieth birthday, an attempt was made to establish historical parallels. It did not succeed; Escher stands apart. He cannot be slotted in, for he has totally different aims from those of his contemporaries.

It is not fitting to ask of a modern work of art what its meaning is supposed to be. It is presumed that there *is* meaning and that the questioner is therefore an ignoramus. Far better to keep one's mouth shut about it, or to confine oneself to such remarks as "A nice bit of carving," "A clever piece of work," "Isn't that fascinating?" "It does something to one, doesn't it?" and so on.

It is quite a different story with Escher's work. Perhaps this is the reason for his own reluctance to reply when asked what his place is in the present-day world of art. Before 1937, a reply would not have been so difficult to give, for at that time his work was, generally speaking, entirely pictorial. He sketched and drew whatever things he found to be beautiful and did his best to depict them in woodcuts, wood engravings, and lithographs.

Had he continued in this vein he would have attained a comfortable place among the graphic artists of his time. As far as work of this period is concerned one would have no trouble in writing about an artist whose landscapes were at once poetic and attractive, who was capable of producing portraits with a remarkably literal likeness (although, apart from himself, he made portraits only of his father, his wife, and his children). He was clearly an artist with a mastery of technique and great virtuosity. The whole of that well-worn jargon with which the art critic normally tries to introduce an artist's work to the general public could have been easily and aptly used when writing about all his work.

After 1937 the pictorial became a matter of merely secondary importance. He was taken up with regularity and mathematical structure, by continuity and infinity and by the conflict which is to be found in every picture, that of the representation of three dimensions in two. These themes haunted him. Now he was treading paths which no others had yet trodden and there was an infinity of discoveries to make. These themes have their own underlying principles which have to be ferreted out and then obeyed. Here chance holds no sway; here nothing can come into being in any way other than that in which it does come. The pictorial is an extra bonus. From this time onward art criticism can get no purchase on his work. Even a critic who is very sympathetic expresses himself with a certain skepticism: "The question which continually comes up in regard to Escher's work is whether his more recent efforts can come under the heading of art . . . he usually moves me deeply, yet I cannot possibly describe all his work as good. To do so would be ridiculous, and Escher is wise enough to realize this." (G. H. 'sGravesande, *De Vrije Bladen*, The Hague, 1940.) It is worthy of note that this was said about work which we have now come to hold in the highest esteem. This same critic went on to say, "Escher's birds, fishes, and lizards defy description; *they call for a mode of thought which is only to be found among few people.*"

Time has proved that 'sGravesande underestimated his public, or maybe he was thinking only of that tiny group of people who faithfully tramp the galleries and the exhibitions, and never miss a single concert.

It is astonishing how Escher himself, apparently unmoved by the criticism of his work, forged ahead on his chosen way. His work was not selling well, official art criticism passed him by; even his closest associates thought little of it, and yet he still went on making pictures of the things that possessed his mind.

## Cerebral

To those who regarded art as the expression of emotions, the whole of Escher's post-1937 work will be a closed book. For it is cerebral both in aim and in execution, although this does not take away from the fact that, alongside the message, alongside the intellectual content which he is aiming to display, the thrill of discovery comes over also, often in the panache (though not sentimental) of the picture. Yet all the critics who admire Escher try to avoid using the word cerebral. In music, and even more so in the plastic arts, this word is almost synonymous with antiart. It really is rather odd that the intellectual element should be so rigorously excluded. The word cerebral hardly ever plays any part in dissertations on literature, and it is certainly not a term which indicates disapproval or rejection. There it is quite obviously mainly a question of getting a thought content across, but of course in such a form as to fascinate, and to stir the emotions. In my view, it is irrelevant whether a work is called cerebral or not. The simple fact is that at the present time, artists are not sufficiently concerned with thought content to be able to draw on it for inspiration for their work. What matters most is that the artist should be able to give unique form to whatever it is that has taken hold of his mind, so that which cannot be expressed in words will come across pictorially. In Escher's case these ideas center on regularity, structure, continuity, and an inexhaustible delight at the way in which spatial objects can be represented on a flat surface. Such ideas he cannot put into words but he certainly can make them explicit in pictures. His work is cerebral to a high degree in the sense that it is of the mind—a pictorial representation of intellectual understanding.

The most important function of an art critic is to talk about a work in such a way as to help the viewer make contact with it, so to direct his attention to it that the work of art itself begins to speak to him.

With Escher's work, in one respect the critic would seem to have a remarkably easy time of it. He has to give an accurate description of what is to be seen in the print; he does not have to display his own subjective emotions. And for a preliminary acquaintance this is more or less all that is needed to get almost any viewer close enough to the print for the "understanding" of the print to be coupled with the excitement of discovery. It was this excitement that formed the kernel of Escher's own inspiration, and the whole aim of the print has been to transmit the excitement his own discovery brought him.

However, most of the prints have something more than this to offer. Every one of Escher's prints is (albeit temporarily) an end phase. Those who wish to understand and enjoy this end phase in any but a purely superficial way will have to be confronted with the total context. His work bears the character of a quest. He is using the print to make a report, a statement of provisional findings. This is where the critic's task becomes more difficult, for now he has to delve into the general underlying problem postulated by the print, and show how the print fits into it. And if the solution arrived at is on a constructional level, then he will have to throw some light on the mathematical background of the print, through a study of the many preparatory sketches that Escher made.

If he does this then he will help the viewer to see the print in all the fire of its creation, thus adding a new dimension to his viewing. Only then can the print become a living experience, its richness and variety harmonizing with its original inspiration.

Speaking of this inspiration, Escher has said, "If only you knew the things I have seen in the darkness of night . . . at times I have been nearly demented with wretchedness at being unable to express these things in visual terms. In comparison with these thoughts, every single print is a failure, and reflects not even a fraction of what might have been."

# 4 Contrasts in Life and Work

## Duality

Escher's predilection for contrast of black and white is paralleled by his high regard for dual concepts in thought.

Good cannot exist without evil, and if one accepts the notion of God then, on the other hand, one must postulate a devil likewise. This is balance. This duality is my life. Yet I'm told that this cannot be so. People promptly start waxing abstruse over this sort of thing, and pretty soon I can't follow them any further. Yet it really is very simple: white and black, day and night—the graphic artist lives on these.

In any case it is obvious that this duality underlies his whole character. Over against the intellectuality of his work and the meticulous care that goes into the planning of it, there is the great spontaneity of his enjoyment of nature's beauty, of the most ordinary events of life, and of music and literature. He was very sensitive and his reactions were emotional rather than intellectual. For those who did not know him personally perhaps this can best be illustrated with a few extracts from the many letters he has written to me.

*October 12, 1956*
. . . meanwhile I am annoyed that my writing should be so shaky; this is due to tiredness, even in my right hand in spite of the fact that I draw and engrave with my left. However, it seems that my right hand shares so much in the tension that it gets tired in sympathy.

The refraction effect of the prisms is so amazing that I should like to try my hand at one or two. [I had sent him a couple of prisms and had drawn his attention to the pseudoscopic effect that can be achieved with them.] As far as my experiments with them have gone, the most striking effect is that of the way in which the far distance comes forward. The farthest branches, half in the mist, suddenly appear smack in front of the tree close at hand like a magic haze. How is it that a phenomenon like this should move us so? Undoubtedly a good deal of childlike wonder is necessary.

And this I do possess in fair quantity, wonderment is the salt of the earth.

*November 6, 1957*
To me the moon is a symbol of apathy, the lack of wonderment which is the lot of most people. Who feels a sense of wonder any more, when they see her hanging there in the heavens? For most people she is just a flat disc, now and then with a bite out of her, nothing more than a substitute for a street lamp. Leonardo da Vinci wrote of the moon, '*La luna grave e densa, come sta, la luna?*' *Grave e densa* heavy and compact one might translate it. With these words Leonardo gives accurate expression to the breathless wonder that takes hold of us when we gaze at that object, that enormous, compact sphere floating along up there.

*September 26, 1957*
Home once more, after a six-and-a-half-week voyage by freighter in the Mediterranean. Was it a dream, or was it real? An old steamship, a dream-ship, bearing the name of *Luna*, bore me, its passenger bereft of will, right beyond the sea of Marmora to Byzantium, that absolutely unreal metropolis with its population of one and a half million Orientals swarming like ants . . . then on to idyllic strands with their tiny Byzantine churches among the palms and agaves. . . .

I am still under the spell of the rhythmic dreamswell which came to me under the sign of the comet Mrkos (1957d). For a whole month and more I followed it, night after night, standing on the pitch-dark deck of the *Luna* . . . as in the glittering heavens, with its slightly curved tail, it displayed itself fiercely and astonishingly . . .

*December 1, 1957*
As I write, there, immediately in front of my large studio window I can watch a fascinating performance, played out by a highly proficient troupe of acrobats. I have stretched a wire for them a few feet away from my window. Here my acrobats do their balancing act with such consummate skill, and get such enjoyment out of their tumbles that I can scarcely keep my eyes off them.

My protagonists comprise coaltits, bluetits, marshtits, long-tailed tits, and crested tits. Every now and then they are chased away by a pair of fierce nuthatches (blue back and orange belly), with their stubby supporting tails and woodpecker type of beak. The shy little robin redbreast (although as intolerant and selfish as any other individual among his own family) can muster up only enough courage to peck the odd seed from time to time, and clears off the moment a tit lays claim to the bird table. I have not seen the spotted woodpecker yet; normally he does not arrive until later in the winter season. The simple, innocent blackbirds and finches stay on the ground and content themselves with the grains that fall down from above. And quite an amount does fall; the nuthatches especially are as rough, ill-mannered and messy as any pirate; so the seed comes raining down on the ground when they are tucking in on the bird table. Every year the tits have to go through the process of learning how to hang head downward so as to peck the threaded peanuts. To start with they always attempt to remain balanced, with flapping wings about the swinging peanut pendant. But it seems that it is impossible for them to peck while flapping or to flap while pecking. And so at last they make the discovery that the best position for pecking at peanuts is hanging upside down.

## Fellow Men

My work has nothing to do with people, nor with psychology either. I have no idea how to cope with reality; my work does not touch it. I'm sure this is all wrong . . . I know you are supposed to rub shoulders with folk, and to help them so that everything turns out for the best for them. But I do not have any interest in humanity; I have got a great big garden for the express purpose of keeping all these folks away from me. I imagine them breaking in and shouting, "What's the big idea of this huge garden?" They

are quite justified of course, but I cannot work if I find them there. I am shy and I find it very difficult to get along with strangers. I have never enjoyed going out. . . . With my work one needs to be alone. I can't bear to have anybody go past my window. I shun both noise and commotion. I am psychologically incapable of making a portrait. To have someone sitting there right in front of me is inhibiting.

Why have we got to have our noses rubbed in all this wretched realism? Why can't we just enjoy ourselves? Sometimes the thought comes to me: "Ought I to be going on like this? Is my work not serious enough? Fancy doing all this stuff, while on TV there is this terrible Vietnam affair . . ."

I really don't feel all that brotherly. I don't have much belief in all this compassion for one another. Except in the case of the really good folk; and they don't make a song about it.

All these rather cynical utterances come from an interview with a journalist from the magazine *Vrij Nederland*. They could be supplemented by many comments taken from personal conversations, ranging from the deceit that is practiced by those who persist in talking people into having religious feelings, through Escher's opinion that all men are at each other's throats and that the strongest always wins, to his views on suicide (viz., if you have had enough you ought to be able to decide for yourself whether or not you want to disappear).

When Escher gave vent to these thoughts he meant them from the bottom of his heart, but here too there emerges a remarkable dichotomy. In his dealings with others he was a truly gentle and kindly person who could not possibly do ill to any man nor dream of harming anyone.

In the same interview in which he expressed his disgust over the fact that there are still people who sacrifice their lives to a false idea by living in monasteries, he showed me with great enthusiasm a newspaper article containing the report of a nun who had dedicated herself entirely to the relief of suffering in Vietnam.

Escher never had money troubles, but if the need arose his father would always give him financial help. When, after 1960, he began to earn large sums for his work, he showed no interest whatsoever in the money. He continued to live frugally, just as he always had, and that means *very* frugally, not far short of asceticism. It gave him pleasure to think that his work should sell so well, and he regarded success as a sure sign of appreciation. The fact that his bank balance was increasing as a result left him cold. "At the moment I am able to sell an incredible amount of my work. If I had assistants in my studio I could be a multimillionaire. They could spend the whole day running off woodcuts to satisfy the demand. I have no intention of doing any such thing; I wouldn't dream of it!"

"That would be no better than a bank note; you just print it off and get so much cash for it." In a personal interview he said, "Do you realize I worked for years on a design for the 100-guilder note, on commission from the Netherlands Bank? That did not come to anything, but nowadays I'm turning out my own five-hundred-dollar bills by my own primitive method!"

When, in later years, he became less financially dependent on his parents and his work suddenly started to bring in a great deal of money, he went on living frugally and gave away much of his earnings to help others who were in difficulties. And all this in spite of his notion that every man ought to fend for himself and that the sufferings of others were really no concern of his.

This ambivalence is a permanent part of his character. Perhaps one can explain the conjunction of such contrasting elements in the one personality by Escher's aversion to all compromise and by his thirst for honesty and clarity. He was aware of his lack of involvement, and that he therefore missed out on a certain something which might have helped him to be more at ease with his fellow men. On the other hand he was never willing to put up any pretense. He was far too absorbed in his work and in those

ideals which are exclusively connected with the sphere of his art to be able to concern himself with the weal and woe of the great family of man. Because he was so well aware of this, and indeed sad about it, he could avoid the admission that the sufferings of others did not concern him. Nevertheless, when he did feel obliged to take to heart the lot of others, he refused to fall back on words only, but helped with deeds.

All this may give the impression that he had no need of any fellow feeling for his work, or that positive and negative criticism alike left him cold. It is true that he found his own direction and style, in spite of the minimal interest in it which he had to endure. But the fact is that his entire way of working was oriented toward widespread distribution. He made no once-for-all prints. Nor did he ever limit the number of impressions. He printed off slowly and carefully, and then only as the requests came in. And when I asked him if I might have six full-sized prints published, so that they could be offered at cost price to young readers of the mathematical magazine *Pythagoras*, he did not have the slightest objection. When the bibliophile De Roos Foundation asked him to write and illustrate a short book, he wrote to me thus:

. . . it has a magnificently precious cover (in my opinion far too splendid, but then so are all these half-baked bibliographies), in a limited edition of 175 copies, destined exclusively for members of De Roos—who have to pay through the nose for the privilege. This whole preciousness of theirs is quite foreign to my nature and I thoroughly deplore the fact that the majority of the copies will come into the hands of people who set more store by the form than by the contents and who will read little or nothing of the text. . . . I always feel a little scornful and aggravated when books are brought out in a limited edition for a so-called select group.

Escher was very proud when Professor Hugh Nichol, in 1960, wrote an article about his work and entitled it *Everyman's Artist*.

It affected him deeply when people whom he knew to have little money purchased his prints: "They save up their precious pennies for them and that speaks volumes; I only hope they get inspiration in return." And happily and tenderly he once showed me a letter he had received from a group of young Americans; underneath a drawing, they had written, "Mr. Escher, thank you for being."

It is sometimes claimed that Escher was a difficult man to get on with; yet I can call to mind very few men more friendly than he. But he resented being approached by people who had no real appreciation of his work, who simply wanted to be able to say that they had once spoken to Escher, or people who wanted to make use of him. He regarded his time as being too valuable to waste on sycophants.

His prints and his work took precedence over everything else. Yet he had the capacity to look at it all from the angle of an outsider, and in relation to the whole output of mankind. While he was actually engaged in making a print, it was to him the most important thing in all the world, and during this time he would not tolerate the slightest criticism, even from the most intimate friends. This would simply have served to take the heart out of any further work on it. Yet once the print reached its final form, then he himself would adopt an attitude of extreme criticism toward it and become open to criticism from others. "I find my work to be the most beautiful and the most ugly!"

His own work was never found in his house, or even in his studio; he could not bear to have it around him.

What I produce is not anything very special. I can't understand why more people don't do it. People ought not to get infatuated by my prints; let them get on and make something for themselves; surely that would give them more enjoyment.

While I am on with something I think I am making the most beautiful thing in the whole world. If something comes off well, then I sit there in the evening gazing lovingly at it. And this love is far greater than any love for a person. The next day, one's eyes are opened again.

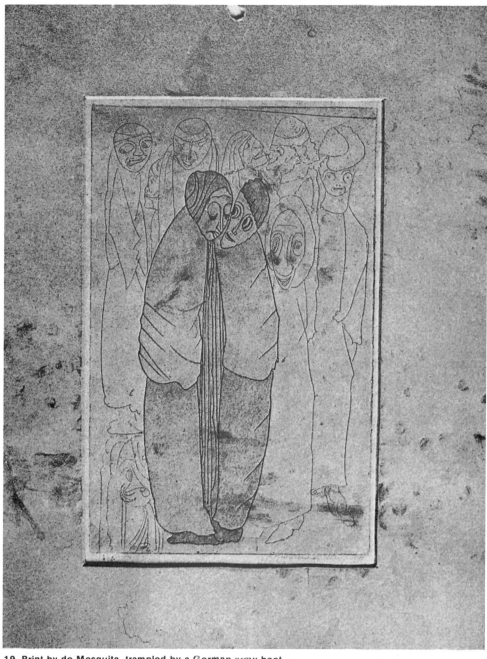

18. Jesserun de Mesquita

19. Print by de Mesquita, trampled by a German army boot

## Escher and Jesserun de Mesquita

It is characteristic of Escher and of his faithfulness and gratitude to his teacher in the art of the woodcut, Jesserun de Mesquita, that he always kept a photograph of his teacher pinned on a cupboard door in his studio. When I asked him if I might have a reproduction made of it, he agreed so long as he could have it back within a week. Escher had a similar attachment to one of Mesquita's prints which he had found in the deserted house after Mesquita had been taken away to a German concentration camp. The words which Escher wrote on the back of this print, in 1945, testify, with his usual precision, to an underlying intensity of emotion:

"Found at the end of February, 1944 at the home of S. Jesserun de Mesquita, immediately behind the front door, and trampled on by German hob-nailed boots. Some four weeks previously, during the night of January 31 to February 1, 1945, the Mes-

quita family had been hauled out of bed and taken away. The front door was standing open when I arrived at the end of February. I went upstairs to the studio; the windows had been smashed and the wind was blowing through the house. Hundreds of graphic prints lay spread about the floor in utter confusion. In five minutes I gathered together as many as I could carry, using some pieces of cardboard to make a kind of portfolio. I took them over to Baarn. In all there turned out to be about 160 prints, nearly all graphic, signed and dated. In November, 1945 I transferred them all to the Municipal Museum in Amsterdam, where I plan to organise an exhibition of them, along with such works of de Mesquita as are already being kept there, and those in the care of D. Bouvy in Bussum. It must now be regarded as practically certain that S. Jesserun de Mesquita, his wife and their son Jaap all perished in a German Camp.

November 1, 1945. M. C. Escher."

# 5   How His Work Developed

**Themes**

Viewing Escher's work as a whole, we find that, in addition to a number of prints which have primarily southern Italian and Mediterranean landscape as their theme, and which were nearly all made prior to 1937, there are some seventy prints (post-1937) with a mathematical flavor.

In these seventy prints Escher never repeats himself. He indulged in repetition only if he was working on a commission. From his free work one can see that from first to last he is engaged in a voyage of discovery and that every print is a report on his findings. In order to gain an insight into his work one must not only make a careful analysis of each separate print but also take all seventy prints and read them as a logbook of Escher's voyage of discovery. This voyage spans three areas—that is to say, the three themes that can be discerned among the mathematical prints.

1. *Spatial structure.* Viewing his work as a whole, one can observe that even in the pre-1937 landscape prints it was not so much the picturesque that was being aimed at, but rather, structure. Wherever this latter feature was almost entirely lacking, as in ruins, for instance, Escher had no interest in the scene. In spite of his ten-year sojourn in Rome, all among the remains of an ancient civilization, he scarcely devoted a single print to it, and visits to Pompeii have left no trace whatsoever in his work.

After 1937 he no longer dealt with spatial structure in an analytical way. He no longer left space intact just as he found it but produced a synthesis in which differing spatial entities came together in one, *and in the same* print, with compelling logic. We see the results of this in those prints where different structures interpenetrate. Attention to strictly mathematical structures reaches its height at a later stage and originates in his admiration for the shapes of crystals. There are three categories of this spatial structure theme:

    a. Landscape prints.
    b. Interpenetration of different worlds.
    c. Abstract, mathematical solids.

2. *Flat surface structure.* This begins with an interest in regular tessellations (i.e., identical or graduated surface divisions),

stimulated in particular by his visits to the Alhambra. After an intensive study, by no means an easy task for a nonmathematician, he worked out a whole system for such periodic drawings.

Finally the periodic drawing turns up again in his approaches to infinity, although in this case the surface is filled up not with congruent figures but with those of similar shape. This gives rise to more complicated problems and it is not until later that we find this kind of print appearing.

Thus flat surface structure studies can be basically divided into these categories:

    a. Metamorphoses.
    b. Cycles.
    c. Approaches to infinity.

3. *The relationship between space and flat surface in regard to pictorial representation.* Escher found himself confronted at an early stage with the conflicted situation that is inherent in all spatial representation—i.e., three dimensions are to be represented on a two-dimensional surface. He gave expression to his amazement about this in his perspective prints.

He subjects the laws of perspective, which have held sway in spatial representation ever since the Renaissance, to a critical scrutiny, and, having discovered new laws, illustrates these in his perspective prints. The suggestion of three dimensions in flat-picture representation can be taken to such lengths that worlds which could not even exist in three-dimensional terms can be suggested on a flat surface. The picture appears as the projection of a three dimensional object on a flat surface, yet it is a figure that could not possibly exist in space.

In this last section too we find three groups of prints:

    a. The essence of representation (conflict between space and flat surface).
    b. Perspective.
    c. Impossible figures.

**Chronology**

Careful analysis of the post-1937 prints shows that the different themes appear at different periods. That this fact has not been

# 1. Spatial structure

**Landscape prints**              **Interpenetration of different worlds**            **Abstract, mathematical solids**

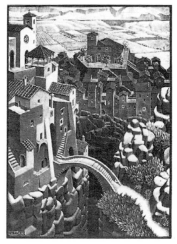

*Town in Southern Italy*

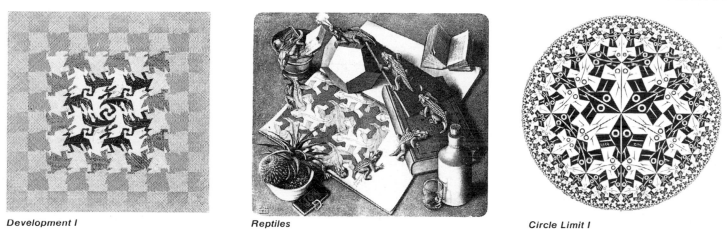

*Hand with Reflecting Sphere*

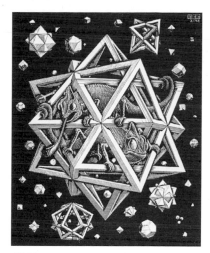

*Stars*

# 2. Flat surface structure

**Metamorphoses**              **Cycles**              **Approaches to infinity**

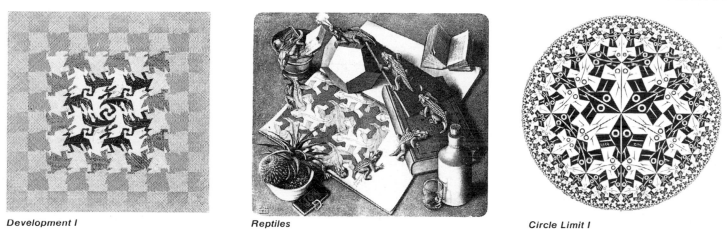

*Development I*              *Reptiles*              *Circle Limit I*

# 3. Pictorial representation of the relationship between space and flat surface

**The essence of representation**           **Perspective**           **Impossible figures**

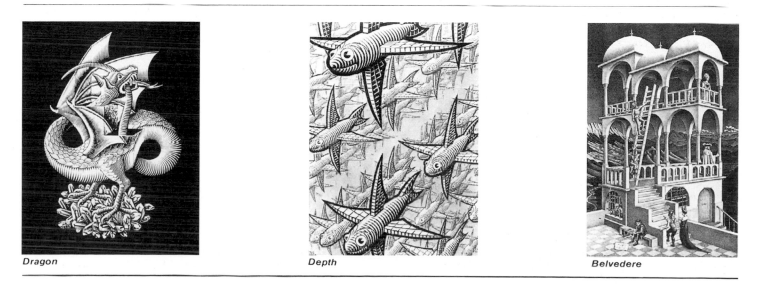

*Dragon*              *Depth*              *Belvedere*

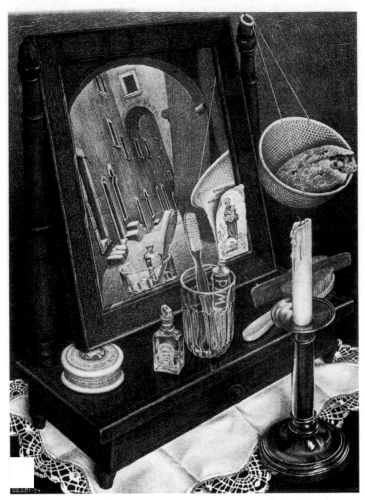

**23.** *Still Life with Mirror,* lithograph, 1934

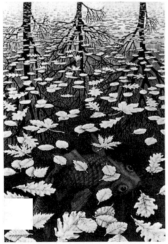

**24.** *Three Worlds,* lithograph, 1955

noticed sooner is probably due to the difficulty of analyzing the prints and to the fact that in any given period a number of themes occupied Escher's mind simultaneously. Moreover, each period had its time of predevelopment, and so did not announce its arrival very clearly; what is more, a particular theme might very well turn up again even when the time of full attention to that theme had passed.

We shall try to assign years to the various periods, marking their beginning and end with certain prints. We shall also try to state which print, in our view, may be regarded as the highest point of the period in question.

### 1922–1937 Landscape Period

Most of these prints depict landscapes and small towns in southern Italy and the Mediterranean coastal areas. Apart from that, there are a few portraits and some plants and animals. A high point was undoubtedly reached with *Castrovalva* (1930), a large-sized lithograph of a small town in the Abruzzi. A new line of thought was showing itself in 1934, in the lithograph *Still Life with Mirror*, in which the mingling of two worlds was achieved by the reflection in a shaving mirror. This theme, which can be seen as a direct continuation of the landscape prints, is the only one which is not tied to any particular period. The last print of this type, which incidentally we might count as the high point, and which appeared in 1955, was *Three Worlds*, a lithograph full of calm, autumn beauty; and the unsuspecting viewer can scarcely realize what a triumph it was for Escher to succeed in representing here three different worlds in the one place, and so realistically too.

### 1937–1945 Metamorphoses Period

The print which heralds this period, *Metamorphosis I* (1937), shows the gradual transformation of a small town, through cubes, to a Chinese doll.

It is not easy to point to any high-water mark in this period. I will pick out *Day and Night* (1938) for this. All the characteristics of the period are to be found in it; it is a metamorphosis and at the same time a cycle, and, what is more, we can observe the change-over from two-dimensional forms (via ploughed fields) to three-dimensional ones (birds). The final metamorphosis-cycle print of this period *(Magic Mirror)* appeared in 1946.

The essence of representation that is already implicitly enunciated in the first of the metamorphosis prints (i.e., transformation from the two-dimensional to the three-dimensional) is explicitly stated only at the latter end of the period, in the print *Doric Columns* (1945). In 1948 there came the most beautiful print, *Drawing Hands,* and the very last print on this theme was made in 1952 *(Dragon).* These last-mentioned prints extend chronologically far into the following period.

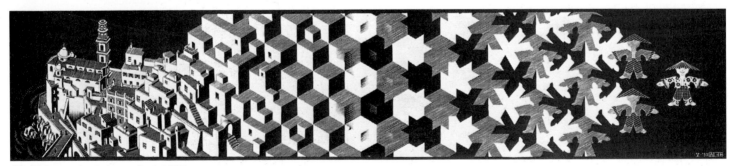

**25.** *Metamorphosis I,* woodcut, 1937

With the making of *St. Peter's, Rome* in 1935 and the *Tower of Babel* in 1928, all Escher's special interest in unconventional standpoints came to the fore. Already it was not so much a question of what one was trying to depict in the picture but rather of the idiosyncracies of the perspective that was being used in it. But it was in 1946 that the great quest really began into the regions beyond the traditional rules of perspective. The mezzotint *Other World* (1946), though not wholly successful as a print, introduced a point which was simultaneously zenith, nadir, and vanishing point. The best example of this period is undoubtedly *High and Low* (1947), in which in addition to a relativity of vanishing points we note bundles of parallel lines depicted as convergent curves.

At the close of this period there is a return to traditional perspective *(Depth)* when Escher is aiming at suggesting the infinity of space.

During this same period Escher's interest in straightforward geometrical spatial figures, such as regular multisurfaces, spatial spirals, and Moebius strips, came to the fore. The origin of this interest is to be found in Escher's delight in natural crystal shapes. His brother was a professor of geology and wrote a scientific handbook on minerology and crystallography. The first print was *Crystal* (1947). *Stars* (1948) is almost certainly the high point. In 1954 the last of the prints entirely devoted to stereometric figuration *(Tetrahedral Planetoid)* was made.

We do meet with a few more spatial figures in later prints, but then only as incidental ornamentation, such as the figures standing on the corner towers in *Waterfall* (1961).

In spite of the fact that they appeared at a later stage, the Moebius prints really belong to this period. Such figures were completely unknown to Escher at the time, but as soon as a mathematician friend of his pointed them out to him, he used them in prints, almost as if he wanted to make good an omission.

*1956–1970 Period of Approaches to Infinity*

This period started off in 1956 with the wood engraving *Smaller and Smaller I.* The colored woodcut *Circle Limit III* (1959) was, even in his own opinion, much the best print dealing with this subject. Escher's very last print, in the year 1969 *(Snakes),* is an approach to infinity.

In this period also the so-called impossible figures appeared, the first being *Convex and Concave* (1955) and the last *Waterfall* (1961).

The cleverest and most impressive print of this period, without doubt a highlight in the whole of Escher's work, is *Print Gallery* (1956). If one were to apply to it the same aesthetic standards as to art of an earlier time, then one could find a great deal of fault with it. But what applies to every one of Escher's prints applies here: an approach through the senses would miss entirely the deepest intentions of the artist. Escher's own opinion was that in *Print Gallery* he had reached the furthest bounds of his thinking and of his powers of representation.

## Prelude and Transition

The remarkable revolution that took place in Escher's work was between 1934 and 1937. This transition definitely coincided with a change of domicile, although it is in no way explained by it. As long as Escher remained in Rome he continued to be entirely oriented toward the beauty of the Italian landscape. Immediately after his move, first to Switzerland, and then to Belgium

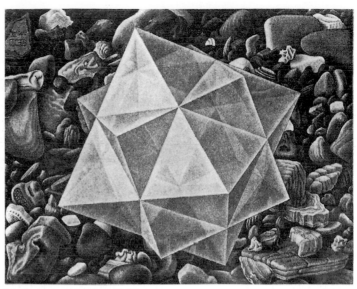

**26. *Crystal*, mezzotint, 1947**

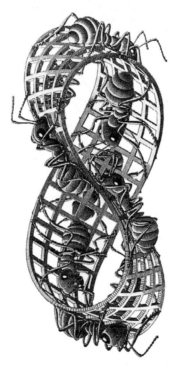

**27. *Moebius Strip II*, wood engraving, 1963**

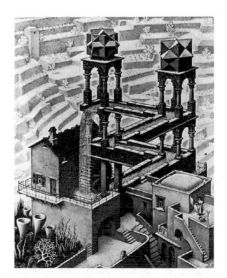

**28. *Waterfall*, lithograph, 1961**

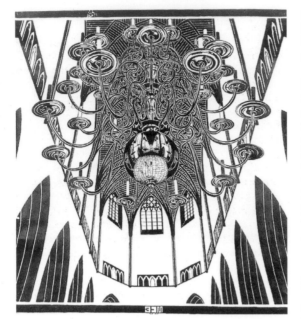

29. *St. Bavo's, Haarlem*, India ink, 1920

30. *Self-Portrait in Chair*, woodcut

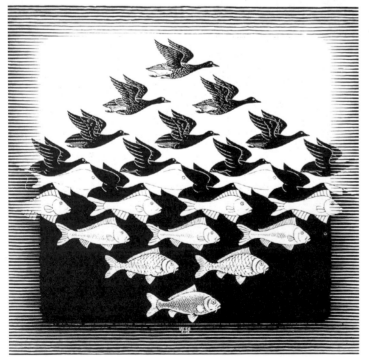

31. *Sky and Water I*, woodcut, 1938

and Holland, an inward change took place. No longer could he find the same inspiration in the outer visual world, but rather in mental constructions which can be expressed and described only mathematically.

It is obvious that no artist can experience such an abrupt transformation out of the blue. Had there not been a predisposition for it, the mathematical turn in his work could never have come about. However, it would be wrong to look for this predisposition in any scientifically mathematical interest. Escher bluntly declared to all who were willing to listen that he was a complete layman in the sphere of mathematics. He once said in an interview, "I never got a pass mark in math. The funny thing is I seem to latch on to mathematical theories without realizing what is happening. No indeed, I was a pretty poor pupil at school. And just imagine—mathematicians now use my prints to illustrate their books. Fancy me consorting with all these learned folk, as though I were their long-lost brother. I guess they are quite unaware of the fact that I'm ignorant about the whole thing."

And yet, this is indeed the truth. Anyone who tried to get a mathematical statement out of Escher, at any rate one which goes beyond what the merest secondary-school student knows, had the same sort of disappointment as that experienced by Professor Coxeter, who was fascinated by Escher's work because of its mathematical content. He took the artist along to attend one of his lectures, convinced that Escher would surely be able to understand it. Coxeter's lecture was about a subject that Escher had used in his prints. As might have been expected, Escher did not understand a thing about it. He had no use for abstract ideas, even though he agreed that they could be very brilliant, and admired anyone who felt at home among abstractions. But if an abstract idea had a point of contact with concrete reality then Escher was able to do something about it, and the idea would promptly take on a concrete form. He did not work like a mathematician but much more like a skilled carpenter who constructs with folding rule and gauge, and with solid results in mind.

In his earliest work, even when he was still at college in Haarlem, we can detect a prelude, although these recurring themes will be revealed only to those who really do know his later work. He did a large pen-and-ink drawing in St. Bavo's Cathedral, in 1920, on a sheet measuring more than a meter square. An enormous brass candelabrum is, so to speak, imprisoned in the side aisles of the cathedral. But in the shining sphere underneath the candelabrum we can see the whole cathedral reflected, and even the artist himself! Here, already, is an involvement with perspective and with the intermingling of two worlds by means of a convex reflection.

Self-portraits are usually made in front of a mirror, but in one of the self-portraits of this period (a woodcut) the mirror, although obviously being used, is invisible. Escher has placed the mirror at an angle at the edge of the bed, and so achieves an unusual viewpoint for this portrait.

A woodcut made in 1922, very early in his career, shows a large number of heads filling the entire surface. It was printed by the repetition of a single block on which eight heads had been cut, four of them right-side up and four upside-down. This sort of thing was not in the program of his teacher, de Mesquita. Both the complete filling up of the surface and the repetition of theme by making imprints of the same block next to each other were done on Escher's own initiative.

After he had visited the Alhambra for the first time, we can see a new attempt to make use of periodic surface-division. A few sketches of this, together with a few textile-design prints, have survived from 1926.* They are somewhat labored and awkward efforts. Half of the creatures are standing on their heads, and the little figures are primitive and lacking in detail. Surely these attempts serve to show very clearly how difficult any exploration in this field was, even for Escher!

After a second visit to the Alhambra, in 1936, and the subsequent systematic study of the possibilities of periodic surface-division, there appeared, in quick succession, a number of prints of outstanding originality: in May, 1937, *Metamorphosis I;* in November *Development;* and then in February, 1938, the well-known woodcut *Day and Night,* which immediately made a vital impact on those who admired Escher's work and which, from that moment onward, was one of the most sought-after of his prints. In May, 1938, the lithograph *Cycle* appeared, and in June more or less the same theme as in *Day and Night* was taken up again, in *Sky and Water I.*

The south Italian landscape and town scenes had now disappeared for good. Escher's mind was saturated with them and his portfolios were filled with hundreds of these sketches. He was to make use of them later, not as main subjects for prints, but rather as filling, as secondary material for prints with totally different types of content. In 1938 G. H. 'sGravesande devoted an article to this new work, in the November number of *Elsevier's Monthly Magazine:* "But the never-ending production of landscapes could not possibly satisfy his philosophical mind. He is in search of other objectives; so he makes his glass globe with the portrait in it a most remarkable work of art. A new concept is forcing him to make prints in which his undoubted architectural propensities can join forces with his literary spirit. . . ." Then there follows a description of the prints made in 1937 and 1938.

At the end of an article written, once again, by 'sGravesande, we read, "What Escher will give us in the future—and he is still a comparatively young man—cannot be predicted. If I interpret things aright, then he is bound to go beyond these experiments and apply his skill to industrial art, textile design, ceramics, etc., to which it is particularly suited." True enough—no prediction could be made, by 'sGravesande or even by Escher himself.

Escher's new work did not result in making him any more widely known; official art criticism passed him by entirely for ten whole years, as we have already seen. Then in the February, 1951, issue of *The Studio,* Marc Severin published an article on Escher's post-1937 work. At a single blow, this made him widely known. Severin referred to Escher as a remarkable and original artist who was able to depict the poetry of the mathematical side of things in a most striking way. Never before had so comprehensive and appreciative an appraisal of Escher's work been made in any official art magazine, and this was heart-warming for the fifty-three-year-old artist.

An even more outspoken and perceptive critique appeared in an article by the graphic artist Albert Flocon, in *Jardin des Arts* in October, 1965.

> His art is always accompanied by a somewhat passive emotion, the intellectual thrill of discovering a compelling structure in it and one which is a complete contrast to our everyday experience, and, to be sure, even calls it in question. Such fundamental concepts as above and below, right and left, near and far appear to be no more than relative and interchangeable at will. Here we see entirely new relationships between points, surface, and spaces, between cause and effect, and these go to make spatial structures which call up worlds at once strange and yet perfectly possible.

Flocon placed Escher among the thinkers of art—Piero della Francesca, Da Vinci, Dürer, Jannitzer, Bosse-Desargues, and Père Nicon—for whom the art of seeing and of reproducing the seen has to be accompanied by a research into fundamentals. "His work teaches us that the most perfect surrealism is latent in reality, if only one will take the trouble to get at the underlying principles of it."

In 1968, on the occasion of Escher's seventieth birthday, a great retrospective exhibition of his work was held in the municipal museum at The Hague. As far as the numbers of visitors were concerned this exhibition did not fall behind the Rembrandt Exhibition. There were days on which one could scarcely get near the prints. The onlookers stood in serried ranks in front of the display walls, and the fairly expensive catalogue had to be reprinted.

The Netherlands Minister for Foreign Affairs commissioned a film about Escher and his work. This was completed in 1970. Inspired by Escher's prints, the composer Juriaan Andriessen wrote a modern work which was performed by the Rotterdam Philharmonic Orchestra, together with a synchronized projection of Escher's prints. The three performances, toward the end of 1970, drew full houses, with audiences especially of young people. Enthusiasm was so great that large sections of the work had to be repeated.

Now Escher is more widely known and appreciated as a graphic artist than any other member of his profession.

**32. Tile mural, (First) Liberal Christian Lyceum, The Hague, 1960**

---

* After reading this part of the manuscript, Escher added this comment: "He is also always concerned with the recognizability of the figures which go to make up his surface-filling. Each element must make the viewer think of some shape which he recognizes, be it in living nature (usually an animal, sometimes a plant) or at times an object of daily use."

# 6   Drawing Is Deception

If a hand is drawing a hand and if, at the same time, this second hand is busy drawing the first hand also, and if all this is illustrated on a piece of paper fixed to a drawing board with thumb tacks . . . and if the whole thing is then drawn again, we may well describe it as a sort of superdeception.

Drawing is indeed deception. We are being persuaded that we are looking at a three-dimensional world, whereas the drawing paper is merely two-dimensional. Escher regarded this as a conflict situation and he tried to show this very closely in a number of prints, such for instance as the lithograph *Drawing Hands* (1948). And in this chapter we shall deal not only with those particular prints but also with some in which this conflict appears as a secondary incidental feature.

## The Rebellious Dragon

At first sight, the wood engraving *Dragon,* made in 1952, merely depicts a rather decorative little winged dragon, standing on a clump of quartz crystals. But this particular dragon is sticking his head straight through one of his wings and his tail through the lower part of his body. As soon as we realize that this is happening, and in a peculiar mathematical way at that, we arrive at an understanding of what the print is all about.

We would not give a second thought to a dragon like the one in figure 35; but then it is worth bearing in mind that in this case, as with all the pictures, the dragon is flat. He is two-dimensional! Yet we are so accustomed to pictures of three-dimensional things expressed in the two dimensions of drawing paper, photograph, or movie screen, that we do in fact see the dragon in three dimensions. We think we can tell where he is fat and where he is thin; we could even try estimating his weight! An arrangement of nine lines we immediately recognize as a spatial object, *i.e.,* a cube. This is sheer self-deception. This is what Escher tried to demonstrate in this *Dragon* print. "After I had drawn the dragon [as shown in figure 35] I cut the paper open at *AB* and *CD,* folding it to make square gaps. Through these openings I pulled the pieces of paper on which the head and the tail were drawn. Now it was obvious to anybody that it was completely flat. But the dragon

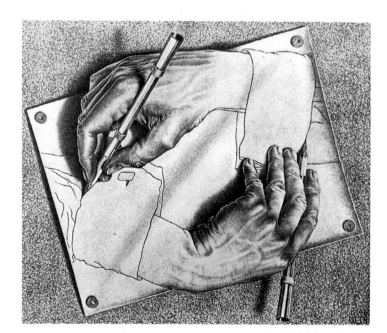

**33. *Drawing Hands,* lithograph, 1948**

didn't seem too pleased with this arrangement, for he started biting his tail, as could only be done in three dimensions. He was just poking fun—and his tail—at all my efforts."

The result is an example of flawless technique, and when we look at the picture we can scarcely realize how immensely difficult it has been to achieve so clear a representation of the conflict between the three dimensions suggested and the two dimensions available for doing it. Fortunately, a few preparatory sketches for this print have been preserved. Figure 36 shows a pelican sticking his long beak through his breast. This particular subject was rejected—because it did not offer enough possibilities.

In figure 37 we find a sketch of the dragon in which all the essential elements of the print are already present. Now comes the difficult task of getting the cut-open and folded part into correct perspective, so that the viewer will unmistakably recognize the gaps. For Escher can suggest that the dragon is completely flat only if he depicts the two incisions and the foldings very

realistically—that is to say, three-dimensionally. The deception is thus revealed by means of another deception! The diamond shapes in figure 38 will help us to follow this perspective more easily. In figure 39 the dragon is really and truly flat, cut, and folded. Finally, figure 40 introduces a possible variation; in this case the folds are not parallel but are at right angles to each other. This idea has not been worked out any further.

## And Still It Is Flat

The upper section of the wood engraving *Three Spheres I* (1945), consists of a number of ellipses, or, if one prefers it that way, a number of small quadrangles arranged elliptically. We find it practically impossible to rid ourselves of the notion that we are looking at a sphere. But Escher would like to get it into our heads that no sphere is involved at all; the whole thing is flat. So he folds back the topmost section and re-draws the resultant figure beneath the so-called sphere. But still we find ourselves given over to a three-dimensional interpretation; we can now see a hemisphere with a lid! Right, so Escher draws the top figure once again but this time lying flat. Yet even now we refuse to accept it, for what we see this time is an oval, inflated balloon, and certainly not a flat surface with curved lines drawn on it. The photograph (figure 42) illustrates what Escher has done.

The engraving *Doric Columns*, made in the same year, has precisely the same effect. It really is too bad that we cannot be convinced of the flatness of the print; and what is worse, the very means that Escher uses are exactly the same as the malady that

**34.** *Dragon*, wood engraving, 1952

**35. The paper Dragon**

**36. A pelican did not offer enough possibilities**

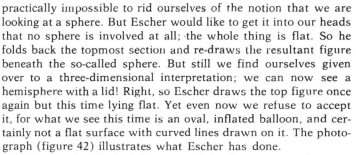

**37.**

**39.**

**38.**

**40.**

Preparatory studies for the wood engraving, *Dragon*

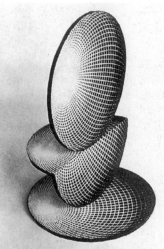

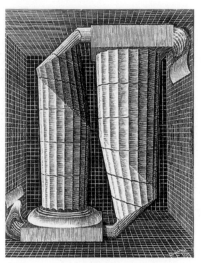

41. *Three Spheres I*, wood engraving, 1945

42. **Photograph of three spheres—** not spheres, but flat circles

43. *Doric Columns*, wood engraving, 1945

he is trying to cure. In order to make it appear that the middle figure is on a flat drawing surface, he makes use of the fact that such a surface can be used to give an impression of three dimensions.

Both from a structural point of view and as a wood engraving, this print is incredibly clever. In earlier days this would have been regarded as a master test for a wood engraver.

## How 3-D Grows Out of 2-D

Because drawing is deception—i.e., suggestion instead of reality—we may well go a step further, and produce a three-dimensional world out of a two-dimensional one.

In the lithograph *Reptiles* (1943) we see Escher's sketchbook, in which he has been putting together some ideas for periodic drawings. At the lower left-hand edge the little, flat, sketchy figures begin to develop a fantastic three-dimensionality and thereby the ability to creep right out of the sketch. As this reptile reaches the dodecahedron, by way of the book on zoology and the set square, he gives a snort of triumph and blows smoke from his nostrils. But the game is up, so down he jumps from the brass mortar on to the sketchbook. He shrivels back again into a figure and there he remains, stuck fast in the network of regular triangles.

In figure 45 we see the sketchbook page reproduced. The remarkably interesting thing about this surface division is the existence of three different types of rotation point. These are: where three heads come together, where three feet touch, and where three "knees" meet. If we were to trace the design on transparent paper, and then stick a pin through both tracing paper and drawing at one of the above named points, we could turn the tracing paper through 120 degrees, and this would make the figures on the tracing paper fit over those of the drawing once again.

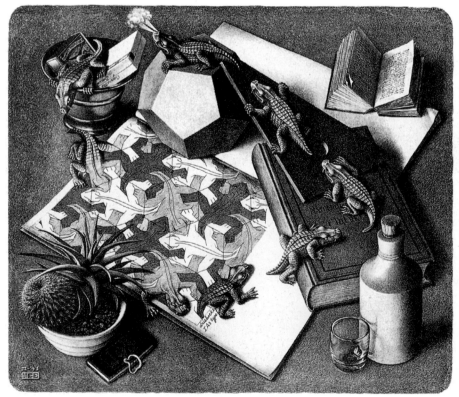

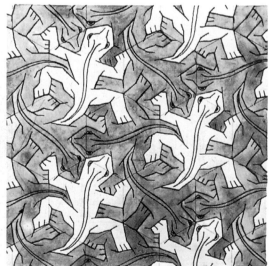

45. **Sketch for *Reptiles*, pen, ink, and watercolor, 1939**

44. *Reptiles*, lithograph, 1943

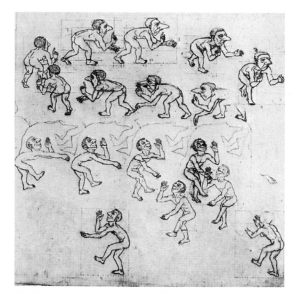

**46. Sketch for *Encounter*, pencil, 1944**

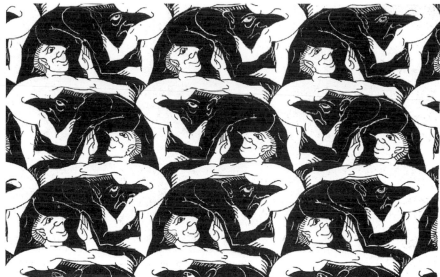

**48. The periodic space-filling that was the basis for *Encounter*, pencil and India ink, 1944**

## White Meets Black

In the lithograph *Encounter* (1944) we can see a periodic drawing division consisting of black and white figures painted on a wall. At right angles to the wall there is fixed a floor with a large circular hole in it. The little men seem to sense the proximity of the floor, because as soon as they get near to it they step down from the wall, take on a further dimension in doing so, and then shuffle in rather a wooden fashion along the edge of the chasm. By the time the black and white figures meet, the transformation into real people is so far advanced that they are able to shake hands. The first time this print was reproduced an art dealer rather hesitated to put it on display because the little white man resembled Colijn, a popular Dutch prime minister! Escher had not intended this in the least; the figures had, so to speak, evolved spontaneously out of the periodic division of the surface.

This periodic drawing has two different axes of glide reflection,

running vertically. By using tracing paper one can easily find them. We shall return to this in the next chapter.

## Day Visits to Malta

On his cargo-boat voyages through the Mediterranean Escher called at Malta on two occasions. These were only short visits and lasted hardly a whole day, just long enough for the ship to load and unload. A sketch of Senglea (a little harbour town on Malta) has been preserved, dated March 27, 1935. In October of that same year Escher made a three-colored woodcut from it. This print is reproduced here, because it is not very well known and because he was later to use several important elements from it for two other prints.

A year later (June 18, 1936), when Escher escaped from Switzerland to make the Mediterranean tour which was to have so

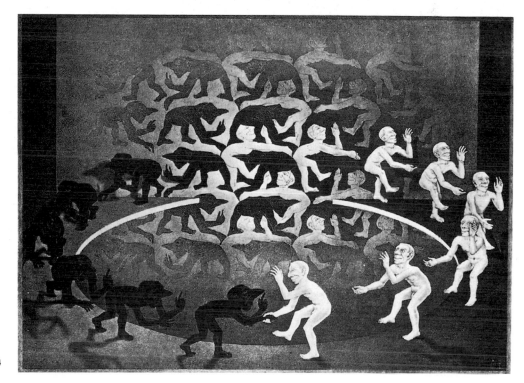

**47. *Encounter*, lithograph, 1944**

great an influence on his work, the ship called once again at Malta and Escher sketched practically the same part of the little harbor town.

There must have been something very fascinating about the structure of this backdrop of buildings, because ten years later, when he was looking for a lively, well-balanced, rhythmic grouping of buildings for a print in which the center could be subjected to expansion *(Balcony)* his choice fell on this 1935 Malta print. And after yet another ten years he used the same sketch again for his unique print *Print Gallery* (1956). In this we can recognize not only the various groups of houses and the rocky coastline (as in *Balcony*) but this time the freighter as well.

## Blow-up

In *Balcony* the center of the print is enlarged four times relative to its edges. We shall look presently at the method Escher used to achieve this effect. The result is a splendid bulge. It is as though the print had been drawn on a sheet of rubber and then inflated from behind. Details that hitherto had been of altogether minor importance have now been transformed and become the center of our attention. If we compare the print with the working sketch that was made for it, and in which the same scene is shown in its undeveloped form, then this particular balcony is not all that easy to find; it is in fact the fifth balcony from the bottom. In the working sketch the four lowest balconies are almost equidistant from each other, whereas in the print the distances between those nearest the bulge have been very considerably

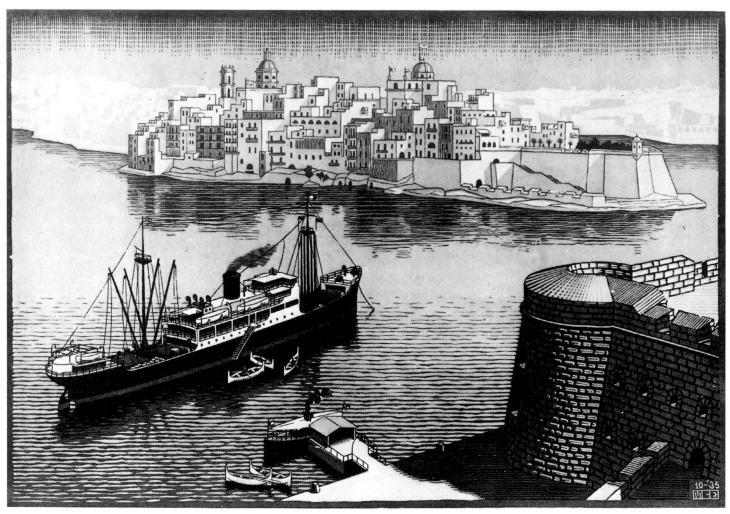

**50.** *Senglea*, woodcut, 1935

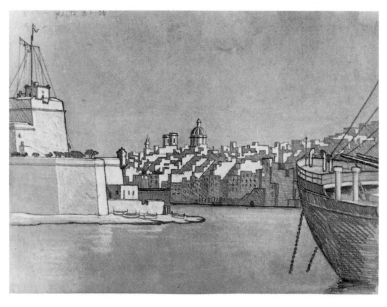

**49. Sketch for Malta**

compressed. For the inflation of the central area has got to be compensated for somewhere else, because the total content of the scene is the same in both working sketch and final print.

In figure 52 we see a square divided up into small squares. The broken circle marks the boundary of the above-mentioned distortion. The vertical lines *PQ* and *RS* and the horizontal lines *KL* and *MN* reappear in figure 53 as curved lines. In figure 54 the center is inflated. *A, B, C,* and *D* are displaced toward the edge and take up the position *A', B', C',* and *D'.* And it is possible to reconstruct the whole network in this way, of course. So we find that an expansion has taken place around the center of the circle and a squeezing together at its circumference; the horizontal and vertical lines have been, so to speak, pressed outward toward the edge of the circle. Figures 51 and 55 show the pictorial contents deformed and undeformed. And that is how the enormous blow-up in the center of *Balcony* has been brought about.

## Growing 256 Times Over

*Print Gallery* arose from the idea that it must also be possible to make an annular bulge. First of all, let us approach the print as an unsuspecting viewer. At the lower right-hand corner we find the entrance to a gallery in which an exhibition of prints is being held. Turning to the left we come across a young man who stands looking at a print on the wall. On this print he can see a ship, and higher up, in other words in the upper left-hand corner, some houses along a quayside. Now if we look along to the right, this row of houses continues, and on the far right our gaze descends, to discover a corner house at the base of which is the entrance to a picture gallery in which an exhibition of prints is being held. . . . So our young man is standing inside the same print as the one he is looking at! Escher has achieved the whole

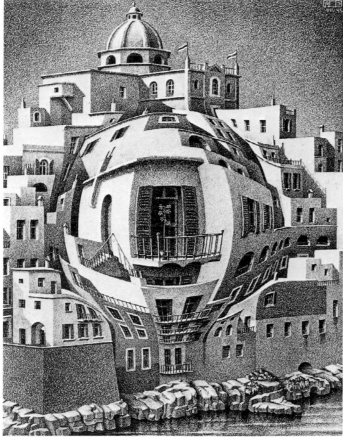

51. *Balcony*, lithograph, 1945

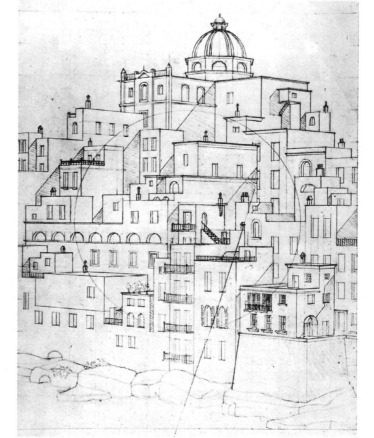

55. Sketch before the center was blown up

52.–53. The construction of the grid for the blow-up of the center

54. The blown-up center

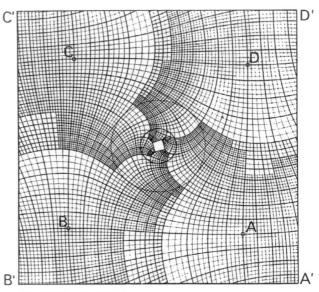

**57.–58. The development of the expansion**

**59. Grid for *Print Gallery***

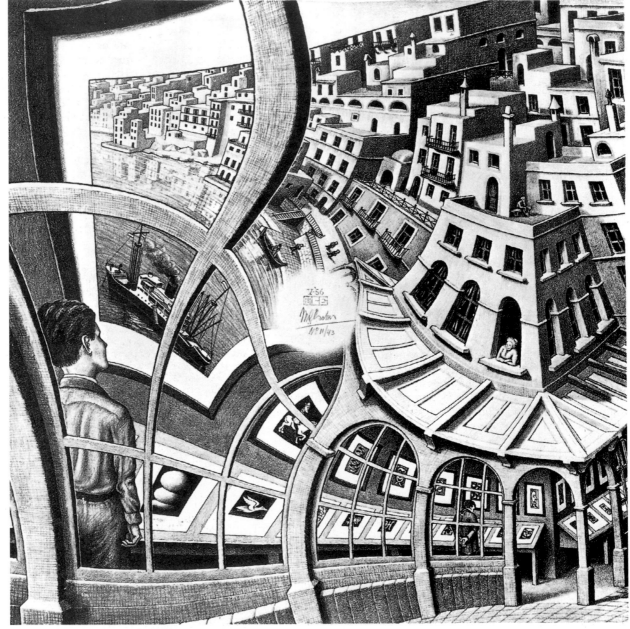

**56. *Print Gallery*, lithograph, 1956**

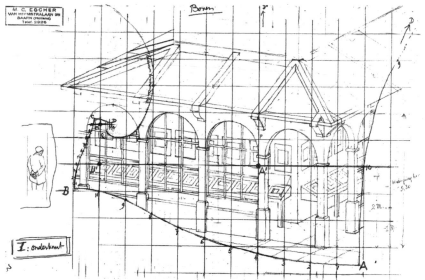

**60. Print Gallery before the expansion**

**61a,b. How the circular expansion was obtained**

of this trickery by constructing a grid that can be used as a framework for the print, marking out a bulge in a closed ring formation and having neither beginning nor end. The best way to gain an understanding of this construction is to study a few schematic drawings.

At the lower right of the square, figure 57, a small square has been drawn, and as we move along the bottom edge toward the left we note that this figure keeps increasing in size, until at the left-hand edge it has reached a fourfold enlargement. The dimensions of the original figure have now become four times as great. Passing upward along the left-hand edge we find a further fourfold increase, thus multiplying the original dimensions by sixteen. Go to the right along the top edge and the dimensions are sixty-four times as great as the original ones; keep on down the right-hand side and the enlargement is 256 times by the time we arrive back at the exit. What originally measured 1 centimeter in length has now become 2 meters 56! It would of course be quite impossible to carry out this exercise in full in the whole picture. In the actual figure we do not get any further than the first two stages (or indeed only one full stage, for at the second enlargement only a small section of the already enlarged figure is used).

At first Escher tried to put his idea into practice using straight lines, but then he intuitively adopted the curved lines shown in figure 58. In this way the original small squares could better retain their square appearance. With the aid of this grid a large part of the print could be drawn, but there was an empty square left in the middle. It was found possible to provide this square with a grid similar to the original one, and, by the repetition of this process a few more times, the grid shown in figure 59 came into being. *A'B'C'D'* is the original square and *ABCD* is an outward expansion that was a necessary consequence and a logical outcome. This marvelous grid has astonished several mathematicians, and they have seen in it an example of a Riemann surface.

In our figure 58 only two stages of the enlargement are shown. This is in fact what Escher has done in his print. We can see the gallery getting larger from right to left. The two further stages could not possibly be carried out within the square, because an ever-increasing area is required to represent the enlargement of the whole. It was a brilliant notion of Escher's to cope with the last two stages by drawing attention to one of the prints in the gallery, for this print itself can be enlarged within the square. Another invention of his was to illustrate within the aforementioned print a gallery that coincided with the gallery he started with.

Now we must find out how Escher, starting out as he did with a normal drawing, was able to transfer this onto his prepared grid. We shall concentrate on only a small part of this rather complicated process. Figure 60 shows one of the detailed drawings, that of the gallery itself. A squared grid was placed over the drawing. We come across the points *A*, *B*, and *A'* again of figure 59. And we also find there the same grid but this time in an altered form—that is to say, becoming smaller to the left. Now the image of each little square is transferred to the equivalent square on the grid. In this way the enlargement of the picture is automatically achieved. For example, the rectangle in figure 61a, *KLMN*, is transferred thus to *K'L'M'N'* in figure 61b.

I watched *Print Gallery* being made, and on one of my visits to Escher I remarked that I thought the bar to the left of the center horribly ugly; I suggested that he ought to let a clematis grow up it. Escher returned to this matter in a letter:

No doubt it would be very nice to clothe the bars of my *Print Gallery* with clematis. Nevertheless, these beams are supposed to be dividing bars for window panes. What is more I had probably used up so much energy already on thinking out how to present this subject that my faculties were too deadened to be able to satisfy aesthetic demands to any greater degree. These prints, which, to be quite honest, were none of them ever turned out with the primary aim of producing "something beautiful," have certainly caused me some almighty headaches. Indeed it is for this reason that I never feel quite at home among my artist colleagues; what they are striving for, first and foremost, is "beauty"—albeit the definition of that has changed a great deal since the seventeenth century! I guess the thing I mainly strive after is wonder, so I try to awaken wonder in the minds of my viewers.

Escher was very fond of this print and he often returned to it.

Two learned gentlemen, Professor van Dantzig and Professor van Wijngaarden, once tried in vain to convince me that I had drawn a Riemann surface. I doubt if they are right, in spite of the fact that one of the characteristics of a surface of this kind seems to be that the center remains empty. In any case Riemann is completely beyond me and theoretical mathematics are even more so, not to mention non-Euclidian geometry.

So far as I was concerned it was merely a question of a cyclic expansion or bulge, without beginning or end. I quite intentionally chose serial types of objects, such, for instance, as a row of prints along the wall and the blocks of houses in a town. Without the cyclic elements it would be all the more difficult to get my meaning over to the random viewer. Even as things are he only rarely grasps anything of it.

## Bigger and Bigger Fish

In 1959, Escher used the same idea and almost the same grid system for a more abstract woodcut, *Fish and Scales*. On the left we see the head of a large fish; the scales on the back of this fish gradually change, in a downward direction, into small black and white fish, which in turn increase in size. They form two schools swimming in among each other. We can see almost exactly the same thing happening if we start with the big black fish on the right. Figure 63 shows the scheme for the lower half of the print, and we find the upper half if we turn figure 64 through 180 degrees about the center of the drawing (small black block)—except that in the upper half the eyes and mouth are reversed in such a way that not a single fish is to be found upside down. Arrows indicate the directions in which the black and white fish are swimming.

Then we find that the scale *A*, swelling into a little fish at *B*, goes on to *C* and grows into the big black fish in the top half of the print. If we draw in lines above and below the swimming directions and then carefully extend this same system of lines to left and right, a rough outline appears of the grid that is used in the print. Thus we can get a much better understanding of what is happening. We can start at *P*, where we find a scale belonging to the big black fish on the right moving upward. This scale grows and changes into the little fish at *Q*. If we move to the left, this little fish goes on increasing in size until it has turned into the big black fish on the left. Now, if we should wish to move downward from *R*, this fish would have to be succeeded by still larger fish, and this is impossible within the compass of this print. Therefore, just as in *Print Gallery* he switched over from the gallery to the print as soon as available space became too small, so now Escher has selected one of the scales from the large fish so as to continue the enlargement process from *R* to *S*. The large fish plays her part in this, for before she has even reached her full size, she bursts open and brings forth some new little fish. In this way the enlargement continues without a break from *S* onward. The little fish at *S* swells up into the big fish on the right, from which once again we can select a scale—and so on.

It will be quite obvious that the grid for *Fish and Scales* is a mirror image of the one for *Print Gallery*.

Now, in *Fish and Scales* two further favorite themes of Escher's are brought out—i.e., periodic drawings and metamorphosis (from scales to fish).

Drawing is deception. On the one hand Escher has tried to reveal this deception in various prints, and on the other hand he has perfected it and turned it into superillusion, conjuring up with it impossible things, and this with such suppleness, logic, and clarity that the impossible makes perfect sense.

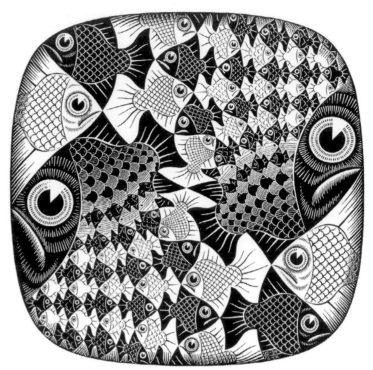

**62.** *Fish and Scales*, woodcut, 1959

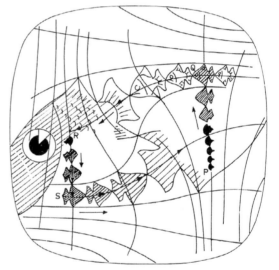

**63. From scale into fish**

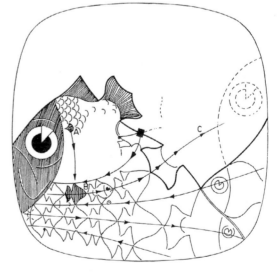

**64. Grid for** *Fish and Scales*

# 7　The Art of the Alhambra

**65. First attempt at regular division of a plane, with imaginary
animals (detail), pencil and watercolor, 1926 or 1927**

### The Stubborn Plane

No theme or topic lay closer to Escher's heart than *periodic
drawing division*. He wrote a fairly extensive treatise on the sub-
ject, going into technical details. There is only one other theme
about which he has written—although by no means at such
length—and that is *approaches to infinity*. What he says on the
latter subject can perhaps be applied with even more justice to
periodic drawing. It is a question of confession:

> I can rejoice over this perfection and bear witness to it with a
> clear conscience, for it was not I who invented it or even discovered
> it. The laws of mathematics are not merely human inventions or
> creations. They simply "are"; they exist quite independently of
> the human intellect. The most that any man with a keen intellect
> can do is to find out that they are there and to take cognizance of
> them.

He also writes (in this instance in regard to regular tessella-
tion): "It is the richest source of inspiration that I have ever
tapped, and it has by no means dried up yet."

We can see how very much predisposed Escher was to the dis-
covery and application of the principles of tessellation, even in
the earliest work reproduced here, done when he was still study-
ing under de Mesquita in Haarlem. The most detailed and fully
developed production of this period is certainly the woodcut
*Eight Heads* (1922). Eight different heads are cut on the one
wood block, four of them right way up and four upside down.
Here, in figure 66, we see the block printed four times over. These
thirty-two heads have a certain theatrical air about them, false,
unreal, *"fin de siècle."*

Neither the covering of the entire surface with recognizable
figures nor the repeated printing from the one block to produce
a rhythmic repetition of the motif (in this case the eight heads
form a single motif) were due to the influence or the inspiration
of de Mesquita.

Until 1926 it looked as though these efforts were to be con-
fined to a youthful period and could not be regarded as a bud of
promise destined later to come into full bloom. In 1926, having
already had some acquaintance with the Alhambra on the occa-

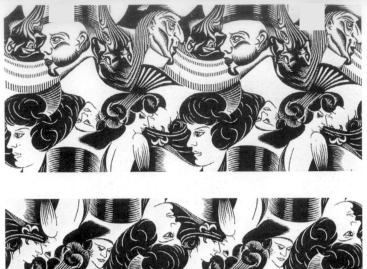

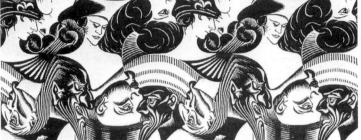

The same print, turned 180°

sion of a brief visit, Escher made tremendous efforts to express a rhythmic theme on a plane surface, but he failed to bring it off. All he could manage to produce were some rather ugly, misshapen little beasts. He was particularly annoyed at the stubborn way in which half of these four-footed creatures persisted in walking around upside down on his drawing paper (figure 65).

It would not have been surprising if Escher, after the failure of all these serious attempts, had come to the conclusion that he was not going to achieve anything in this sphere. For ten whole years space-filling was out for him—until, in 1936, accompanied by his wife, he paid another visit to the Alhambra. For the second time he was impressed by the rich possibilities latent in the rhythmic division of a plane surface. For whole days at a time he and his wife made copies of the Moorish tessellations, and on his return home he set to work to study them closely. He read books about ornamentation, and mathematical treatises he could not understand and from which the only help he got was to be found in the illustrations; and he drew and sketched. Now he could see clearly what it was he was really searching for. He built up a wholly practical system that was complete, in broad outline, by 1937, and which he set out in writing in 1941 and 1942. But by that time he was busy assimilating his discoveries in metamorphosis and cycle prints. The full story of how Escher struggled with this stubborn material and how he conquered it so well that, as he said later, he himself did not have to think up his fishes, reptiles, people, houses, and the rest, but the laws of periodic space-filling did it for him—all this would itself call for more space than the whole of this present book. We shall have to content ourselves with a short introduction, in the hope that it will give the reader a greater insight into this important (in Escher's view the *most* important) aspect of his work.

## Principles of Plane Tessellations

In figure 68 we see a simple design: the entire surface is covered with equilateral triangles. Now we must discover in what ways this design can be "mapped onto" itself—that is, brought to coincide with itself. For this purpose we must make a duplicate of it by tracing it on transparent paper, and then laying it over the original pattern so that the triangles cover each other.

If we shift the duplicate over the distance *AB* it will cover the underlying pattern once again. This movement is referred to as *translation*. Thus we can say that the design maps onto itself by translation.

We can also turn the duplicate through 60 degrees about the point *C*, and we find that once again it covers the original pattern exactly. Thus this design can be said to map onto itself by *rotation*.

If we draw in the dotted line *PQ* on both the original pattern and the duplicate, and then remove the duplicate from the figure, turn it, and lay it down again in such a way that the dotted lines coincide, we shall notice that once more duplicate and original cover each other. We term this movement *reflection* on the mirror axis *PQ*. The duplicate is now the mirror image of the original figure, and yet it still coincides with it.

Translation, rotation, reflection, and—to be considered later—glide reflection; these are the possible shifts whereby a pattern can be made to map onto itself. There are some patterns that admit only of translation and there are others that are susceptible of both translation and reflection, and so on.

If we categorize the patterns according to the kinds of shifts whereby they map onto themselves, we discover that there are seventeen different groups. This is no place to list them all or even to summarize them, but we may at least point to the remarkable fact that Escher discovered all these possibilities without

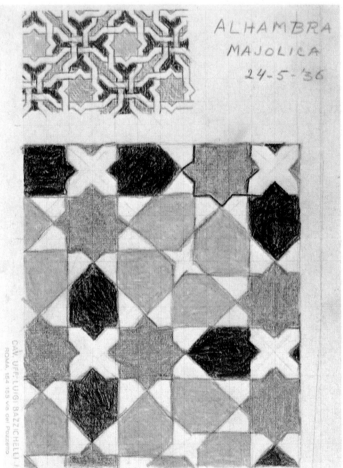

67. Sketches made in the Alhambra, pencil and colored crayon, 1936

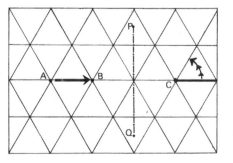

68. Possible movements in a flat surface

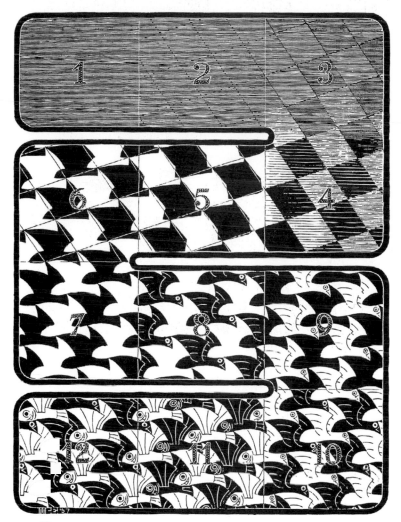

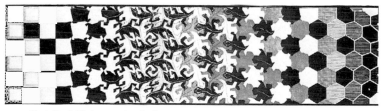

**69. In this drawing Escher shows the creation of a metamorphosis**

Detail of *Metamorphosis II*

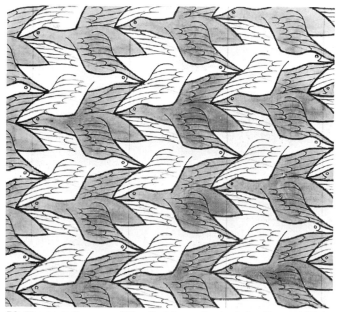

**70. The periodic space-filling that forms the basis for *Day and Night***

the benefit of any appropriate previous mathematical knowledge. In her book *Symmetry Aspects of M.C. Escher's Periodic Drawings* (published in 1965 for use by students of crystallography), Professor C.H. McGillavray speaks of her astonishment at the fact that Escher even discovered new possibilities whereby color too might play an important role, and which had not been mentioned in scientific literature before 1956.

A particular characteristic of Escher's tessellations (and in this he is well-nigh unique) is that he always selects motifs that represent something concrete. On this subject he writes:

> The Moors were masters in the filling of a surface with congruent figures and left no gaps over. In the Alhambra, in Spain, especially, they decorated the walls by placing congruent multicolored pieces of majolica together without interstices. What a pity it was that Islam forbade the making of "images." In their tessellations they restricted themselves to figures with abstracted geometrical shapes. So far as I know, no single Moorish artist ever made so bold (or maybe the idea never dawned on him) as to use concrete, recognizable figures such as birds, fish, reptiles, and human beings as elements of their tessellations. Then I find this restriction all the more unacceptable because it is the recognizability of the components of my own patterns that is the reason for my never-ceasing interest in this domain.

## Making a Metamorphosis

Escher always regarded periodic surface-division as an instrument, a means to an end, and he never produced a print with this as the main theme.

He made the most direct use of periodic surface-division in connection with two closely related themes: the metamorphosis and the cycle. In the case of the metamorphosis we find vague, abstract shapes changing into sharply defined concrete forms, and then changing back again. Thus a bird can be gradually transformed into a fish, or a lizard into the cell of a honeycomb. Although metamorphosis in the sense described above also appears in the cycle prints, nevertheless the accent is more on continuity and a return to the starting point. This is the case, for instance, with the print *Metamorphosis I* (1937), a typical metamorphosis print in which no cycle appears. *Day and Night* is also a metamorphosis print in which scarcely any cyclic element is found. But most of the prints display not only metamorphosis but also a cycle, and this is because Escher derived more satisfaction from turning the visual back upon itself than from leaving his picture open-ended.

In his book *Plane Tessellations* (1958), he shows us in a most masterly way, by both text and illustration, how he brings a metamorphosis into being. We give a brief resume of his argument by means of figure 69.

At 4 the surface is divided into parallelograms, distinguished from each other by virtue of the fact that a white one is always bounded by a black.

In 5 the rectilinear nature of the black-and-white boundaries is slowly changing, for the boundary lines curve and bend in such a way that an outward bulge on the one side is balanced with an equal-sized inward bulge in the opposite side.

In 6 and 7 the process continues, in the sense that there is a progressive alteration, not in the nature or in the position of the outward and inward bulges, but in their size. The shape arrived at in 7 is maintained up to the end. At first sight nothing remains of the original parallelogram, and yet the area of each motif stays exactly the same as that of the original parallelogram, and the points where the four figures meet are still in the same positions relative to each other.

In 8, details are added to the black motifs to signify birds, so that the white ones become the background, indicating sky.

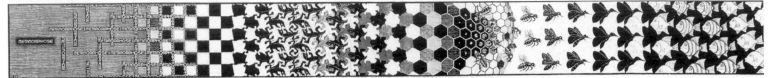

*Metamorphosis II*, woodcut, 1939-40

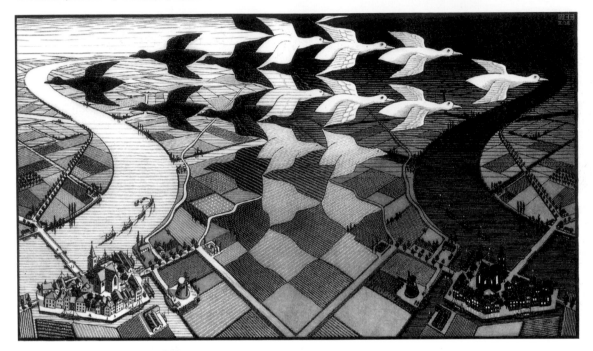

72. *Day and Night*, woodcut, 1938

9. This can be just as easily interpreted the other way round, with white birds flying against a dark sky. Night has fallen.

10. But why not have white *and* black birds simultaneously covering the whole surface?

11. The motif appears to allow of two different interpretations, for by drawing into the tails of the birds an eye and a beak, and turning the heads into tails, the wings almost automatically become fins, and from each bird a flying fish is born.

12. Finally, of course, we may just as well unite the two sorts of creature in one tessellation. Here we have black birds moving to the right and white fishes to the left—but we can reverse them at will.

The refinement with which Escher was so soon able to develop the metamorphosis can be seen in the woodcut *Metamorphosis II* (1939-40), the largest print Escher ever made. It is 20 centimeters high and 4 meters long! And later, in 1967, he added a further three meters when the print, greatly enlarged, was to be used as a mural for a post office. It is not so much the change-over, say from honeycomb to bees, that is of interest (for these depend more on the association of ideas); but when squares change, by way of lizards, into hexagons, he displays a tremendous virtuosity in the handling of his material. There is also *Verbum* (1942), not reproduced here, which comes definitely within the category of metamorphosis, and which is taken to its furthest possible extreme. In later prints we find a decline in the exercise of virtuosity for its own sake; and the metamorphoses come to be more subservient to other representational concepts, for instance in *Magic Mirror*.

## The Most Admired Picture of Them All

Figure 70 illustrates one of the simplest possibilities of surface-filling. The pattern of white and black birds maps onto itself by translation only. If we shift a white bird over to the right and upward, the same pattern is found there again. There would be more possibilities if the white bird and the black bird were congruent. Escher used this type of tessellation in the woodcut *Day and Night* (1938) which is, to date, the most popular of all Escher's prints. This print definitely introduces a new period, as was clear even to the critics of that time. From 1938 to 1946 Escher sold 58 copies of this print, up to 1960 the total rose to 262, and in 1961 alone he sold 99! The popularity of *Day and Night* exceeded that of the other much-sought-after prints *(Puddle, Sky and Water I, Rippled Surface, Other World, Convex and Concave, Belvedere)*, so much so that we may safely conclude from this that Escher has succeeded, in this print more than in any other, in putting across to the viewer his sense of wonderment. In the center above us we see much the same tessellation as in figure 70, but this does not provide the basis for *Day and Night*—that is to be found in the center below the print. There one finds a white, almost diamond-shaped field, and our gaze is automatically drawn upward from it; the field changes shape, and very swiftly at that, for it takes only two stages to turn into a white bird. The heavy, earthy substance is suddenly whisked aloft to the sky and is now quite capable of flying to the right, flying as a bird high above a little village by the riverside, enveloped in the darkness of the night.

We could just as easily have chosen one of the black fields down there, to the right and left of the center line. And as it too rises in the air it turns into a black bird and flies away to the left, up above a sunny Dutch landscape which, in a most remarkable way, turns out to be a mirror image of the nocturnal landscape on the right!

From left to right there is a gradual transformation from day to night and from below upward we are slowly but surely raised

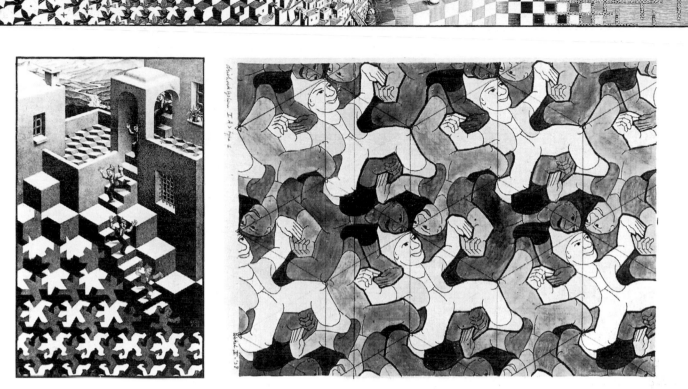

73. *Cycle*, lithograph, 1938

74. Study of periodic space-filling of a plane with human figures, India ink, pencil, and watercolor, 1938

toward the heavens . . . and the fact that this can be achieved through the vision of the artist explains, in my view, why this print appeals to so many people.

## The Stone Lad

In *Cycle* (1938) we see a quaint little fellow emerging, gay and carefree, from a doorway. He rushes down the steps, oblivious of the fact that he is about to disappear down below and become dissolved into a whimsical geometric design. At the bottom of the print we come across the same pattern as in figure 74, about which more anon. It turns out to be this lad's birthplace.

This metamorphosis from human figure to geometric pattern is, however, not the end of the affair, for at the top left the pattern gradually changes to simpler, more settled shapes, until these achieve a diamond form; then the diamonds go to make up a block that is used as building material or as the pattern of the tiled floor of the little walled courtyard.

Thereupon, within some secret chamber of the house, these lifeless shapes seem to undergo a further transformation, being turned back into little men, for we see that cheerful young fellow leaping out of his doorway once again.

The periodic pattern used here has three axes of symmetry, and these are of three different types: that in which the three heads meet, that with three feet coming together, and one where three knees touch. At each one of these points the whole pattern can be mapped onto itself by rotation through an angle of 120 degrees. Of course, the little men will change color with each rotation.

## Angels and Devils

The same kind of space-filling is basic to the print *Reptiles* (figure 44) and *Angels and Devils*.

In figure 75 we see a periodic space-division with fourfold symmetry. At every point where wing tips touch we can turn the whole pattern through 90 degrees and cause it to fit over itself. Yet these points are not equal. The point of contact of the wing-tips in the center of the picture at *A* and the points *B, C, D,* and *E* are not the same. However, the points *P, Q, R,* and *S* do have exactly the same context as *A*.

Now we can draw horizontal and vertical lines through the body axes of all the angels and devils (in the sketch these lines are indicated by the letter *m*). These lines are mirror axes. Lastly, there are still axes of glide reflection, which make angles of 45 degrees with the reflection axes. They are also the lines we can draw through the heads of the angels, labelled *g* in the figure 76. The only way in which we are likely to be able to prove that axes of glide reflection are present is to carry out an actual glide-reflection shift. For this purpose, trace the outlines of the angels onto transparent paper and at the same time the axes of reflection *g*. Now rotate the tracing paper and lay it down again in such a way that *g'* on the tracing coincides with *g* of the original. If you take care, at the same time, to ensure that the head of the angel furthest to the left coincides with its original, you will have effected a reflection.

It can be seen that with this reflection the traced pattern does not cover the original one. However, if you shift the tracing diagonally upward along the axis of reflection you will notice that both patterns map onto each other the moment you get the traced angel head onto the next angel head in the original — something you might not have expected.

It was not because of any aesthetic excellence that I chose

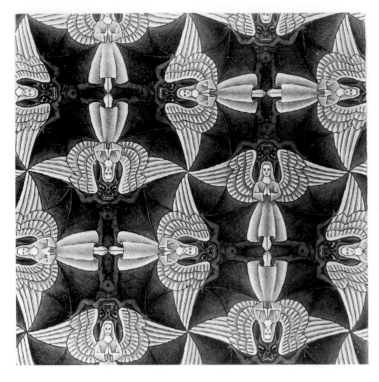

75. Periodic space-filling in *Angels and Devils*, pencil, India ink, crayon, and gouache, 1941

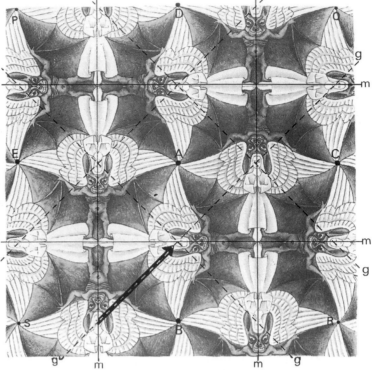

76. Rotation points, mirror axes, and glide-reflection axes in the flat pattern of *Angels and Devils*

figure 75 out of all the others — indeed, the angels might well have stepped straight out of some pious print of the thirties. But it is astonishing that such detailed figures as these can fill up the entire surface without leaving any gaps whatever, and in such a wide variety of orientations, and yet can still map onto themselves in so many different ways.

Escher never made use of the above version of his angels and devils, but at a later date, in 1960, he did make a circular print of them (figure 77). For a description of the circle limit prints, see chapter 15. Here we have not only fourfold axes but threefold as well. This can be seen where three angels' feet come together.

At a later date the same angel-devil motif was adapted to a spherical surface. On commission from Escher's American friend, Cornelius Van S. Roosevelt, who has one of the biggest collections of his work, and by means of instructions and drawings that Escher furnished, two copies of an ivory ball were produced in Japan by an old *netsuke* carver. The entire surface of the little sphere is filled by twelve angels and twelve devils. It is interesting to note how, in the hands of the old Japanese carver, the facial characteristics of the little angels and devils have taken on a typically Oriental look.

Thus Escher has made three variations of this surface-filling:

1. On a boundless flat surface, there is an interchange of double and quadruple axes.

2. On the (bound) circle-limit we find triple and quadruple axes.

3. On the spherical surface the same motif is used again, with double and triple axes.

## A Game

When dealing with periodic space-filling I cannot refrain from describing a game that took Escher's fancy in 1942, and to which he attached no importance beyond that of a private diversion. He never reproduced it or made use of it in any more serious work.

Escher carved a die shown by figure 79a. On each side of the square, three corresponding connections are possible. If one prints from this stamp a number of times, so that the imprints come next to each other, then the bars form continuous lines throughout the whole figure.

Because the stamp can be printed off in four different positions, and because Escher cut the figure again in its mirror image (once again capable of being printed in four positions), it is possible to use it to conjure up a large number of interesting designs. In figure 79b you can see a few examples, and in figures 80 and 81 two of the many designs Escher colored in.

## A Confession

The significance periodic space-division has had for Escher is difficult to overestimate. In this chapter we have shown something of it with just a few, indeed all *too* few, examples. This restriction does not tally with Escher's own view of his work.

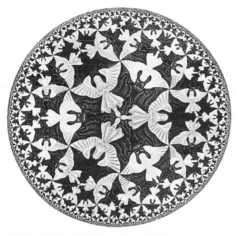

77. *Circle Limit IV*, woodcut, 1960

78. *Sphere with Angels and Devils*, stained maple, 1942 (diam. 23.5 cm.)

79a. Stampform for flat patterns

79b. Possible positions of the stamp and its mirror image

80. Stamped and colored ornament I

81. Stamped and colored ornament II

So let us allow Escher to have the last word in this chapter:

... I wander totally alone around the garden of periodic drawings. However satisfying it may be to possess one's own domain, yet loneliness is not as enjoyable as one might expect; and in this case I really find it incomprehensible. Every artist, or better every *person* (to avoid as much as possible using the word art in this connection), possesses a high degree of personal characteristics and habits. But periodic drawings are not merely a nervous tic, a habit, or a hobby. They are not subjective; they are objective. And I cannot accept, with the best will in the world, that something so obvious and ready to hand as the giving of recognizable form, meaning, function, and purpose to figures that fill each other out, should never have come into the head of any other man but me. For once one has crossed over the threshold of the early stages this activity takes on more worth than any other form of decorative art.

Long before I discovered a relationship with regular space-division through the Moorish artists of the Alhambra, I had already recognized it in myself. At the beginning I had no notion of how I might be able to build up my figures systematically. I knew no rules of the game and I tried, almost without knowing what I was about, to fit together congruent surfaces to which I tried to give animal shapes ... later the designing of new motifs gradually came with rather less struggle than in the early days, and yet this has remained a very strenuous occupation, a real mania to which I became enslaved and from which I can only with great difficulty free myself.

M. C. Escher, *Regelmatige Vlakverdeling*
*(Periodic Space-Filling)*,
Utrecht, 1958

The Magic Mirror of M.C. Escher      41

# 8  Explorations into Perspective

## Classical Perspective

From the very first moment that man started to draw and paint he represented spatial reality on a flat surface. The objects which the primitive cave-dweller wanted to reproduce were quite definitely spatial—bison, horses, deer, etc., and he painted them on a rock wall.

But the common method of representation we now call perspective came into being only in the fifteenth century. We can see that Italian and French painters wanted to make their pictures duplicates of reality. When we are looking at the illustration we are supposed to get exactly the same image on our retina as when we are looking at the actual object that is being illustrated.

In earlier days this was done intuitively, and many mistakes were made, but as soon as a mathematical formula for this method of representation had been worked out, it became clear that both architect and artist approached space in the same way.

We can define the mathematical model as in figure 84: the eye of the beholder is situated at $O$; some distance in front of him we are to imagine a perpendicular plane, i.e., the picture. Now the area behind the picture is transferred to it point by point; in order to do this a line is drawn from point $P$ to the eye, and the point of intersection of this line with the picture is the point $P'$, at which $P$ is depicted.

This principle was well demonstrated by Albrecht Dürer (1471–1528) who took great interest in the mathematical side of his craft (figure 82). The artist has a glass screen in front of him (i.e., the picture) and he draws the man sitting behind the screen point by point. The extremity of a vertical bar fixes the position of the artist's eye.

Of course it is not at all feasible for any artist to work like this. Indeed Dürer's apparatus was used only to solve difficult problems of representation. In the majority of cases the artist relied on a number of rules which could be deduced from the mathematical model.

Here are two important rules:

1. Horizontal and vertical lines running parallel to the picture are to be depicted as horizontal and vertical lines. Like distances along these lines in reality are to be shown as like distances in the picture.

2. Parallel lines that recede from us are to be depicted as lines passing through a single point, i.e., the vanishing point. Like distances along these lines are not to be depicted as like distances in the picture.

Escher meticulously concurred with these rules of classical perspective in the construction of his prints; and it is for this reason that they are so suggestive of space.

In 1952 there appeared a lithograph called *Cubic Space Division*

**82. Dürer's demonstration of the principles of perspective**

in which the sole aim was to depict an infinite extent of space, and no means were used other than the laws of classical perspective. It is true that we can see this infinite extent of space through a square window, as it were, but because this space is divided up into completely similar cubes by bars running in three directions, a suggestion of the whole of space has been achieved.

If we project the vertical bars they appear to meet at a single point, which is the footprint or nadir. There are two further vanishing points, and these can be obtained by projecting the bars that point upward to the right and the bars that point upward to the left. These three vanishing points lie far beyond the area of the drawing, and Escher had to use very large sheets of drawing paper for the construction.

The aim of the wood engraving *Depth* (1955) was much the same, but in this case the small cubes marking the corners of the large ones were replaced by what look like flying fish, and the joining bars are nonexistent. Technically, this problem was much more difficult, for the fish had to be drawn decreasing in size, with very great accuracy; also, in order to enhance the suggestion of depth, the further away they got the less contrast had to be shown. This would have been fairly simple in a lithograph, but it is much more difficult with a woodcut because every bit of the print must be either black or white, and therefore it

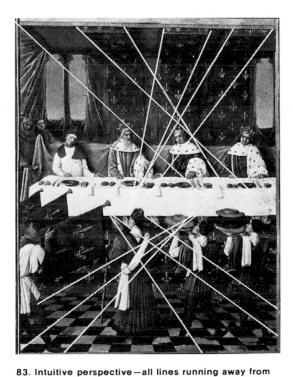

**83. Intuitive perspective—all lines running away from the spectator should converge in the same vanishing point**

**85.** *Cubic Space Division,* lithograph, 1952

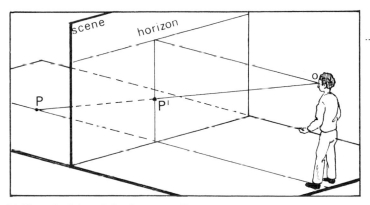

**84. The principles of classic perspective**

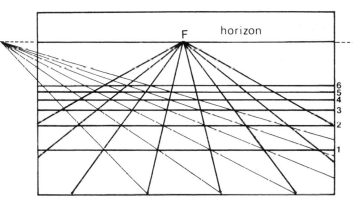

is impossible to achieve contrast by using gray. However, by using two colors Escher has managed to introduce what is known as light-perspective as a means of increasing the suggestion of space, beyond the considerable limitations imposed by geometric perspective. Figure 87 shows how exactly Escher worked out in perspective the situation around each grid-point.

## The Discovery of Zenith and Nadir

Classical perspective lays it down that sets of parallel lines also running parallel with the picture are to be depicted as parallel lines themselves. This means that these sets of lines have no vanishing point, or, in the terminology of projective geometry, their point of intersection is at infinity. Now this would seem to belie our own experience; when we are standing at the bottom of a tower we see the rising vertical lines converging toward one point, and if we look at a photograph taken from this same viewpoint it becomes clearer still. However, the rules of classical perspective are in fact being followed, for the simple reason that our picture is no longer perpendicular to the ground. If we lay

the picture down horizontally and look down on it, then we shall see all the vertical lines converging toward a single point under our feet—in other words, the nadir. Escher took up just such an extreme viewpoint in an early woodcut *Tower of Babel* (1928), in which we can see the tragedy of the great confusion of tongues as described in the Bible played out on each of the terraces. In the wood engraving *St. Peter's, Rome* (1935) Escher has had a "personal experience" of the nadir, for here we have a case not merely of construction but of reality perceived. He spent hours on the top-most gallery of the dome sketching the scene that lay below him, and when tourists inquired, "Say, don't you get giddy up here?" Escher's laconic reply was, "That's the whole point."

The first time he consciously used the zenith as a vanishing point was in 1946 when he was making a small engraving for the Netherlands Ex-Libris Club. This print showed somebody clambering out of a deep well into the light of day. The caption ran. "We will come out of it"—a reference, this, to the aftermath of World War II.

Figure 91 shows how the zenith comes to be the point of intersection for the vertical lines. The photographer or painter lies on the ground and looks straight ahead and upward. The parallel lines $l$ and $m$ now appear at $l^1$ and $m^1$ in the picture, and they intersect at the zenith immediately above the observer.

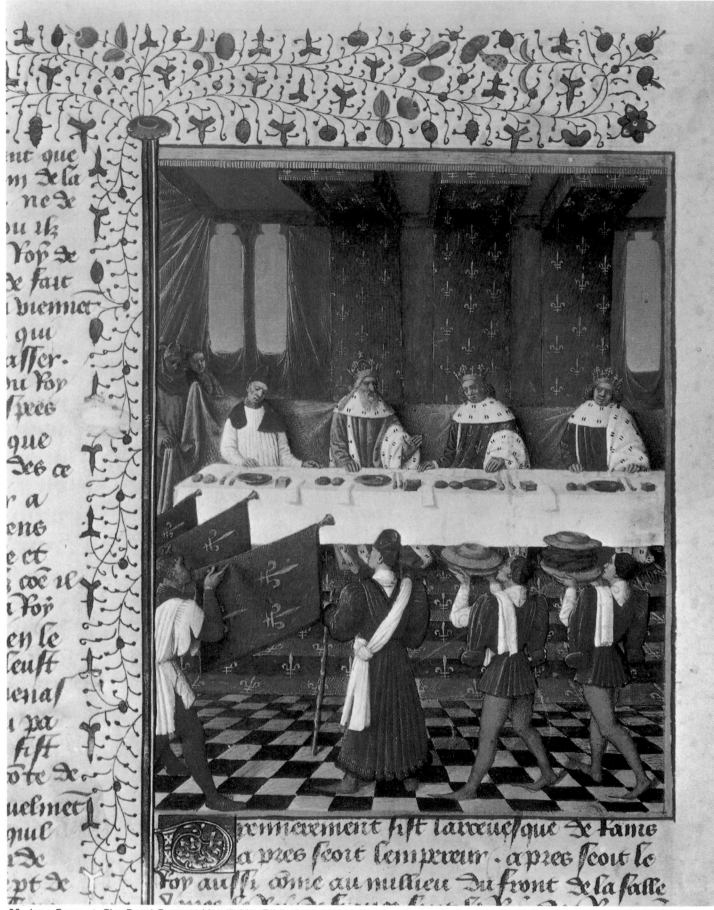

86. Jean Fouquet, *The Royal Banquet* (detail) (the Bibliotheque Nationale, Paris). A natural impression is achieved notwithstanding the incorrect perspective

44  The Magic Mirror of M.C. Escher

87. Preliminary study for *Depth*, pencil, 1955

88. *Depth*, wood engraving, 1955

89. *St. Peter's, Rome*, wood engraving, 1935

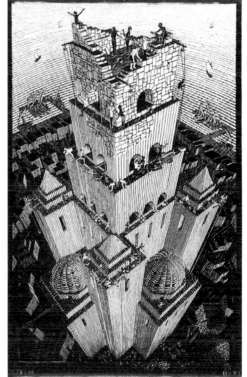

90. *Tower of Babel*, woodcut, 1928

The Magic Mirror of M.C. Escher          45

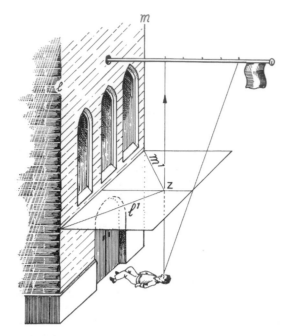

91. The zenith as vanishing point

## The Relativity of Vanishing Points

If we draw a number of lines converging on a single point, then this point can represent all kinds of things, including zenith, nadir, point of distance, and so on. Its use depends entirely on its context. Escher was trying to demonstrate this discovery in the prints *Other World I* and *Other World II*, in 1946 and 1947.

In the 1946 mezzotint we see a long tunnel with arched openings. This tunnel runs, in rather hazy darkness, to a point that may be used, according to the context, as zenith, nadir, or distance point. If we look at the tunnel wall on the right and on the left, then what we observe is a lunar landscape lying horizontally. And the tunnel's arches are so drawn that they fit into the horizontal aspect of this landscape. In this context the vanishing point of the tunnel limits takes on the function of distance point.

However, if we turn to the upper part of the picture, we now find ourselves looking straight down on a lunar landscape, and we see a Persian man-bird and a lamp from above. (This sculpture is called a *simurgh* and was a present from Escher's father-

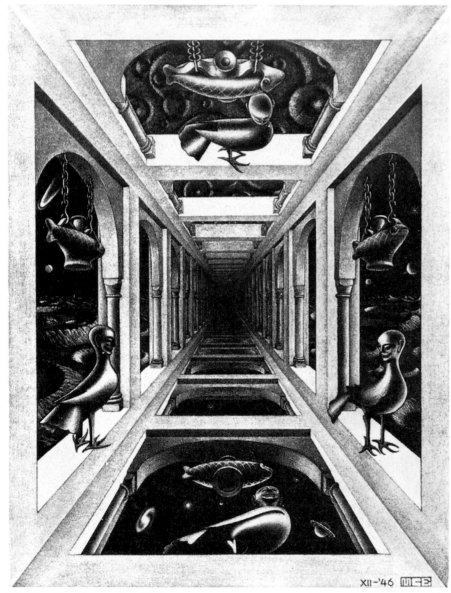

92. *Other World*, mezzotint, 1946

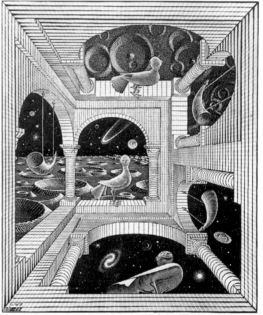

93. *Other World*, wood engraving, 1947

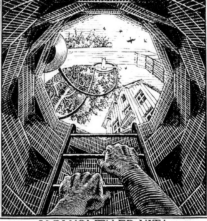

94. Bookmark with zenith as vanishing point (We Will Come Out of It), woodcut, 1947

in-law, who had bought it in Baku, Russia). So now this same vanishing point has changed to the nadir.

The final use for this vanishing point is that of zenith for the lower part of the print, for this time we are looking up into the heavens and seeing the bird and the lamp from below.

Escher himself was not at all happy with this print; the tunnel had no clear limits, the vanishing point was shrouded in darkness, and it took *four* planes to represent three landscapes.

A year later he produced a new version, in which he eliminated these (to him) irritating shortcomings. This four-colored wood-cut holds together in a most ingenious way. The long tunnel has disappeared and we find ourselves in a strange room where "above," "below," "right," "left," "in front," and "behind" can be interchanged at will, according to whether we decide to look out of one or another of the windows. And he has thought up a very clever solution of the problem of how the threefold function of the single vanishing point can be suggested by giving the building three pairs of *almost* equal-sized windows.

In each of these *Other World* prints there is only one vanishing point. However, in *Relativity*, a lithograph made in 1953, there are three vanishing points lying outside the area of the print, and they form an equilateral triangle with sides two meters in length! Each of these points has three different functions.

## Relativity

Here we have three totally different worlds built together into a united whole. It looks odd, yet it is quite plausible, and anybody who enjoys modeling could make a three-dimensional model of this print.

The sixteen little figures that appear in this print can be divided into three groups, each of which inhabits a world of its own. And for each group in turn the whole content of the print is *their* very own world; only they feel differently about things and give them different names. What is a ceiling to one group is a wall to another; that which is a door to one community is regarded by the other as a trapdoor in the floor.

In order to distinguish these groups from each other let us give them names. There are the Uprighters—for instance, the figure to be seen walking up the stairs at the bottom of the picture; their heads point upward. Then come the Left-leaners, whose heads point leftward, and the Right-leaners with their heads pointing to the right. We are incapable of taking a neutral view of these folks, for we obviously belong to the community of the Uprighters.

There are three little gardens. Upright number 1 (lower center)

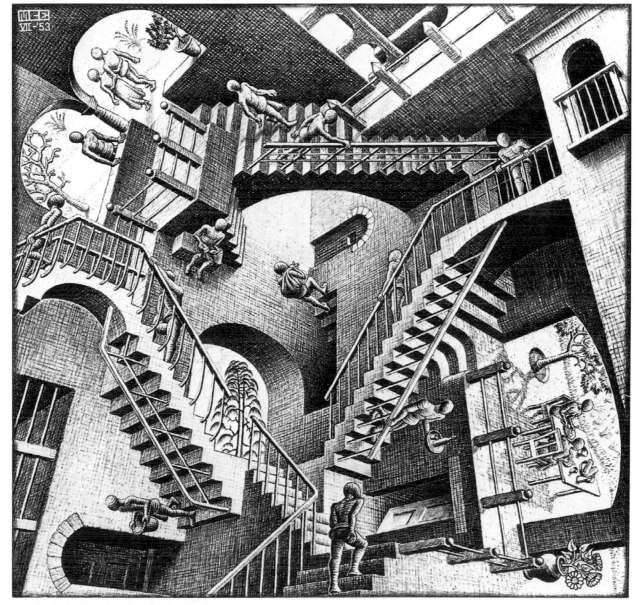

95. *Relativity*, lithograph, 1953

can reach his garden by turning to the left and walking up the stairs. All we can see of his garden is a couple of trees. If he stands beside the archway leading to his garden he has a choice of two stairways leading upward. If he takes the left-hand one he will come across two of his companions; up the right-hand stairway and along the landing, he will find the two remaining Uprighters At no point are we able to see the ground on which the Uprighters are standing, but quite large areas of their ceiling are visible in the upper part of the print.

In the center of the print, and up against one of the Uprighters' side walls, a Left-leaner sits reading. If he were to look up from his book he would see an Uprighter not far away from him. He would think this other's position very odd indeed, for he would appear to be gliding along in a recumbent pose. If he were to stand up and climb the stairs on his left, he would discover another remarkable figure skimming along over his floor, a Left-leaner this time; and the latter is quite convinced that he is on his way out of his cellar with a sack over his shoulder.

The Right-leaner goes up the stairs, turns to the right, and climbs a further stairway, where he meets up with one of his colleagues. There is someone else on this stairway—a Left-leaner who, in spite of the fact that he is moving in the same direction, is going *down*stairs instead of up. The Right-leaner and the Left-leaner are at right angles to each other.

We have no difficulty in discerning how the Right-leaner is going to reach his garden. But see if you can show that Left-leaner with the sack of coals on his back, and also the Left-leaner with the basket at the lower left of the print, how they can find theirs.

Two out of the three large stairways around the center of the print can be climbed on both sides. We have already seen that the Uprighters are able to use two of these stairways. How about

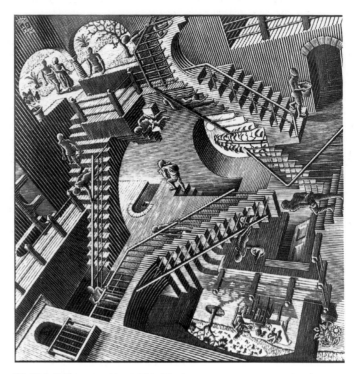

**97.** *Relativity* **as woodcut. This block was never printed.**

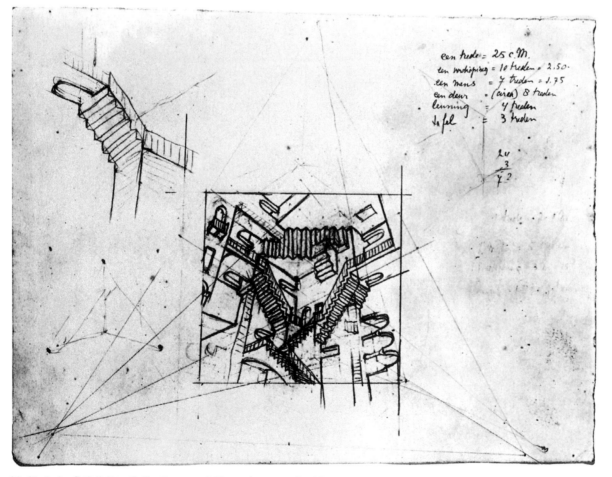

**96. Study for** *Relativity* **with the three vanishing points, pencil, 1953**

the Left-leaners and the Right-leaners—are they also able to walk up two or three stairways?

A very extraordinary situation arises on the stairway that runs horizontally across the top of the print. Is this same situation possible on the two other stairways?

Clearly there are three different forces of gravity working at right angles to each other in this print. This means that one of the three existing surfaces serves as a ground for each of the three groups of inhabitants, each of which is subject to the influence of only one of the fields of being.

I daresay an intensive study of this print would come in handy for astronauts; it might help them to get accustomed to the notion that every plane in space is capable of becoming a ground at will, and that one must be prepared to come across one's colleagues in any arbitrary position without getting giddy or confused!

Another version of *Relativity* is to be found, among Escher's nonmultiple reproduction work. That is, he made instead of a lithograph a woodcut of the same print. Apart from a proof, the block was never used for printing (figure 97).

## New Rules

If we look at figure 98, then we shall see all the vertical lines converging toward the nadir, which is situated at the center of the lower edge of the drawing. It does not strike us as at all unnatural that these lines should be curved—rather than straight, as they ought to be according to the traditional rules of perspective.

This is one of the most important of all Escher's innovations

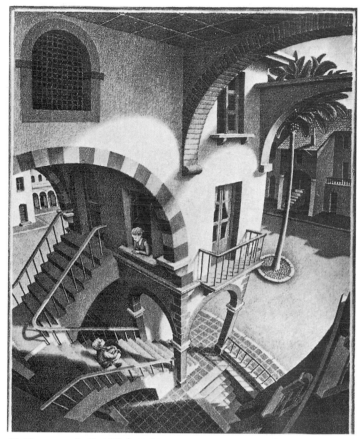

98. The upper half of *High and Low*

99. Miniature of Jean Fouquet, 1480

in the realm of perspective; these curved lines correspond to our view of space much more accurately than straight lines do. Escher never used this invention as the main subject of any print; he did, however, immediately start to bring it into play. Therefore, in order to give an idea of the way in which the new principle can be applied in a normal picture, we have reproduced just half of the print *High and Low*.

How is this exchange of straight lines for curved brought about? To find the answer to this we can look at figure 100. Here is a person lying on the grass between two telegraph poles and looking at two parallel wires. The points $P$ and $Q$ are closest to him. If he looks straight ahead, he sees the wires coming together at $V_1$; if he looks back over, he sees them meeting at $V_2$. Thus the telegraph wires, continuing endlessly on both sides, would be shown as the lozenge-shaped figure $V_1QV_2P$ (figure 100b). But we simply don't believe it! We have never seen a kink like the one at $P$ and $Q$, and so for the sake of continuity we end up with curved lines as in figure 100c.

We once confirmed the way in which this method of presentation tallies with what we really see, when we made a panoramic photograph of a river. We stood by the water's edge and took twelve photographs; after each exposure the camera was turned through about 15 degrees. When the twelve photographs were fixed together the picture of the river bank looked very much as in figure 101b.

Painters and draftsmen alike have arrived at this curved-line perspective. In a number of his works the miniaturist Jean Fouquet (*circa* 1480) "has drawn the straight lines curved" (figure 99) and Escher has told how once, when he was drawing a small cloister in a southern Italian village, he drew both the horizontal stretch of the cloister wall and the central church tower with curved lines—simply because that was how he saw them.

As we have said above, it is for the sake of continuity that we arrive at the use of curved lines. But what is the geometrical aspect of this? Is there any explanation of why these lines have

Escher's explanation of the telegraph-wire effect

a

b

c

**100. The telegraph-wire effect**

**101a.**

**101b.**

**102.**

**103a.**

**103b.**

104-106. Escher's explanation of the construction of *High and Low*

got to be rendered as curved? And what sort of curves are they? Are they segments of a circle, parts of a hyperbola, or parts of an ellipse?

To get to the bottom of this matter we can study figure 101a. $O$ is the eye of the man lying beneath the telegraph wires. When he looks straight ahead he can see the wires projected, as it were, onto a picture $T_1$. If he looks up a little then the picture moves up too ($T_2$). The picture always stands at right angles to the axis of his eye. The pictures $T_1$ to $T_6$ correspond to the series of river photographs. Of course it is artificial to take only six photographs; in reality their number is infinite (figure 101b). The whole picture, then, is cylindrical, and in this figure we see drawn a transverse section of it.

In figure 102 the whole cylinder is illustrated, and $a$ is a line crossing the axis at right angles just as a telegraph wire would. Now how will this appear on the cylinder? To show this we must connect $O$ to every point along $a$; and all the points where these connecting lines intersect the cylinder outline will be image-points of $a$.

Of course, we can also construct a surface passing through $a$ and the point $O$. This plane intersects the cylinder in the form of an ellipse and $a$ is shown as that part of it marked $ABC$.

In figure 103a, $a$ and $b$ are two telegraph wires, and also the cylindrical image is drawn in, together with the eye of the observer at $O$.

The pictures of $a$ and $b$ are the semiellipses $a'$ and $b'$. We observe at the same time that they intersect at the vanishing points $V_1$ and $V_2$.

Finally we have to see that our picture comes out flat, because we want to show it on a flat surface. There is, however, no difficulty here. We cut through the cylinder along the lines $PQ$ and $RS$ and fold the upper portion flat (figure 103b); $a'$ and $b'$, though, no longer remain as semiellipses but turn into sinusoids. (Space does not allow of an explanation of this.)

Escher himself arrived at the above result by a process of intuitive construction. For instance he had no idea that his curved lines were sinusoids, yet it has been shown by measuring up his lines of construction that they do in fact correspond fairly accurately with sinusoidal curves. As he himself has explained in a letter on the subject of how he decided on curved lines, he used figures 104 to 106.

## High and Low

As we have already remarked, Escher did not use sets of curved lines on their own in any print but proceeded to combine them with the relativity of vanishing points in the lithograph *High and Low* (1947). In the sketch (figure 106) he once sent to me with a view to clarifying the construction of *High and Low*, we can see not only the curves but also the dual function of the center point of the print, *i.e.*, as zenith for the lower tower and as nadir for the upper one.

Now, first of all, let us take a close look at *High and Low*. Together with *Print Gallery*, it is probably the best print in the whole of Escher's work. Not only is its meaning put over with very great skill, but the print itself is a remarkably handsome one.

Anyone coming up the cellar steps to the right of the bottom of the print will be quite incapable of understanding yet what his point of departure is. But he won't be allowed much time to stand around wondering; it is as though he were shot upward along the curved lines of the pillars and the palm trees to the dark tiled floors in the center of the print. But his eye cannot rest there; automatically it leaps further up again along the pillars and seems to be forced to swing away up the left across the archway, with its two-colored blocks of stone.

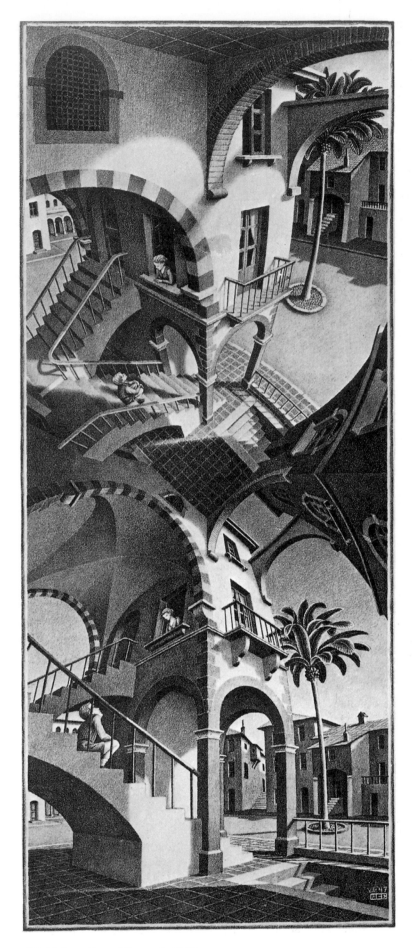

107. *High and Low*, lithograph, 1947

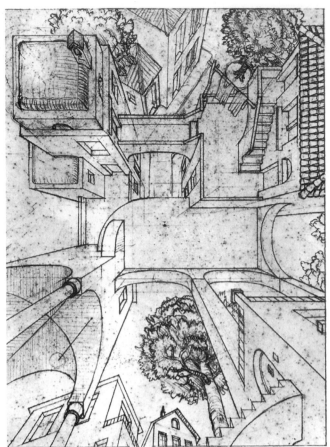

108. First version of *High and Low*, pencil, 1947

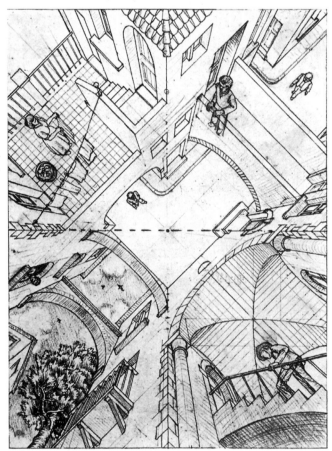

109. Second version of *High and Low*, pencil, 1947

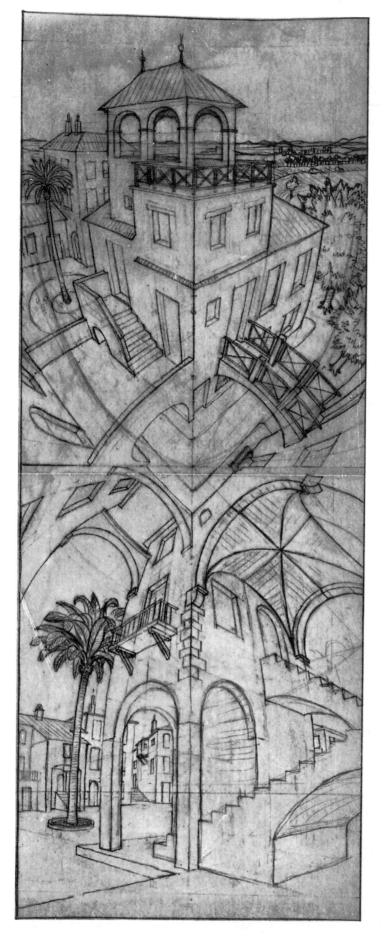

10. Version of *High and Low* with curved lines and two different images,
pencil, 1947

We experience a similar soaring sensation if we try to follow the print from the top downward. At first, then, all we can do is leap up and down in this strange world where the main lines fan out from the center and plunge back into it again—such as the leaves of the palm tree, which appear twice in the print. To study this print in peace and calm, the best thing to do is to cover the upper half of it with a sheet of paper. There we find ourselves standing between a tower, on the right, and a house. At the top, the house is joined to the tower by two stones, and if we get the opportunity to stop and survey the scene we find we are looking down over a peaceful, sunny square such as might be met with anywhere in southern Italy.

On the left we can reach the first floor of the house up two flights of stairs, and here at the window a girl is looking down and holding a wordless conversation with the boy on the stairs. The house appears to stand at the corner of a street and to be joined to another house on the left, outside the print.

In the middle of the upper part of the uncovered section of the print we can see a tiled ceiling; this is immediately above us and its central point is our zenith. All rising lines curve inward toward this point. If we now slide the masking paper so that only the top half of the print is visible, as in figure 109, then we get a view of precisely the same scene again—the square, the palm tree, the corner house, the boy and the girl, the stairs, and the tower.

Just as forcibly as our gaze was at first dragged upward so it is now equally forcibly dragged downward. It is as though we are looking down on the scene from a great height; the tiled floor—yes indeed, a tiled *floor* now—comes at the bottom edge of the visible part of the sketch. Its central point is directly below us. What was at first ceiling is now floor, for the zenith has become the nadir and serves as vanishing point for all downward-curving lines.

At this point we can clearly see where it was we entered the print; we were entering from the door that leads to the tower.

And now we can take away the piece of paper and have a look at the complete drawing. The tiled floor (alias ceiling) appears three times over—at the bottom as a floor, at the top as a ceiling and in the center as both floor *and* ceiling. We are now in a position to study the tower on the right as a whole; and it is here that the tension between above and below is at its most acute. A little above the middle is a window, turned upside down, and a little below the middle is a window right way up. This means that the corner room at this spot takes on some highly unusual features. There must be a diagonal line running through this room, one that cannot be crossed without a certain amount of danger, because along this diagonal "above" and "below" change places, and so do the floor and the ceiling. Anyone who thinks he is standing fairly and squarely on the floor has only to take one step over the diagonal to find himself suddenly hanging down from the ceiling. Escher has not drawn this situation in the interior but he implies it by means of the two corner windows.

There is still more to observe in the middle of the print. Just go down the stairs toward the tower entrance; if you continue all the way down then you will be walking upside down toward the top of the tower. No doubt, on discovering this you will hurriedly return to walking right way up. Now just take a look out of the topmost window of the tower. Are you looking at the roofs of the houses, or at the underside of the square? Are you high up in the air or crawling about under the ground?

And then on the left, up along the stairway where the boy is sitting, there is a viewpoint from which you can get horribly giddy. Not only can you look down below to the central tiled floor, but you can look beneath-below. Are you hanging or standing? And how about the boy in the top half—suppose he should lean over the banisters and gaze down at himself on the lowest stair? And can the girl at the very top see the boy at the very bottom?

This is very much a print with a mind of its own, for the top

half is by no means the mirror image of the bottom half. Everything stays firmly in its right place. We can see above and below precisely as they are; only we are driven to take up two different standpoints. In the lower half of the print eye level comes just about where the letterboxes of the houses would have been, if drawn, and one's eye is instinctively drawn upward toward the center of the print. In the upper part of the print eye level is where the two highest windows come, and we look out of them almost automatically downward toward the center of the print. No wonder our eye cannot stay still, for it cannot decide between two equally valid standpoints. It keeps on hesitating between the scene above and scene below; and yet in spite of this the print comes over to us as a unity, a mysterious unity of two incompatible aspects of the same scene expressed visually.

Why did Escher draw this on his lithographic stone? What secret lurks behind this fantastic construction?

From the constructional point of view two main elements immediately come to the fore:

1. All vertical lines are curved. On closer inspection we find that some horizontal lines are also curved (for instance, those of the guttering on the tower, to the right of the center of the print).

2. All these "vertical curves" can be seen to radiate from the center of the print. Where the verticals in the top half are concerned, we interpret this central point, for the time being, as basepoint or nadir. Yet the same point also serves as zenith for the lower half.

The two elements mentioned above are independent of each other. Two very elaborate preparatory studies for the print *High and Low* were based on the second of these elements only—that is to say, the twofold function of an identical vanishing point in the drawing. Figure 108 does not use any curved lines. Escher considered this to be too uninteresting and so he turned the linear

111. Cubic space filling with curved lines (study for *House of Stairs*, India ink and pencil, 1951)

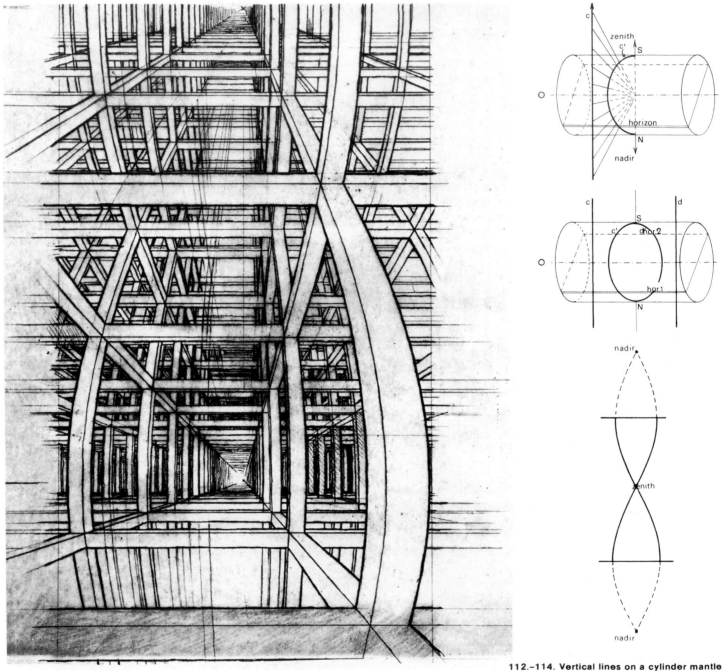

112.–114. Vertical lines on a cylinder mantle

54  The Magic Mirror of M.C. Escher

construction through 45 degrees. These drawings are thus in the same category as the *Other World* prints. It is not until one of the later preparatory drawings that we come across curved vertical lines pointing with increasing compulsion toward the zenith-cum-nadir point.

Strange as it may seem, this produces a greater suggestion of reality. The lower part of figure 110 is already very similar to the lower part of the finished print *High and Low*. However, none of the preparatory sketches approached here have yet managed to supply any satisfactory solution to the empty space around the zenith-nadir point. It has to be an area both of sky and of pavement, something which it is scarcely possible to draw. In the finished print, however, a truly remarkable unity has been achieved by the simple device of using only one picture twice. Thus the very difficult problem of the zenith-nadir point is solved with considerable charm; in the center we find some tiling that can serve both as floor covering and as ceiling decoration.

## A New Perspective for Cubic Space-Filling

The drawing illustrated as figure 111 may be regarded as a trial run for the lithograph *House of Stairs* (1951). However, it deviates from it to such an extent that it would be preferable to deal with it as an entirely independent print, albeit one not intended for multiple reproduction. The subject is identical with that of *Cubic Space Division* (1952), which we have already considered, except that in this case the newly discovered laws of perspective, involving curved lines, have been applied and our eye is immediately caught by the relativity of vanishing points. Is the vanishing point at the top of the drawing a distance point or a zenith?

**115.** Grid for *House of Stairs*

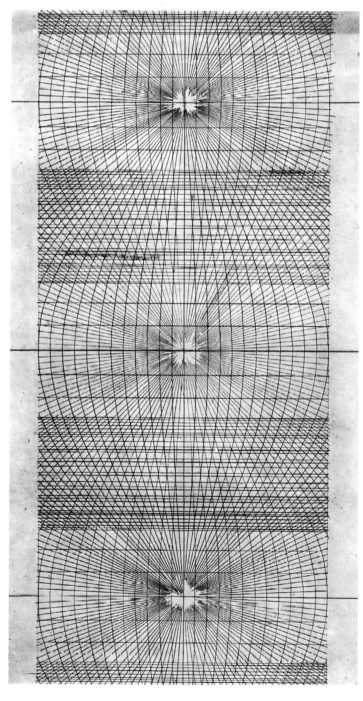

**118.** *House of Stairs*, lithograph, 1951

The Magic Mirror of M.C. Escher      55

Let us reconstruct step by step the perspective grid that forms the basis of this drawing.

In figure 112, O is once again the position of the viewer's eye, and we can imagine a cylindrical image. How is the line c to be shown on the outline of the cylinder? If we construct a surface passing through c and O this will intersect the cylinder edge in the shape of an ellipse c' (only the front side of which has been drawn). In figure 113 we observe that the parallel vertical lines c and d are shown as the ellipses c' and d'; the upper point of intersection is the zenith and the lower one is the nadir. If the cylinder side is then cut and folded open we arrive at figure 114, in which the sinusoids intersect at the zenith and then again at the nadir, the upper nadir point having coincided with the lower one on the cylinder.

Now we must find out what will appear on the side of the cylinder when both horizontal and vertical lines are drawn. Figure 116 shows the horizontal lines a and b, as already seen in figure 103a, coming out as a' and b', and, at the same time, the vertical lines c and d coming out as c' and d'. Only the front half of these last two has been drawn, in order to keep the diagram easy to follow. Figure 117 gives the cylinder wall. The section between horizon 1 and horizon 2 almost coincides with the grid pattern that Escher used for *High and Low*. But now comes the abstraction, on which the grid pattern has no bearing. We can imagine our sinusoids running upward and downward without limit. Every line that passes through a point of intersection on the vertical axis can represent a horizon, and any point of intersection can be zenith, nadir, or distance point, at random.

We have used only a few lines here in sketching a diagram of the guide pattern; a more complete version of it made by Escher, and which he used both for the drawing in figure 111 and for *House of Stairs*, can be seen in figure 115. Here only three vanishing points are to be seen; however, the diagram could be endlessly extended upward and downward.

## House of Stairs

The basic pattern for this extremely complicated and sterile house of stairs, inhabited purely by mechanically moving beasts (Curl-ups, Escher calls them)—either walking on six legs or else, in their contracted state, rolling along like a wheel—is the grid shown in figure 115.

119. The construction of *House of Stairs*

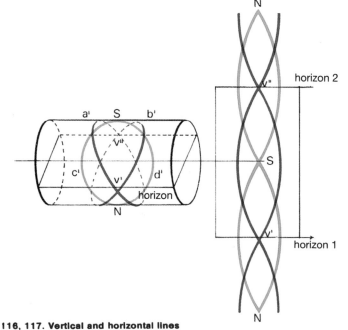

116, 117. Vertical and horizontal lines
on the cylinder mantle

In figure 119 we see a number of lines from this grid drawn across the print. It can be observed from this that the print has two vanishing points, through which horizontal lines are drawn. It can be quite unambiguously established for each Curl-up, whether such or such a vanishing point is zenith, nadir, or, for that matter, distance point. This is the case, for instance, with the large Curl-up, which is to be seen stretched out horizontally in the center of the plate. $V_1$ being its distance point and $V_2$ its nadir. A concomitant of all this is that the walls have a different significance for each one of the little creatures, and can serve not only as ground but also as ceiling or as side wall.

It is an infinitely complicated print yet one that is put together with the minimum of constructional material. Even the section between $A$ and $B$ contains all the essential elements. The section about it contains exactly the same elements as this $A$ and $B$ section, by means of glide reflection. This we can verify simply by transferring the $A$-to-$B$ section, making a rough outline on tracing paper. If we turn this tracing over, with its underside uppermost, and then slide it upward, we shall find that it fits exactly over the higher section. The same thing applies to the section lower down. In this way it would be possible to make a print of infinite

length having congruent sections alternating with their mirror images. Figure 121 shows one of the many preparatory sketches for *House of Stairs*.

Perhaps it has already struck you that the cylinder perspective used by Escher, leading to curved lines in place of the straight lines prescribed by traditional perspective, could be developed even further. Why not a spherical picture around the eye of the viewer instead of a cylindrical one? A fish-eye objective produces scenes as they would appear on a spherical picture. Escher certainly did give some thought to this, but he did not put the idea into practice, and therefore we will not pursue this further.

120. Curl-up, the animal that lived in *House of Stairs*

121. One of the preliminary studies for *House of Stairs*

# 9 Stamps, Murals, and Bank Notes

At first, Escher undertook almost every possible commission, for he felt duty bound to earn his own living, by his own work in so far as this was possible. He did illustrations for books. The last of these, a book about Delft for which he made the woodcuts in 1939, was never published. In 1956 Escher did both text and illustrations for a bibliophile edition published by the De Roos Foundation. Its subject is periodic surface-division. Escher found working on it a very tiresome experience. He had to try to put into words things he had long known but which he preferred to draw rather than write about. But what a pity it was that this book appeared in such a limited edition (of only 175 copies), for the text is excellent and makes a good introduction to the understanding of the prints in which Escher dealt with periodic surface-division.

In 1932 he even took over the job of official artist for an expedition in the boot of Italy. This expedition was under the leadership of Professor Rellini, and a Dutch participant was Leopold, codirector of the Netherlands Historical Institute in Rome. The drawings remained in Leopold's possession and nobody knows what became of them. Other smaller works commissioned included bookplates, wrapping paper and damask designs, magazine covers, and various solid items. These last were single pieces, except for a candy tin in the shape of an icosahedron decorated with starfish and shells, which was used by a firm of tin manufacturers (Verblifa) as a public-relations handout on the occasion of the seventy-fifth anniversary of the firm in 1963.

So there was, on the average, at least one commission a year to occupy Escher over and above his independent work. However, none of the commissions ever led to important new work. Inspiration did not flow from them; in fact the opposite was the case. He would choose for his commissioned work themes and designs he had already tried out in his independent work. This more or less goes without saying, for those who did the commissioning chose Escher for the job for the simple reason that they knew certain aspects of his work and wanted to have these expressed in the things they had ordered.

His designs for postage stamps can be counted among the most important of his commissions. He designed a stamp for the National Aviation Fund in 1935, one in 1939 for Venezuela, one for the World Postal Union in 1948, one for the United Nations in 1952, and a European stamp in 1956.

His work on the Netherlands bank notes was of longer duration. In July, 1950, he was commissioned to submit designs for the ten-guilder, twenty-five guilder, and hundred-guilder bills. Later there was the design for a fifty-guilder bill. He did some intensive work on it and had regular discussions about his designs with those who had commissioned them. In June, 1952, however, the commission was withdrawn; Escher had not been able to harmonize his designs with the requirements of the checkering machine used to produce the highly complicated curves needed to make forgery an exceedingly difficult operation. All that is now left of this work can be found in the museum of Johan Enschedé, bank-note printers in Haarlem.

He received the first commission for decorative work on a building in 1940, for three inlaid panels for the Leiden city hall; a fourth was added in 1941. Later commissions in this sphere were for work on interior and exterior walls, and on ceilings and pillars. Some of these he carried out himself—for instance, the wall paintings for the Utrecht cemetery; but in most cases he simply supplied the design.

The last great mural was completed in 1967. Engineer Bast, at that time director of posts and telegraphs, used to have the large 1940 *Metamorphosis* hanging in his board room and would gaze at it during boring meetings. So he recommended this self-same *Metamorphosis*, greatly enlarged, as a mural for one of the large post offices in The Hague. The original *Metamorphosis* print was four meters in length, and the plan was to make it four times as big. This did not work in very well with the dimensions of the wall, and so Escher spent half a year on an additional three meters. The final *Metamorphosis*, Escher's swan song, is now seven meters long. This print was enlarged with very great accuracy (to a length of 42 meters) on the post-office wall, to calm the troubled minds of all the people waiting at the counters.

A lesser commission, in 1968, was the very last—the tiling of two pillars in a school in Baarn.

# FELICITAS 1956

## EUGÈNE & WILLY STRENS

Congratulations card commissioned by
Eugene and Willy Strens

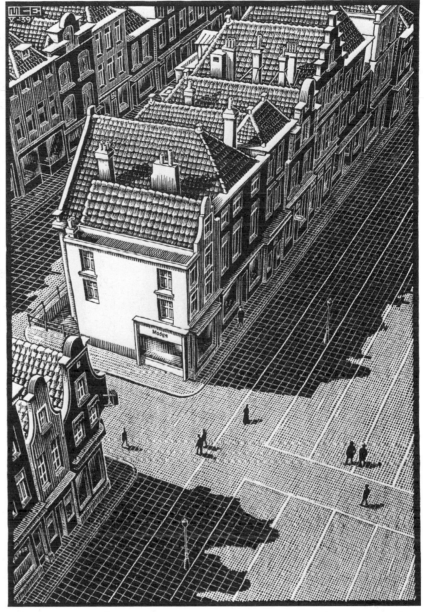

122. Woodcut for a never published book about Delft, 1939

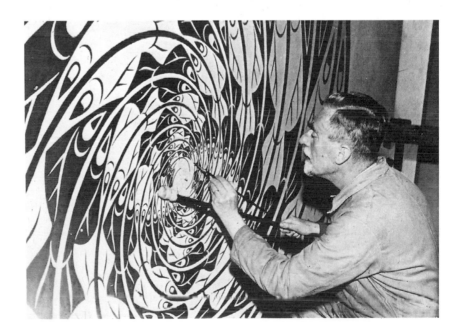

Escher working on mural for cemetery

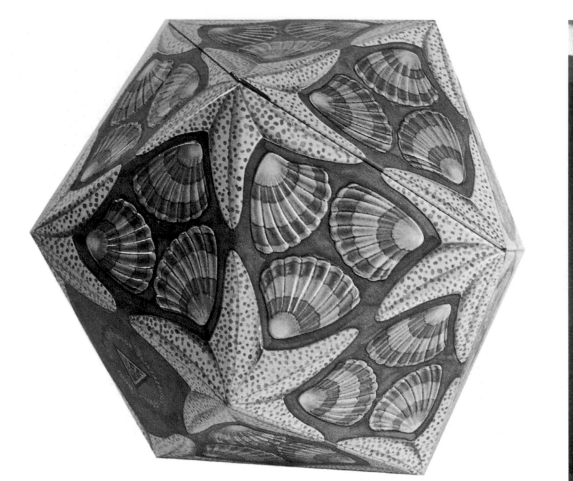

125. Icosahedron with starfish and shells—a candy box produced by
Dutch can manufacturers as anniversary premium

123. The elongated version of *Metamorphosis* in the hall of the
Kerkplein Post Office, The Hague, 1968

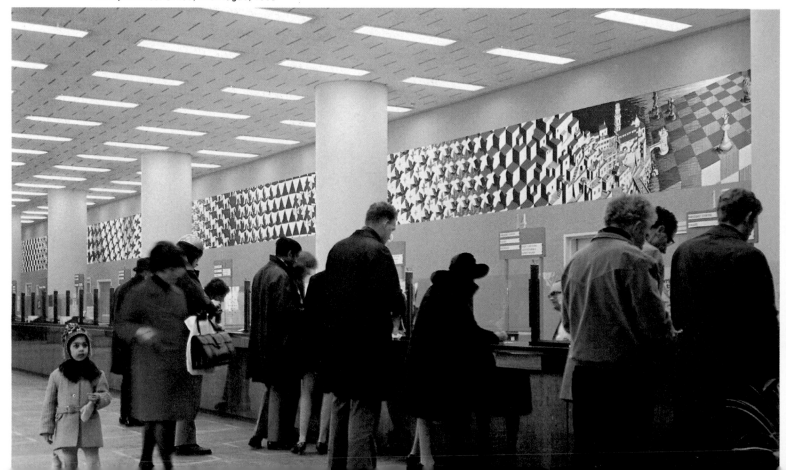

126. Glazed tile column, new girl's
school, The Hague, 1959

124. Stamps designed by Escher

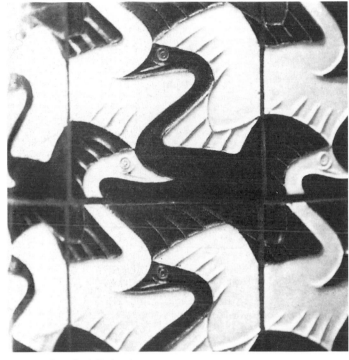

Detail of tiled column

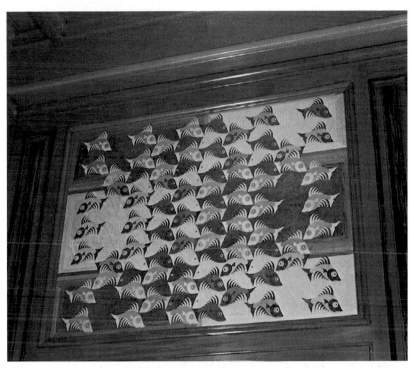

127. Two intarsia panels in the city hall of Leiden

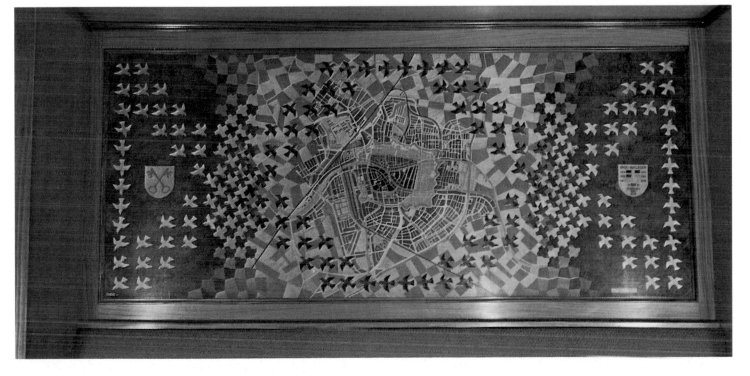

The Magic Mirror of M.C. Escher     61

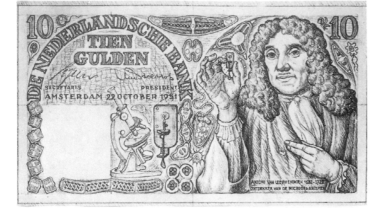

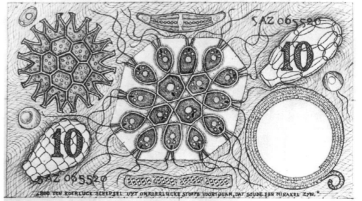

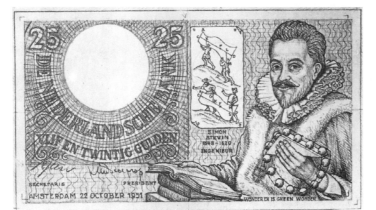

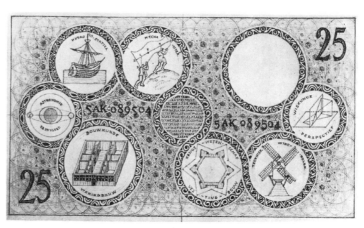

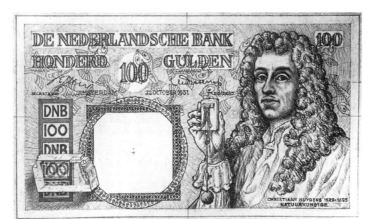

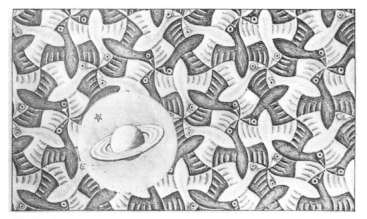

128. Bank note designs that were never used.

Design for a ten guilder bank note, with a portrait of Anthoni van Leeuwenhoek (1632-1723), the Dutch discoverer of microorganisms. Escher has gone to great pains to illustrate as many of van Leeuwenhoek's discoveries and pronouncements as he possibly can using both the obverse and reverse sides. The result is a pleasing if somewhat conventional composition.

Design for a 25 guilder note. The subject is the Dutch engineer Simon Stevin (1548-1620) whose writings contributed to the popularization of the natural sciences. The only typical trace of Escher to be found here is the ribbon-shaped ornamentation which encloses the nine circles on the reverse side.

Design for a 100 guilder note: obverse, reverse and watermark. The subject is the Dutch scientist Christian Huygens (1629-1695). At the bottom left corner of the obverse, we see a birefringent crystal, the properties of which were so profoundly studied by Huygens; and the way in which it is shown is typical of Escher. On the reverse there is a regular surface division with fish, and in the watermark a particularly attractive surface division with birds.

# Part Two: Worlds that cannot exist

# 10    Creating Impossible Worlds

*"Tell us, master, what is art?"*

*"Do you want the philosopher's answer? Or are
you seeking the opinion of those wealthy folk who
decorate their rooms with my pictures? Or again,
do you want to know what the bleating herd think
of it, as they praise or denigrate my work in
speech or written word?"*

*"No, master—what is your own answer?"*

*After a few moments Apollonius declared,
"If I see, or hear, or feel anything that another
man has done or made, if in this track that he
has left I can perceive a person, his understand-
ing, his desires, his longings, his struggles—
that, to me, is art."*

*I. Gall.*, Theories of Art

An important function of representational art is to capture
an all-too-transient reality, to prolong its existence. The general
notion is that anyone who has his portrait painted is being
"perpetuated." Before photography brought this perpetuation
within the grasp of all, it was *par excellence* the work of the artist.
Not only in pictorial art, but throughout the whole history of
artistic expression, we find the idealization of reality. The picture
must be more beautiful than the actual object it represents. The
artist must perforce correct any faults and blemishes by which
reality is marred.

It was a very long time before people began to value, not the
picture nor the idealization, but rather, the personal vision of the
artist as it shows up in his work. Of course, the artist had never
discarded this vision; it would have been impossible to do so.
But he had not displayed the vision for its own sake, nor did
those who commissioned the works, or the public themselves,
value the artist for his self-revelation. It is expected of the present-
day artist that his work should be first and foremost an expres-
sion of himself. Thus reality is now regarded more as a veil hiding
the work of art than as the means whereby self-expression can be
manifested. Thus we find emerging a nonfigurative art in which
form and color are made the servants of the artist's self-expres-
sion. And at much the same time there has appeared a further
negation of reality—that is to say, surrealism. Here shapes and
colors are in no wise abstracted from reality. They do remain
linked to recognizable things; a tree remains a tree—only its
leaves are not green; they are purple, or they have each taken on
the shape of a bird. Or the tree has remained intact, in shape
still a true-to-life tree, and yet its normal relationship to its sur-
roundings has gone. Reality has not been idealized; it has been
abolished, sometimes ending up in contradiction to itself.

If one should wish to see Escher's work, or at least a part of it,
in the light of art history, then probably this can best be done
against the background of surrealism—not that his work is sur-
realistic within the meaning attached to it by art historians. But
the background of surrealism does serve as a contrast, and a
selection of surrealistic work could be made at random for this
purpose. We have chosen a few works by René Magritte, in the
first place because Escher himself had a high regard for his work,
and secondly because the extremely obvious parallels of subject
matter, aim, and effect can be used to bring out the totally dif-
ferent nature of Escher's work.

In Magritte's *The Voice of Blood* (1961) we see a lonely plain.
A river flows through it and a few trees stand at its edge: in the
distance a dim mountain scene; in the foreground a hill on which
there stands a mighty tree (an oak, perhaps), taking up more than
half of the picture—strong and sturdy oak with an enormous
crown of foliage. But Magritte makes the massive trunk come
open, as though it were a tall, narrow, triple-doored cupboard
revealing a mansion and a sphere. This is simply impossible.
Such a "cupboard-tree" is a pure fake, quite incapable of growing
or of producing any rich leafy adornment. What is worse, the
dimensions of the mansion, with all its room lights blazing, are
much greater than those of the hollow cupboard-tree itself. Or can
it be a Lilliputian house? Is the sphere in the middle section also
as big as the house? And what might be lurking behind that third
door?

All we have to do is to close the doors and there stands a great
and healthy tree once more: an impressive chunk of reality. Or is
it really that? For, after all, we are now aware of the fact that
a house and a sphere live inside the trunk.

What are we to make of such a picture? Or rather: what does
such a picture do to us? It is absurd, and yet it is attractive in its
absurdity.

It is an impossible world. Such a thing cannot really exist. But
then Magritte has in fact achieved it; he has turned a tree into a

129. René Magritte, *La Voix du Sang* (The Voice of Blood), 1961 (Museum des XX Jahrhunderts, Vienna, © Copyright ADAGP, Paris)

words and according to normal rules of grammar.

Here is a literary version of Magritte's visual absurdities. One can philosophize at great length over Magritte's surrealism but even his contemporaries and friends held radically different opinions about its meaning. I should like to look into the way in which Magritte uses, transforms — yes, does violence to reality, in order to stimulate our predilection for that which astonishes. In *The Voice of Blood* reality is upset in two ways. The massive interior of the tree trunk is made hollow; and different size-scales are used next to each other. Thus the thickness of a tree trunk becomes greater than the width of a fine big building. And so the resultant scene is presented as a bold assertion: "That's the way it is — crazy."

Nevertheless the whole rendering comes so close to reality that it is as though Magritte were telling us, "As a matter of fact, everything to do with our whole existence is crazy and absurd — a great deal more absurd than anything I have shown in this picture of mine." Magritte hides nothing, does nothing in secret. Our very first glance at his picture tells us, "This is impossible." And yet, if we take a closer look at it our intelligence begins to waver and we experience the pleasure which the abolition of reason brings. In our daily lives we are so imprisoned within the straitjacket of reality that there is a great deal of pleasure to be obtained from giving ourselves over to surrealism, a temporary deliverance from reality. The discursive, reasoning intellect takes a vacation and we stagger around delightfully in an inexplicable world.

Anyone who tries to discover subtlety of meaning in all this, or who would like to know what it is all about in its deepest essence is probably looking for the very thing the painter is trying to release him from.

The impossible worlds Escher has made are something totally different from this. Although he expressed admiration for *The Voice of Blood* as a picture (and this is unusual in view of the low opinion that is all that he could muster for most of his contemporaries), he is not able to approve of the naivete with which Magritte sets forth his statements of visual absurdity. To Escher this is just shouting in the wind. It is all too easy to astound everybody momentarily with a daring statement decked out in attractive forms and colors. You must show that absurdity, *sur*-reality, is based on reality.

Escher has created impossible worlds of an entirely different character in that he has not silenced intellect but has in fact made use of it to build up the world of absurdity. Thus he creates two or three worlds that manage to exist in one and the same place simultaneously.

When Escher begins to experiment with the representation of simultaneous worlds he makes use of methods that display a remarkable similarity to those of Magritte. If we compare Magritte's *Euclidean Walks* (1955) with Escher's *Still Life and Street* (1937), it can be seen that the aims of the two artists do not widely diverge. In Magritte's case, inside and outside are mainly united by the painting on the easel, and in Escher's case by making the structure of the surface of the windowsill coincide with that of the pavement.

We find an even greater similarity when we compare Magritte's *In Praise of Dialectic* (1927) with Escher's *Porthole* (1937). With Magritte, any logic and any connection with reality are fortuitous; with Escher they are consciously pursued. The surrealist creates something enigmatic; and it must perforce remain an enigma to the viewer. Even if there were any solution to it, we should never be able to find it. We have to lose ourselves in the enigma, standing as it does for so much that is puzzling and irrational in our existence. With Escher, too, we find the enigma, yet at the same time — albeit somewhat concealed — the solution. With Escher it is not the puzzle that is of prime importance. He asks us to admire the puzzle but no less to appreciate its solution. To those who

cupboard and has placed a mansion on a shelf inside it. The title, *The Voice of Blood*, serves to heighten the absurdity. It would seem as though Magritte has chosen a title as difficult as possible to relate to the visual content.

In 1926 Rene Magritte wrote an unusual literary contribution to the first issue of a paper of which he himself was one of the editors: *"Avez-vous toujours la même épaule?"*

"Do you always have the same shoulder?" Thus one shoulder becomes a separate entity, and the possibility is introduced that one may or may not have it. The grammatical construction is perfectly normal but opens up something absurd: the possibility of being able to choose one's own shoulder at will. The meaning is surrealistic, but the statement is constructed from ordinary

131. *Still Life and Street*, woodcut, 1937

130. René Magritte, *Les Promenades d'Euclide* (Euclidean Walks), 1953 (The Minneapolis Institute of Art, © Copyright ADAGP, Paris)

132. René Magritte, *L'Empire des Lumières II* (The Empire of Light II), 1950 (Museum of Modern Art, New York, © Copyright ADAGP, Paris)

cannot see this, or who, though seeing it, are incapable of evincing any appreciation of this highly rational element, the essential meaning of Escher's work remains a closed book.

Escher constantly returns to the theme of the mingling of several worlds. To the problems presented by this theme he finds ever more satisfying solutions. Furthest along this path stand *Rippled Surface* (1950) and *Three Worlds* (1955), prints of great skill and beauty; yet even they will reveal Escher's rational purpose only to such as have steeped themselves in the whole range of his work.

Magritte shows no signs whatever of being influenced in his work by the possibility of merged or interpenetrating worlds. On the contrary, the rational possibility of such merging would

be a hindrance to him, would reduce his power to surprise and be detrimental to the absurdity. How far apart from each other Escher and Magritte are, is perhaps best shown by a comparison between Magritte's *The Empire of Light II* (1950) and Escher's *Day and Night* (1938) or *Sun and Moon* (1948). *The Empire of Light* may be regarded as one of the most important of Magritte's works; for it he was awarded the Guggenheim Prize for Painting in Belgium. Magritte himself wrote of this picture:

What I put into a picture is what the eyes can see; it is the thing, or things, that people must know about already. Thus the things portrayed in the painting *The Empire of Light* are those things

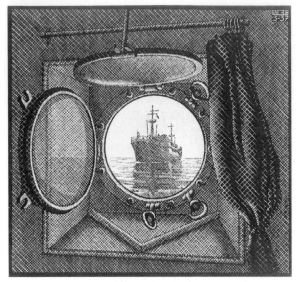

**133.** *Porthole*, woodcut, 1937

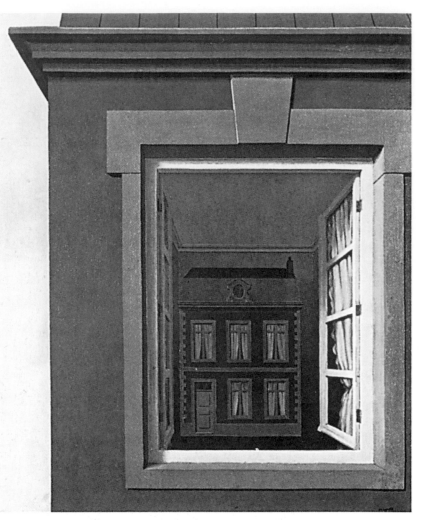

**134.** René Magritte, *L'Éloge de la Dialectique* (In Praise of Dialectic), 1937 (Private Collection, London, © Copyright ADAGP, Paris)

which I know about, or, to be precise, a nocturnal scene together with a sky such as we can see in broad daylight. *It seems to me that this summoning up of night and day together gives us the power to be both surprised and delighted.* This power I call poetry.

By summoning up day and night together, Magritte seeks to surprise and to delight — to surprise because it is an impossibility. When Escher summons up *Day and Night* or *Sun and Moon* it is also in order to surprise . . . but precisely because it is not an impossibility. It does surprise and delight, simply because it has a look of the impossible about it. But it surprises still more because Escher has discovered a means, a perfect, complete pictorial logic, whereby the impossible can be turned into the possible.

If we seek a literary parallel to this we can find it, so far as Escher is concerned, essentially in the detective novel. The mystery makes no sense until it can be seen in the light of the more-or-less thrilling denouement. And, also in the detective novel, the mystery can take on an absurd, surrealistic form, as is often the case with G. K. Chesterton. In *The Mad Judge*, the judge playing hopscotch in a prison yard is a complete absurdity. In *The Secret Document*, a sailor jumps overboard; no splash is heard, no movement is seen in the water, the man has completely disappeared. Then we have somebody stepping out of the window and leaving no trace. A work of Magritte's such as *The Unexpected Answer* might well have served as an illustration for this. But Chesterton's triumph always turns up a dozen pages later, when he demonstrates that what at first seemed so weird is really strictly logical, normal, part of an overall grand design. The range of Escher's impossible worlds is much greater than the theme from which we

have so far drawn our examples. Escher shows us how a thing can be both concave and convex at one and the same time; that the people he has created can walk, at the same moment and in the same place, both upstairs and down. He makes it clear to us that a thing can be simultaneously inside and outside; or, if he uses differing scales in the one picture, there exists a representational logic capable of rendering this coexistence as the most natural thing in the world.

Escher is no surrealist, conjuring up for us some mirages. He is a constructor of impossible worlds. He builds the impossible according to a strictly legitimate method that everyone can follow; and in his prints he demonstrates not only the end product but also the rules whereby it was arrived at.

Escher's impossible worlds are discoveries; their plausibility stands or falls by the discovery of a plan of construction, and this Escher has usually derived from mathematics. And useful plans of construction were not just there for the picking!

Finally, we should like to point to one uniquely fascinating aspect of Escher's impossible worlds. A century ago it was impossible to travel to other planets or to transmit pictures of them. With the advance of science and technology all sorts of things that are still impossible today will become realities. Nevertheless, some things there are that are totally impossible, such as a squared circle. It is to this latter category that Escher's impossible worlds belong. They remain forever impossible and have their existence purely and simply within the bounds of the print, and by virtue of the imaginative power of the man who made them.

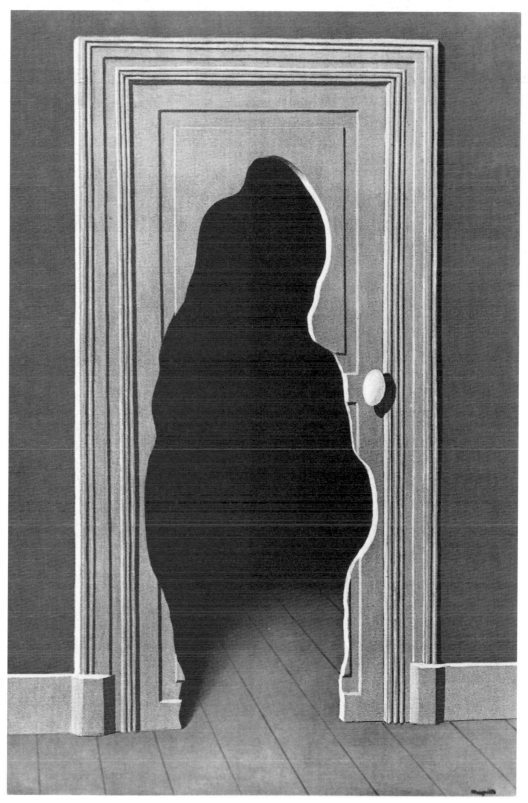

**135. René Magritte,** *La Reponse Imprevue* **(The Unexpected Answer), 1933**
**(Museés Royaux des Beaux Arts de Belgique, Brussels)**
**( © Copyright ADAGP, Paris)**

# 11  Craftsmanship

## Drawing

"I am absolutely incapable of drawing!" This is a most extraordinary remark to come from someone who was busy drawing from earliest childhood to the age of seventy. What Escher really means is that he was incapable of drawing when relying only on his imaginative faculty. It is as though the essential link were between his eyes and his hands. In his case the intermediate emergence of visual concepts is but poorly developed. In his later prints, whenever buildings and landscapes were needed as a setting, he copied these with considerable accuracy from real life. In the calm period that followed the completion of a print he would go through his portfolios of travel sketches, for here was the source material he needed in order that new ideas should take shape.

Whenever he needed human or animal figures he had to draw these from nature. He modeled his Curl-up creatures, in various attitudes, in clay. The ants that are to be seen on *Moebius Strip II* were modeled in plasticine; a praying mantis that landed on his drawing pad during one of his wanderings in southern Italy was swiftly drawn and later pressed into service as a model for his print *Dream,* and when he was working on the last of his prints, *Snakes,* he bought some books of snake photographs. For his print *Encounter* he needed little people in all the required positions; then he posed himself in front of the mirror. "Yes, I am quite incapable of drawing, even the more abstract things such as knots and Moebius rings, so I make paper models of them first and then copy them as accurately as I can. Sculptors have a much easier job. Everyone can model clay—I have no difficulties with that. But drawing is terribly arduous for me. I can't do it well. Drawing, of course, is much more difficult, much more immaterial, but you can suggest much more with it!"

**136. Clay models of Curl-ups for** *House of Stairs*

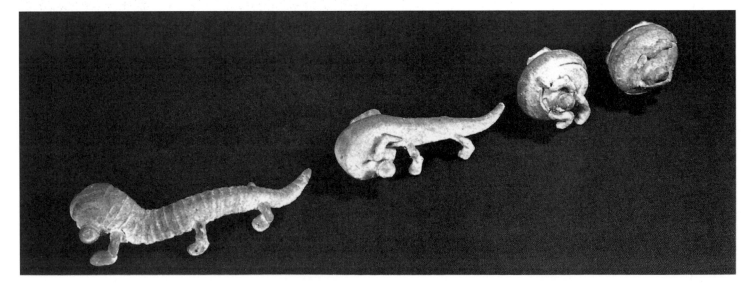

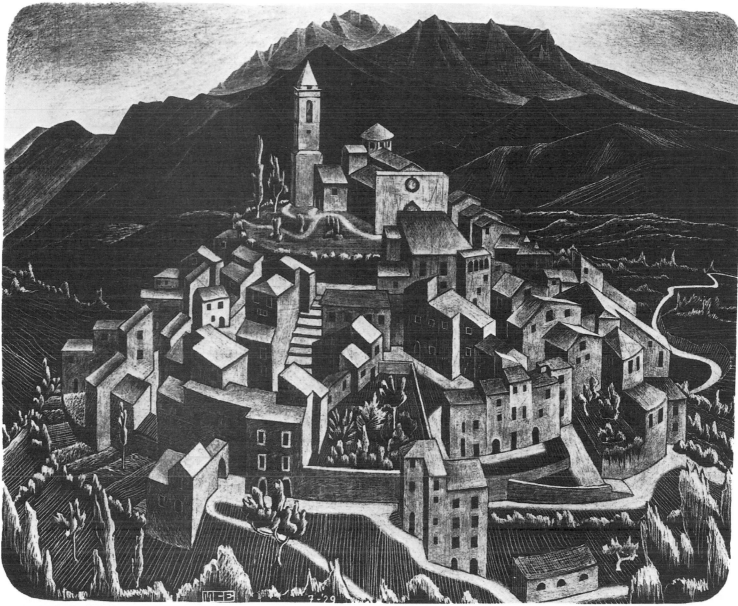

139. Escher's first lithograph: *Goriano Sicoli, Abruzzi*, 1929

137. Ant, plasticine model for *Moebius Strip II*

138. Cardboard model for *Knots*

## Lithographs and Mezzotints

During his time as a student Escher came to know several graphic techniques. But etching did not suit him at all because, owing to his allegiance to the linocut and woodcut, he had a predilection for working from black to white. To start with, all is black; whatever he cuts away will be white. This was how he made his scraper drawings. A sheet of paper was entirely blacked over with wax crayon, then, taking his knives and pens, he removed those parts that were to become white.

The need to be able to make reproductions of his work also led to the lithograph. At first he went to work on this medium just as though he were trying to execute a scraper drawing on the lithographic stone. The whole surface was blackened and the white was removed. All his early lithographs were produced in this way. In the first lithograph, *Goriano Sicoli* (1929), showing a small town in the Abruzzi, one can see how unaccustomed he still was to the new technique. He used too great an area of the stone, with the result that it is difficult to take good copies of the whole print.

From 1930 onward he was drawing on the stone normally, with lithographer's chalk. It gave him greater freedom of expression than the woodcuts. There was no longer any problem over a smooth transition from black, through gray, to white. He never printed his own lithographs. In Rome, this was done for him by a small commercial printing firm and in the Netherlands also he had a number of skilled people who could do it for him. It is a pity that when he began this work he used borrowed stone. Owing

to the closure of a printing firm from which he had borrowed stones, these latter were lost, and so a large number of prints could no longer be printed.

To anyone who is very fond of the woodcut, with its striking contrast between black and white, a lithographic print is always something of a disappointment. The lithographic chalk drawing on the stone shows up blacks very clearly and well, and there is a good range of contrast. On printing, however, this contrast range recedes and becomes in fact less marked even than what can be achieved with a pencil drawing.

In Brussels Escher made the acquaintance of Lebeer, the keeper of the print room, who was also buying his work privately. Lebeer advised him to turn his attention to the mezzotint, sometimes called the black art. To initiate this process one takes a copper plate and roughens it all over (an endless task, done by hand). This roughened plate holds a great deal of ink and on printing leaves a deep black surface. For the parts that are to be white or a certain shade of gray the roughened plate has to rubbed more or less smooth with steel tools. This is also a technique working from black to white; thus, in contrast to the lithograph, it produces a good range of contrast.

Escher made only seven of these because the technique was particularly time-consuming and because only fifteen or so good prints can be made from each plate. Only if the copper plate is specially hardened or tempered beforehand are more prints possible. All his mezzotints were printed by the bank-note printing firm Enschede, in Haarlem.

Escher was not in any way fettered by the techniques which he

**140.** *Rome at night (Basilica di Massenzio)*, **woodcut, 1934**

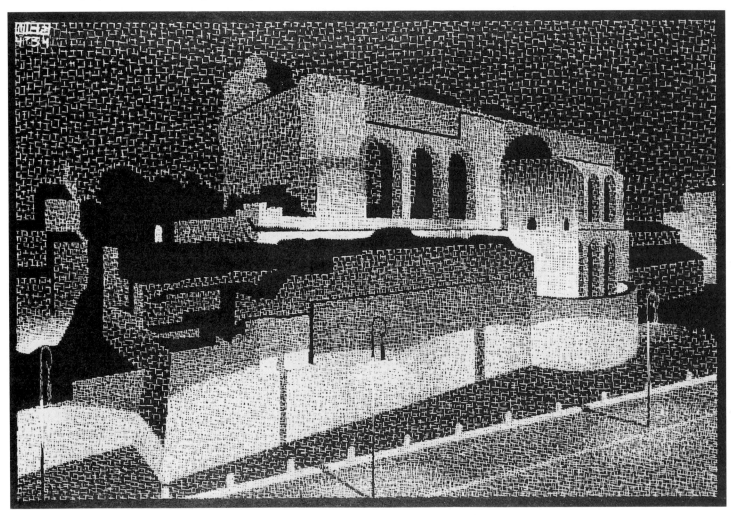

used. He regarded them as a means to an end, and only experimented with them so long as they could be considered needful. If one studies the finest details of his woodcuts through a magnifying glass, one can form an idea of how keen was his eye and how firm his hand.

## Multiple Reproduction

"I make things to be reproduced in quantity; that's just my way." When Escher was at high school in Arnhem he made linocuts. The fairly brief training that he received from de Mesquita consisted entirely in an extension of this work. He applied himself almost exclusively to woodcuts, using side-grained wood, which meant that the structure of the wood was still visible in the prints. One of the most beautiful examples of this is certainly the large portrait of his wife, *Woman with Flower* (1925). His virtuosity was apparent in a series of prints which he made of nocturnal scenes in Rome, in 1934. For some of these both sketch and woodcut were completed within twenty-four hours! And in each print he had restricted himself to cutting in one or more predetermined directions, so that this series of prints became a kind of sample card of possibilities.

He did make one more linocut, *Rippled Surface*, in 1950 (figure 149) and that was for the simple reason that he had no suitable wood on hand at the time.

As he came to feel the need to depict finer details, he gradually began to change over from side-grain, which de Mesquita had so assiduously recommended, to end-grain wood. Then it was that the first wood engravings appeared: *Vaulted Staircase* (1931), and *Temple of Segeste, Sicily* (1932). The woodcuts and wood engravings were printed, not on a press, but by an old Japanese method using a bone spoon. The printing ink was spread over the wood with a roller and a sheet of paper was laid on it. Then each place of contact between wood and paper was rubbed over with the bone spoon. It is a primitive and complicated method, and yet the wood remains sound and serviceable for a much longer time than is the case with a press; with the latter one has to exert a much greater pressure in order to obtain a good print.

If more than one block of wood was needed, he used an equally primitive method to ensure that the various blocks were printed in the correct positions. Notches on the edge of each block indicate the points where the block is to be held in position with pins. By making notches on the second block correspond with those of the one that was used first, it can be fixed accurately in place.

## Modern Art

When an exhibition was held showing the work of twenty-two Dutch artists (at which one of Escher's prints was hung) he sent me the complimentary copy of the catalog he had received. On the cover he had scribbled, "Whatever do you make of such a sick

141. *Rome at Night (Column of Trajanus)*, woodcut, 1934

142. *Vaulted Staircase*, wood engraving, 1931

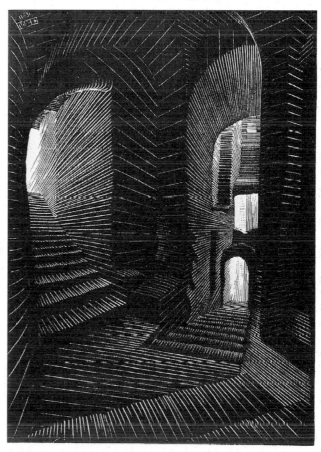

effort as this? Scandalous! Just throw it away when you have looked at it."

His unsympathetic attitude toward most expressions of modern art served as a key to his view of his own work. He could not put up with anything obscure. During an interview with a journalist, the conversation turned on the work of Carel Willink. "If Willink paints a naked woman in a street, I wonder to myself, 'Now, why should he do that?' and if you ask Willink you'll get no reply. Now, with me, you will always get an answer to the question why."

When the conversation turned to the high prices that modern art fetches, Escher became furious. "They are complete fools! It's like the Andersen fairy tale—they buy the Emperor's new clothes. If the art-dealers smell a profit, the work is pushed and sold for big money." But then he took back his words somewhat. "I don't want to condemn it too much. I don't know—it's a closed door to me."

At that time Escher did not foresee that his work would also attract collectors to spend a lot of money on his prints, and that after his death thousands of dollars would be paid for a single copy!

He reproached most modern artists for their lack of professional skill, referring to them as daubers who can do no more than play around. For a Karel Appel he could not muster the slightest feeling of appreciation. But for Dali, on the other hand: "You can tell by looking at his work that he is quite an able man." And yet he was jealous of any artists who had a complete mastery of technique. Among the graphic artists he regarded Pam Ruiter and Dirk van Gelder as being more skilled than himself. However, he was not necessarily attracted by mere mathematical precision. Vasareli's abstract work he regarded as soulless and second-rate. "Maybe other artists can work up an appreciation of my work, but I certainly can't for most of what they turn out. Anyway, I don't want to be labelled as an artist. What I have always aimed at doing is to depict clearly defined things in the best possible way and with the greatest exactitude."

That spontaneity of work which the modern artist holds in such high esteem is altogether lacking in Escher. Every print called for weeks and months of thought and an almost infinite number of preparatory studies. He never allowed himself any "artist's license." Everything was the outcome of a long quest, because it had to be based on an inner principle. This detective work on underlying concepts is the most important feature of his work. The setting, the houses, the trees, and the people are all so many "supers" whose job it is to call attention to things that are taking place according to the rules in the print.

In spite of his infallible sense of composition, refinement of form, and harmony, these things are but by-products of a thoroughly explored inner discipline. When he had almost completed *Print Gallery*, I passed a remark about those ugly curved beams in the top left-hand corner; they were horrible! He looked at the drawing pensively for a while and then he turned to me and said, "You know, that beam has just got to go like that. I constructed it with great exactness; it can't go any other way!" His art consists of discovering principles. The moment he is on the track of something he has got to follow it with sensitivity and, indeed, obedience.

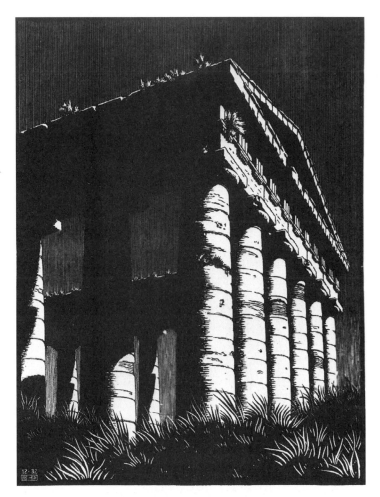

143. *Temple of Segeste, Sicily*, **wood engraving, 1932**

# 12   Simultaneous Worlds

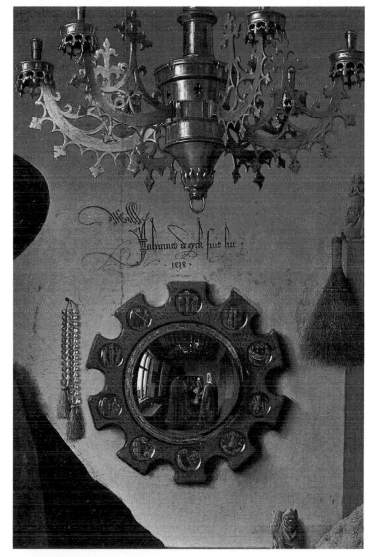

44. Jan van Eyck, *The Arnolfini Marriage* (detail)
(The National Gallery, London)

## Globe Reflections

Two different worlds existing in one and the same place at the same time create a sense of being under a spell. For this is an impossibility; where one body is, there the other cannot be. We have to think up a new word for this impossibility—"equilocal"—and this we can define as "occupying the same place simultaneously." None but an artist can give us this illusion, thereby procuring for us a sensation of the first order, a sense experience wholly new.

From 1934 onward Escher made prints in which he was consciously seeking this sensation of equilocality. He managed to unite two, and at times three, worlds so naturally in a print that the viewer feels, "Oh yes, that is quite possible; I am quite able to comprehend in thought two worlds at the same time."

Escher discovered an important expedient for these—reflections in convex mirrors. In one of his first great drawings, the *St. Bavo's, Haarlem* (figure 29) we can already see an intuitive adoption of it.

In 1934 *Still Life with Reflecting Sphere* appeared, a lithograph in which not only the book, the newspaper, the enchanted Persian bird, and the bottle can be seen, but also the whole room and the artist himself appear indirectly, as a reflection.

A simple construction taken from optical geometry (figure 148) shows us that this whole mirror-world is contained within a small area within the reflecting globe, and indeed that, in theory, the whole universe, except for that part of it immediately behind the sphere, can be reflected in such a globe.

This reflection in a convex mirror can be found among the works of several artists, as, for instance, in the famous portrait of the Arnolfinis where man and wife, together with the room in which they are standing, are shown again very clearly indeed, reflected in the mirror. But with Escher this is no mere fortuitous element, for he is consciously seeking new possibilities, and so, over a period of almost twenty years, prints keep appearing in which reflections serve to suggest simultaneous worlds.

In *Hand with Reflecting Sphere*, a lithograph made in 1935, this phenomenon is depicted in so concentrated a form that we could well class it as *the* globe reflection; for the hand of the

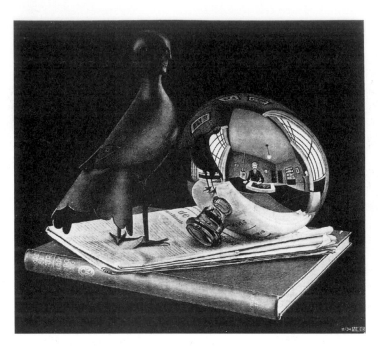

145. *Still Life with Reflecting Sphere*, lithograph, 1934

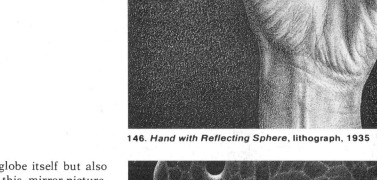

146. *Hand with Reflecting Sphere*, lithograph, 1935

artist is seen to be supporting not only the globe itself but also the whole of the area surrounding him, in this mirror-picture. The real hand is touching the reflected hand, and at their points of contact they each have the same dimensions. The center of this mirror world is, not by chance but in the essential nature of things, the eye of the artist as he stares at the globe.

In the mezzotint *Dewdrop* (1948) we can see three worlds at once, the succulent leaf, the magnified section of that leaf under the drop of water, and the mirror picture of the area facing the drop—all this in a perfectly natural setting; no man-made mirror is needed.

## Autumn Beauty

It is also possible to suggest the interweaving of several different worlds by means of flat mirror reflections. We see a first attempt in this direction in 1934, in the lithograph *Still Life with Mirror*, in which a little street (drawn in the Abruzzi) comes right into the world of a bedroom.

In the linocut *Rippled Surface* (1950) all this takes place in a much more natural manner. A leafless tree is reflected in the surface of the water, which would not show up at all were it not for the fact that its smoothness is disturbed by a couple of falling raindrops. Now both mirror and mirror-picture manifest themselves in one and the same place. Escher found this an unusually difficult print to make. He had closely observed the scene in nature

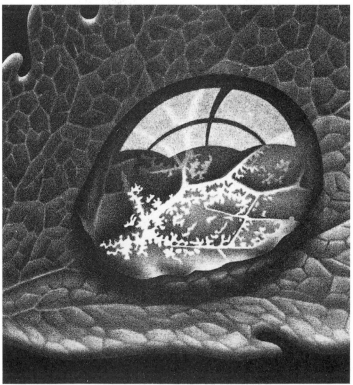

147. *Dewdrop*, mezzotint, 1948 (detail)

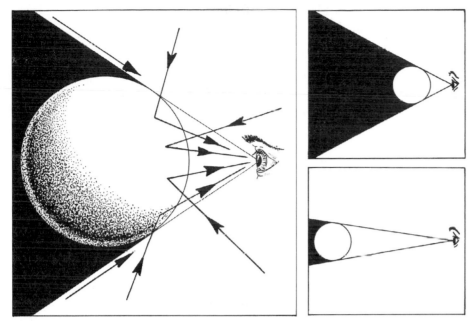

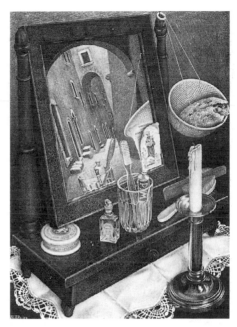

148. In a convex mirror the eye sees the mirror image of the whole universe, with the exception of the part that is covered by the globe. The farther the eye is removed from the convex mirror, the larger the uncovered part becomes.

150. *Still Life with Mirror*, lithograph, 1934

149. *Rippled Surface*, linocut, 1950

151. Pencil study for *Rippled Surface*

152. *Three Worlds*, lithograph, 1955

153. *Magic Mirror*, lithograph, 1946

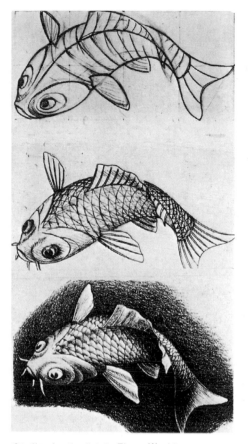

Studies for the fish in *Three Worlds*

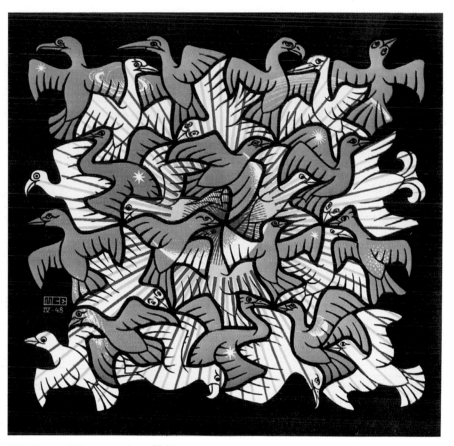

154. *Sun and Moon*, woodcut, 1948

and reconstituted it at home without the aid of sketches or photographs. The circular waves had to be shown very precisely as ellipses, in order to suggest the reality of a water surface which was receding into the distance. One of the many working drawings is reproduced here (figure 151).

While *Rippled Surface* with its bare trees and pale solar disk, and its two worlds merged, gives an impression of winter or late autumn, the print *Three Worlds* is typically autumnal. "I was walking over a little bridge in the woods at Baarn, and there it was right before my eyes. I simply had to make a print of it! The title emerged directly from the scene itself. I returned home and started straight away on the drawing."

The direct world is represented here by the floating leaves; they indicate the surface of the water. The fish represents the underwater world and everything above the water is shown as a reflected image. All these worlds are intertwined in a perfectly natural way and presented with such an atmosphere of melancholy autumn mood that the real meaning of the print's title is clear only to those who will give it more than a moment's thought.

## Born in a Mirror

In the lithograph *Magic Mirror* (1946), Escher takes things a step further. Not only is there a reflected image but it is even suggested that the reflections come to life and continue their existence in another world. This calls to mind the mirror world from *Alice in Wonderland* and *Through the Looking Glass*, stories that greatly delighted Escher!

On the side of the mirror nearest to the viewer we can see, under the sloping stay, a tiny wing appearing together with its mirror image. As we look further along the mirror there gradually emerges a fully winged dog. Yet this is not all, for its mirror image is growing similarly; and as the real dog moves away from the mirror so does the mirror dog on the other side. On arrival at the edge of the glass this mirror image appears to take on reality. Each line of animals doubles itself twice as it moves forward and so these lines together make a regular space-filling in which white dogs develop into black ones, and vice versa.

Both realities multiply and merge into the background.

## Intermingling of Two Worlds

In the woodcut *Sun and Moon* (1948) Escher has used surface-division as a means of creating two simultaneous worlds. Fourteen white and fourteen blue birds fill the entire area. If we turn our attention to the white birds then we are transported into the night; fourteen bright birds show up against the deep blue night sky, in which we can observe the moon and other heavenly bodies.

Now if we concentrate on the blue birds we see these as dark silhouettes against the bright daytime sky, with a radiant sun forming the center. On closer inspection we discover that all the birds are different; so we are dealing here with one of the very few entirely free surface-fillings that Escher has made. (*Mosaic: I*, 1951, and *Mosaic: II*, 1957).

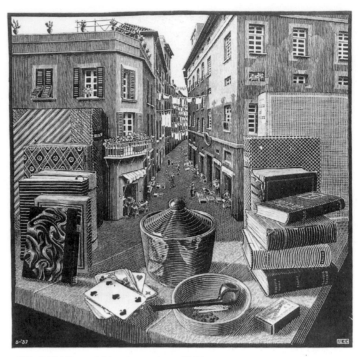

155. *Savona*, black and white crayon, 1936

156. *Still Life and Street*, woodcut, 1937

## Windowsill Turned Street

A small street in Savona, near Genoa, was the origin of the association of ideas to be found in the woodcut *Still Life and Street* (1937). Here we have two quite distinctly recognizable realities bound together in a natural, and yet at the same time a completely impossible, way. Looked at from the window, the houses make book-rests between which tiny dolls are set up. Looked at from the street, the books stand yards high and a gigantic tobacco jar stands at the crossroads. Actually, the fitting-together device is a very simple one. The borderline between windowsill and street is dispensed with, and the materials of the windowsill merge with those of the street.

In the same year, 1937, Escher made the woodcut *Porthole*, and in this we can see a ship through a porthole and can at the same time take the print to be a painting of a ship in a frame shaped like a porthole. In *Dream* (1935), we see the effigy of a sleeping bishop surrounded by vaulted archways. A praying mantis is sitting on the effigy's chest. But the world of the marble bishop and that of the praying mantis are totally different. The praying mantis is magnified more than twenty times.

Thus we find running through the whole of Escher's work attempts, often with completely different means, to connect different worlds together, to make them pass through one another, to weave them together—in short, to make them coexist. Even in prints that do not have this amalgam of worlds as their main objective, we still find the theme appearing obliquely, as for instance in the mezzotint *Eye* (1946), *Double Planetoid* (1949), *Tetrahedral Planetoid* (1954), *Order and Chaos* (1950) and *Predestination* (1951).

## The Print That Escher Never Made

There are many prints for which Escher drew sketches but which never reached completion. But for none of these did Escher so greatly grieve as for the one I am now going to describe to you. Do you know the fairy tale about the magic gate? In a completely normal landscape—meadows, clumps of trees, low hills—there stands a very ornamental gate. A senseless gate, for it gives access to nothing; all you can do is walk around it. But as soon as the gate opens it leads into a lovely, sun-drenched landscape, with strange kinds of plant growth, golden mountains, and rivers flowing with diamonds. . . .

This fairy tale is known in many countries and has numerous variations. This magic gate would fit perfectly into the series of prints we have been dealing with in this chapter. Did Escher ever consider making it? He had it on his mind first in 1963. What brought it to his attention was a visit from Professor Sparenberg, who told him something about Riemann surfaces and showed him a sketch (figure 158). Two weeks later Escher wrote a letter to the professor referring to the sketch and making a further suggestion. As the content of this letter is very indicative both of Escher's method of working and of his thought processes, we quote the following more important passages:

*June 18, 1963*

. . . This idea is so fascinating that I only hope . . . I shall be able to obtain the necessary peace and quiet and concentration to be able to work out your plan in a graphic print.

May I, in the first place, have a try at putting into words what I, as a mathematical layman, see in your sketch. . . .

For convenience' sake, I call your "two spaces" *Pr.* (for the Present) and *Pa.* (for the Past). It was only after the closer examination of your drawing that the key to it dawned on me, i.e., that *Pr.* may be regarded not only as a gap in *Pa.* but also as a disk masking a part of *Pa.* Thus *Pr.* is both in front of *Pa.* and also behind it; in other words they each exist as separate spatial projections in exactly the same area of the drawing.

Now there is something in your method of presentation that does not entirely satisfy me—that there is a much greater area devoted to *Pa.* than to *Pr.* Is the past so much more important than the present? As they are shown here as "moments" it would seem to me logical, and more aesthetically satisfying, from the point of view of composition, if they were each to take up an equal amount of space.

In order to achieve such an equivalence I submit the enclosed schematic sketch for your judgment [figure 158]. It may well be

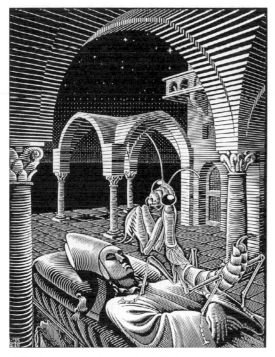

**157.** *Dream*, wood engraving, 1935

**158. Sketch made by Prof. Sparenberg and,** *below,* **Escher's interpretation of his idea.**

that I am doing violence to Riemann with it and am adulterating the purity of mathematical thought.

It seems to me that the advantage of my apportionment over yours would be as follows. In the center two bulges lie next to each other; on the left is *Pa.*, ringed around by *Pr.,* and on the right *Pr.* ringed by *Pa.*

When I think of the flow of time I realize that it moves from the past, via the present, to the future. Leaving the future out of our consideration (for it is unknown and so cannot be depicted) there is a stream moving from *Pa.* to *Pr.* Only historians and archaeologists have thoughts that sometimes move in the opposite direction; maybe I too might be able to imagine it that way.

But the logical stream, from *Pa.* to *Pr.*, might be depicted by, say, a perspective series of prehistoric birdlike creatures in flight, diminishing toward the horizon, maintaining their correct shape (in their domain, *Pa.*) until they reach the frontier of *Pr.* The moment they cross this frontier they change, let us say, into jet airplanes belonging to the domain *Pr.*

Now there is a further advantage, in that two streams can be represented, i.e., the one to the left of the horizon emerging from the *Pa.* supply bulge, increasing in size in the direction of the edge where *Pr.* is to be found; and the one to the right of the *Pa.* edge, speeding away, and diminishing, toward the horizon of the *Pr.* swelling.

Suggestive though the telegraph wires in your drawing may be, they don't please me, because in an archaic, prehistoric world, the telegraph hadn't been invented.

You can see how this whole problem takes me! By writing about it I am hopeful that I shall achieve a greater clarity of thought and that I can stir up my inspiration (to use that great clumsy word again).

This whole problem persisted in Escher's mind as the problem of the magic gate he not only wanted to draw, but to which he so much wanted to give a form that would serve as a compelling evidence for the truth, the reality of what he had depicted.

It is a great pity that he was unable to achieve this *tour de force.* The thought of it nagged at him like a headache. And perhaps no other man but Escher could have depicted this for us, using methods he had adopted in his other prints in so masterly a way—that is, reflection, perspective, surface-division, metamorphoses, and the approach to infinity.

# 13  Worlds That Cannot Exist

## Concave or Convex?

**161.**

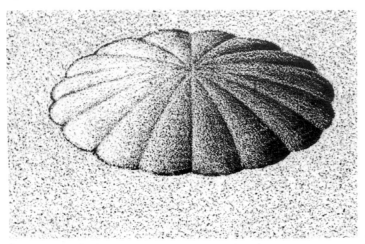

What do you see when you look at the above print? Is it the outer edge of a convex, shell-shaped ceiling ornament? If so, then you are probably sitting with the main stream of light coming from the right. Contrariwise, if what you see is a shell-shaped basin set in the floor, then the light that aids your vision must be coming from the left, for the image projected on your retina allows of both of these interpretations. You can see it as either concave or convex. One minute your "cerebral calculating center" works it out that you are seeing something convex, and the next minute it tries to persuade you that you are seeing something concave.

Figure 161 is an enlarged detail from the print *Convex and Concave* (1955), which is constructed entirely with elements susceptible to two opposite interpretations. It is only the architectonic filling in, together with the human and animal figures and clearly recognizable objects, that restricts it to one single interpretation. The result of this is that now and again these find themselves in a totally incomprehensible world—that is, the moment we make a wrong interpretation of their environment.

Before we embark on a study of the picture it will be well to become conversant with the more elementary forms of this ambivalence within the one drawing. If we take a brief look at the weather vane (fig. 160) we shall observe that at a given moment it will suddenly change direction. For instance, if you start by seeing its right-hand side pointing more or less toward you, lo and behold, after a few moments the situation changes and the same section is now turned away from you. In the two drawings

below we have tried to emphasize each one of these interpretations equally, but it may be that you will still find the reversal taking place after you have stared at them for a while. Thus we meet the phenomenon here in a very simplified form.

We can take this further (figure 159a). Let us draw a line *AB*. Which do you conclude is nearer to you—*A* or *B*?

Now we draw two parallel lines. By presenting them as very thick bars we can imply that *Q* and *R* are closest to us. And what is more, we no longer see two parallel lines, but two lines crossing each other at right angles. And we can use other methods of imposing one of the possible alternatives on the viewer. This comes out very clearly in the construction with four parallel lines in figure 159b, transformed as they are into two dipole antennae in a totally different position.

We do the same thing with two diamond shapes (figure 159c). These are completely identical, yet a different interpretation is accentuated in each lozenge, with the result that we see the first as a plank at close quarters that we can look up to from below, and next as one we can look down on from above.

In the case of a diamond drawn next to a square, the number of possibilities becomes even greater; and the small illustrations show the four different interpretations (figure 162).

Thus even a single line drawn on a blank sheet of paper allows of two quite distinct interpretations, and obviously this twofold interpretation can also be a feature of the most complicated figures, indeed of every print, every photograph, and every picture. The fact that we usually do not notice this is due to the way in which numerous details of the picture represent things that clearly have only a single meaning in the tangible world of experience. Whenever this does not apply it will be found that one interpretation can be arrived at just as well as another, especially if we change the direction in which the light is shining on the paper. In figure 163 the same photograph of a dewdrop on the leaves of an *Alchemilla mollis* plant has been printed twice over, once in its normal position and once upside down. No doubt you will see the leaves in the one photograph as concave and those in the other as convex. The same thing applies to the lunar landscape which can be seen twice printed in figure 164.

Because the foremost architectural details in the print *Convex and Concave* are the three cubical temples with cross-vaulting, we hae drawn two identical cubes in figure 165 just as they appear in the print. But possible interpretations have been stressed, while their position vis-a-vis the observer is indicated by a number of angular points. *F* stands for in front and *B* stands for behind; *u* is under and *a* is above. These two cubes can easily be recognized in the furthest left and furthest right temples in the print.

The lithograph *Convex and Concave* is a visual shock. Apparently, or in any case at first sight, it is a symmetrical edifice;

**159a.**

**159b.**

**159c.**

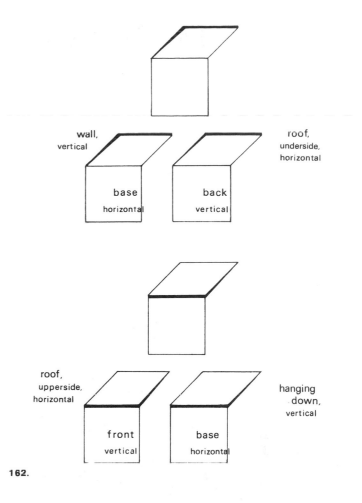

wall, vertical

roof, underside, horizontal

base horizontal

back vertical

roof, upperside, horizontal

hanging down, vertical

front vertical

base horizontal

**162.**

**160. The weather vane effect**

**163. Dewdrops can give a concave or convex effect**

**164 The same goes for the craters on the moon**

thus the left-hand side is the mirror image of the right-hand side, the transition in the middle being not abrupt but gradual and entirely natural. However, when the center is crossed something takes place that is worse than falling into a bottomless abyss, for everything is turned literally inside out. Topside becomes underside, front becomes back. The people, the lizards, and the flower pots do resist this inversion, for they are easily identifiable with palpable reality and this, to our way of thinking, cannot have an inside-out form. Yet even they have to pay the price if they dare to cross the frontier: they end up in such an odd relationship with their surroundings that the mere sight of them is enough to make one dizzy. To take a few examples: at the bottom left there is a man climbing up a ladder to a landing. Ahead of him he sees a small temple. He can go and stand beside the sleeping man and wake him up to ask him why the shell-shaped basin in the middle is empty. Then he can have a try at mounting the stairs on the right. By then it is too late, for what looks like a stairway when viewed from the left turns out to be the underside of an arch. He suddenly finds that the landing, once firm ground beneath his feet, has now become a ceiling to which he is strangely fixed, just as if there were no such thing as a force of gravity.

The same thing will also happen to the woman with the basket if she walks down the stairs and then steps over the central line. However, if she stays on the left-hand side nothing untoward will happen to her.

Perhaps we experience our most marked visual shock when we look at the flute players on the opposite side of the vertical middle line. The one to the upper left is looking out of a window and down on the cross-vaulted roof of a small temple. He could, if he wished, climb out and go and stand on that vaulting, then jump down from there onto the landing. Now if we take a look at the flute player slightly lower down to the right, we observe that he can see an overhanging vault above him; he may as well put right out of his head any notion of jumping down onto the "landing," for he is looking down into an abyss. The "landing" is invisible to him because in his half of the print it extends backward. On the banner in the top right corner the

print has been provided with an emblem neatly summarizing the picture's content. If we let our eye travel slowly over from the left half of the print to the right, it is possible to see the right-hand archway as a stairway also—in which case the banner's appearance is totally unreal. We can leave further excursions into this print to the viewer.

Figure 166 gives a diagram of the contents, and here the print is divided into three vertical strips. The left-hand strip has a distinct "convex architecture" and it is as though, at every point, we are looking downward from above. If the print were drawn using normal perspective we should be bound to find a nadir below the bottom limit of the plate. Yet the vertical lines remain parallel, because in this instance what is called oblique or angular perspective is being used, so we must think rather in terms of a pseudo-nadir. In the section to the far right we see everything from below; the architecture is concave and the eye is drawn upward towards a pseudo-zenith. In the central section the interpretation is ambivalent. Only the lizards, the plant pots, and the little people are susceptible to just one single interpretation.

In figure 168 we are shown the plan on which the print has been drawn. It is of course somewhat more complicated than the symbol on the banner, but in any case it presented Escher with many more possibilities.

A fair number of preparatory sketches for the print *Convex and Concave* have been preserved, among which figures 169, 170, 171, and 172 are very intriguing. A year after *Convex and Concave* appeared, Escher wrote to me about it thus:

Just imagine, I spent more than a whole month, without a break, pondering over that print, because none of the attempts I made ever seemed to turn out simple enough. The prerequisite for a good print—and by "good" I mean a print that brings a response from a fairly wide public quite incapable of understanding mathematical inversion unless it is set out extremely simply and explicitly—is that no hocus-pocus must be perpetrated, nor must it lack a proper and effortless connection with reality. You can scarcely imagine how intellectually lazy the "great public" is. I am definitely out to give them a shock; but if I aim too high, it won't work.

165.

apparent zenith ▲

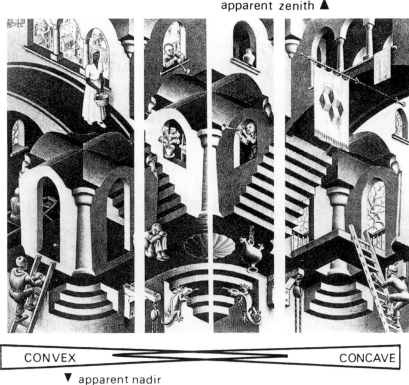

CONVEX      CONCAVE

▼ apparent nadir

**166**. The structure of *Convex and Concave*

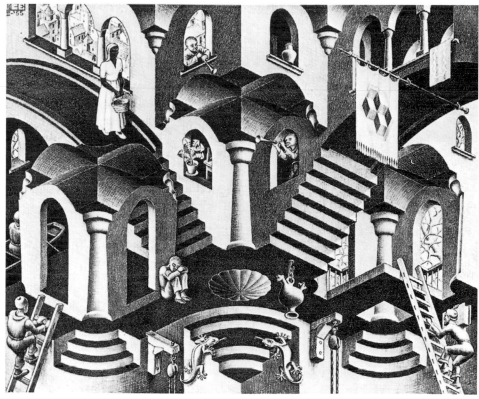

167. *Convex and Concave*, lithograph, 1955

170.

171.

168. Cube scheme for *Convex and Concave*

169.

172.

169-172. Studies for *Convex and Concave*

At this same period I introduced Escher to the phenomenon of pseudoscopy, whereby, with the use of two prisms, the retinal images of both eyes can be interchanged. He was most enthusiastic, and for a long while he took the prisms around with him, so as to try out the pseudoscopic effect on all sorts of spatial objects. Here is one of his many descriptions:

> Your prisms are basically a simple means of undergoing the same sort of inversion that I have tried to achieve in my print *Convex and Concave*. The tin staircase that the mathematician Professor Schouten gave me, which gave rise to the print *Convex and Concave*, will definitely invert if one looks at it through the prisms. I mounted them between two pieces of cardboard which were held together with elastic bands; this made a handy little viewing box. I took them with me on a walk in the woods and enjoyed myself looking at a pool with fallen leaves, the surface of which suddenly stood on its head; a watery mirror with the water on top and the sky beneath, and never a drop of water falling "down."
>   And even the interchange of left and right is fascinating too. If you study your own feet, and try moving your right foot, it looks as though it is your left foot that moves.

If you wish to observe a pseudoscopic effect you should obtain two right-angle prisms (of the kind to be found in most binoculars). Mount these between two pieces of cardboard as shown in figure 173. You will have to be able to give a slight turn to at least one of these prisms. As a first object for pseudoscopic observation it is best to select a somewhat exotic flower shape—for instance a double, large-leaved begonia. Hold the pseudoscope in front of your eyes and close your right eye. Make sure that you are looking at the begonia with your left eye. Now close the left eye and, without moving either the pseudoscope or your head, look through the right-hand prism with your right eye. If you cannot see the flower, or if it is not in the same place, turn the right-hand prism until you view the flower from the correct angle. Then open both eyes. As soon as you become accustomed to it, both parts will come together and you will see an inverted image. Indeed everything will seem to have turned back to front. You can see a box or a glass turned out; an orange turns into a paper-thin cavity; the moon advances right up to your window and hangs among the trees in the garden; if you look at a glass of beer while it is filled by somebody, you will have a well-nigh incomprehensible experience. The entire spatial world becomes for you an ever-changing *Convex and Concave* movie!

## Cube with Magic Ribbons

The subject embarked upon in the print *Convex and Concave* was too attractive a one not to be pursued further. While *Convex and Concave* was a whole story, the same thing comes to us as a pithy phrase in *Cube with Magic Ribbons*, which came into being a year later. For here too we have the possibility of ever-changing interpretation, in front and behind, concave or convex, while in this case there is also a contrast with an object that has been depicted in such a way as to allow of only one single interpretation. The main theme of the print consists of two ellipses intersecting each other at right angles and broadened out into bands. Each of the four half-ellipses is able to appear turned both toward and away from the viewer, and each point of intersection allows of four different interpretations. The ornaments on the ribbons can be seen as protruding half-spheres with holes in the middle or else as circular depressions with half-spheres in the middle. The reversal effect seen here very closely resembles what we have seen in the moon photograph in figure 164.

Escher's preparatory studies reproduced here show that the idea of a cube did not emerge at first, and that the ornamentation of the ribbons was originally attempted in other ways.

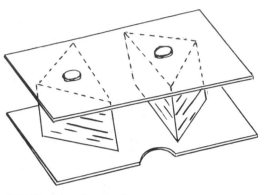

**173. The "pseudoscope"**

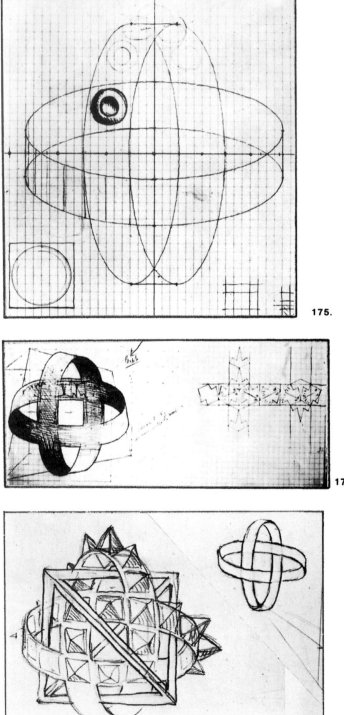

**175.**

**176.**

**177.**

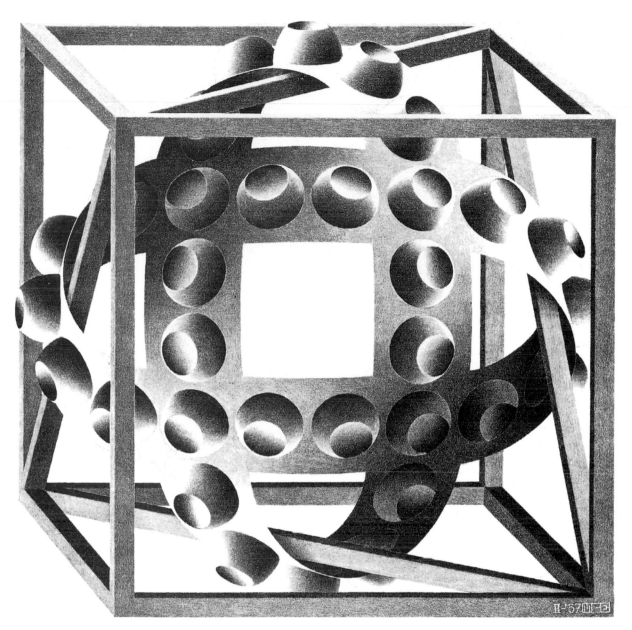

174. *Cube with Magic Ribbons,* lithograph, 1957

178.

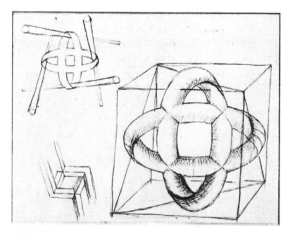

179.

175-180. Studies for *Cube with Magic Ribbons*

## Phantom House

In the trial studies for the lithograph *Belvedere* (1958) the edifice was repeatedly called *Phantom House*. But, because the atmosphere of the final print had nothing ghostly about it, the name was changed. Anyhow, ghostly or not, the architecture is quite impossible. Any representation of three-dimensional reality is reckoned to be the projection of that reality on a flat surface. On the other hand, every representation does not have to be a projection of three-dimensional reality. This is made abundantly clear in *Belvedere*, for although it certainly looks as though it is the projection of a building, yet no such building as is illustrated in *Belvedere* could possibly exist. We can see below the basic theme of the print—that is to say, the cubelike shape the pensive young man is holding in his hands (figure 181). In the middle we can see the extremely bizarre outcome of this construction—i.e., a straight ladder standing inside the building and yet at the same time leaning against the outside wall! (Figure 183.)

*Belvedere* is closely related to *Convex and Concave*, and this we can see by studying figures 182a, b, and c. Figure 182a represents the framework of a cube. We have already seen that the projection of two different realities can be observed within it. We arrive at one of these by assuming points 1 and 4 to be near at hand and 2 and 3 to be further away from us. For the other reality 2 and 3 are close to us and 1 and 4 further off. This play on both possibilities was the theme of *Convex and Concave*. But it is also possible to regard 2 and 4 as in front and 1 and 3 as behind. Now this goes entirely contrary to our concept of a cube, and so for that reason we do not naturally arrive at this interpretation. However, if we allow some volume to the ribs of the cube, we can force this interpretation on the viewer, making the rib *A*2 pass in front of the rib 1-4, and *C*4 in front of 3-2. At this juncture figure 182b emerges, and this is the basis of *Belvedere*. And even another cuboid shape is possible, as in figure 182c. Now let us study the print itself.

In *Belvedere* one could almost fancy one hears the playing of a spinet.

A Renaissance prince—let us call him Gian Galeazzo Visconti—has had this pavilion built, with its view over a valley in the Abruzzi. However, on closer examination it turns out to be a rather weird-looking place. This is due not so much to the presence of the raging prisoner, of whom nobody seems to take the slightest notice, but to the way the place is built. It would appear that the top floor of the belvedere lies at right angles to the one beneath it. The longitudinal axis of this top floor is in line with the direction in which the woman at the balustrade is gazing, while the axis of the floor below corresponds to the line of vision of the wealthy merchant as he stands looking out over the valley.

**181. Detail from *Belvedere***

**183. Detail from *Belvedere*—the ladder, starting on the inside and coming out on the outside...**

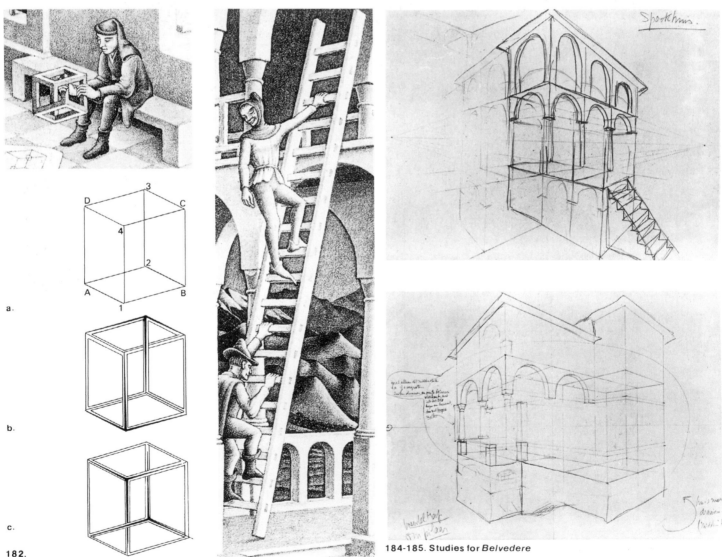

**182.**

**184-185. Studies for *Belvedere***

Then, too, there is something very unusual about the eight pillars that join the two storeys together. Only the extreme right and the extreme left pillars behave normally, just like the ribs *AD* and *BC* in figure 182a. The other six keep on joining front side to rear side, and so must somehow or other pass diagonally through the space in the middle; and this the merchant, who has already laid his right hand against the corner pillar, would quickly discover if he were to place his left hand on the next pillar along.

The sturdily constructed ladder is dead straight, and yet clearly its top end is leaning against the outer edge of the belvedere while its foot stands inside the building. Anyone standing halfway up the ladder is not going to be able to tell whether he is inside or outside the building. When viewed from below he is definitely inside, but from above he is quite as definitely outside.

If we cut the print through the center horizontally, then we shall find that both halves are perfectly normal. It is simply the combination of both parts that constitutes an impossibility. The young man sitting on the bench has worked this out from a much-simplified model which he is holding in his hands. It resembles the framework of a cube, but the top side is joined to the underside in an impossible way. It is in fact, probably quite impossible to hold such a cuboid in one's hands, for the simple reason that such a thing could not exist in space. He might be able to solve this riddle if he were to make a careful study of the drawing which lies on the ground in front of him.

In the bottom left-hand corner of one of the preparatory studies (figure 185), there is an interesting note: "spiral staircase around pillar." The definitive version certainly includes a ladder, but one would love to know how on earth Escher could have managed to draw a spiral staircase running around one of the pillars joining the front and rear sides of the building.

There has been no lack of attempts to produce a spatial model of the cuboid form used by Escher in *Belvedere*. A very skillful achievement can be seen in figure 187, a photograph by Dr. Cochran of Chicago. But his model consists of two separate pieces that resemble this cuboid only when photographed from a certain angle of vision.

## Wrong Connections

In the British *Journal of Psychology* (vol. 49, part 1, February, 1958), R. Penrose published the impossible "tribar" (figure 188). Penrose called it a three-dimensional rectangular structure. But it is certainly not the projection of an intact spatial structure. The "impossible tribar" holds together as a drawing purely and simply by means of incorrect connections between quite normal elements. The three right angles are completely normal, but they

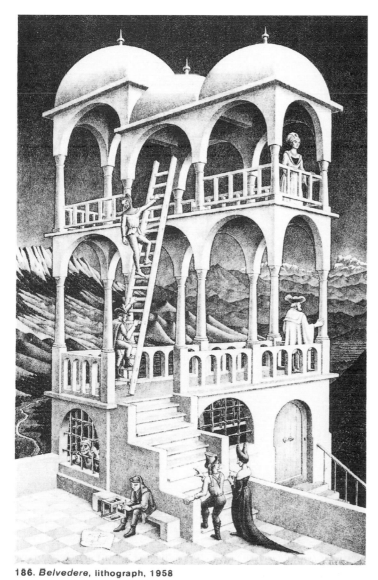

186. *Belvedere*, lithograph, 1958

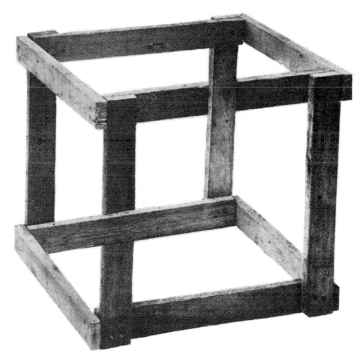

187. "Crazy Crate," photographed by Dr. Cochran, Chicago

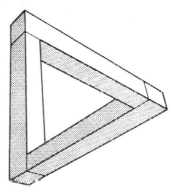

188. Tribar by R. Penrose

have been joined together in a false, spatially impossible way, so as to make a kind of triangle whose angles, incidentally, add up to 270 degrees!

Nowadays innumerable varieties of impossible figures are known, all of them being derived from false junctions. A very simple, although less well-known one, can be seen in the top row in figure 189. Below it sections of it are shown again; and these could very well exist in space, their false connections having been omitted.

It is perfectly feasible to take a photograph of the impossible tribar (figure 191). In this case, just as in the case of the crazy crate in figure 187, this photograph of the unconstructable object can be taken only from a single given point.

Escher came across Penrose's figure just at the time he was engrossed in the construction of impossible worlds, and the tribar gave rise to the lithograph *Waterfall* (1961). In this picture he linked together three such tribars (figure 190). The preparatory sketches show that his original intention was to draw three colossal building complexes. Then the idea suddenly came to him

that falling water could be used to illustrate the absurdity of the tribar in a most intriguing way.

If we start by looking at the upper left part of the print we see the water falling and thereby causing a wheel to turn. It then flows away through a brick outlet-channel. If we follow the course of the water we find that it unquestionably flows continually downward, and at the same time recedes from us. All of a sudden the furthest and lowest point turns out to be identical with the highest and nearest point; therefore the water is able to fall once again and keep the wheel turning; perpetual motion!

The surroundings of this impossible watercourse have the function both of strengthening the bizarre effect (the greatly enlarged mosses in the little garden, and the polyhedrons perched on top of the towers) and at the same time, of lessening it (the adjacent house and the terraced landscape in the background).

The relationship between *Belvedere* and *Waterfall* is obvious, for the cuboid that is basic to *Belvedere* also owes its existence to the intentionally false way in which the corner points of the cube are joined together.

189. Impossible connections

191. Photograph of impossible tribar

192.

193.

190. Three tribars linked together

192-193. Pencil studies for *Waterfall*, seen as a building

**194. Another building-like sketch**

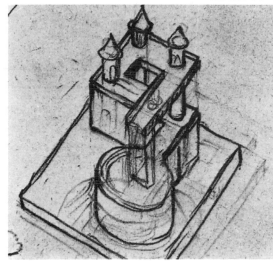

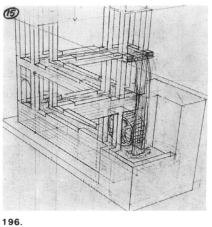

**196.**

**195.**

**197.**

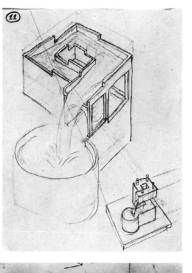

**198.**

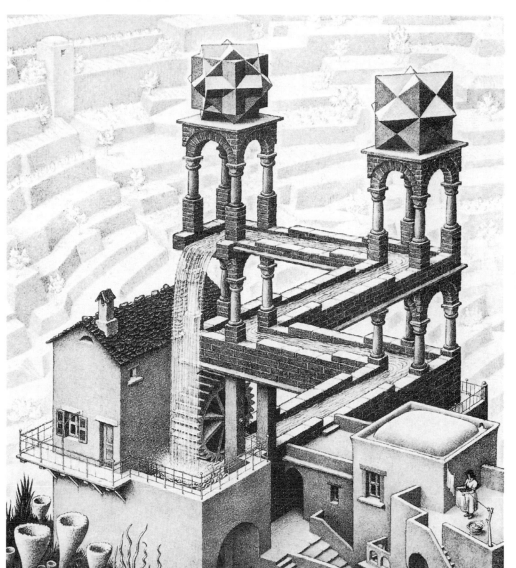

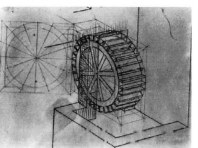

**199.**

**200. *Waterfall*, lithograph, 1961**

## The Quasi-Infinite

Escher has tried to represent the limitless and infinite in many of his prints. The spheres that he carved in ivory and wood, the surfaces he completely covered with one or more human or animal motifs, display both limitlessness and infinity.

In his limit prints, both the square and the circular ones, infinity is depicted by the continuous serial reduction of the figures' dimensions.

In the print *Ascending and Descending*, a lithograph made in 1960, we are confronted with a stairway that can be said to go upward—and downward—without getting any higher. Herein lies the connection between this print and *Waterfall*. If we study the print and follow the monks step by step we shall discover without the slightest doubt that each pace takes a monk a step higher. And yet on completion of one circuit we find ourselves back where we started; therefore in spite of all our ascent we are not a single inch higher. Escher also discovered this concept of quasi-endless ascent (or descent) in an article by L. S. Penrose (figure 203a). The deception is revealed, if we decide to cut the building into slices. Thus we find slice 1 (upper left) repeated at the bottom (right front), at a much lower level (figure 203b). So the sections do not lie in horizontal planes, but they go upward (or downward) spirally. The horizontal is seen to be in reality a spiral movement upward, and it is only the stairway itself that remains in a horizontal plane.

To demonstrate the possibility of drawing a continuous stairway in a horizontal plane, we have set out to construct one ourselves (figure 204a, b, c, and d). *ABCD* represents a quadrilateral lying horizontally. We have then drawn vertical lines from the central point of each side. It is easy to draw steps, which form a stairway rising from *A*, over *B*, to *C* (figure 204a). The trouble arises when we want to continue from *C*, over *D*, and back to *A*.

In figure 204b this is done in such a way that the steps take us downward, and so the whole beauty of the idea is lost. We take two steps up and two steps down, so it comes as no surprise when we find ourselves back at our starting point. However, if we alter the angles (figure 204c) then the stairway does in fact continue to go upward; so this diagram would serve our purpose. However, a building drawn according to this diagram would still have an unsatisfactory shortcoming. The dotted lines indicating the direction of the side walls slope toward each other at the upper right; there is nothing wrong with that, for they fit in (having vanishing point $V_1$) with the perspective representation of a building of this sort. But the other two dotted lines meet at the point $V_2$ at the lower right and this plays havoc with the notion of a print drawn with proper perspective.

We can, of course, get $V_2$ at the upper left if we make the sides *BA* and *DA* longer, as shown in figure 204d. In this way each of the two sides becomes one step longer. Escher's print demonstrates how this solution achieves a semblance of verisimilitude.

We have discovered where it is that this print fools us—i.e., the stairway lies in a completely horizontal plane, whereas the rest of the building, such as the plinths of the columns, the window frames, etc., which really ought to lie in horizontal planes, are in fact moving upward spirally. So the front of the building looks absolutely plausible, but if Escher had drawn the rear view in another print, we should then have discovered that the whole building had collapsed.

Now we can take a further look at the staircase from this point (figure 205). If we draw lines along each large strip we notice that this delineates a prismatic shape whose side surfaces have breadths in the ratio 6:6:3:4. Those parts of the print which appear at a similar height form a spiral (shown in dots). Figure 206 sums up this print once again. But the thin lines indicate horizontal planes (and therefore parallel to the stairway), while the thick-lined spiral shows the quasihorizontal lines of the building.

**203a. Original drawing by Penrose**  **203b. The Penrose drawing sliced**

**201. Preparatory sketch for *Ascending and Descending***

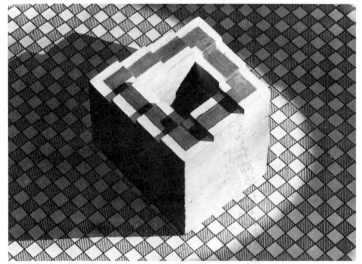

**203c. Plaster of Paris mold of the impossible Penrose stairs**

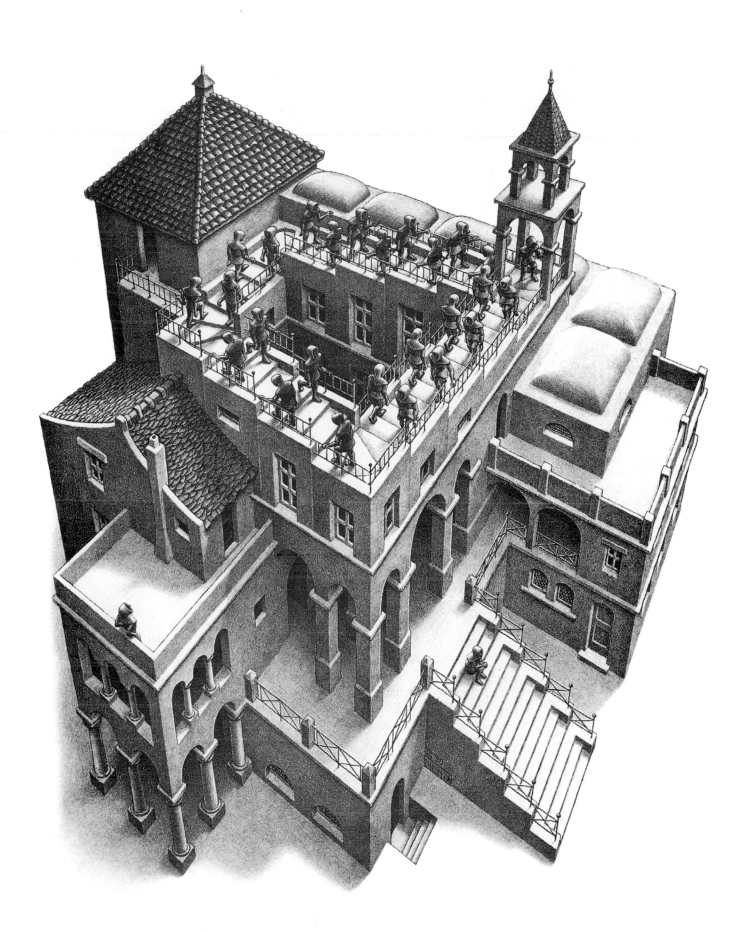

**202.** *Ascending and Descending,* lithograph, 1960

a

b

c

d

# 14 Marvelous Designs of Nature and Mathematics

207. "Long before there were men on this globe, all the crystals grew within the earth's crust."

*"Long before there were men on this globe, all the crystals grew within the earth's crust. Then came a day when, for the very first time, a human being perceived one of these glittering fragments of regularity; or maybe he struck against it with his stone ax; it broke away and fell at his feet; then he picked it up and gazed at it lying there in his open hand. And he marveled.*

*"There is something breathtaking about the basic laws of crystals. They are in no sense a discovery of the human mind; they just 'are'— they exist quite independently of us. The most that man can do is to become aware, in a moment of clarity, that they are there, and take cognizance of them."*

M. C. Escher, 1959

Escher on the subject of crystals was lyrical. He would take out a minute sample from his collection, lay it in the palm of his hand, and gaze at it as though he had dug it up out of the earth that very minute and had never seen anything like it in his life before. "This marvelous little crystal is many millions of years old. It was there long before living creatures had appeared upon earth."

He was fascinated by the regularity and the inevitability of these shapes, which are to men at once secret and almost wholly unfathomable. And this is what they were to him also, as he modeled them in all sorts of materials and depicted them in many different positions on his paper.

On a flat surface he had to work out ways of producing periodic surface-division. In the spatial world of crystals various configurations had already been realized, and these cried out to be drawn and to be so manipulated that their characteristics could be displayed with greater clarity.

Then too, Escher shared this interest in regular polyhedra (produced in nature as crystal shapes) with his brother, the geologist Professor B. G. Escher. When, in 1924, the latter was appointed to a lectureship in the University of Leiden in general geology, mineralogy, crystallography, and petrography, he found himself held up for lack of a good textbook. So he wrote a standard work of more than five hundred pages on general mineralogy and crystallography, which appeared in 1935.

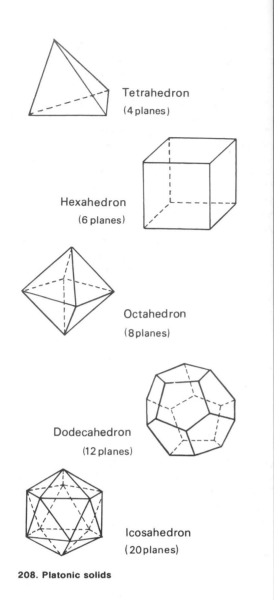

Tetrahedron
(4 planes)

Hexahedron
(6 planes)

Octahedron
(8planes)

Dodecahedron
(12 planes)

Icosahedron
(20planes)

**208. Platonic solids**

**209. Stars,** *wood-engraving, 1948*

**210. Escher with a model of Platonic solids**

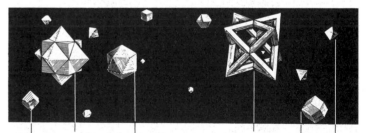

cube+octahedron     two tetrahedra   octahedron
kite-octahedron    icosahedron     rhombo-dodecahédron

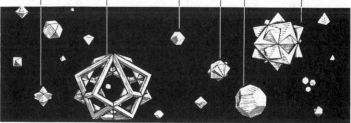

two cubes     2cubes    3 octahedra
two tetrahedra    kite-octahedron   dodecahedron

**211.**

The Greek mathematicians already knew that only five regular solids were possible. They can be bounded by (1) equilateral triangles, as in the cases of the tetrahedron (regular four-faced figure), the octahedron (regular eight-faced), and the icosahedron (regular twenty-faced); (2) by squares, such as the cube, or (3) by regular pentagons, as in the dodecahedron (regular twelve-faced figure) (figure 208).

In the wood engraving *Stars* (1948) (figure 209) we find these Platonic solids, as they are called, illustrated. *Tetrahedral Planetoid* (figure 212) is an inhabited tetrahedron. When, in 1963, the tin-container manufacturing firm Verblifa asked Escher for a design for a biscuit tin he harked back to the simplest polyhedra and gave it the form of an icosahedron, which he decorated with starfish and shells (figure 125).

In order to have before him a permanent reminder of how these five Platonic solids are put together, Escher made a model out of wire and thread (figure 210). When, in 1970, he moved from his own house in Baarn, where he had lived for 15 years, to the Rosa-Spier Home in Laren, he gave away most of his belongings and handed over a number of stereoscopic models, which he himself had made, to The Hague municipal museum; but that great brittle model made entirely from wire and thread he took along with him to hang up in his new studio.

The Platonic solids are all convex. Kepler and Poinsot discovered four more, concave, regular solids. If one accepts different (regular) polyhedra as the boundaries of a regular solid then there are twenty-six further possibilities (the Archimedean solids). Finally, we can take different interpenetrating solids as new regular solids; thereupon we can get an almost infinite series of composite regular solids. In these cases we are going far beyond what nature has contrived in the way of crystal shapes. Of the Platonic solids only the tetrahedron, the octahedron, and the cube appear as natural crystals, and no more than just a small number of the other possible polyhedra. So it looks as though, in this matter, human fantasy is richer than nature.

All these spatial figures fascinated Escher and kept him busy: we come across them in his prints, sometimes as the main subject, as in *Crystal* (1947), *Stars* (1948), *Double Planetoid* (1949), *Order and Chaos* (1950), *Gravity* (1952), and *Tetrahedral Planetoid* (1954), and sometimes as decorative features, as in

*Waterfall* (1961), in which regular solids crown the two towers. Escher also made a few regular solids in wood and in plexiglass, not as models to be copied but as *objets d'art* in their own right.

One of the finest of these pieces is *Polyhedron with Flowers* (figure 218), which he carved in maple in 1958. It is about thirteen centimeters high and is made up of interpenetrating tetrahedra. Before starting on this elegant freehand version, he had first carved an exact model. He also designed and carved himself the wooden puzzle which, when fitted together, makes an Archimedean solid called a stellated rhombic dodecahedron. A puzzle of this type has long been known, but it had never been so symmetrically constructed as this one of Escher's. Closely related to these spatially constructed regular solids are the various spheres that he covered completely with relief carvings of congruent figures. In *Sphere with Fish* (1940) (figure 217), made out of beechwood and with a diameter of fourteen centimeters, there are twelve identical fish entirely filling up the spherical surface. On other spheres, two or three different figures are used. Take, for instance, *Sphere with Angels and Devils* (1942), which has already been mentioned.

There are some copies of these spheres, carved in ivory by a Japanese at the request of a keen admirer of Escher, the engineer Cornelius Van S. Roosevelt, grandson of President Theodore Roosevelt, who recently donated his collection of about two hundred Escher prints to the National Gallery of Art, Washington, D. C.

## Stars (1948)

This little universe is filled with regular solids. Close-up in the center of our field of vision, we see a framework composed of three octahedra. "This handsome cage is inhabited by a chameleon-type creature, and I shouldn't be surprised if it wobbles a bit. My first intention was to draw monkeys on it."

## Tetrahedral Planetoid (1954)

This planetoid has the shape of a regular, four-faced solid (that is to say, a tetrahedron). We can see only two faces of it.

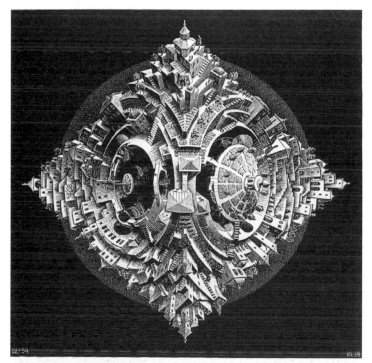

**212. Tetrahedral Planetoid, woodcut, 1954**

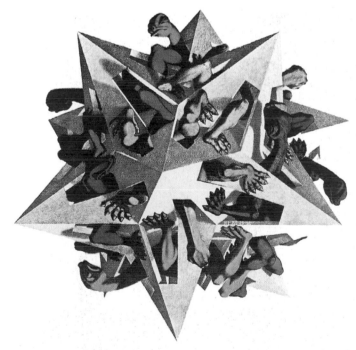

**213. Gravity, lithograph, 1952**

The inhabitants have made the greatest possible use of all the faces and have built terraces on them. This planetoid's atmosphere does not extend to the corner points, so the folk who live up there must have some method or other of taking a bit of atmosphere with them in order to keep alive. Escher constructed these terraces with great accuracy by imagining the planetoid to be carved out of a globe built up in concentric layers like an onion. After he had cut off the globe in order to get his tetrahedron, every ring was carefully carved at right angles.

## Gravity, (1952)

This is a stellated dodecahedron, one of the regular solids discovered by Kepler. This interesting solid may be regarded as being constructed in various different ways. Inwardly it consists of a regular twelve-faced body (a dodecahedron), each face of which is a regular pentagon. And upon each of these faces there is superimposed a regular, five-sided pyramid.

A more satisfying way of looking at it is to regard the whole solid as consisting of five-pointed stars, but with each of the rising sides of every pyramid belonging to another five-pointed star.

Escher was very fond of this spatial figure, because it is at once so simple and so complex. He made use of it in a number of prints. Here we see each star-*cum*-pyramid as a little world inhabited by a monster with a long neck and four legs. A tail could not be coped with, because each pyramid has only five openings. For this reason Escher had first thought of having his solid peopled with tortoises (figure 214).

**214. The rejected tortoise**

**215a. Foldout of the tetrahedra and the octahedra**

Fold-out of tetrahedron

60°

60°  60°

Tetrahedron bounded by 4 equilateral triangles

Fold-out of octahedron

Octahedron bounded by 3 equilateral triangles

**216. Flatworms, lithograph, 1959**

**215b. Combinations**

The walls of each monster's tent-shaped house serve as floors on which five of the other monsters are standing. Thus every single surface we can point to is both floor and wall.

Escher called this hand-painted lithograph *Gravity*, because each of these heavily built monsters is so forcibly drawn toward the center of the stellated polyhedron.

There is a definite link between this print and various perspective prints in which the multiple function of surfaces, lines, and points is brought to the fore. Compare, for instance, the concept of this print with that of *Relativity*, which appeared a year later.

## New Types of Building Blocks

It is possible to use random-shaped blocks in the building of walls, floors, and ceilings. In large constructions building blocks of similar shape would be preferable, whether they were fired bricks or quarried stone. And the shape of such block is almost without exception barlike—that is to say, a spatial figure bounded by right angles. We are so very accustomed to this shape in building blocks that we find it difficult to imagine any other.

And yet it is quite possible to fill up the whole of space (leaving no gaps) with blocks of a totally different shape from this. The queer-looking underwater building to be seen in the lithograph *Flatworms* (1959) is constructed entirely of two different types of blocks, the octahedron and the tetrahedron.

Now it would not be possible to fill the space completely with tetrahedra only, or with octahedra only, for there would always be gaps left between them. But it can be done if one effects a certain alternation of each type of block. And Escher has produced this print to demonstrate the fact. If you wish to make a further study of this strange edifice then there is nothing for it but to cut some octahedra and tetrahedra out of cardboard and stick them together yourself. A fold-out of each of these spatial figures can be seen in figure 215a. The dotted lines indicate where the folds should come. If you set about playing with these spatial figures you will find that you can make with them all the shapes that are to be seen in the print. To help you over this, figure 215b shows how, in a number of places on the print, the tetrahedra and octahedra lie in relationship to each other. To my way of thinking, it would be an incredibly difficult task to make a spatial copy of the whole print using both types of building block; but if any reader has got the courage and energy to tackle it, they are in for a good deal of enjoyment. Of course, there will not be any horizontal or vertical floors or walls to be found in this, and I believe that nobody is going to feel very much at ease in such a building. Indeed, this is why Escher allocated it to the flatworms for their dwelling.

On reading the foregoing description of his print *Flatworms*, Escher asked me to add the following remarks:

In spite of the lack of horizontal and vertical planes, it is possible to build columns and pillars by piling up tetrahedra and octahedra in such a way that, when viewed as a whole, they do in fact stand vertically. Five of these pillars are shown in the print. The two that stand in the right-hand half of the print are in a sense the reverse of each other. The further to the right of these shows only octahedra, but there must be invisible tetrahedra inside, whereas the pillar to the left of this appears to be built entirely of tetrahedra, yet there must be an internal vertical series of octahedra one on top of the other like beads strung on a necklace.

In addition to folding cardboard and sticking it, it is also possible, and less time-consuming, to make tetrahedra and octahedra by modeling them out of small lumps of plasticine, about the size of a large marble. To fill the space completely you will need twice as many tetrahedra as octahedra. The advantage of this method is that, at room temperature, the plasticine building blocks can easily be fitted together without adhesive and can also be pulled apart again. In this way it is possible to play about and experiment with them. The rules of the game can be made even clearer if different colors of plasticine are used for tetrahedra and for octahedra.

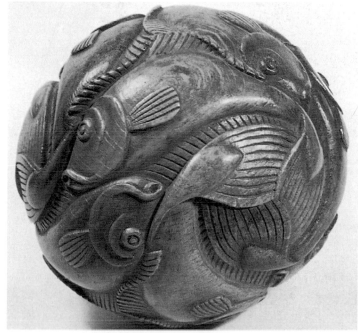

217. Sphere with Fish, stained beech, 1940 (diam. 14 cm.)

218. Polyhedron with Flowers, maple, 1958 (diam. 13 cm.)

## Superspiral

Escher was not interested only in spatial figures that have a close relationship with crystal shapes. Any interesting regular spatial figure gave him the urge to depict it. Between 1953 and 1958 he made five prints in which the subject was *spatial spirals*. Let us discuss the first of these: *Spirals* (figure 220), a wood engraving in two colors. The origin of this print is worthy of note.

Now, an artistic effort may well be a response to a challenge. One child says to another, "Hey, you can't draw a horse!" And a horse is promptly drawn. The print *Spirals* itself was the outcome of a challenge. In the print room of the Rijksmuseum in Amsterdam Escher came across an early book of perspective, *La pratica della perspectiva* by Daniel Barbaro (Venice, 1569). The opening of one of the chapters was decorated with a torus, the surface of which consisted of spiral-shaped bands (figure 219). The engraving was not particularly good and the intended geometrical shapes were not very well drawn—two things about it which annoyed Escher and were not unconnected. Escher set himself the even more difficult problem of how to present not simply a

219. Frontispiece of *La pratica della perspectiva*, by Daniel Barbaro, Venice, 1569

220. *Spirals*, wood engraving, 1953

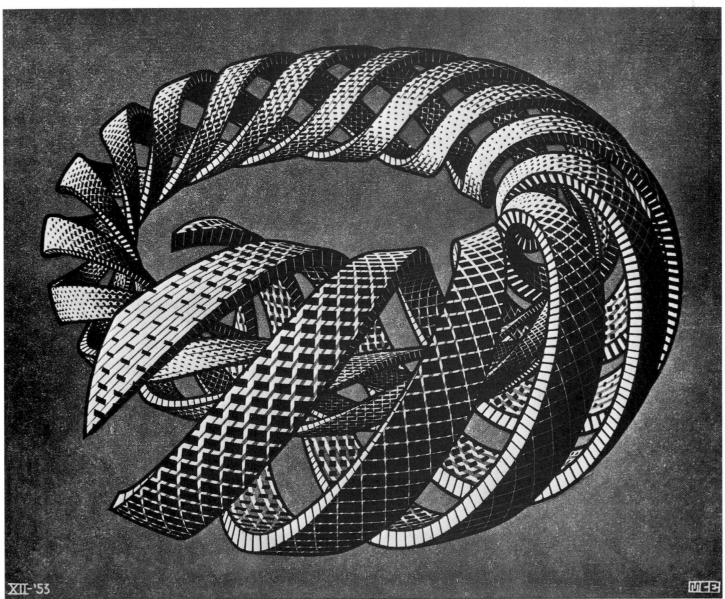

XII-'53

torus, but a body that would become thinner and thinner and would keep spiraling back into itself. "A self-centered sort of thing," as he later referred to it, ironically. The problems caused by this were very troublesome and necessitated months of planning and construction work. We have reproduced only a few of the trial sketches here (figure 221). The final outcome is a remarkably brilliant print in which the artist gets across to us something of his own wonderment at the pure laws of form. Four bands, getting progressively smaller, wind themselves as spatial spirals around an imaginary axis, and this axis itself has the shape of a flattened spiral.

Anyone who could see the many preparatory studies for this engraving would be impressed by the infinite trouble Escher had taken to produce an accurate presentation of the spatial figure he had visualized. Indeed, he would have found it easier to take a photograph of such an object.

However, this spatial object is by no means to be had for the asking. No doubt a worker in precious metals could make one, but it would call for a great deal of time and skillful craftsmanship. This presentation is truly unique; Escher is showing us something we have never seen before.

## Moebius Strips

"In 1960 I was exhorted by an English mathematician (whose name I do not call to mind) to make a print of a Moebius strip. At that time I scarcely knew what this was."

In view of the fact that, even as early as 1946 (in his colored woodcut *Horseman*, figure 91), then again in 1956 (the wood engraving *Swans*), Escher had brought into play some figures of considerable topological interest and closely related to the Moebius strip, we do not need to take this statement of his too literally. The mathematician had pointed out to him that a Moebius strip with a half-turn has some remarkable characteristics from a mathematical point of view. For instance, it can be cut down the middle without falling apart as two rings, and it has only one side and one edge. Escher makes the first of these characteristics explicit in *Moebius Strip I* (1961) (figure 222) and the second—which is closely related to it—in *Moebius Strip II* (1963) (figure 226).

These strips are named after Augustus Ferdinand Moebius (1790–1868), who was the first to use them for the purpose of demonstrating certain important topological particularities. It

222. *Moebius Strip I*, **wood engraving, 1961**

221.

223. **How to make a Moebius Strip**

is a very simple matter to make a model of one (figure 223). First of all we make a band by pasting together a strip of paper. *AB* is the place at which it has been joined. This cylindrical strip has two edges (upper and lower) and both inner and outer surfaces. Next, we imitate Moebius, putting a twist in the strip so that *A* comes next to *B* and *B* next to *A*. And now it comes to light that the strip has only one edge and one side. For if you start to paint the "outside," it turns out that you can keep on doing so until the entire surface of the paper has been colored; and if you run your finger along the "upper" edge toward the right, without taking it off, you will make two circuits and arrive back at your starting point; nor will you have missed touching any single bit of the edge. Thus, the Moebius ring has only one edge and one side. To make this drawing Escher constructed large spatial models, both of the ants and of the strip itself.

Now, if we cut an ordinary cylindrical strip down the center we get two new cylindrical strips that can be taken apart completely. But if we try to do the same thing with a Moebius strip, we shall not end up with two loose parts—it remains intact. Escher demonstrated this in *Moebius Strip I* in which there are snakes biting each other's tails. The whole thing is a Moebius

strip cut lengthwise. If we follow the snakes with our eye, they look as though they are fixed together all the way along; but if we pull the strip out a little we shall find we have got one strip with two half-turns in it.

In *Horseman*, a three-colored woodcut made in 1946, we see a Moebius strip with two half-turns. If you make one for yourself you will find that it automatically forms itself into a figure-eight. This strip definitely has two sides and two edges. Escher has colored one side red and the other blue. He conceives of it as a strip of material with a woven-in pattern of horsemen. The warp and woof are of red and blue thread, so that one horseman comes out blue and the other red. The front and the rear of a horseman are mirror images of each other, and there is nothing unusual in this, for it could be said of any figure one cares to choose. But now Escher starts manipulating the strip so that an entirely different topological figure is produced. In the center of the figure-eight he joins the two parts of the band together in such a way that the front and the rear sides become united. We can copy this in our paper model if we use Scotch tape to turn the middle of the figure-eight into a single plane surface. From a purely topological point of view, we ought at this point to drop one of the two colors,

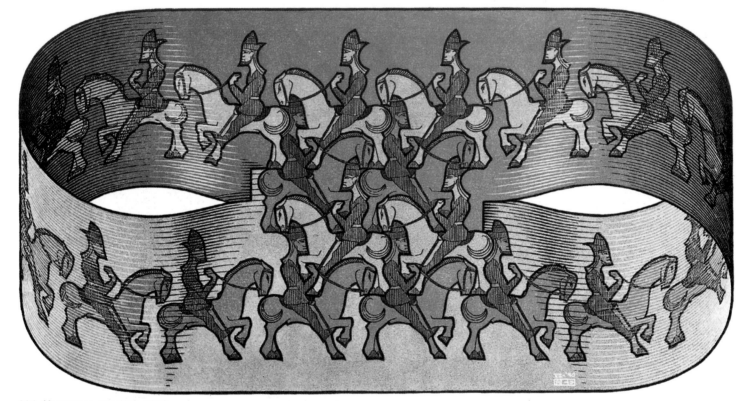

**224.** *Horseman*, **woodcut, 1946**

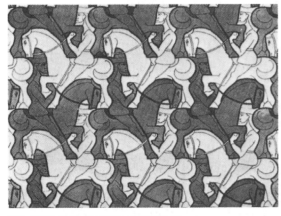

**225. Page from Escher's sketchbook**

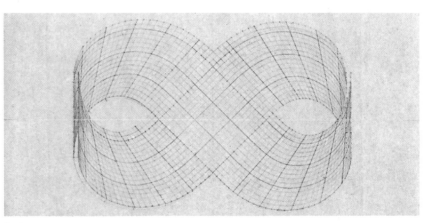

**Grid for the print** *Swans*

100    The Magic Mirror of M.C. Escher

but this is not really what Escher intended. He wishes to show how the little red horsemen on the underside of the print combine with the blue ones, which are their mirror image, to fill up the surface completely. This is achieved in the center of the print.

Of course, we can also find this in a very fine page from Escher's space-filling sketchbook (figure 225), but in this particular print it is presented in a most dramatic way, for here we can see the filling process actually taking place before our eyes.

Escher also deals with a topological subject in his woodcut *Knots* (1965) (figure 227). He came across the idea for this knot in a de luxe loose-leaf printed book by the graphic artist Albert Flocon. The latter is a keen admirer of Escher and has done a great deal to make Escher's work more widely known in France. In this book, consisting mainly of copperplate engravings, Flocon too was trying to explore the relationship between space and the depicting of it on a flat surface. In this he is, however, much more theoretical than Escher (witness, for example, his reflections on perspective), and on the other hand his engravings are much freer, less exact, less directed toward principles or essential requirements. It was in Flocon's book *Typographies* that Escher found the picture shown on the left in the print *Knots*. At all events

he considered this knot, consisting of two bands set at right angles to each other, so remarkable that he thought he would devote a separate print to it. A drawing made in 1966, when he was on a visit to his son in Canada, indicates that he was still working on it a year later. The large knot is square in section and appears to be made out of four different strips; however, if we follow one of these strips we find that we traverse the entire knot four times, without going over any bounds, finally arriving back at the place where we started. So there is only one strip after all! We can make a model of it ourselves by using a long piece of foam plastic, square in section. Having tied a knot in it we must then turn the ends toward each other and stick them together. There are several possibilities.

The open-work caterpillar-wheel style of the knot was the outcome of repeated attempts to find a form in which both the outside and the inside of the structure would be clearly visible. This is a problem Escher wrestled with many a time, and several prints have had to remain in the planning stage because he was unable to achieve a clear presentation of interior as well as exterior.

**226.** *Moebius Strip II*, **wood engraving, 1963**

**227.** *Knots*, **woodcut, 1965**

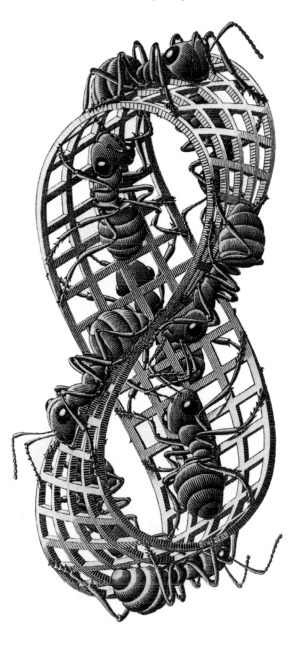

# 15  An Artist's Approach to Infinity

In an article published in 1959 Escher expressed in these words what it was that inspired him to depict infinity:

> We find it impossible to imagine that somewhere beyond the furthest stars of the night sky there should come an end to space, a frontier beyond which there is nothing more. The notion of "emptiness" does, of course, have some meaning for us, because a space can be empty, at all events conceptually, but our powers of imagination are incapable of encompassing the notion of "nothing" in the sense of "spacelessness." For this reason, as long as there have been men to lie and sit and stand upon this globe, or to crawl and walk upon it, to sail and ride and fly across it (and fly off it), we have held firmly to the notion of a hereafter, purgatory, heaven, hell, rebirth, and nirvana, all of which must continue to be everlasting in time and infinite in space.
>
> It is to be doubted whether there exist today many draftsmen, graphic artists, painters, sculptors, or indeed artists of any kind, to whom the desire has come to penetrate to the depths of infinity by using motionless, visually observable images on a simple piece of paper. For artists nowadays are motivated rather by impulses which they are unable or unwilling to define, or by some compulsion, incomprehensible, unconscious or subconscious, which cannot be expressed in words.
>
> And yet it can happen, so it seems, that someone who has accumulated but little of exact knowledge or of the learning that previous generations achieved through study—that this individual, filling up his days, in the way that artists will, toying with more or less fantastic notions, feels one fine day ripening in him a definite and conscious desire to approach infinity through his art, as accurately and closely as he can.
>
> What kind of shapes is he going to use? Exotic, formless blobs that can awake in us no associative thoughts? Or abstract, geometrical, rectilinear constructions, squares or hexagons which at most will bring to mind a chessboard or a honeycomb? No, we are not blind, deaf, or dumb; we consciously perceive the shapes that are all around us and that, in their rich variety, speak to us in a clear and fascinating language. And so the shapes we use to build up our surface-division are recognizable tokens and clear symbols of the animate or inanimate material all around us. If we are going to construct a universe then let it not be some vague abstraction but rather a concrete image of recognizable objects. Let us build up a two-dimensional universe out of an infinite number of similar-shaped, and at the same time clearly recognizable, building blocks.

**228. Development II, woodcut, 1939**

It can become a universe of stones and stars, of plants and beasts, or people.

> What has been achieved in periodic surface-division . . . ? Not infinity, of course, but certainly a fragment of it, a part of the "reptilian universe." If this surface, on which forms fit into one another, were to be of infinite size, then an infinite number of them could be shown upon it. But we are not simply playing a mental game; we are conscious of living in a material, three-dimensional reality, and it is quite beyond the bounds of possibility to fabricate a flat surface stretching endlessly and in all directions.

However, there are other possible ways of presenting the infinite, many without bending our flat surface. Figure 228 shows a first attempt in this direction. The figures that were used to construct this picture are subjected to a constant radial reduction in size,

working from the edges toward the center, the point at which the limit is reached of the infinitely many and the infinitely small. And yet even this treatment remains no more than a fragment, for it could be extended outward just as far as we would like, by the addition of even larger figures.

There is only one possible way of overcoming this fragmentary characteristic and of obtaining an "infinity" entirely enclosed within a logical boundary line, and that is by going to work the other way round. Figure 243 shows an early, albeit clumsy, application of this method. The largest animal shapes are now found in the center and the limit of infinite number and infinite smallness is reached at the circumference.

The virtuosity in periodic surface-division that Escher had reached stood him in good stead with his approaches to infinity. However, an entirely new element is called for: networks to facilitate the representation of the infinite surface on a piece of flat material.

## Prints with Similar-shaped Figures

When, after 1937, Escher first started flat surface-division, he used congruent figures only, and it was not until after 1955 that we find him using, to some degree, similar-shaped figures to approach infinity through serial formations. And this possibility was seen and used as early as 1939 in the print *Development*

**229. The inner part of *Smaller and Smaller I*, wood engraving, 1956**

*II.* But the figures' increase in size outward from the infinitely small at the center is still entirely subservient to the concept of metamorphosis.

The figures are not only small in the center but also unidentifiable; and it is not until they reach the outer rim that they appear as complete lizards. The very title of this print indicates its close connection with metamorphosis, for *Development I* (1937) is a metamorphosis print in which congruent rather than like-shaped figures are used.

We can distinguish three groups among the similar-shaped-figure prints if we take note of the patterns that serve as their underlying frameworks.

### 1. Square-Division Prints

These are the simplest in construction and yet the first of them did not appear until 1956 *(Smaller and Smaller I)*. A year later Escher worked on a book for the bibliophile club De Roos(M. C. Escher, *Periodic Space-Filling*, Utrecht, 1958), and in it he showed the diagram on which this kind of print is based, also drawing a simple print of a reptile so as to demonstrate the fundamental principle involved. In 1964 he used this diagram once again for a more complicated print, *Square Limit* (figure 230), but this time with the quite clear intention of trying to represent infinity in a print.

The fact that this diagram was so simple was probably the reason why Escher gave up using it.

### 2. Spiral Prints

The plan of these prints—a circular surface divided up into spirals of like-shaped figures—had already been established with the appearance of *Development II*. The following prints are based on it: *Path of Life I* (1958), *Path of Life II* (1958), *Path of Life III* (1966), and *Butterflies* (1950).

We could probably add *Whirlpools* to this category. The aim of the *Path of Life* prints is not so much to represent infinite smallness as to depict an expansion from infinitely small to infinitely large and back to small again, a process analogous to the one of birth, growth, and decline.

### 3. The Coxeter Prints

In a book by Professor H. S. M. Coxeter, Escher discovered a diagram that struck him as being very suitable to the representation of an infinite series. This gave rise to *Circle Limit* prints numbers I to IV (1958, 1959, 1959, 1960). *Circle Limit* I, III and IV are reproduced in figures 243, 244 and 77.

Escher's last print, *Snakes* (1969) (figures 245 *et seq.*), also belongs to this group, although the network for this has been adapted to Escher's particular aim in a most ingenious way.

## Square Limits

What have we got here (figure 230)? We might say it is an infinite number of flying fish. In figure 231 we see a simple solution to the problem of depicting infinity; the right-angled isosceles triangle *ABC* is the starting point. Two more right-angled isosceles triangles, *DBE* and *DCE*, are drawn on the side *BC*. We repeat this process and so get the triangles 3 and 4, 5 and 6 and so on.

We could continue the process to infinity and still end up very much where we started. If the square *EFCD* is one decimeter in length, then the squares below it must have sides measuring $\frac{1}{2}$ decimeter, those below again $\frac{1}{4}$ decimeter and so forth (see figure 231, right). A simple calculation tells us that $\frac{1}{2} + \frac{1}{4} + \frac{1}{8} + \frac{1}{16} + \frac{1}{32} + \frac{1}{64}, = 1$. Therefore $CG = 2$ decimeters and nevertheless we find we have an infinite number of squares continually diminishing in size. Figure 231 may be fascinating for the mathematician but not for the average observer. Escher has brought this framework to life by filling each of the triangles with a lizard (figure 232). He made this print as an illustration for a book about periodic surface-division. The same plan is basic to *Smaller and Smaller*, a wood engraving made in 1956 (figure 229).

The woodcut *Square Limit* (1964) has a rather more complicated basic pattern. In figure 233 a quarter of it is shown, plus a

**230. *Square Limit*, woodcut, 1964**

little bit more around the central point of the print at *A*. We come across figure 231 again in several parts, and only along the diagonals of the square is a different solution to be found. Escher made the following marginal note on this print in a letter:

> *Square Limit* (1964) was made *after* the series *Circle Limits I, II,* and *III*. This occurred because Professor Coxeter pointed out to me a method of "reduction from within outwards" which I had been looking for in vain for years. For a reduction from without inwards (as in *Smaller and Smaller*) does not bring with it a philosophical satisfaction because no logical, self-contained, or fully effective composition is to be found within it.

After this empty satisfaction of my longing for an intact and complete symbol of infinity (the best example was achieved in *Circle Limit III*), I tried to substitute a square form for the circular one—because the rectilinear nature of walls of our rooms calls for this. Rather proud of my own invention of *Square Limit*, I sent a copy of it to Coxeter. His comment was, "Very nice, but rather ordinary and Euclidean, and therefore not particularly interesting. The circle limits are much more interesting, being non-Euclidean." This was all Greek to me, being, as I am, a complete and utter layman in things mathematical. However, I will gladly confess that the intellectual purity of a print such as *Circle Limit III* far exceeds that of *Square Limit*.

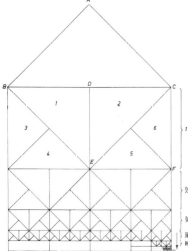

**231. Principle of the square division prints**

**233. Part of** *Square Limit*

**234. The three different meeting-points**

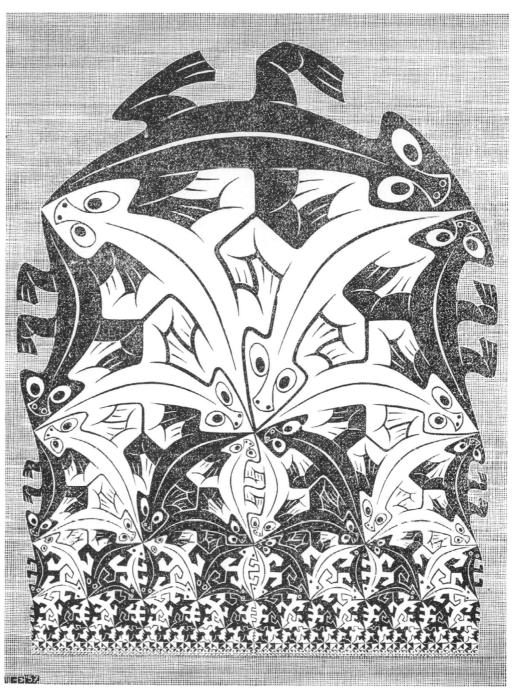

**232. From** *Regelmatige Vlakverdeling* (Periodic Space-Filling) by Escher.
Published as a Bibliophile Publication by the De Roos Foundation, 1958.

If we think we have now completely understood this print, we are deceiving ourselves. The simple question, why does Escher have to use three tints for this print and why can he not make do with two, may well cause us confusion. Let us look at figure 234, in which the same part is illustrated as in figure 233. If we focus our attention on the points where the fish come together, then we shall see that there are three different kinds. At *A* four fins of four different fish come together, at *B* four heads and four tails touch, and at *C* three fins meet. At *A* only two colors are required, and at *B* also, if it is merely a question of keeping the creatures apart. But three tints are necessary for this at *C*.

If we look for several points of the *A* variety then the first thing we notice is that these points are to be found only on the diagonals of the print. In the center are the fins: gray/black/gray/black; on the diagonal from lower left to upper right we find repeated: white/gray/black/gray and on the diagonal from lower right to upper left we have: white/black/gray/black. No other combinations appear.

When it comes to the *B* points all we can expect is white/gray/black; but at the *C* points we start finding some surprising combinations again, if we look closely at the fish heads.

However often one looks at this print it continues to fascinate with its great wealth of variety.

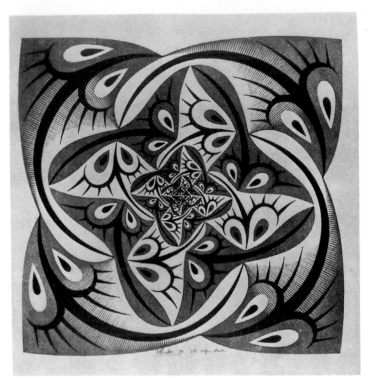

235. *Path of Life II*, woodcut, 1958

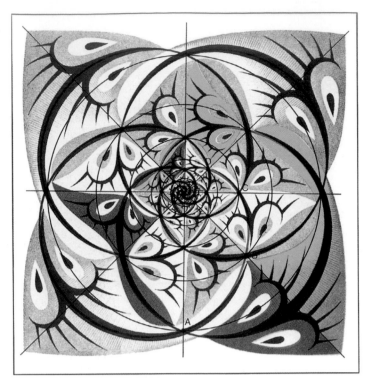

236. The construction of *Path of Life*

## Birth, Life, and Death

The network giving the basic pattern of the *spiral prints* is a series of logarithmic spirals. Escher was not acquainted with that mathematical concept but constructed it as follows: First a number of concentric circles are drawn and the distance between them becomes smaller toward the center. Then he drew a number of radii dividing the circles into equal sectors.

Starting at a point on the circumference of the outermost circle, he marked the points of intersection both of consecutive radii and of consecutive circles, moving inward. He then joined up the resultant points with a flowing line. We can also do this moving in the opposite direction. Figure 239 shows such a construction.

The entire structure of circles, radii and spirals forms a grid pattern of similar-shaped figures continuously diminishing in size toward the center. In *Path of Life I* Escher has used double spirals starting at eight points on the circumference. In *Path of Life II*, which to my mind is the finest of them all, there are four starting points, and in *Path of Life III* the twelve spirals set out from six points.

This basic pattern was already drawn up in 1939, when Escher used it for *Development II* (figure 228), but in this instance it serves only to produce steadily diminishing figures. In the *Path of Life* prints this network is used in a more sophisticated way, for here we have two spirals starting out from different points on the circumference, and joined together round the outside. Thus we can reach the center via a spiral from the outer edge and return from thence spiraling to the circumference until we meet up with our first spiral once again. We now shall use *Path of Life II* in order to make a closer study of this.

The large fish at the lower left (figure 235) has a white tail and a gray head. This head is contiguous with the tail of a smaller though similarly shaped fish. And so we proceed via three further and smaller fish in our spiral course toward the center. Close to the center the fish get so small that it is no longer possible to draw them—yet there is an infinite number of them!

In figure 236 the spiral we have just been following is drawn in red; along this path we find only gray fish. From the point of infinite smallness white fish grow out of the gray ones and swim away from the center along the blue spiral. On reaching the edge this merges into the red spiral along which we set out. At this point the fish change color again; white becomes gray and a new cycle begins. Of course, the whole idea of this is that a white fish, coming to life at the center, grows up to its maximum size, only to grow old and to sink back, as a gray fish, whence it came.

I regard this print as a maximum achievement both for the succinct way in which the concept is presented and for its great simplicity and elegance. I rate this print very high indeed and regard it as the best of all Escher's approaches to infinity.

We reproduce only a working drawing of *Butterflies* (1950) (figure 237) and this does not show the basic network very clearly. If one were to attempt an analysis of the final print without realizing that the framework for it was derived from that of the spiral prints, one would be totally misled by the great number of shapes. In this case the strict regularity of them would be almost entirely hidden.

The impressive woodcut *Whirlpools* (1957) (figure 238) came into being prior to the *Path of Life* prints. The same construction is used here as was used for the spirals, while a number of possibilities inherent in this framework were not utilized. Only two spirals are drawn simultaneously in the upper and lower constructions and they both move in the same direction. These spirals are in line with the backbones of two opposing series of fish, and at the center one construction merges with the other.

The gray fish are born in the upper pool and, growing larger, keep swimming further outward. Then they start on their journey (already diminishing in size) toward the lower pool, where after an endless series of reductions, they disappear at the central point. The red fish swim in a contrary direction, from the lower pool to the upper.

The whole picture is printed from two blocks only. The one from which the gray fish of the lower part are printed is used over again to print the red fish of the upper part. This is why we see Escher's signature and the date twice on the same print.

Toward the end of the year in which *Whirlpools* appeared,

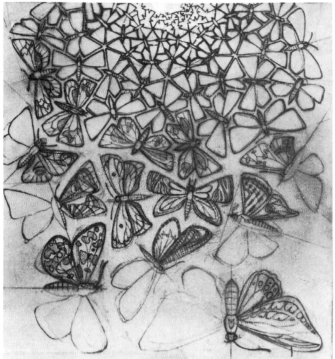

**237. Sketch for the wood engraving** *Butterflies*

**239. Logarithmic spirals as a network for the spiral prints**

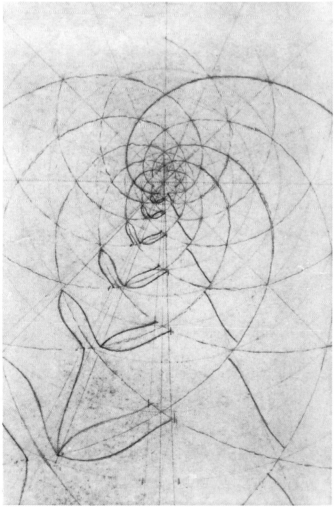

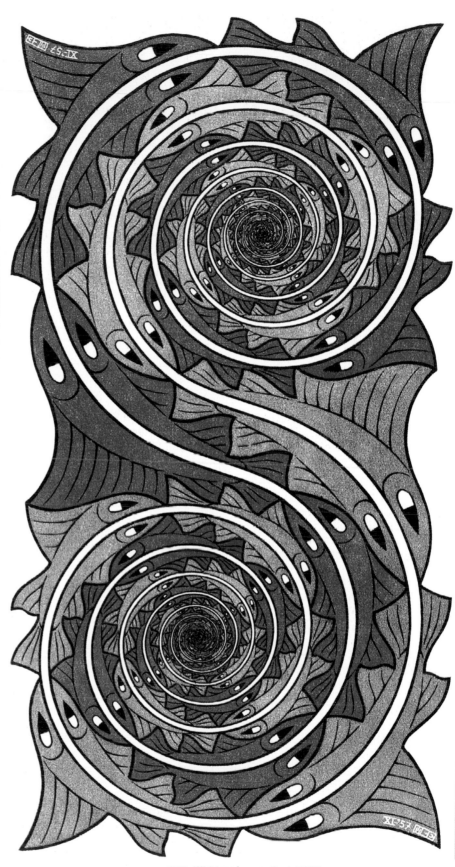

**238.** *Whirlpools,* **woodcut, 1957**

The Magic Mirror of M.C. Escher     107

240. The author and M. C. Escher a few weeks before his death. "I consider my work the most beautiful and also the ugliest."

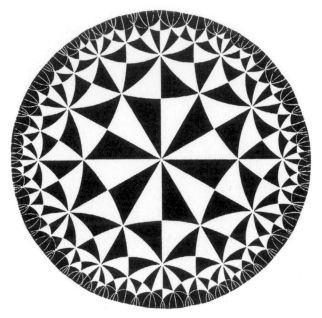

242. The Coxeter illustration

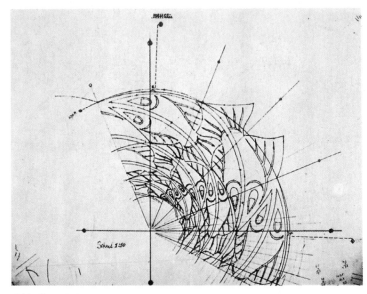

241. Sketch for cemetery mural

243. *Circle Limit I*, woodcut, 1958

Escher received a commission from the city of Utrecht for a mural in the main hall of the third municipal cemetery. This is done as a circular painting with a diameter of 3.70 meters. Not only did Escher produce the design but he carried out the actual painting himself (page 59). This wall-painting is almost an exact replica of one half of *Whirlpools*.

## The Coxeter Prints

In order to demonstrate hyperbolic geometry* the French mathematician Jules Henri Poincaré used a model in which the whole of an infinite flat plane was shown as being within a large finite circle.

From the hyperbolic point of view no points exist on or outside the circle. All the characteristics of this type of geometry can be deduced from this model. Escher discovered it illustrated in a book by Professor H. S. M. Coxeter (figure 242) and he immediately recognized in it new possibilities for his approaches to infinity. On the basis of this figure he arrived at his own constructional plan.

This was how *Circle Limit I* came into being in 1958; it was described by Escher himself as a not entirely successful effort:

This woodcut *Circle Limit I*, being a first attempt, displays all sorts of shortcomings. Not only the shape of the fish, still developed from rectilinear abstractions into rudimentary creatures, but also their arrangement and their position vis-à-vis one another

* In contradiction to the long-known principles of Euclidean geometry, through any given point outside a line there pass precisely two lines parallel to that line.

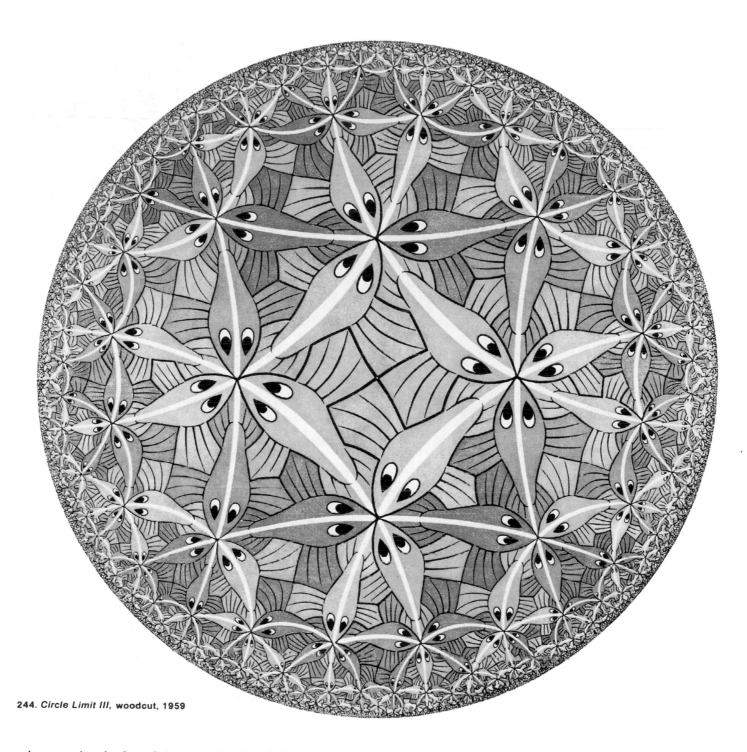

**244. Circle Limit III, woodcut, 1959**

leave much to be desired. It is true that three different series can be discerned, accentuated by the way in which the axes of their bodies run on from one to the other, but these consist of alternating pairs of white fish with their heads together and black ones with their tails touching. Thus there is no continuity, no "traffic flow," nor unity of color in each row.

*Circle Limit II* is not a very well-known print. It much resembles *Circle Limit I*, but in place of fish it has crosses. Once in a conversation Escher joked about it, saying, "Really, this version ought to be painted on the inside surface of a half-sphere. I offered it to Pope Paul, so that he could decorate the inside of the cupola of St. Peter's with it. Just imagine an infinite number of crosses hanging above your head! But Paul didn't want it."

*Circle Limit IV* (and here the figures are angels and devils) also closely follows the Coxeter scheme. The best of the four is *Circle Limit III*, dated 1959 (figure 244), a woodcut in five colors. The network for this is a slight variation on the original one. In addi-

tion to arcs placed at right angles to the circumference (as they ought to be), there are also some arcs that are not so placed. Here is how Escher himself describes this print:

In the colored woodcut *Circle Limit III* the shortcomings of *Circle Limit I* are largely eliminated. We now have none but "through traffic" series, and all the fish belonging to one series have the same color and swim after each other head to tail along a circular route from edge to edge. The nearer they get to the center the larger they become. Four colors are needed so that each row can be in complete contrast to its surroundings. As all these strings of fish shoot up like rockets from the infinite distance at right angles from the boundary and fall back again whence they came, not one single component ever reaches the edge. For beyond that there is "absolute nothingness." And yet this round world cannot exist without the emptiness around it, not simply because "within" presupposes "without," but also because it is out there in the "nothingness" that the center points of the arcs that go to build up the framework are fixed with such geometric exactitude.

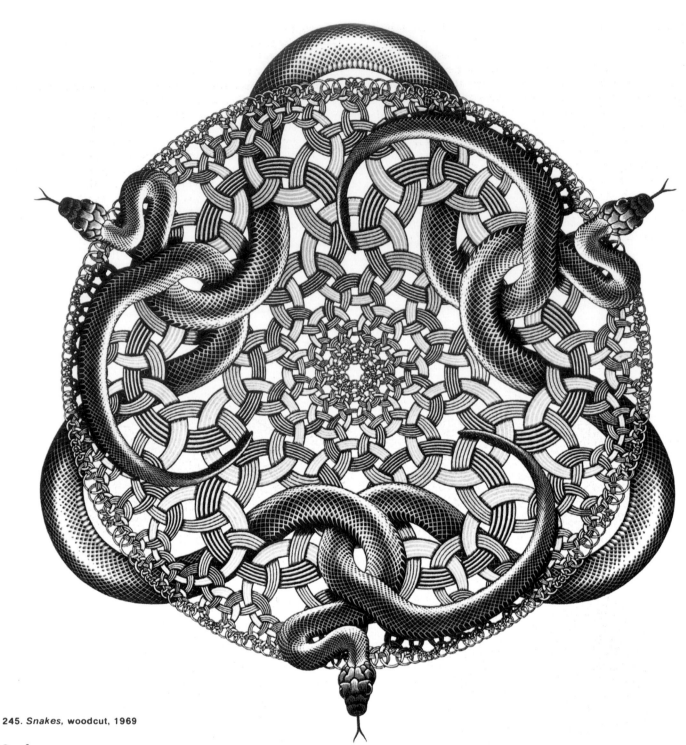

**245.** *Snakes*, woodcut, 1969

## Snakes

In 1969, when Escher was already aware that he would once again have to undergo a serious operation, he used every possible moment in which he felt sufficiently fit to work on his last print: *Snakes*. He gave me a vague description of it at the time—a chain mail, edged with small rings and having large rings at the center. Snakes would be made to twist in and out of the larger gaps. This was a new invention; infinitely small rings would grow out of the center of the circle, reach their maximum size, and then diminish again as they approached the edge. But he wasn't going to divulge any more about it. I was not even allowed to see the preparatory studies. He was staking everything on getting the print finished and he could not put up with any criticism at all, for he was afraid that this might take away his keenness to pursue it.

There is no sign whatsoever, either in the print itself or in the preliminary studies, that Escher was calling upon his last reserves of strength. The drawings are powerful and firm and the final woodcut is particularly brilliant. It does not bear any marks at all of exhaustion or old age.

It is true that the presentation of infinity is considerably less obtrusive. In earlier prints Escher took things to fanatical lengths and, using a magnifying glass, cut out little figures of less than half a millimeter. For the center of the wood engraving *Smaller and Smaller I* he purposely used an extra block of end-grain wood so that he could work in finer detail. In *Snakes* he makes no attempt whatever to keep on with the small rings until they fade away into the thick mist of infinitely small figures. As soon as the

idea of constant diminution has been suggested, he takes it no further.

In the sketch of the rings (figure 246), drawn almost entirely freehand, we can see the sophisticated structure of the network. From the center of the biggest ring toward the outer rim of the circle, we come across the Coxeter network once again; but toward the center the arcs curve in opposite directions. By introducing these curved lines Escher achieved a diminution toward the center also. This is a case of Escher's playing the part not merely of a mathematician but of a carpenter using his tools with extraordinary skill, thereby setting the mathematician himself a puzzle as to how this new network can be interpreted.

One can search the biological textbooks in vain for the three snakes that serve to raise the print above mere abstraction. This type of snake is what Escher himself regarded as beautiful and the most "snakish" of all, after studying a large number of snake photographs.

Five of the many preparatory sketches show again how carefully Escher worked and how well considered every detail had to be before he began to cut his wood.

And this meticulous attention to detail was characteristic of the artist. Escher's art is the expression of a lifelong celebration of reality, interpreted in his visualizations, unique to his talent, of the mathematical wonder of a grand design that he intuitively recognized in the patterns and rhythms of natural forms, and in the intrinsic possibilities hidden in the structure of space itself. Over and over again, his work shows the inspired effort to open the eyes of less talented men to the wonders that gave him so much joy. Although he himself has said he spent many nights wretched with his failure to achieve his visions, yet he never gave up the sense of wonder at the infinite ability of life to create beauty.

**246. Sketches for _Snakes_**

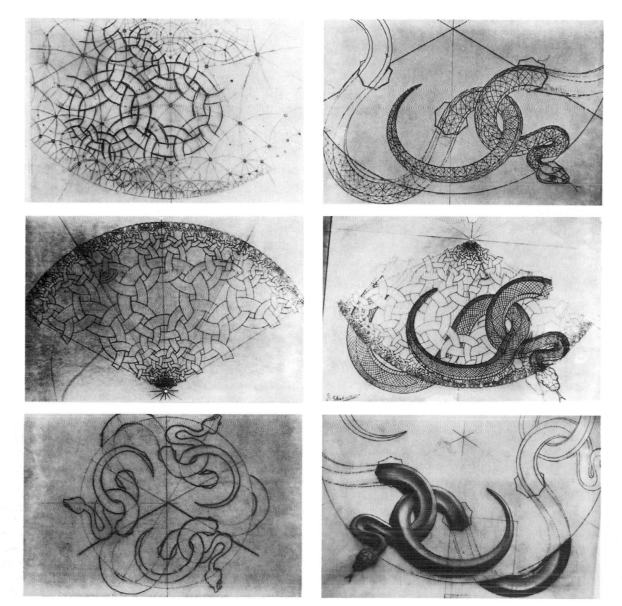

# Index to Escher's Work Used for this Book

(Italic numbers denote pages with illustration)

BRUNO ERNST

# Adventures with
# Impossible Objects

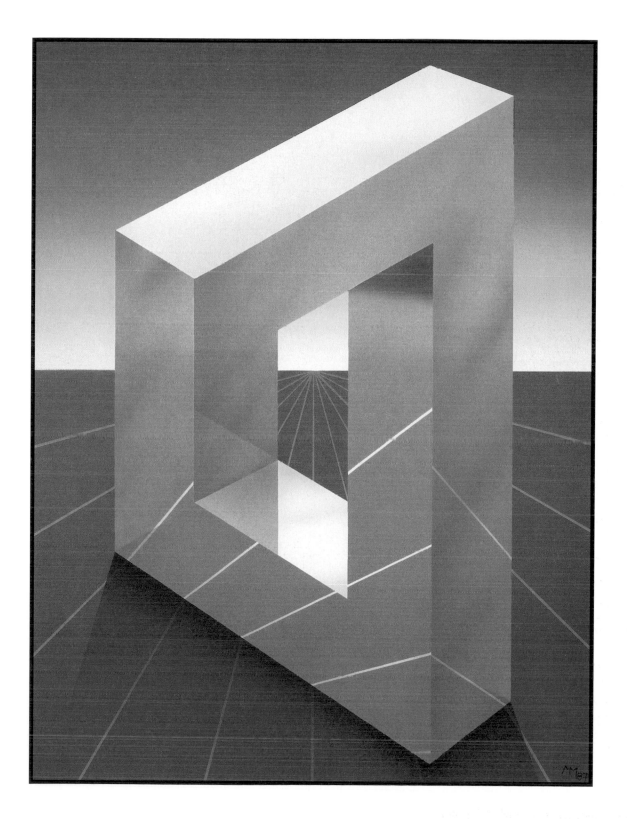

We would like to thank Bruno Ernst, Joop van Bossum, Monika Buch and Jos de Mey for kindly
granting us permission to reproduce the illustrations on pages 14, 29, 39, 45 and 47. The illustration on the front
cover is by C. Michael Mette; all the other full-page colour illustrations were created by Ulrike Bleyle
after designs by Bruno Ernst.

# Contents

# Introduction

This book is about impossible objects. Objects which can be beautifully illustrated in the finest detail, but which do not exist. This in itself is nothing unusual: there is no such thing as a woman with a fishtail, yet we have no difficulty in visualizing and drawing a mermaid. We can even make a sculpture of one. Equally, as a viewer, we accept such a mermaid without raising an eyebrow.

In the following pages, however, we will be confronted by objects of a truly impossible kind. Any attempt to recreate them in sculptures or cardboard models is doomed from the start. They cannot exist in our three-dimensional world.

Yet the impossibility of these objects is not as absolute as that of a square circle, for example, which can neither be imagined nor drawn. The impossible objects with which we are concerned can, strangely enough, be easily visualized, wherein lies their attraction. They open up a whole new world and thereby illuminating a part of the incredibly complex process that we call *vision*.

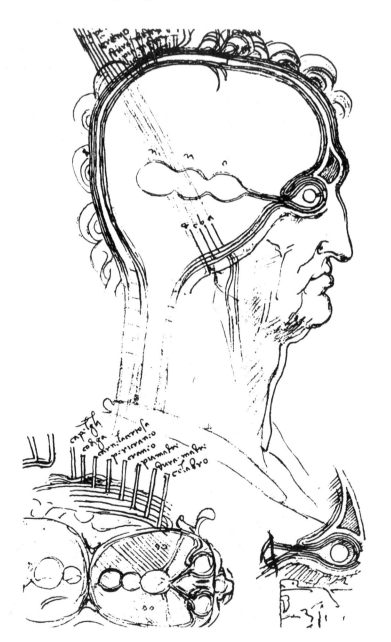

Leonardo da Vinci drew this cross-section of a head around 1500. Although the anatomical details bear little relation to medical reality, Leonardo nevertheless recognizes the direct connection between the eye and the brain.

# 1. Impossible objects

Let us examine the drawing below right: what kind of object does it show? What does the figure represent?

In asking ourselves such questions, we are doubly deceived. The first deception is so familiar that we scarcely stop to think about it – namely, the illusion that we are seeing an object at all, when in actuality we are looking simply at a set of lines and colour planes on a piece of paper. But the second deception...?

For the moment, suffice it to say that we see in the drawing an object which is made up of three bars. Just as we visualize other simple items, such as a box, a pencil or a teacup, and imagine them in different positions, let us now attempt to rotate this object in our mind's eye. On the left I have sketched what the object might look like as seen (in the imagination) from two other angles. It is precisely here that we are once more deceived: the object (we shall in future call it a *tri-bar*) in fact looks quite different.

Indeed, the question arises as to whether this tri-bar can in fact be rotated at all!

For if we take a closer look at the first drawing, we realize that bar A is perpendicular to C and run towards us, while bar B is also perpendicular to C yet runs away from us. How, then, can A and B meet at the top?

The three bars, moreover, make up a triangle with three angles of 90 degrees. That too is impossible. It follows, therefore, that this tri-bar cannot exist. And yet, if we look at the bars and the corners at which they meet, all the joins are correct.

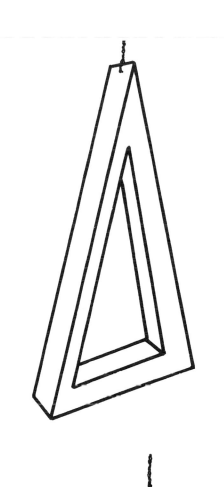

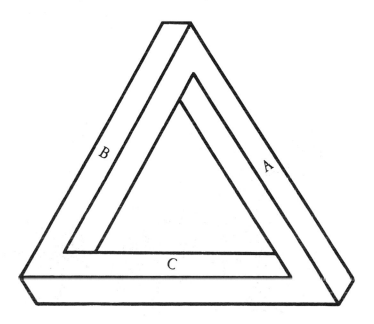

Below we see a real photograph of an impossible tri-bar. If a tri-bar can be built, you might argue, it cannot be impossible. We have therefore included a mirror in the photograph to show how the impression of a tri-bar was created.

Let me assure any disbelievers that this is not a trick photo. The object – which in fact consists of six strips of wood glued together – can simply be made to *appear* as an impossible tri-bar when seen from a certain angle. At the same time, the object revealed in the reflection bears no relation to the impossible tri-bar which we see standing in front of the mirror.

A curious situation which deserves a more detailed investigation.

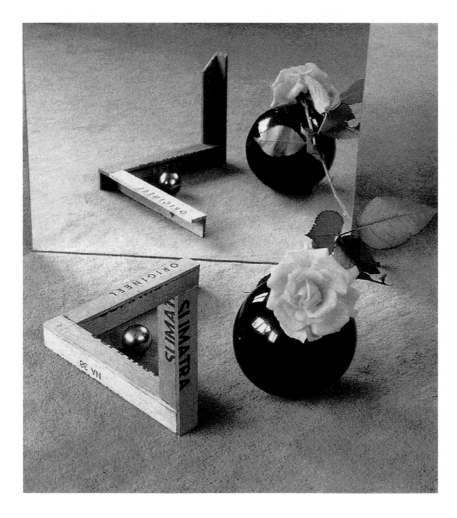

Left:
Viewed from a certain angle, the model seen in the mirror assumes the shape of an impossible tri-bar.

Right:
The tri-bar is one of the simplest impossible objects, yet makes a powerful optical impact.

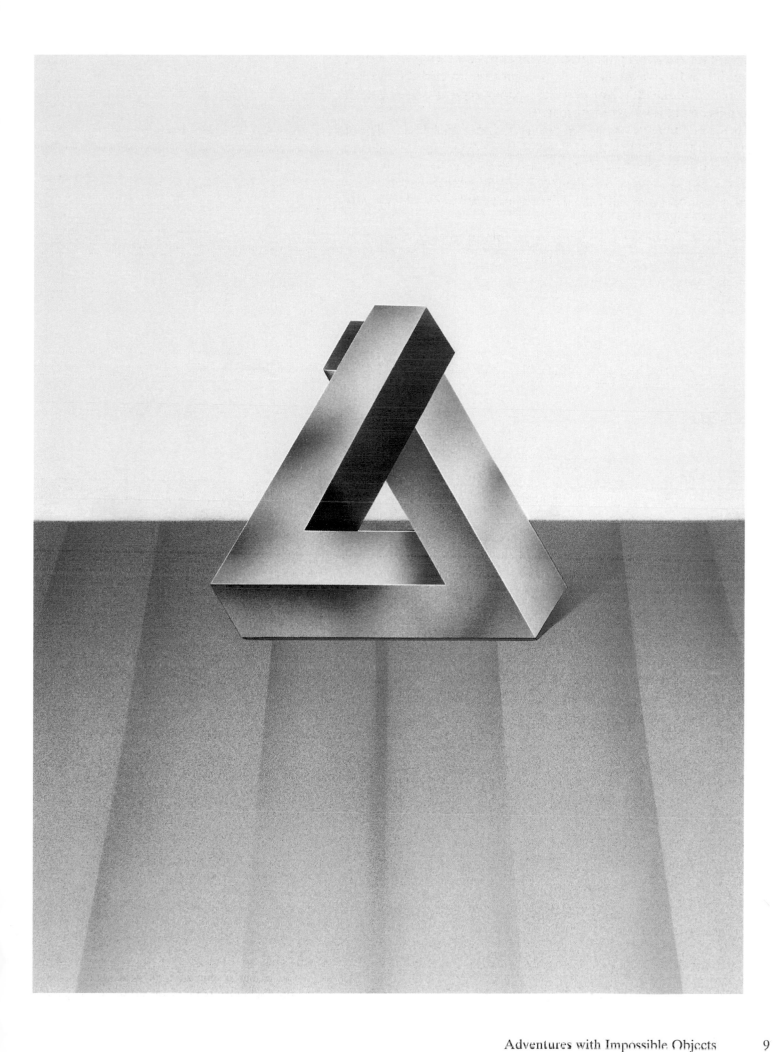

# The eye

The eye may be compared to a spherical mini camera. The lens projects an image onto the area at the back of the eye called the retina, which is made up of more than one hundred million photosensitive cells. Signals from the retina are sent to the brain by about one million nerve fibres, bundled together into the optic nerve.

The information carried by the optic nerve is processed in a specific part of the brain. Although much has been discovered about this highly complex process over the past ten years, there still remains a great deal to learn. For the sake of brevity, in the following chapters we shall refer to the entire visual system (eye, nerve fibres, vision centre in the brain) simply as the eye.

Cross-section of the eye, the "mini camera" which projects an image of the outside world onto the photosensitive cells of the retina.

The eye. The course followed by the visual information-processing system is shaded in grey. Compare this with Leonardo's drawing on page 6.

# Real or unreal?

We are unable to perceive the three-dimensional arrangement of objects around us *directly* with our eyes. First, the outside world is translated into a *flat* retinal image, which is then reconstructed by the eye into a picture of spatial depth. (This should not be confused with stereoscopic vision, the perception of depth using two eyes, which we shall not be discussing here.)

We can still receive a good impression of the objects around us even when we only use one eye. The eye makes its "calculations" on the basis of information from the flat retinal image, delivering its result within a fraction of a second. Thus we are able to walk into a room and instantly recognize the objects within it. We can immediately state, for example: "There is one chair over here and another one over there". This is an extraordinary feat which has yet to be simulated by any computer. Although complex artificial intelligence programmes now exist which allow computers to distinguish between the basic shapes of a cube, a pyramid and a cylinder in various different positions, no one has written a programme which enables a computer, analogous to the eye, to process data on the photosensitive surface of a TV camera. "Robot vision" of this kind still has a vast way to go before it approaches the sophistication of the human eye.

It is clear from the above that it does not particularly matter whether we are looking directly at the real three-dimensional world or at a two-dimensional representation of it (e.g. a drawing or a photograph). In both cases, the eye is presented with a flat retinal image from which it constructs a three-dimensional model.

What happens when we look at an impossible object such as an impossible tri-bar? We already know the answer from looking at the drawings on the previous pages: the eye immediately interprets it as a three-dimensional object. Our visual computer then continues its calculations and a few seconds later (sometimes longer) arrives at the conclusion that this object cannot, in fact, exist as spatially interpreted.

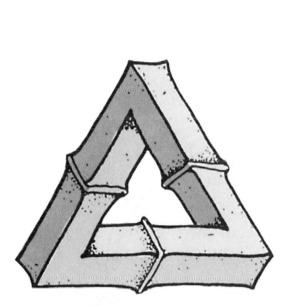

Japanese tri-bar.

Impossible tri-bar in a landscape.

The data contained in the drawing or photograph are mutually contradictory: the bar running towards us and the bar running away from us cannot meet at the same point in space. It takes us hundreds or even thousands of times as long to reach this verdict as to arrive at our first conclusion: the tri-bar is an object.

What happens next is extremely curious. Over the course of millions of years, the eye has evolved into an instrument with which we can analyse the outside world, so that we can react to it in an appropriate manner. As soon as the eye reaches the verdict that the object cannot exist in space, its first conclusion becomes meaningless. We might now expect the object constructed by the eye to disintegrate or vanish in some way or another; at the very least, we might expect it no longer to be perceived as an object, but rather as a set of lines without three-dimensional coherence. But none of these things happen. Instead, we continue to see an object even as our eye insists that this object cannot exist!

The eye thus creates a spatial absurdity. It holds fast to its two contradictory conclusions: it is a thing and it is impossible – a nothing. It appears that the eye is happy to distance itself from the conflict and leave the final decision to a higher authority.

Meanwhile, the impossible object has established its own kind of reality. Even though the figure it introduces into our visual vocabulary is impossible, it is nevertheless accorded the same status as the houses, trees and chairs which the eye identifies from our retinal images. This is what is so fascinating about impossible objects.

Two forms of impossible tri-bar, each the mirror image of the other.

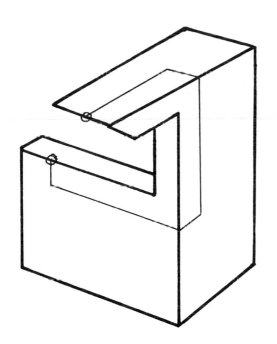

# Making a model of an impossible tri-bar

To make a three-dimensional model of an impossible tri-bar, it is not necessary to glue together strips of wood as I did for the photograph on page 8. Instead, you can use the model below. Since the object (which naturally is not really an impossible tri-bar) needs to be strong enough to stand on a table, I suggest you make a photocopy of the page and glue it to stiff paper or thin card before you start.

If you cut out and fold the cardboard according to the instructions, you will end up with a three-dimensional model which, if viewed or photographed from a certain angle, forces the eye to see an impossible tri-bar.

Model of an impossible tri-bar.

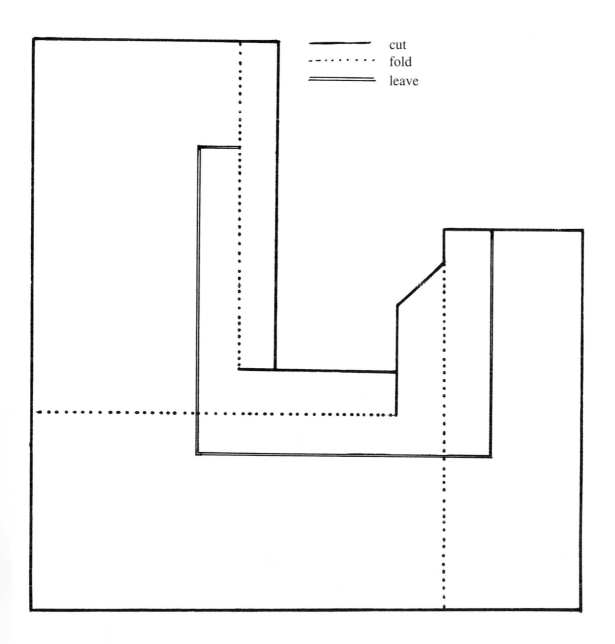

| ——————— | cut |
| -·-·-·-·-· | fold |
| ========= | leave |

# The first impossible tri-bars

In 1934 the Swedish artist Oscar Reutersvärd drew nine cubes in an impossible configuration. The first impossible tri-bar had been created. Reutersvärd continued to experiment in this field and pursued his new discoveries in hundreds of drawings.

Appreciation for his work came relatively late. In 1982 the Swedish Post Office issued a special set of Reutersvärd stamps. That same year saw the publication of a book containing a selection of his drawings, which was subsequently translated into several languages.

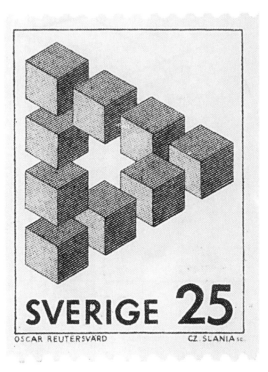

Swedish stamps featuring impossible motifs by Oscar Reutersvärd.

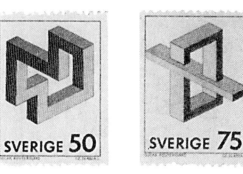

hommage à Bruno Ernst
perspective japonaise n° 293 a

Oscar Reutersvärd, *Hommage à Bruno Ernst,*
*perspective japonaise n° 293 a*
Coloured drawing, 46 x 48 cm.

The scientific world was introduced to the impossible tri-bar in 1958, when L.S. and R. Penrose published a short article in the *British Journal of Psychology* entitled "Impossible Objects: A Special Type of Visual Illusion". Here they discussed the characteristics of impossible tri-bars and continuous flights of steps, and made reference to the work of the Dutch artist M.C. Escher. It was through Escher, in turn, that the impossible tri-bar would be made known to a much broader public.

*Waterfall,* Escher's famous lithograph of 1961, is based on a zig-zag of three impossible tri-bars and provides a clear demonstration of the wondrous properties of this extraordinary device. Escher here creates a *perpetuum mobile* in which water is continually flowing downhill and yet always ends up back at its starting-point. It thereby passes over a waterfall which drives a waterwheel, keeping the whole impossible system in perpetual motion!

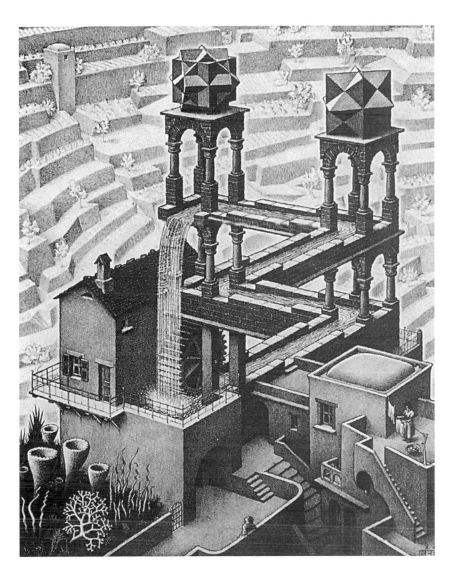

*Waterfall,* 1961, one of Escher's best-known lithographs.

# Composition and volume

With the help of two drawings, let us demonstrate once again just how real an impossible tri-bar can be – or in other words, just how tenaciously we hold on to our eye's initial conclusion that it is indeed an object. The sketch on the right shows how an impossible tri-bar can apparently be constructed out of three bars and three cubes. Most of us, even those who know such a tri-bar cannot be built, still feel tempted to have a go ... only to discover it is indeed impossible.

The drawing below shows that it is even possible to calculate the surface area and the cubic volume of an impossible tri-bar. If each cube measures 1 x 1 x 1 cm, the surface area is 48 cm² and the volume is 12 cm³. Check it for yourself – it is simply a matter of counting!

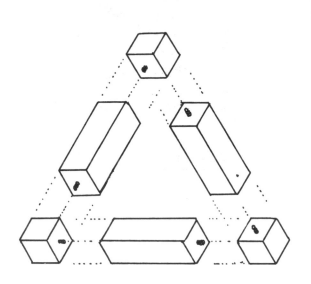

# Variations on a tri-bar theme

The impossible tri-bar can be introduced into drawings in a wide variety of ways. A few examples are illustrated below and on the following pages.

I drew *Fifty Years Impossible Figures* as a 50th-anniversary poster for Oscar Reutersvärd. The opening in the upper corner of the room is a variation upon an impossible tri-bar. Reutersvärd's original impossible tri-bar (cf. p. 14) appears as a celestial body in the sky.

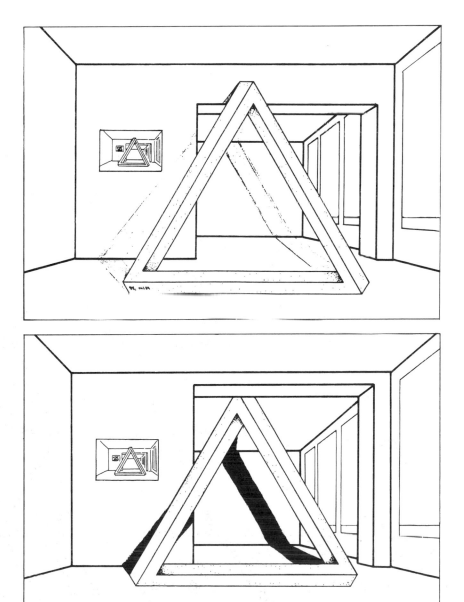

In this drawing I sketched an impossible tri-bar in the conventional surroundings of the hall of my apartment.

I sent my drawing to Reutersvärd, who immediately introduced an interesting variation: the tip of the tri-bar now disappears behind a beam.

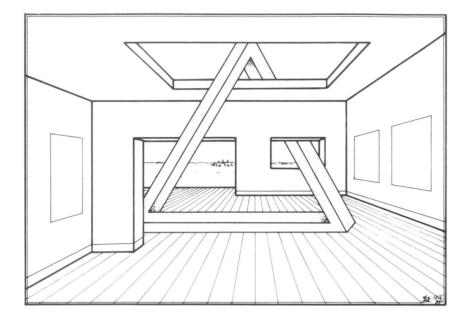

Inspired by this, I drew a fresh version in which another type of impossible object (cf. Chapter 7) is used to create an impossible setting for the tri-bar. The room has now become an art gallery in which the placing of the model causes serious problems!

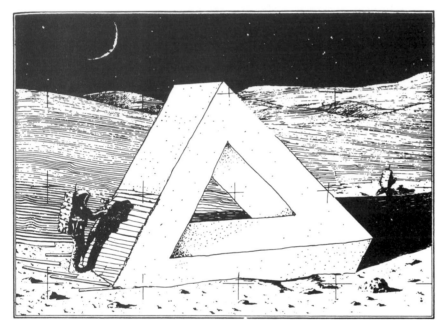

A monument for the year 2034 – an impossible tri-bar is erected on the moon to commemorate 100 years of impossible objects. The setting is borrowed from Macaulay.

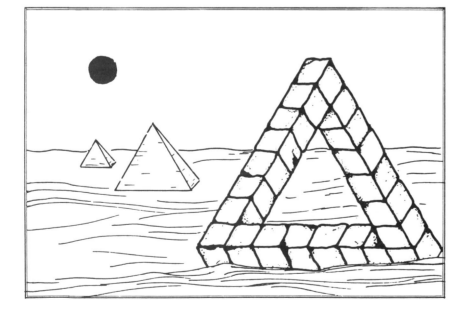

If the Great Pyramid were ever to disappear, a giant impossible tri-bar could be erected in its place. It would require a considerably smaller quantity of material.

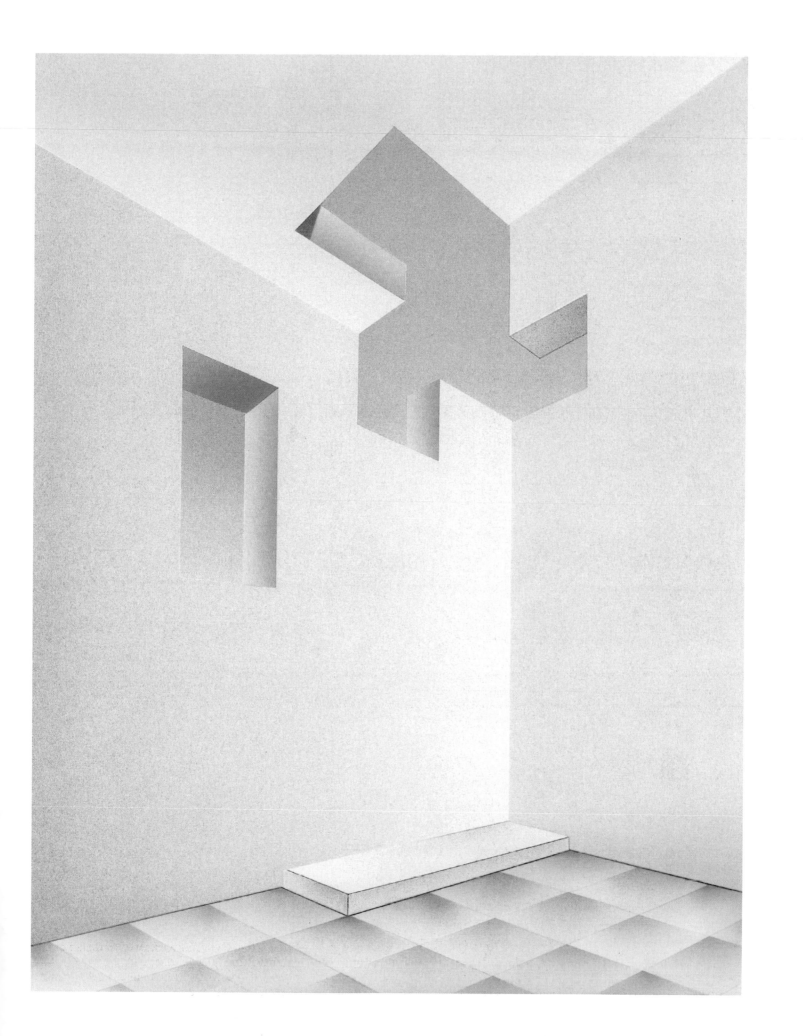

# 2. An impossible box

In this chapter we shall expand our inventory of impossible objects with the introduction of the impossible two-bar and the impossible four-bar. We shall also examine whether we can continue the list with an impossible five-bar, six-bar and so on. But perhaps the greatest surprise comes right at the end: the impossible mono-bar!

## Impossible box and impossible two-bar

"How many cubes would fit in this box?", asked Professor X, showing me a drawing of an impossible box that he had sketched the previous day (far left).
"I'm sorry", I replied, "but I can't even see the box."
Professor X: "Well, let me explain. I started with an impossible two-bar (2nd from left) and sawed off a section at the far end to give me a smaller impossible box."
"I think I'm beginning to see it. What a strange object! It looks twisted – horizontal at the front and vertical at the back!"
Professor X: "And now my original question: how many cubes does the box hold?"

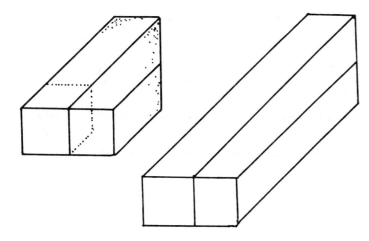
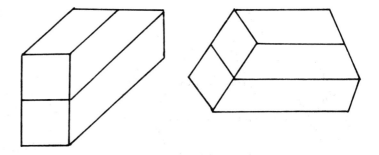

After thinking hard for a few moments, I asked: "Can you show me what the box looks like from the back?"
Professor X sketched the box accordingly (2nd from right).
"One last request: what does it look like from the side?"
Professor X, patient as ever, made another sketch (far right).
"I think it holds more than four cubes. But tell me the real answer!"
Professor X: "Exactly five!"
"Can you explain how you work that out?"
"In a minute", he replied with a smile.

# From an impossible tri-bar to an impossible four-bar

Professor X now drew an impossible tri-bar and then moved the right-hand bar along the axes *l* and *m* as illustrated below.

After a quick glance, I could immediately see that he had created an impossible four-bar. This was all very well, but what did it have to do with the impossible box?

Professor X: "This is how you can create an impossible four-bar out of an impossible tri-bar."

I nodded in agreement, but refrained from any further comment since I was eager to get on to the main question of how Professor X had been able to calculate the volume of his impossible box so precisely.

Professor X: "The bottom left-hand drawing shows a four-bar in which the side of the original tri-bar has been shifted just one cube to the right. I shall number the cubes – there are fourteen of them altogether – so that you can follow what is happening. Imagine that I have now taken away the top cubes 5 and 6, and filled the gap left between 4 and 7 with a new cube. The result is the four-bar in the bottom right-hand drawing, which now contains only thirteen cubes."

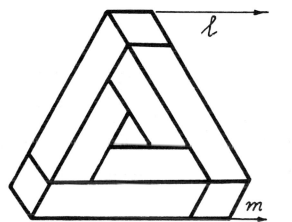

"Yes, I see; we now have one cube less than before."

Professor X: "Correct. So if I do the same thing again..."

"...you end up with a four-bar with twelve cubes." My interruption did not prevent Professor X from painstakingly numbering all the cubes in the new four-bar (below).

Professor X: "You are beginning to get the picture. Can you now see that, if we go one stage further, we arrive at an impossible two-bar? I haven't numbered it, but you will surely agree that, on the principle that we take away two and add one, it must contain eleven cubes."

I was delighted to be able to interrupt Professor X's monologue with an intelligent comment at this point: "Now I understand; this is the two-bar you used to make the impossible box."

Professor X: "Good, I see you are still following me. Let us now take away the six cubes on the right."

"And there's your impossible box!", I said triumphantly. "And now I see why it contains five cubes; eleven minus six equals five."

"Not bad for a six-year-old", remarked Professor X sarcastically. "And I don't need you to tell me that we can draw an even smaller box containing just three cubes. Most people would have difficulty in seeing it as a box at all, however."

Right:
Impossible four-bar.

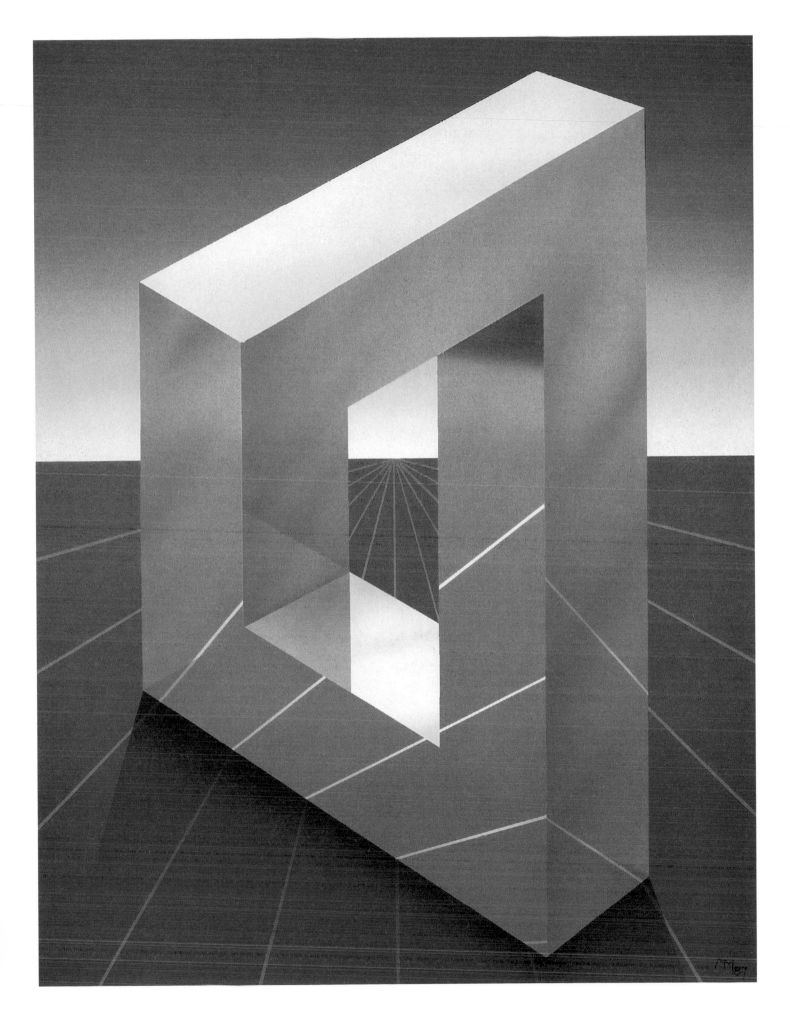

Adventures with Impossible Objects    23

# The impossible four-bar

The four-bar illustrated on page 23 features two parallel bars and two bars which appear to cross at right angles.

Just as with the impossible tri-bar, the eye immediately tells us that this is an object. More specifically, it is a frame made up of bars. This qualifying information does not follow later, but is delivered simultaneously with the eye's conclusion that the four-bar is an object.

For the eye to recognize the object as a frame, it must draw on a databank of other types of frame stored in our visual memory. (How and in what form such images are stored is still a mystery, but they are there.) The upper half of the four-bar on page 23 is the same as the upper half of the left-hand frame shown here, while the lower half similarly corresponds to that of the frame on the far right.

The impossible four-bar thus combines elements of two normal frames. The bars themselves are normal, and each of their joins is correct, and yet the top bar appears to run away from us, while the bottom bar runs towards us. How, then, can the right-hand upright connect their two ends?

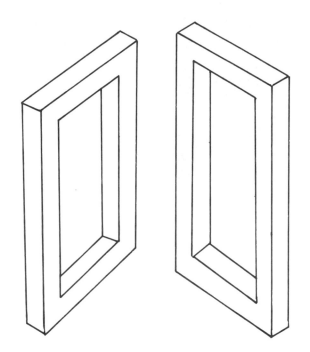

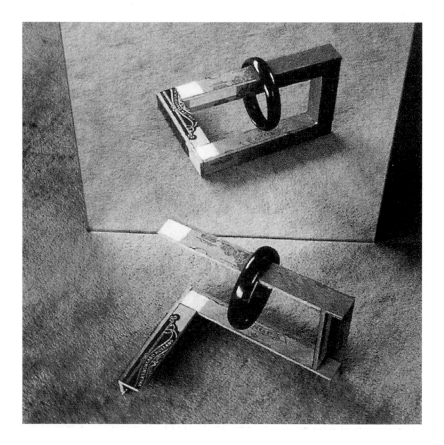

Model and mirror image of an impossible four-bar.

## Model of an impossible four-bar

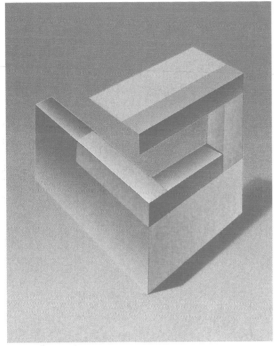

As with a tri-bar, we can also make a model of an impossible four-bar. The photograph on page 24 shows a wooden model placed in front of a mirror. It is clearly only the angle of the camera that makes the model appear as an impossible four-bar in the reflection. You can make up a model of a four-bar using the cut-out below. Follow the instructions on page 13.

In the drawings on the following pages, impossible four-bars are deployed in unusual situations. Strange rooms are composed of impossible four-bars whose boundaries suddenly vanish into thin air.

Model of an impossible four-bar.

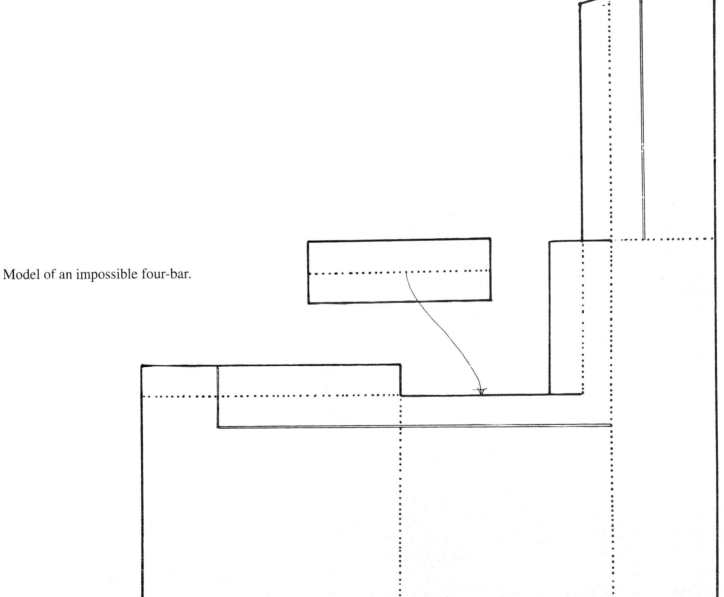

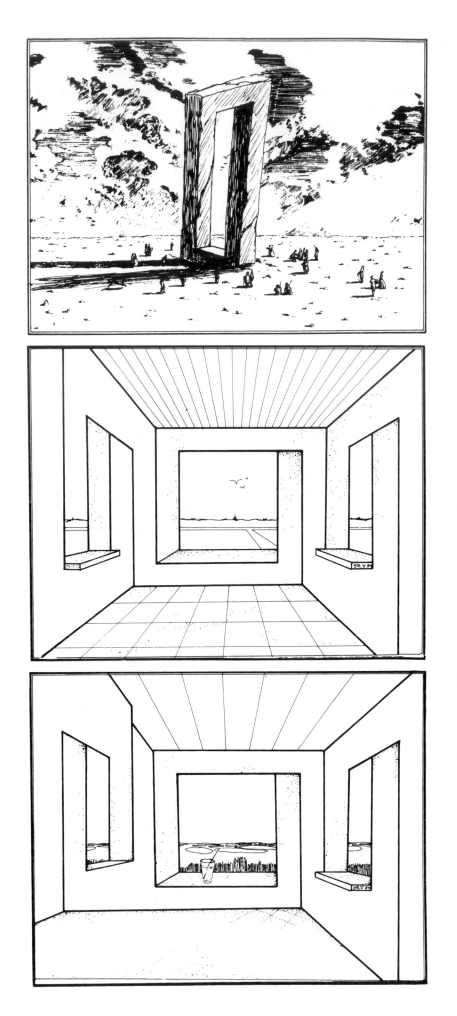

The setting in this drawing is borrowed from Macaulay.

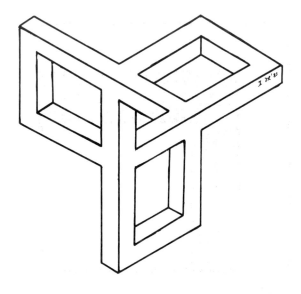

Centre and below:
Strange rooms.

# Impossible frames with parallel bars

The shaded figure below represents a solid frame which is above and to the left of our viewpoint.

From this angle, each corner is seen differently and can be numbered 1–4. The frame as whole can thus be described as (1234). By employing the individual corners in different combinations, we can now create a series of new frames. Some of these present the eye with contradictions and thus reveal themselves to be impossible four-bars. The four examples illustrated below include one possible frame, seen square on from a close distance, and three impossible four-bars.

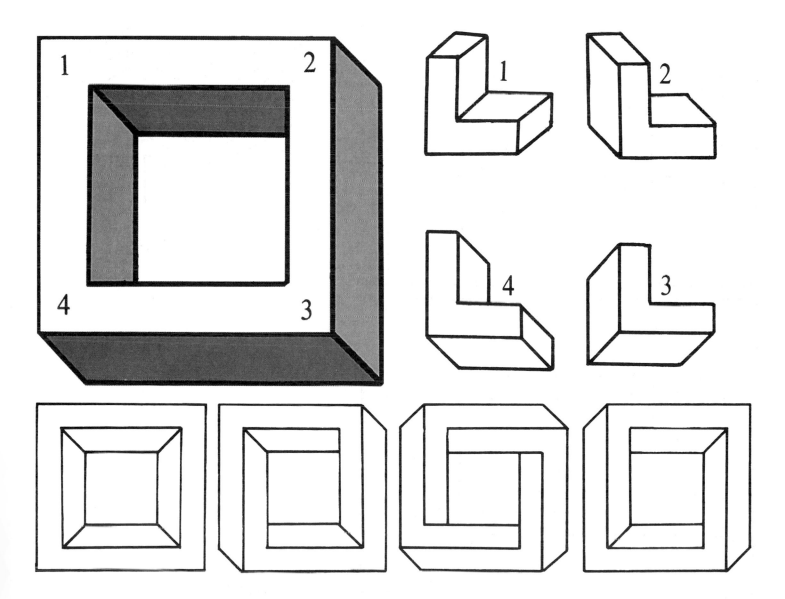

# Impossible multi-bars

It is not difficult to combine more than four bars into an impossible object. For two reasons, however, the impossible multi-bars produced in this way are less compelling than their tri-bar and four-bar cousins.

Firstly, multi-bars contain no right angles. This is significant because the presence of right angles in an impossible object (suggested through a perpendicular combination of bars, for example) gives the eye a useful reference point from which to determine directions in space. Any contradictions will thereby be made more apparent. The arms of a multi-bar, however, always meet at an angle greater than 90°. Its impossibilities are consequently less obvious to the eye.

The potency of an impossible multi-bar is weakened secondly by its complexity. The more bars and lines an object contains, the less its contradictions will strike the eye.

Multi-bars are nevertheless simple to create. We merely combine our four standard corner shapes in any order desired. An example is the (13143) five-bar illustrated here.

If we create a (444444) six-bar and "read" it in a clockwise direction, each successive bar appears to lie behind the one in front. Yet our eyes are led back to the point at which they started... something which is surely impossible!

Finally, let us move briefly to another, circular type of impossible two-bar. The (44) example shown here has been worked into a number of exquisite drawings by Sandro del Prete. It also surfaces in impossible multi-bar alphabets, where its curved form is ideally suited for rounded letters.

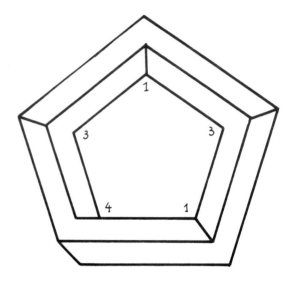

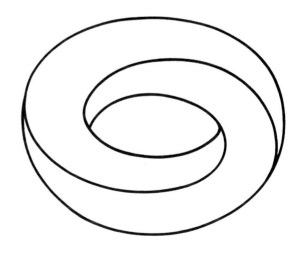

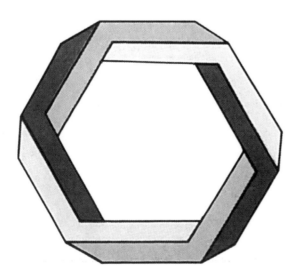

Joop van Bossum, *Gyration*
Acrylic on card,
100 x 100 cm, 1986.

# Impossible mono-bars

It may come as something of a surprise to learn that an impossible mono-bar can in fact exist at all. Indeed, there appears to be nothing impossible about the example on the right. Most people will see it as a bar with the ends sawn off at a slant. Depending on the position of the bar, the two sawn-off ends are either exposed (top sketch) or concealed (lower sketch). But in certain combinations this mono-bar can become an impossible object, as we shall see in the following examples.

The fascinating mono-bar below was drawn by Zenon Kulpa. At first glance we seem to see two parallel bars, but on closer inspection we find that the bar on the right is in fact made up of the side and the shadow of the bar on the left. It follows that the second bar does not exist! Perhaps this object is best described as an impossible one-and-a-half bar.

# Passing through closed doors

In the illustration on the following page, the middle bar has been rendered impossible by its setting. The eye sees the middle bar lying on top of the one below and beneath the one above. At the same time, however, it recognizes that the upper and lower bars meet along one edge, leaving no room for the middle bar to pass through. A fairy-tale comes true: we can pass through closed doors!

Right:
The middle bar appears to pass over the one beneath – and yet the upper and lower bars are hermetically sealed along one edge.

# 3. Visual clues

An impossible object, as we have already seen, is born out of a conflicting set of spatial data. There are three types of visual clue, in particular, upon which the eye relies in its "reading" of the outside world:
1. Overlapping and joining of planes,
2. Continuity of planes,
3. Orientation of planes.

## Overlaps and joins

The examples on the right illustrate how overlaps and joins offer important clues to the position of the two bars in space. In the drawing top right, for example, we know that A is in front of B because B is partially concealed behind A. In the second example the situation is reversed, while in the third A and B – now joined – are clearly equidistant from us.

The importance of these visual clues is demonstrated in the adjacent sketch of the ladder. The ladder begins inside the room and ends outside. This is an impossibility; it arises because the ladder passes over the top line.

## Continuity

In the illustration bottom right, the two cross-bars should intersect in the middle. Since one overlaps the other, however, an impossible object is born. Here again we are presented with conflicting information: on the one hand, the horizontal central bar partially conceals the vertical bar, creating an impression of depth; on the other hand, the continuity of the planes forming the outside of the frame indicates that the perimeter is flat.

This effect can be amplified with the help of other conflicting visual clues. The impossible "sandwich" (opposite page) simultaneously presents itself as layered and flat: on the left, the vertical positioning of the corners reinforces the use of overlapping to create an impression of three levels, while the continuity of the planes on the right insists that only one level is present. We can invent many more variations upon these last two impossible objects if we start from the impossible four-bars met in Chapter 2.

# Orientation

The arrows in the illustration below indicate the three perpendicular directions which a cube defines in space. In the example on the right, in which three bars meet at a corner, these directions are stated even more emphatically. The eye applies this information to the retinal image as a whole. Below are three different tri-bars. The first is "normal"; the right-hand bar passes in front of the left in line with the directions indicated by the corners. The second is impossible: with their different orientations, the bars cannot overlap as they do. The third is similarly impossible: in this case, the bars meet at the top in defiance of their opposite orientations.

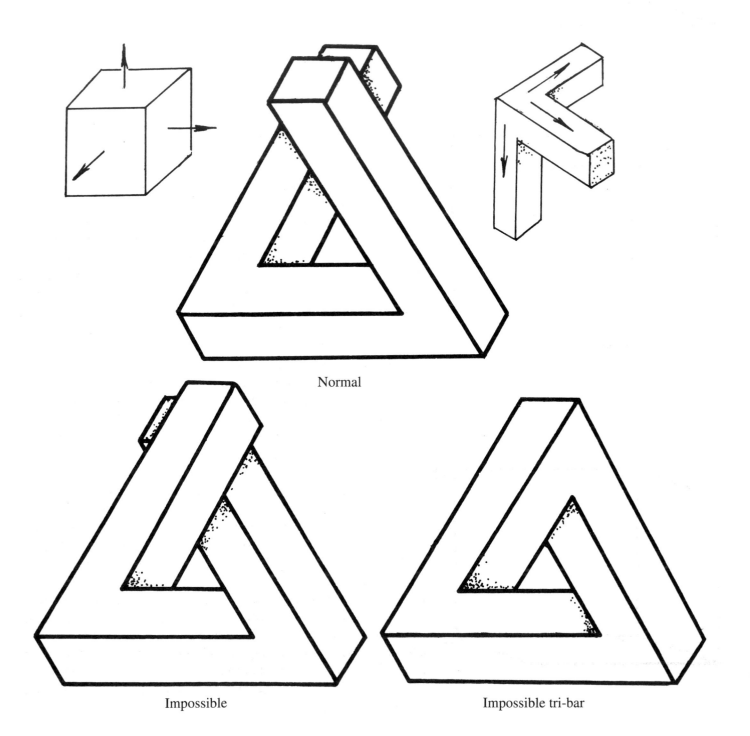

Normal

Impossible

Impossible tri-bar

# 4. Inversion

Fig. 1

Before we introduce yet further categories of impossible objects, such as impossible cubes and continuous flights of steps, let us first meet another kind of object which the eye is only rarely required to process in our normal environment. These are so-called ambiguous figures, for which the eye offers us two or perhaps even more equally valid interpretations. In such cases, the eye processes the information provided and concludes that the object can be one thing or another thing. Although the two things are different, they are not mutually contradictory. In the case of an impossible figure, however, the eye reaches a different conclusion: the object is both one thing *and* another thing at the same time.

Fig. 2

Fig. 3

## Perceptual inversion

Inversion describes a process of pictorial transformation. The term has a number of meanings: it denotes something different in the field of mathematics, for example, than in optics (pseudoscopy). Here we shall use the term in a much more limited sense, applying it solely to the behaviour of the cubes sketched on the left.

Fig. 1 shows a cube in which all twelve lines are equally solid (this has become known as the Necker cube, after the first scientist to discuss its properties). If we look at the line AA', we cannot tell which point is closer to us, A or A'. The same is true of the other three pairs of points (BB', CC' and DD').

As we look at this cube, our eye appears to see it alternately from two different angles: one in which the plane ABCD appears nearer to us than A'B'C'D', and one in which it lies further away. These two orientations are made visible in Figs 2 and 3: here, the ambiguity of the Necker cube is removed by the introduction of dotted lines which allow just one interpretation in each case.

This switching from A-is-nearer-than-A' to A-is-further-away-than-A' we call perceptual inversion. The cube in Fig. 2 is thus the inverse representation of the cube in Fig. 3, and vice versa.

When we follow the inversions of the Necker cube, we do not necessarily register the shift in the relative distances of ABCD and A'B'C'D' straight away. What we do notice immediately, however, is the fact that the two cubes have quite different orientations: one is seen from above and faces left, the other is seen from below and faces right. AD and A'D' thereby change places, although remaining parallel to each other. The phenomenon of perceptual inversion can be defined more closely as follows: all the lines in the retinal image have the same orientation, but as soon as the interpretation switches to the inverse figure, all the lines appear to change their orientation (in space).

Such changes of orientation can be highly dramatic, as we shall see. The upper illustration of dice on the following page again presents the two inversions of a Necker cube side by side. Both illustrations are in fact based on two photographs of the same configuration of dice, but taken from different angles. The left-hand dice was placed against a wall, and squares of the same size as its sides were marked out on the wall and ground. The lower drawing makes the completely different orientations of the dice more than clear.

The angle at which the Necker cube is seen determines the angle through which its sides will project after inversion. In the first pair of drawings on the right, showing the two possible interpretations of a Necker cube, this angle is only small; in the second pair (which corresponds to the dice on the next page), it is as large as it can be. The exact size of the angle can be determined from the drawing below. The diagonal AC is seen as exactly the same length as the side AB. A cross-section of the two cubes (through AB and perpendicular to the horizontal plane) is shown on the right. The sides of the triangle ABC are 1, $\sqrt{2}$ and $\sqrt{3}$. From this we can calculate that the angle $B_1 = 54.7°$. If AM = BM, $B_2$ must also be $54.7°$. Hence the angle ABD is $109.4°$.

Pair 1

Pair 2

# Concave and convex

Although the Necker cube suggests two different geometric forms, the terms "concave" and "convex" can be applied to neither; we can always see both the inside and the outside of the cube at once. This situation changes when we omit from our drawing three planes which meet at or near the centre of the cube (as, for example, in the illustrations on the right). We now obtain a figure which again suggests two inverse three-dimensional bodies, but of a different nature: one convex, in which we see only the *outside* of the cube, and one concave, whereby we perceive only three of the planes *inside* the cube.

Most people see the convex form first, but have difficulty seeing the concave form unless further clues are added, such as the teacup in the example on the right.

By wrapping up the cube with a ribbon and a bow, as in the second illustration, it becomes almost impossible to see the concave form. The spatial information contained in even such small decorative details is astonishingly persuasive.

In the drawing below, the two cubes have been positioned so that they share a common edge (compare the upper pair of dice on p. 37). It is interesting to observe how our interpretation of the left-hand cube (A) affects our interpretation of its right-hand counterpart (B). The figure as a whole can be read in four different ways:
1. A is concave and B is concave,
2. A is concave and B is convex,
3. A is convex and B is concave,
4. A is convex and B is convex.

This prompts us to ask a number of questions:
– Which interpretation do we see first?
– Which inversions take place spontaneously and which ones are more difficult to see?
– Does a single orientation dominate both halves? In other words, does the orientation which asserts itself on one side also assert itself without difficulty on the other?
Personally, I find 4 the easiest to see. For me, the convex form is dominant, followed by 2 and then 3. Only with great difficulty can I see 1.

We might further ask what effect the addition of shading or other details has on our interpretation. The dots on the dice (p. 37), for example, make it almost impossible to see 1, 2 and 3.

Right:
Monika Buch, *Illusory Cube*
Acrylic on card, 60 x 60 cm, 1983.

# Two conflicting orientations

It is now time to turn our attention back to impossible objects. The two inverse forms that we perceive when we look at the Necker cube are mutually exclusive. We see first one and then the other, alternately. Let us now examine whether it is possible to see an object as *simultaneously* convex and concave.

We can do this by adding details which lay down one orientation for one plane but accentuate a different orientation for another plane. An example of this can be seen at the bottom of the opposite page.

Is this an impossible object? I tend to think not. It fails to form an *overall picture*. When we look at the left-hand side of the cube, we perceive it as convex, with the window on the right being ignored as something which doesn't belong.

If we look at the right-hand side, we can – with some effort – see a concave cube. But as soon as we shift our focus back to the left-hand side, the cube switches back to its convex form. In this example, the convex is clearly the dominant form.

A more complex version of this figure lies at the heart of the lithograph *Concave and Convex* by M.C. Escher. Examining this central section in closer detail (opposite), we see that it never succeeds in establishing itself as a stable impossible figure. Instead, it performs the same sudden and irreconcilable switch in orientation encountered above. Indeed, it was Escher's intention that this switch should be clearly palpable to the viewer reading the picture, whether from right to left or left to right. In *Concave and Convex*, the inversion is experienced as a movement, not as a static conflict. This is similarly true of *Cube with Magic Bands*, the more abstract counterpart to *Concave and Convex*.

*Cube with Magic Bands* by M.C. Escher, 1957.

The central section of the lithograph *Concave and Convex* by M. C. Escher (1955).

Two conflicting orientations.

Fig. 1 shows an impossible mono-bar similar to that encountered earlier on page 30. As the two convex cubes drawn below the figure demonstrate, the left-hand end of the bar has a different – conflicting – orientation to the right-hand end. But no one "believes" this: our eye perceives the object as a bar whose two ends have simply been sawn off at an slant... in other words, it sees nothing impossible!

Our next step is to add to the mono-bar at both ends (Fig. 2). The result is a figure which forces us to accept two different orientations. In my opinion, this is a true impossible object. Both arms form a right angle with the bar, yet their orientations – one extending forwards, the other backwards – are clearly contradictory. Moving from A to B forces us to switch orientation, but without any loss of stability or cohesion. It is this that makes the figure an impossible object.

In Fig. 3 we have introduced a second change of orientation, again resulting in an impossible object. Finally, in Figure 4, our original mono-bar has expanded into a four-sided frame, similar to the impossible four-bars already encountered in Chapter 2.

It is thus possible to construct stable impossible objects which force our eye to accept mutually exclusive orientations.

In some cases we can heighten the complexity of an already impossible object by forcing a change of orientation upon the eye. The figures top right and on the opposite page are examples of this.

Fig. 1

Fig. 2

Fig. 3

Fig. 4

# The Thiéry figure

On page 38 we slid two cubes together so that they shared a common edge. The illustrations on the right show what happens if we now slide them even closer together, so that they share a common plane. The resulting figure was first thought of at the end of the last century by Armand Thiéry, who used it in his investigations into optical illusions. The Thiéry figure – as it has come to be known – is not impossible. We can use it, as Thiéry did, as a means of testing perceptual inversion. That is not all, however. By adding more lines, we can make the figure more stable (cf. illustration bottom right). This is rather significant, since it suggests that the dividing line between unstable concave/convex figures and stable impossible objects is not all that great. Several artists have invented variations upon the Thiéry figure in order to create illusions which lie on this borderline. One example of very stable impossible forms is the double alphabet designed by Tsuneo Taniuchi, of which the letters H, S and T are reproduced below. Taniuchi's alphabet was printed in full in "Upper and Lower Case", *The International Journal of Typographics,* vol. 10, no. 3, September 1983.

A number of people have made interesting but relatively complicated three-dimensional models of the Thiéry figure. Less well-known, but remarkably simple, is one suggested to me by Professor J.B. Deregowski, resembling a sort of pyramid with a flat top. On page 46 you will find a model which you can assemble yourself, and which demonstrates more clearly than a perspective drawing just why the Thiéry figure is not impossible. This particular model lacks a base, but you can add one of your own with no problem.

Monika Buch, *Thiéry Figure II*
Acrylic on card, 60 x 60 cm, 1983.

In view of the fact that the Thiéry figure can be an entirely normal three-dimensional object, why doesn't the eye recognize it spontaneously as such? Part of the explanation probably lies in the fact that the two obtuse-angled triangles bordering the longer sides are hidden from view – although the eye is well-trained in "imagining" the presence of invisible planes.

Another special feature about this model is that it can suggest different three-dimensional forms, depending on the angle from which it is seen. The photograph and the illustrations below show some of these. In the photo, the model is standing in front of a mirror, demonstrating two different views at once.

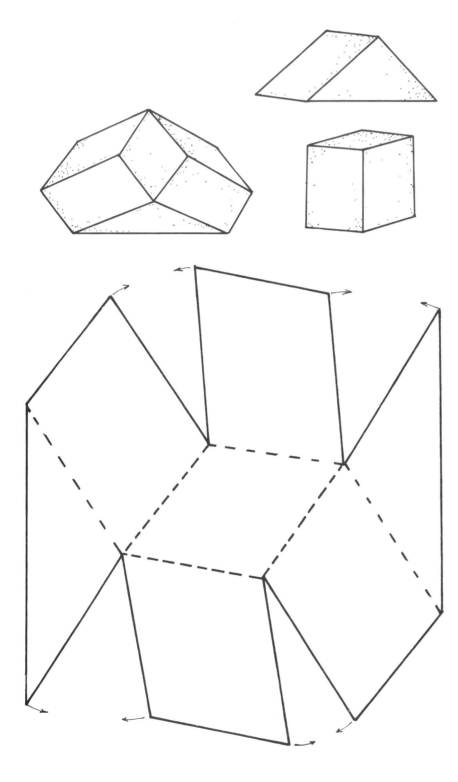

Left:
Model of a Thiéry figure.

Right:
Jos de Mey, *Illusory Cube*
Oil on canvas, 1977.

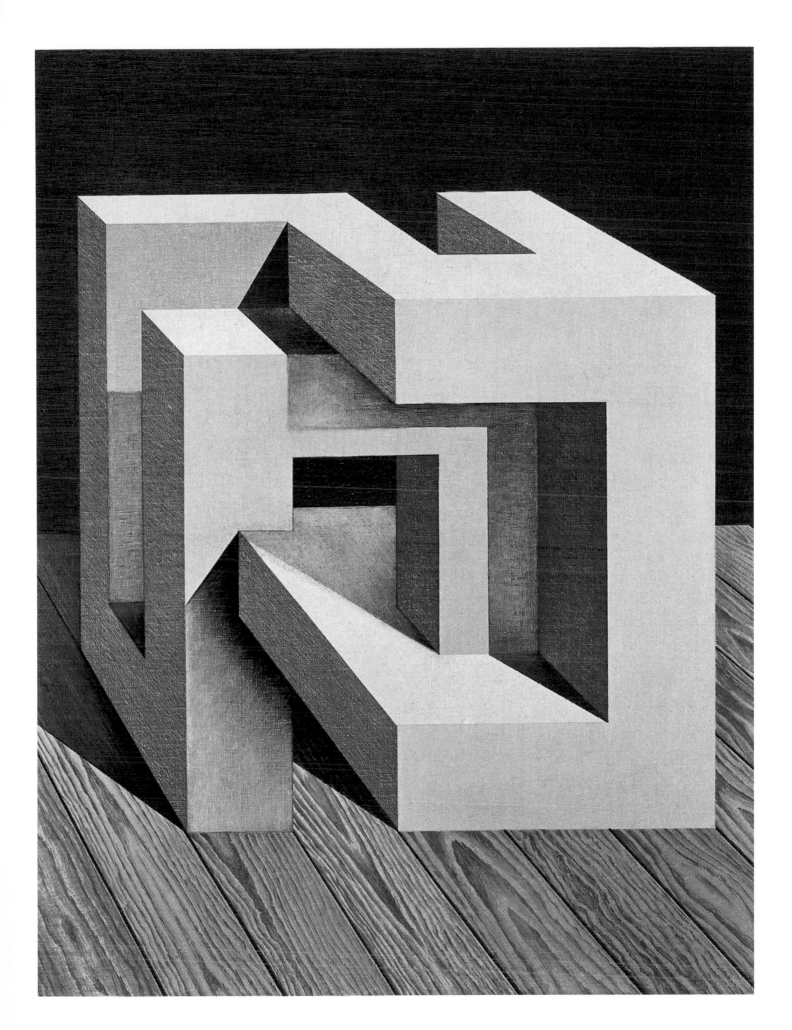

# 5. Cuboids

In Chapter 2 we saw that the more bars and lines there are in an impossible multi-bar, the less its contradictions will strike the eye, weakening its impact (p. 28).

Impossible objects of four bars or more can still be recognized, however, if they resemble a well-known shape from our standard repertoire of three-dimensional forms. One such shape is the cuboid, a figure having the shape of a cube. A cuboid has twelve edges and eight corners, at which three of its six sides meet at right angles.

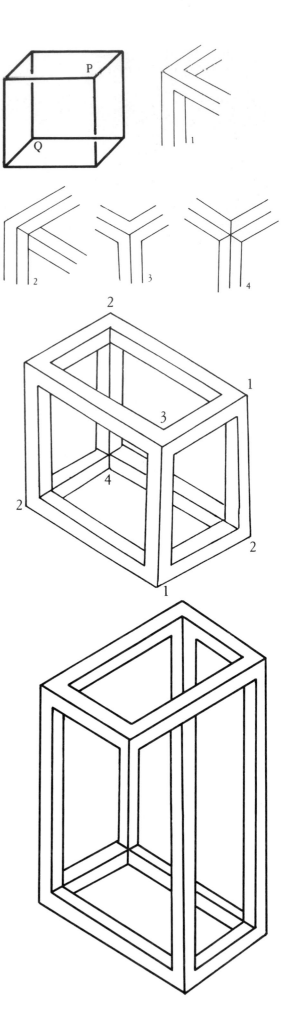

## Impossible overlaps and joins

As we have seen in the example of the Necker cube (p. 35), a cube drawn with twelve solid lines can be interpreted in two different ways – as a cube seen from above and projecting to the left, or as a cube seen from below and projecting to the right. In both cases, the cube itself is normal. In the figure top right, however, we have confused the issue by leaving gaps in two of the lines, suggesting that one line is passing in front of another. In consequence, P and Q both appear to lie equidistant from the viewer – and that is impossible. It is therefore an impossible object.

When we draw solid bars rather than just lines, visual clues are provided not only by overlaps of this kind, but also by the shape of the corners, at which three bars meet. A contradictory relationship between these corner shapes, even where any overlaps are normal, means we are dealing with an impossible object.

If we look at the normal cuboid on the right purely in two-dimensional terms, we can identify four different corner shapes. Shapes 1 and 2 alternate around the outer edge of the drawing, while shapes 3 and 4 are found inside. Let us now create a cuboid using corner shape 1 six times and shape 3 twice (see opposite page). The result is just one of the many impossible cuboids that can be created in this way. A particular feature of this example is that, starting from any point in the cuboid, you can trace a continuous line through almost all the visible faces of the bars.

Another type of impossible cuboid features vertical bars of different lengths, as in the example on the right.

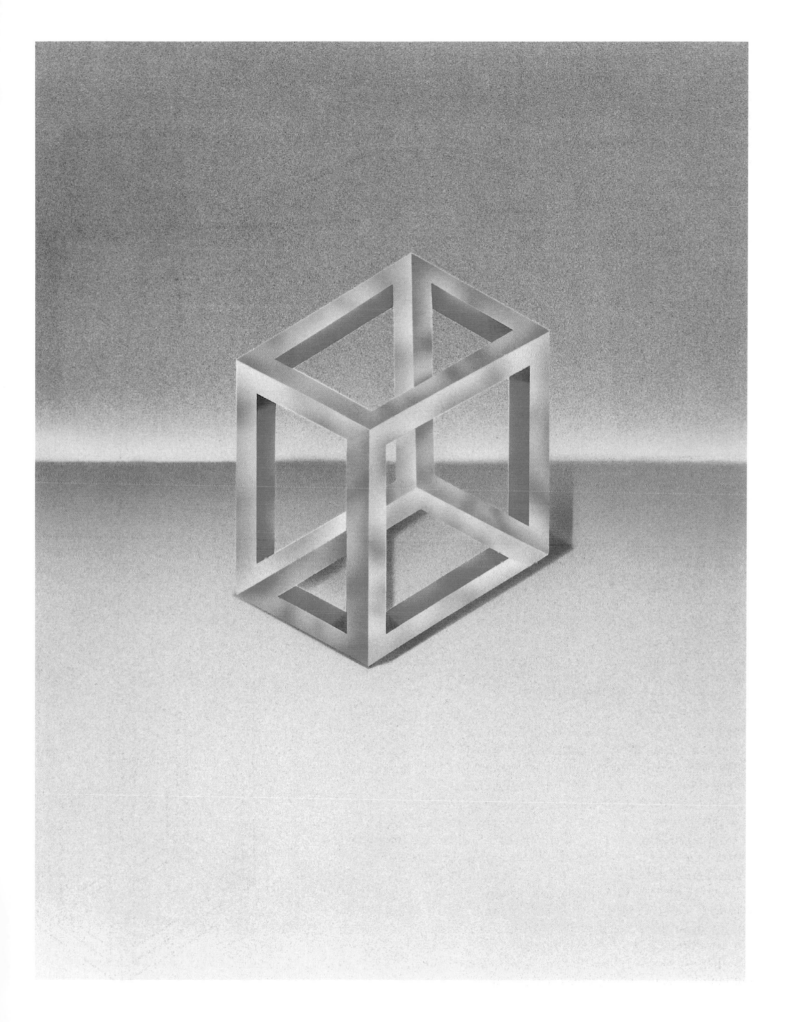

# Escher's *Belvedere*

The impossible cuboid is most effective on its own. A picture which contains several at once is too difficult to interpret; the eye is unable to make sense of the excess of contradictory information with which it is presented, and sees nothing but a chaotic confusion of lines.

By strengthening some contradictions and weakening others, and by adding secondary visual clues, we can create an impossible cuboid which expresses both the impossibility and the apparent reality of this remarkable and fascinating figure.

Maurits Cornelis Escher was a master of this art. Let us take a closer look at his *Belvedere* of 1958 (p. 51), in order to show how carefully he designed an impossible cuboid in order to make the most of its properties.

What is striking is the very unobtrusiveness of the impossible cuboid at the centre of the composition. As we can see from the diagrams on the right, its horizontal planes are long and narrow, and the points P and Q lie far apart. This leaves a relatively large and open space in the centre of the composition. Most astonishingly, point P is in fact invisible and point Q is barely detectable. Escher has thus deliberately camouflaged the two most striking features of an impossible cuboid, and the two most disturbing to the eye. He weakens the centre yet further by means of arcades in the upper level and a balustrade on the lower level. What remains of the impossible cuboid is shown in the figure below right. The solid and detailed composition above and below this skeletal framework both reinforces the reality of the picture as a whole and at the same time accentuates the conflicting orientations of the top and bottom of the cuboid. Thus the upper storey appears to lie at right angles to the one below - an impression heightened by the different directions in which the woman on the top floor and the man on the floor below are each gazing. A minimum of four pillars are necessary to connect the top and bottom planes of an impossible cuboid, whereby the two outermost pillars cannot be "impossible"; here, Escher uses eight pillars, six of them establishing impossible connections. He thereby more than compensates for the impossibility "lost" by camouflaging points P and Q. Finally, the ladder leading from the floor to the ceiling represents another impossible connection: the absurdity here is that it starts from inside the cuboid and ends on the outside.

Art historians paid little attention to Escher at first. As his work has become more and more popular, however, Escher has also earned the recognition of the academic world.

Escher's *Belvedere* demonstrates the ingenuity and flair with which the artist set about portraying the impossible as realistically as possible.

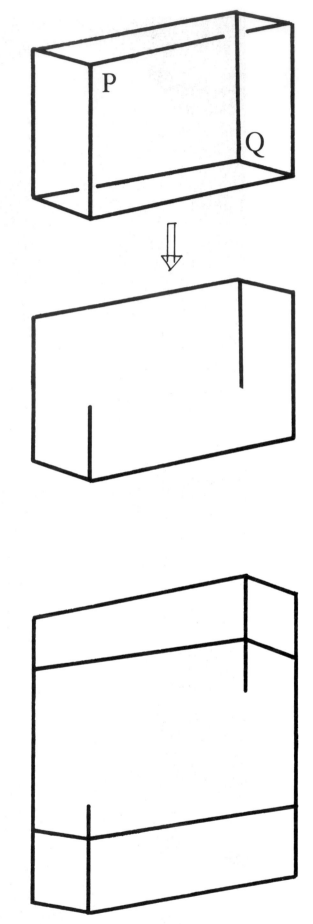

Opposite page: M.C. Escher, *Belvedere*
Lithograph, 46.2 x 29.5 cm, 1958.

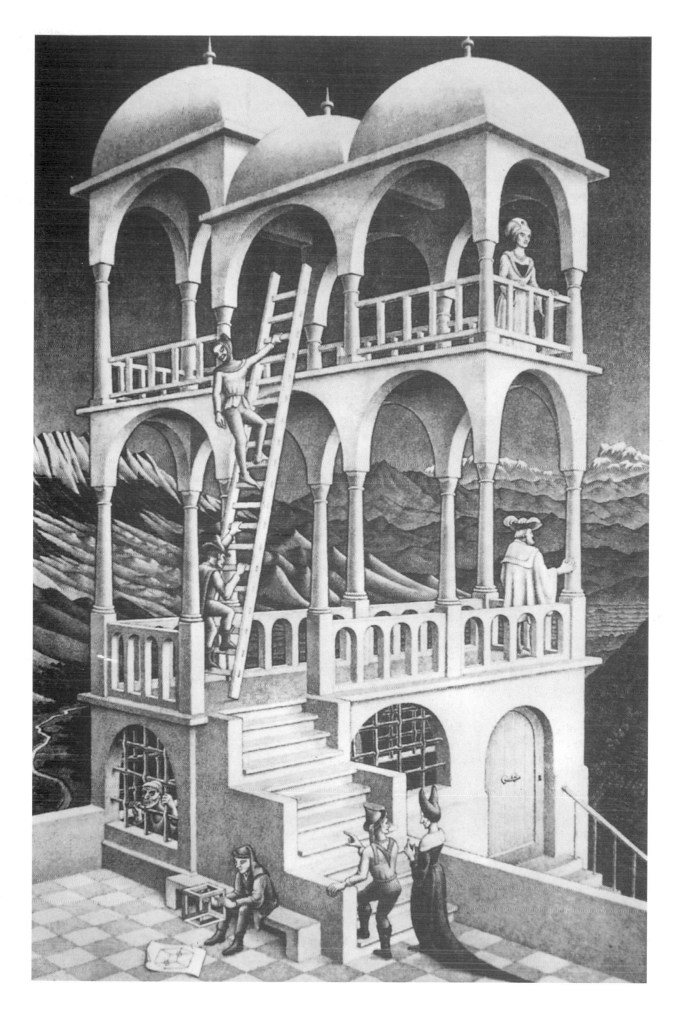

# Cuboids with impossible connections

The impossible cuboids that we have seen so far have all borne a close resemblance to a normal cube whose twelve bars terminate at eight corners.

We can also make quite radical changes to such figures, however, without losing the overall impression of a cube. In the impossible cuboids shown on this page, some of the bars no longer serve as a direct link between corners. A corner may be connected instead to the middle of the bar opposite, for example. We may complicate the figure even more by playing with impossible overlaps and joins, introducing a join where we would normally expect an overlap, and vice versa. The resulting cuboids thereby incorporate a range of impossible tri-bars and four-bars. The examples seen here are merely a starting-point for an endless succession of variations on this intriguing theme.

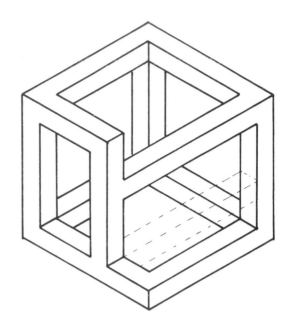

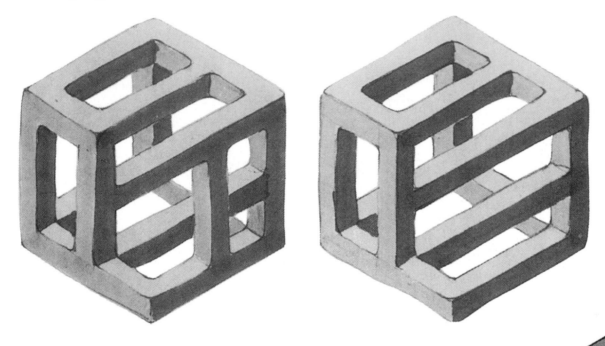

# Incomplete cubes

If, as in the drawing on the right, we omit three of the twelve bars which make up a normal cube, we are left with a set of incomplete bars perpendicular to each other. Yet the eye has no difficulty in recognizing the figure as a cube.

The cube shown here is related to those already encountered in Chapter 4, in which we explored concave and convex inversions. In the illustration on page 53, we see the same object transformed into an impossible cube in which "correct" joins have been replaced by "incorrect" overlaps. We can even observe changes of orientation within one and the same bar!

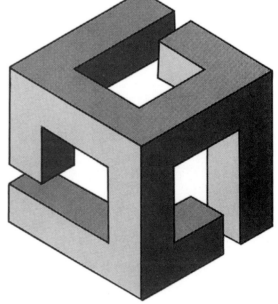

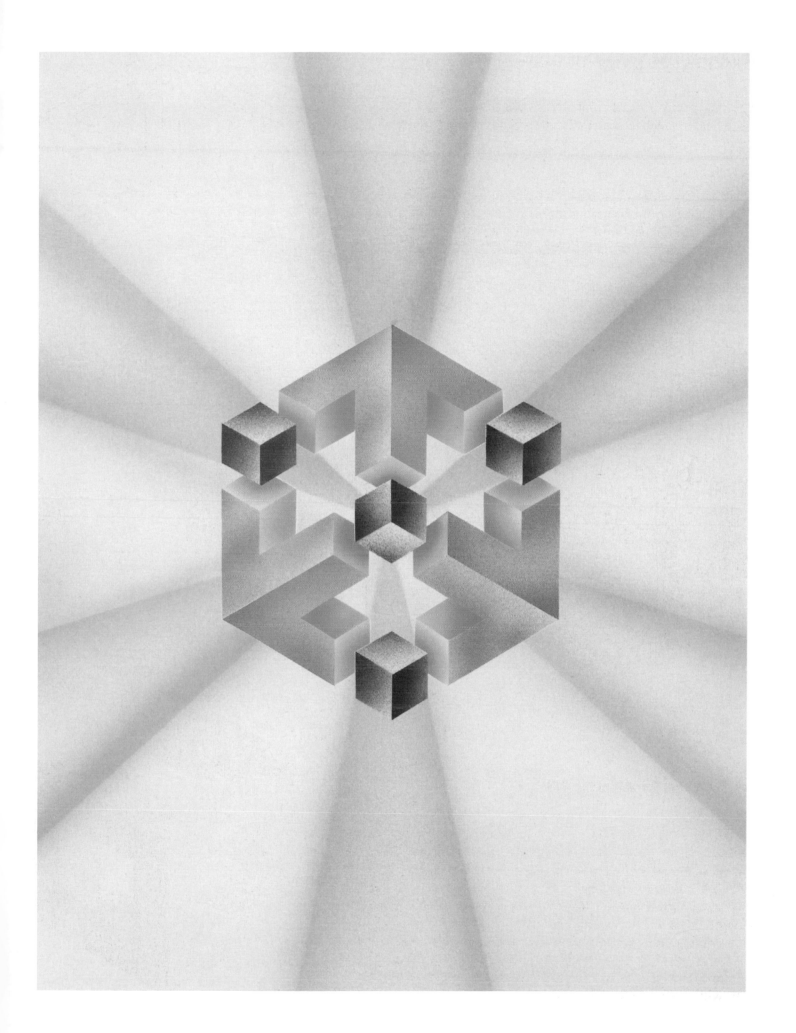

# Impossible frames

As my starting-point for the two drawings below I took a normal frame. Inside I drew a second three-dimensional figure, which I then connected "impossibly" to the corners and sides of my original frame. This created a tension between the outer frame, which theoretically should contain the inner figure within its own plane, and the figure's clear projection behind and in front of the frame. (This is particularly pronounced in the drawing on the right.) It would also be possible, of course, to start with an impossible four-bar as the frame and then follow the same procedure.

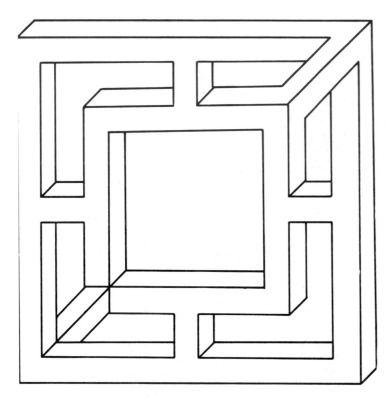 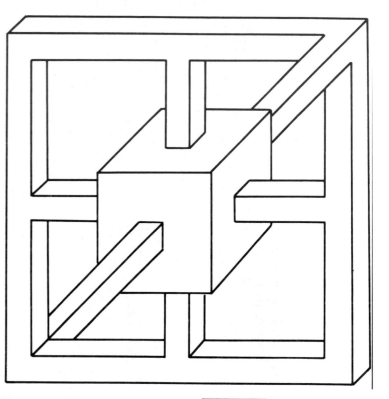

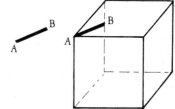

## 6. Continuous stairs

Presented with the line AB purely on its own (right), we cannot judge its position in space. We cannot even say for sure that it is a straight line – it might equally well represent a circle seen sideways, for example. Even if we assume that AB is straight, we still know nothing about its orientation in space. For that the eye needs additional visual clues. If we now incorporate AB into the drawing of a cube, as in the two examples on the right, the positions of A and B are immediately established. In the top drawing, A is higher and nearer to the viewer than B, while in the bottom drawing B is higher and nearer than A.

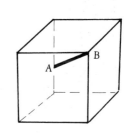

The eye cannot gauge the orientation of the line AB in space until it is provided with additional visual clues.

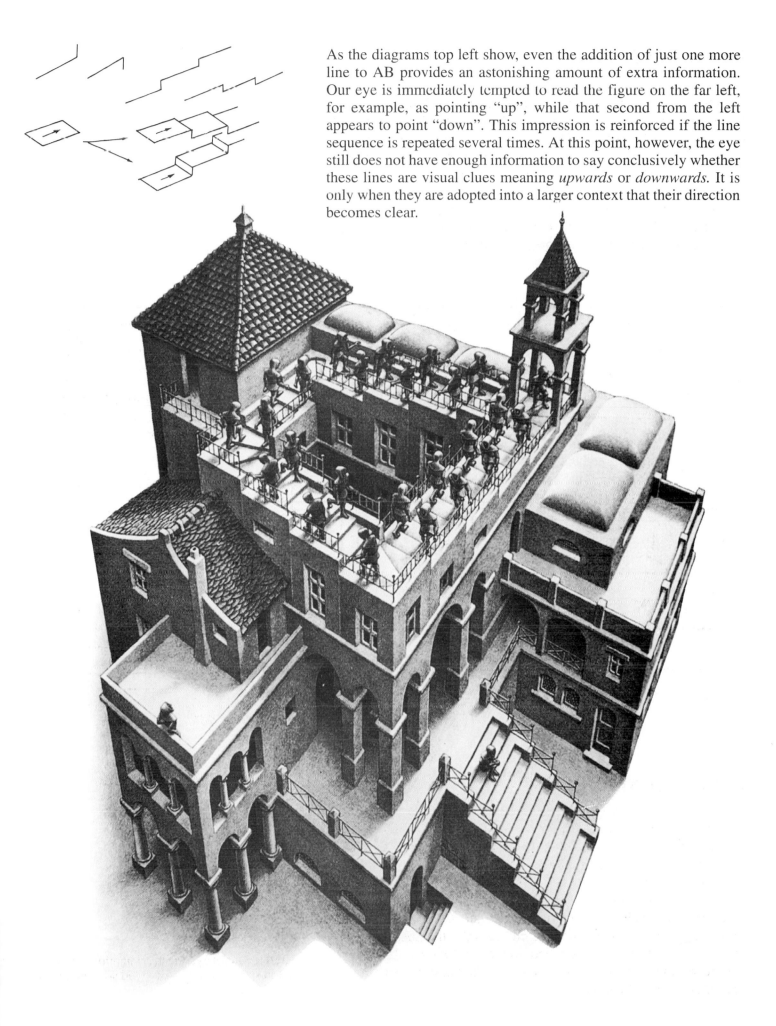

As the diagrams top left show, even the addition of just one more line to AB provides an astonishing amount of extra information. Our eye is immediately tempted to read the figure on the far left, for example, as pointing "up", while that second from the left appears to point "down". This impression is reinforced if the line sequence is repeated several times. At this point, however, the eye still does not have enough information to say conclusively whether these lines are visual clues meaning *upwards* or *downwards*. It is only when they are adopted into a larger context that their direction becomes clear.

# Ascending and descending

Right:
Endless staircase with just four steps.

The most fascinating aspect of Escher's lithograph *Ascending and Descending* of 1960 (p. 55) is the fact that its hooded figures are marching endlessly up (or down) the stairs without actually gaining (or losing) any height. Escher adopted this continuous flight of stairs from L.S. and R. Penrose, who discussed the phenomenon in the same article in which they introduced the impossible tri-bar.

When looking at a flight of steps, we first decide in which horizontal direction we wish to follow it. Having chosen our direction, further visual clues will then enable us to judge whether the stairs lead up or down. The direction of the actual surface of the treads plays no part in this process (cf. the diagrams on p. 55, top left). Steps can also freely change direction, regardless of whether they are rising or falling. These facts are all part of the secret of the endlessly marching figures in Escher's *Ascending and Descending*.

A similar endless staircase can be created with just four steps, as in the illustration opposite. If we follow this staircase in a clockwise direction, we find ourselves continuously descending. If we turn around and go the other way, this turns into a continuous ascent. The impossible manner in which the stairs overlap sows a confusion between "upwards" and "downwards".

This confusion is removed in the drawing of a normal flight of stairs below. Here it is clear that the steps descend in a clockwise direction, since the fourth step has arrived back three steps lower than the first.

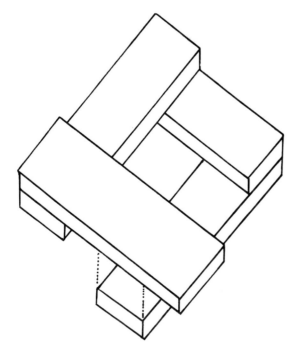

Left:
This staircase is descending clockwise.

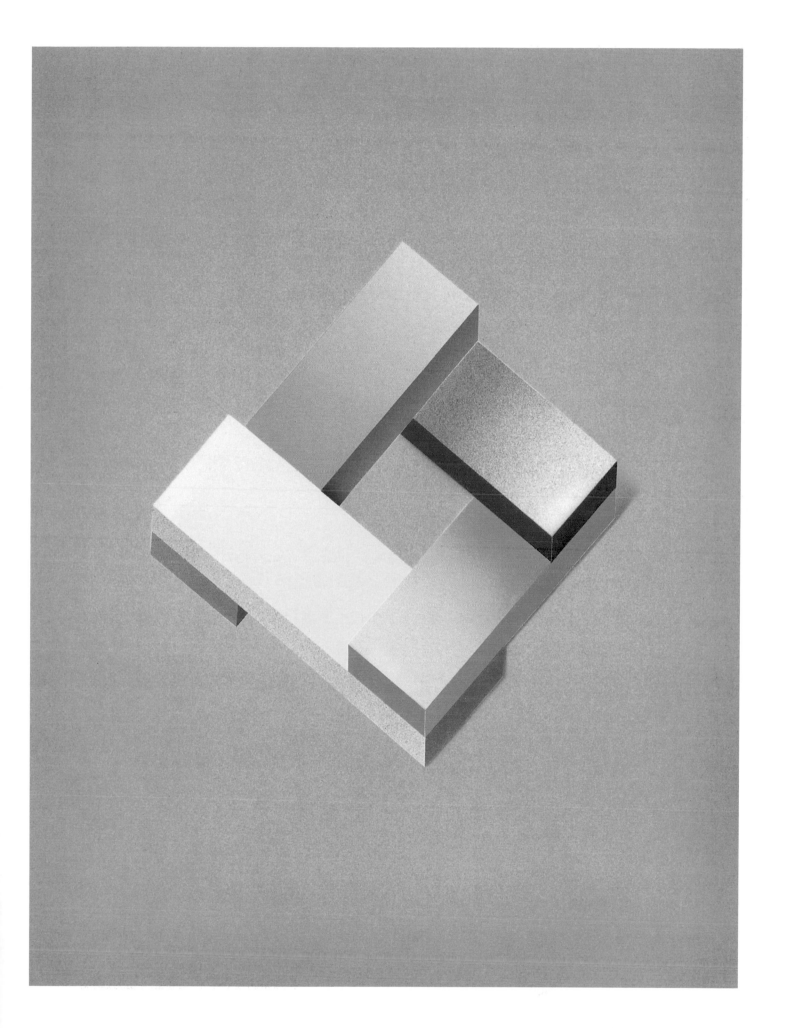

# Tiled floors and chessboards

"Upwards" and "downwards" indicators are accepted by the eye without question. In the drawings below, however, the left-hand edge of a tiled floor suggests a succession of rising steps, yet the right-hand edge remains flat. The result is an impossible plane in which the rise in floor level indicated on the left contradicts the flatness indicated on the right. If we look back at Escher's *Waterfall* (p. 15), we can now see that he establishes the direction in which the water is flowing by presenting each arm of the impossible tribar channel as a succession of steps!

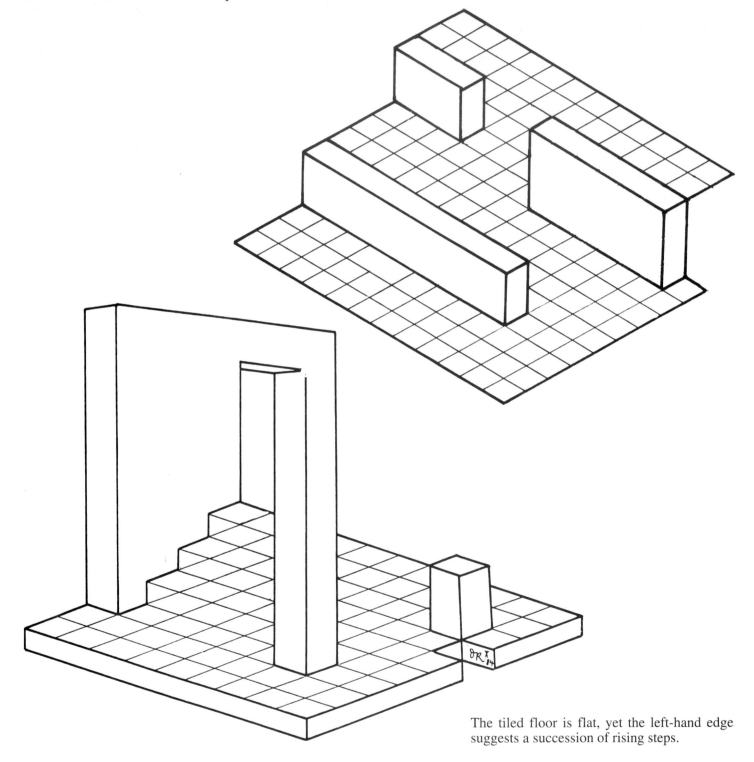

The tiled floor is flat, yet the left-hand edge suggests a succession of rising steps.

While experimenting with photographs of a modified version of a chessboard, I discovered that the most convincing impossible configurations are created with a minimum number of squares. There is a powerful tension in these photographs between flatness and height. Even if we include a mirror in the picture (below left), the illusion remains just as convincing.

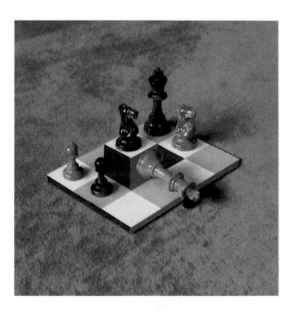

The chess pieces in these photographs appear to stand at two different heights, and yet in reality all the chessboards are flat.

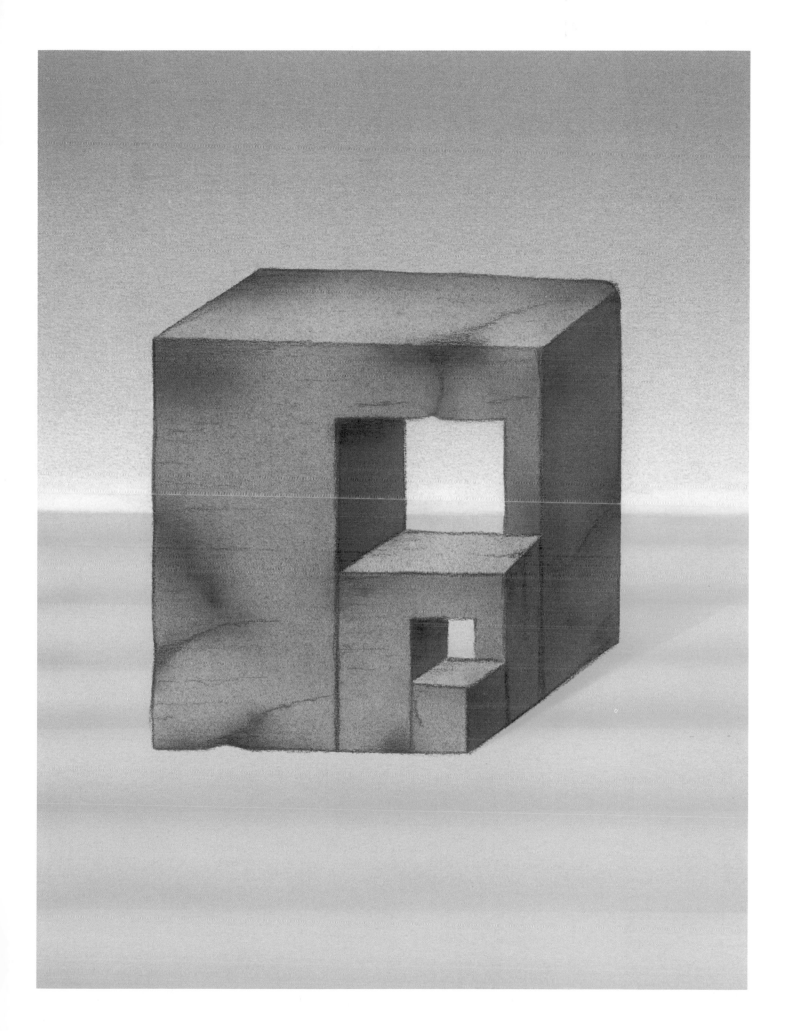

# 7. Planes both far and near

The drawings at the bottom of the page include, above left, a figure which the eye recognizes as an inverted U-shape with one long leg and one short leg. Even if we give this figure more volume (above right), this interpretation remains more or less the same – the figure has simply been sawn out of a thicker plank of wood.

In the bottom two figures, however, the situation has changed. The introduction of a small cube at the foot of the right-hand leg presents the eye with a new and contradictory set of information: the legs are both the same length and stand on the same horizontal plane, whereby the right leg is further away than the left. The front of the figure (identical in all four drawings) thus falls into two planes at once, the right-hand side lying further back than the left. Impossible!

We can now make another impossible object out of the small cube and add an even smaller one, as in the illustration on page 61. We could continue this process for ever – but perhaps three cubes are enough for now!

We can play a similar game with three or more pillars with a cross-beam resting on top. The cross-beam tells us that the pillars are all aligned within the same vertical plane – yet their feet end at different points on the floor. One such set of pillars is illustrated on the opposite page.

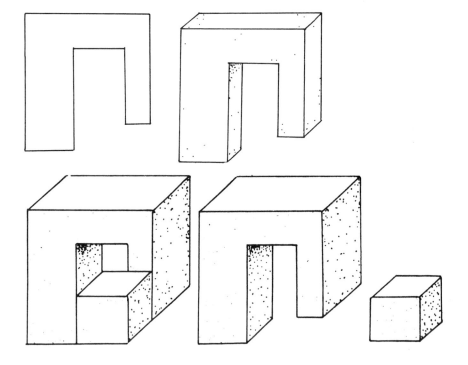

Right:
Inspired by the works of Magritte, the Belgian artist Jos de Mey has produced a large number of highly realistic paintings based on the principle of the dual plane. A similiar device was employed in the previous chapter (p. 58), albeit with two pillars.

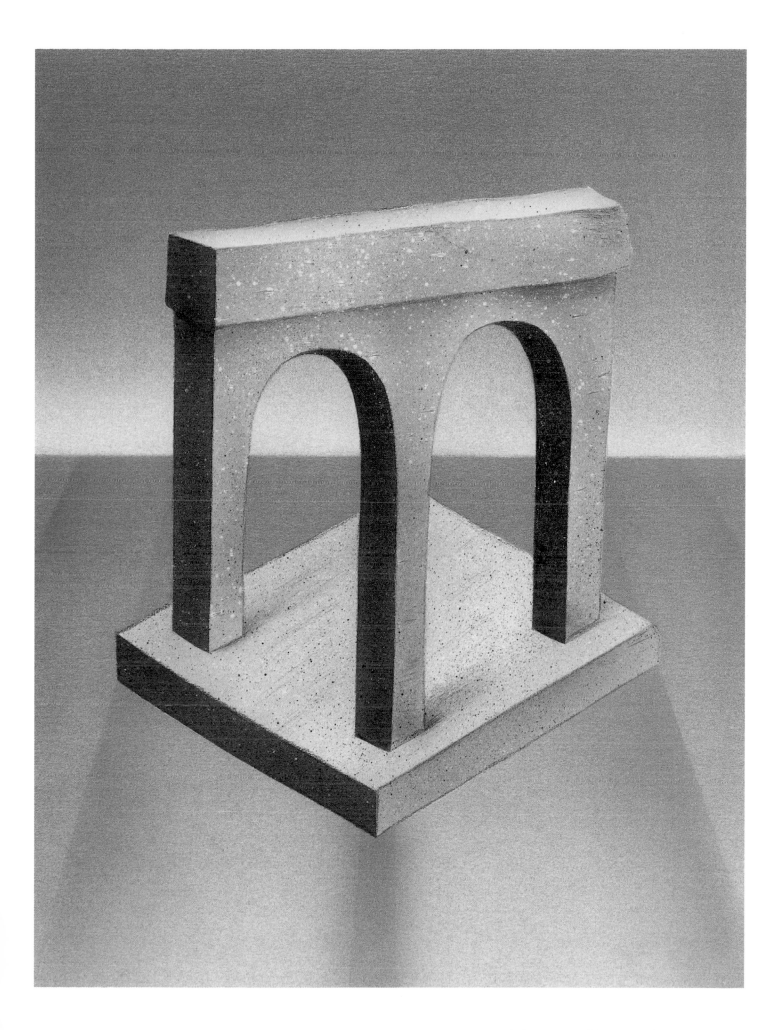

A variation on the 15th-century fresco in the Grote Kerk in Breda, in a perspective drawing by H. Rotgans.

# An example from the 15th century

An arcade of this type is probably the first impossible object to have been deliberately employed by an artist. In 1902 (according to Siebers, the administrator of the church), restoration work in the Grote Kerk in Breda uncovered a 15th-century fresco of the Annunciation. The scene is framed by two arches, the outside pillars being located in the foreground, while the central pillar disappears behind a table in the background!

To counter any objections that this is simply the contentious view of someone determined to see impossible objects wherever they look, let us quote the description of the mural given by the art historian J. Kalf in his book *De monumenten in de voormalige Baronie van Breda* (Utrecht 1912):

"The picture, 2.7 m wide from inside edge to inside edge and 2.5 m tall from the bottom to the highest point of the arches, shows a room divided into two halves by a (perspectivally misplaced) red pillar with a grey capital..."

Kalf was thus immediately struck by the impossible position of the central pillar, but put it down to an error of perspective. The drawing above left is inspired by the Grote Kerk wall-painting and demonstrates the effect of displacing the central pillar of a double arch into the background.

Right:
15th-century fresco in the Grote Kerk in Breda, in which an impossible object has been employed for thoroughly practical reasons: the artist wanted to avoid separating the two foreground figures by an obtrusive central pillar.

Left:
The thick wall with the doorway in it lies at two different distances from us, as does the opening in the ceiling from which the pendulum is hanging.

# Piranesi's *Carceri*

In 1760 a collection of engravings by Giovanni Battista Piranesi was published under the title of *Carceri d'invenzione* (Imaginary Prisons). The collection represented a revised and expanded version of an earlier set of engravings by Piranesi, published in 1745. Numerous authors have tied themselves up in knots trying to interpret these engravings. The interiors they depict are extremely difficult (if not impossible) to analyse, as Piranesi misses no opportunity to sow seeds of spatial confusion. Impossible objects would naturally have offered him an excellent means to this end, but they were not yet as well-known in Piranesi's day as they are now.

In Plate XIV (the left half of which is reproduced here), Piranesi nevertheless arrives unaided at an impossible object of the type we have been discussing in these pages. The drawing above right shows a diagrammatic version of the original engraving. The impossibility arises between points A and B, as the bridge marked C disappears behind the pillar to which it should be running parallel. This is made even clearer in the lower drawing, where A, B and C correspond to the letters in the top diagram.

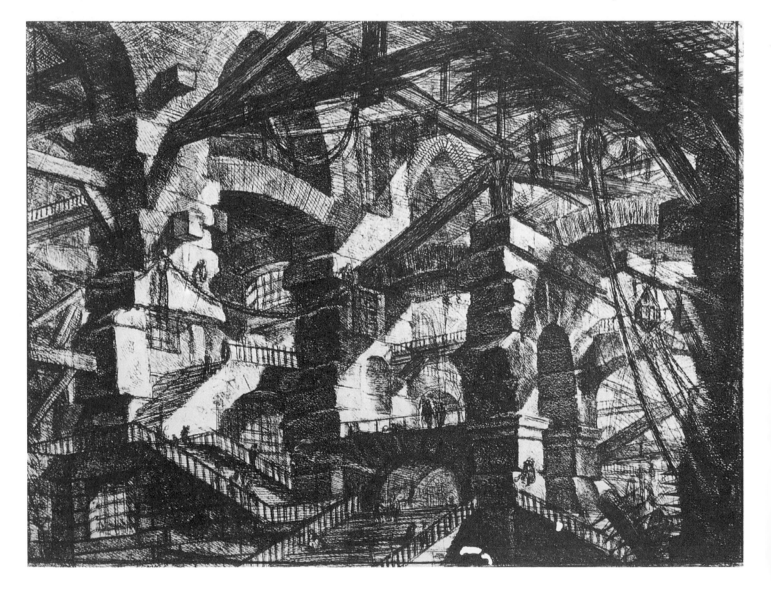

Rudy Kousbroek drew my attention to this composition and described the detail as an impossible four-bar. Although this is not quite true, the impossible object in Piranesi's engraving certainly bears a close similarity to the impossible four-bars encountered in this book.

# 8. Planes both horizontal and vertical

A flat plane cannot be horizontal and vertical at once. It may, of course, be curved – gradually rising from horizontal to vertical, for example. Such planes can be geometrically described as straight lines which gradually change their orientation. This is illustrated in the drawing top left, where AB is horizontal and CD vertical.

Flat planes with a dual orientation, such as the trapezium PQRS, have other characteristics. Looking at the left-hand side of the figure, PQ appears to lie horizontal, but this illusion is destroyed as soon as we move rightwards to RS, which appears to be vertical. There is no gradual transition between the two orientations.

Most people will see PQRS simply as a two dimensional trapezium confined to the pictorial plane. This changes, however, when we incorporate it into the representation of a three-dimensional object. In the drawing on the left, the top and bottom blocks clearly establish what we are to see as horizontal and what as vertical. The orientations of PQ and RS are also determined, and PQRS as a whole assumes a three-dimensional identity. The information it provides is contradictory, however, since PQRS cannot be horizontal and vertical at the same time.

## Temple on a pyramid

Flat planes which are both horizontal and vertical have inspired a rich gallery of impossible objects. A particularly interesting example, which I discovered only recently, is the impossible pyramid (cf. p. 69), in which the number of steps leading to the top of the pyramid seems to multiply in a miraculous way. Thus there are three steps leading up the left-hand side of the pyramid, five rising from the right, and nine just discernible to the rear. This transformation is effected by the presence of six planes with dual orientations, two incorporated within the steps on the left, and four within the steps on the right.

We can create a number of different variations on this impossible pyramid by drawing each step correctly. If we omit all the planes

with both horizontal and vertical orientations, the result is no longer impossible (cf. p. 67 below left and p. 68 below right).

The impossible temple below is drawn in perspective. Most of the illustrations in this book, on the other hand, have been drawn as axonometric projections. This means that their parallel lines are shown as parallel and do not converge towards the distance. Nor are objects further away from us made to appear smaller, as they would in a perspective drawing. As far as the eye is concerned, this seems to make little difference; it would appear that, in most cases, the visual clues provided by scale reduction carry little weight. In some of the interiors illustrated in this book (e.g. pp. 17 above left and 64), two different axonometric projections have been used for the top and bottom halves of the room. While the reason for this was to show the floor and ceiling as they appear from inside, it also gives rise to a strange sense of perspective.

Each stairway leads to the top; whether we take the quick or the laborious way is up to us.

# 9. Vanishing boundaries

The impossible objects we have met so far all arise out of inherent contradictions in their composition and orientation in space. In this chapter, however, we shall meet a new group of impossible objects based on a very different principle.

Is the candlestick on the opposite page one that could really exist? If you take a closer look, you will see that at certain points the arms appear to vanish into thin air. Let us examine this phenomenon in more detail.

## Disappearing blocks

In the drawing above right, block A appears to be normal. Block B, however, only seems to exist at the bottom of the drawing; as we raise our eyes, it vanishes into thin air. The same is true of C, albeit the other way round: it exists at the top but not at the bottom. You will probably recognize block D from Chapter 8 as a plane combining two orientations: the plane facing front at the bottom is facing the side at the top.

Let us concentrate on blocks B and C. What is the secret behind their remarkable vanishing trick? If we look at the line PQ, we can see that it serves a dual function: it forms the boundary of both block A and block B. Our eye cannot accept this; a real object has boundaries which belong to that object alone, and which cannot form part of another object at the same time.

The problem can perhaps be better explained in terms of the way in which the eye processes information. The eye converts outlines directly into information about planes. Thus the eye deduces, for example, that B is a plane because it lies within outlines. But because the eye cannot see a "top" to B, encountering instead the boundary of C, its conclusion that "there is a block B" is contradicted. And so the process continues.

The presence of dual-function outlines sows the same confusion in emphatically two-dimensional images as in representations establishing spatial depth. One of the best-known examples is the drawing of the vase opposite, which can also be read as two faces seen in profile. It is impossible to see the faces *and* the vase simultaneously, which is why this is not an impossible figure. It simply offers two possibilities: it is either a vase or two faces.

Things are not always what they seem.

# Impossible tuning forks and telescopes

The group of impossible objects introduced here build upon the principle of the vanishing boundary. Once again, the impossibility of these objects arises out of a contradiction: the individual components are so intertwined that we are forced to assign an outline first to one object and then (upon shifting our eyes) to another. Things are not always what they seem!

What would an astronomer make of this telescope? (Drawing by Govert Schilling.)

Right:
Negative sound: this tuning fork has only one solid arm. Hence the sound waves are issuing from its shadow in the background.

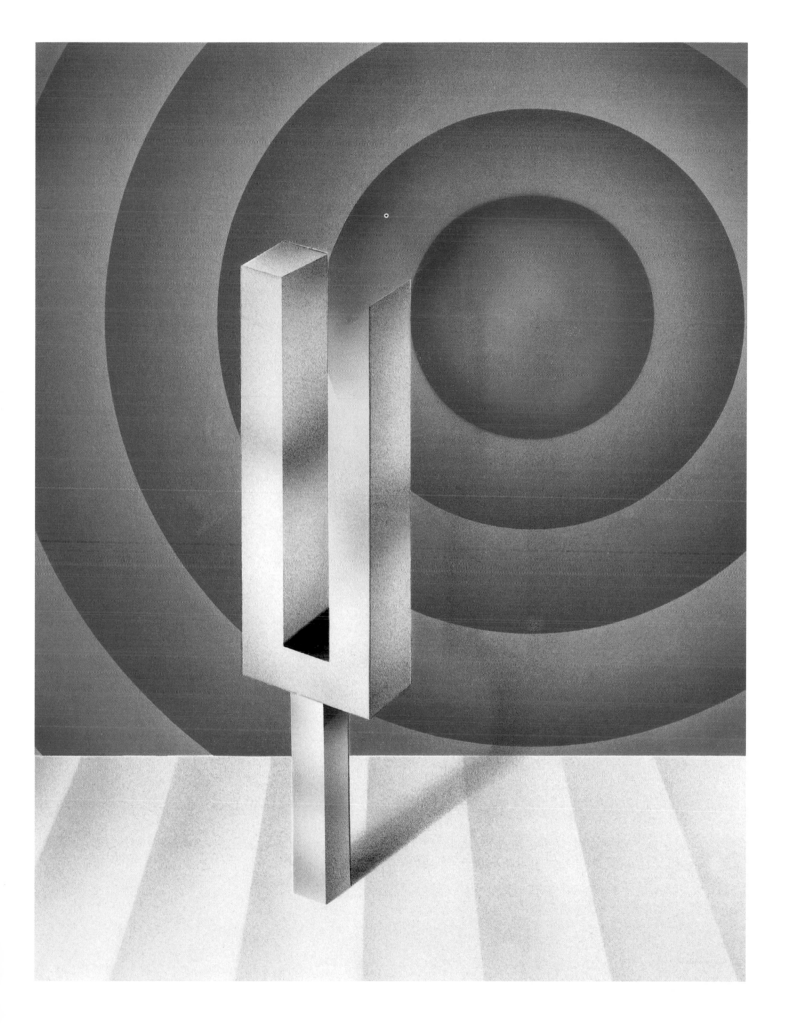

We shall conclude this overview of the various types of impossible object with the classic example below: a "construction drawing" of an impossible part, complete with details of measurements and materials.

# 10. Recognizing impossible objects

Let us imagine that we have drawn an object which absolutely cannot exist in real life. Will the eye always recognize it as impossible? In other words, having established that "it is an object", will the eye then arrive at the second conclusion: "... but the object cannot exist"?

Take the illustration opposite. A truncated pyramid, yes... but an impossible one. Try working out for yourself exactly why it is impossible, without looking at the solution (which can be found on p.79).

In this case, the eye is genuinely fooled. To discover where the impossibility of the pyramid lies, we need to use another part of our brain – our powers of reasoning. Even when we know the answer, however, we cannot persuade the eye to "change its mind": as far as the eye is concerned, the object remains a normal truncated pyramid. And that's final!

Right:
Although it is not immediately obvious, this truncated pyramid is an impossible object. The eye, however, accepts it spontaneously and without subsequent questioning.

# A test for impossibility

There have been several attempts to devise a test that would allow us to determine whether an object is impossible or not, without involving the eye.

How such a test might work is illustrated in the following example. The drawing below consists of a closed loop which has wound itself into a complex pattern. It has thereby divided the pictorial plane into fields lying inside and fields lying outside the loop. The question is now: does A lie inside or outside the loop?

The eye has great difficulty solving this problem. As you will find if you look at the drawing yourself, the maze of lines is simply too complicated for the eye to decipher.

To find the answer we need to back up our eye with our powers of reasoning – we need to think! Let us draw a line from A to a point outside the drawing. Each time this line intersects a line in the drawing, we cross either from the inside to the outside of the loop, or from the outside to the inside. If the number of lines crossed is uneven, it follows that A must lie inside; if the number is even, A is outside.

Our eye is unable to identify whether A lies inside or outside the loop. To find the answer, we must use our powers of reason.

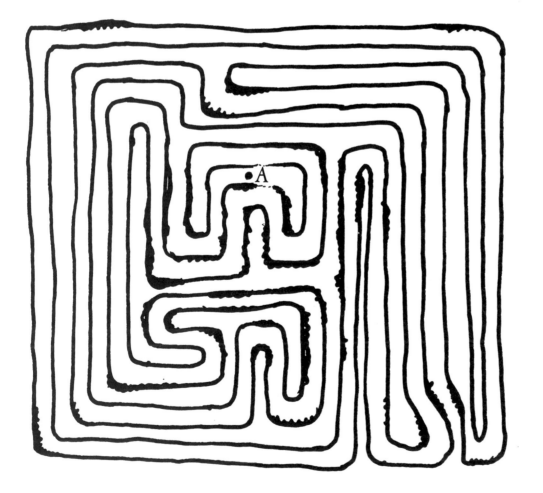

Other methods have also been devised for testing whether an object is impossible, but many of these can only be applied to specific figures like the tri-bar, four-bar and multi-bar.

The method set out below is one which the eye uses in its own decision-making process and which can be applied to many different types of impossible object.

Imagine a flat plane S slicing through an object such as a tri-bar, as illustrated below. Cover the part of the object below this plane with a piece of paper and sketch the cross-section which the top half makes with S. Then cover up the top section and draw the cross-section of the lower half with S.

If the two cross-sections differ in any way, the object is impossible. The eye has clearly managed to build an object out of parts which cannot fit together.

One way of finding out if an object is impossible is to slice it in half horizontally. If the two cross-sections are not identical, it is an impossible object.

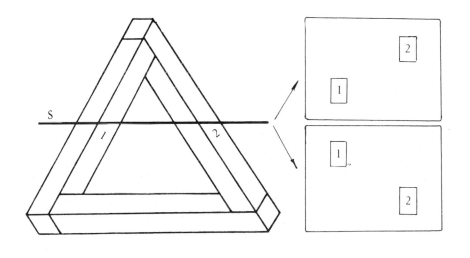

The impossible two-bar devised by Professor X.

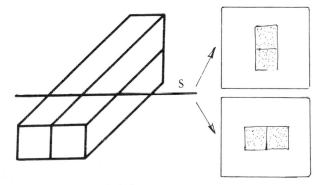

The examples that follow show that this method can be used to test numerous kinds of impossible objects: the impossible two-bar devised by Professor X (p. 77 below), a normal frame, an impossible cuboid and an impossible tuning fork (cf. p. 73).

This method does not work in the case of impossible objects which the eye is unable to recognize, such as the truncated pyramid at the start of this chapter. The eye will continue to be hoodwinked into seeing a real object.

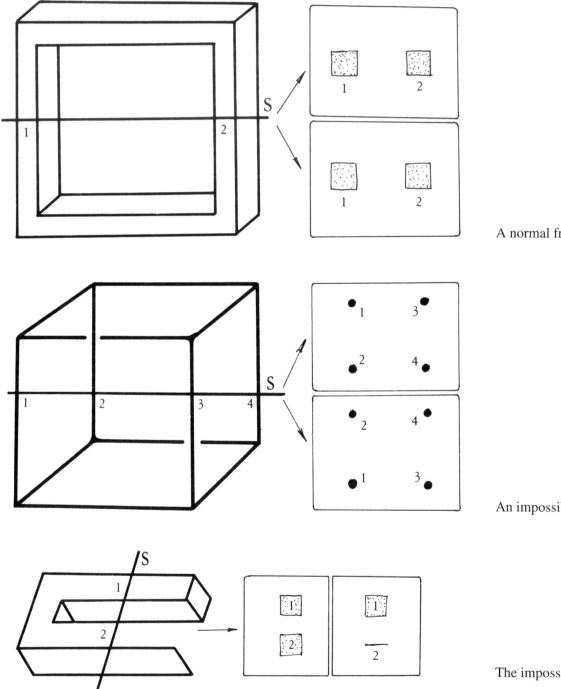

A normal frame.

An impossible cuboid.

The impossible tuning fork.

## A unique phenomenon

With the conscious discovery of the first impossible objects in 1934, an entirely new dimension has been added to our visual world – one which stretches our powers of the imagination to new limits. In this sense, impossible objects may be seen as an enrichment of the human spirit. They represent a special category of objects. They are not mathematical, although mathematical methods can be used to describe and analyse them. They are not works of art; while they may assume harmonious and expressive forms, they are equally effective devoid of artistic qualities. They represent a world in itself – a world which clearly holds a powerful fascination.

Impossible objects also provide us with a potent means of finding out more about the functioning of the eye. The knowledge we thereby gain is of great value in the field of artificial intelligence and the development of robot vision – one of the goals high on the list of computer experts. It is perhaps unsurprising that, of the over one hundred articles which have been published on impossible objects since 1970, most have appeared in specialist computer journals.

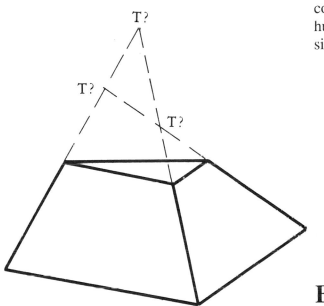

If we complete the sides of the truncated pyramid, we discover that they end at three different apexes. The object is indeed impossible.

# Bibliography

An exhaustive list of all the books and articles that have been written about impossible objects lies outside the scope of this book. We have therefore restricted ourselves to just one particularly informative article, which also contains an extensive bibliography for those who would like to explore the subject in more depth. The books listed all contain large numbers of works of art based on impossible objects.

Zenon Kulpa: "Are impossible figures possible?", in: *Signal processing,* vol. 5, no. 3, 1983, pp. 201–220
Sandro del Prete: *Illusorismen,* Berne, 1984 (3rd ed.)
Franco Grignani: *A methodology of vision,* Milan, 1975
Mitsumasa Anno: *Strange Pictures,* Tokyo, 1968
Toshihiro Katayama: *Visual construction, square movement, topology: homage to the cube,* Tokyo, 1981
Oscar Reutersvärd: *Onmöjliga figurer,* Bodafors, 1982
Oscar Reutersvärd: *Onmöjliga figurer i färg,* Lund, 1985 (this book contains different illustrations to one above)

1 Léander, "Statue of an impossible tri-bar", oil on canvas, 70 x 70 cm, 1984

# BRUNO ERNST

# Optical Illusions

Source of illustrations:

Unless otherwise indicated, the illustrations in this book stem from the archive of the author or the publisher. The following drawings were provided by Artidee, Alkmar: p. 6/ill. 3, 7/5, 10/12, 17/11, 24/8, 25/10–12, 29/18, 31/24–25, 32/27–30, 36/6–7, 37/9, 48/3–4, 49/6, 50/6, 51/10, 55/22–23, 58/32–34, 64/53, 66/57, 73/9–11, 91/2.

Photographic acknowledgements:

Bayerische Staatsbibliothek, Munich, p. 68 left,

K. de Boer, Academische Ziekenhuis, Maastricht, 12/3,

Studio Bokma, Amsterdam, 93/6–8,

Pieter von der Meer, Rotterdam, 49/5, 53/17, 56/25, 35/4,

Jan Minnaard, Utrecht, 38/11,

Rolf ter Veer, Breda, p. 68 right,

A. J. W. M. Thomassen, Nijmegen, 18/12.

Permission was kindly granted by the copyright holders for the reproduction of the following:

11/1 (© Ciba-Geigy Corporation) and 11/2 from: R.G. Kessel and R.H. Kardon, *Cellen, weefsels en organen*, Natuur en Techniek, Maastricht-Brüssel 1983,

12/4, 13/6, 18/12, 19/13–14, 20/15–16 from: D. Marr, *Vision. A Computational Investigation into the Human Representation and Processing of Visual Information*, W. F. Freeman and Company, San Francisco 1982, (12/4, 18/12 and 19/13 © 1986 Department of Electrical Engineering and Computer Science, Massachusetts Institute of Technology, Cambridge, Mass.; 19/14, 20/12–13 © 1986 The Royal Society, London),

13/7 from: *Meaning, Use and Interpretation of Language*, Walter de Gruyter, Berlin/New York 1983,

31/25, 41/15–16 (© 1986 Mitsumasa Anno) from: *The Unique World of Mitsumasa Anno: Selected Illustrations 1968–1977*, Kodansha Ltd., Tokyo 1977.

Originally published as "Het begoochelde oog"

# Contents

2  Sandro del Prete, "The quadrature of the wheel", pencil drawing

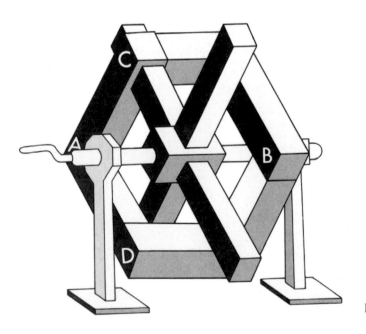

Figure 3

# 1 Introduction: Impossible objects and ambiguous figures

The author of the drawing opposite (fig. 2) has combined considerable mathematical imagination with a generous portion of technical skill to produce a new type of flywheel. Its individual components are detailed in the plans pinned to the wall on the left, while the frontal view of the axle hanging on the right reveals the design of a quadratic wheel. But the viewer remains rightly unconvinced: no such wheel can be built. There is nothing impossible about the six beams composing the outer rim of the wheel, even though they do not lie within the same plane, but the four spokes simply cannot be attached as shown. The inventor of this particular wheel challenges us to find even one join within the entire composition which is demonstrably false. But as we soon discover, all are correct. And yet . . . the object illustrated here in such precise detail cannot exist in space: it is an impossible object! Only by separating the joins at certain points do we arrive at an object which can indeed be built – Figure 3 shows one of the possibilities. The result, however, is something entirely different to what the inventor originally intended: a bizarre three-dimensional construction whose possibility has left it useless . . .

Sandro del Prete has incorporated two impossible tri-bars into this "impossible wheel". The tri-bar is the simplest and at the same time the most fascinating of all the impossible objects we know (fig. 4). It looks very "real", and yet it cannot exist. It is a most peculiar no-thing.

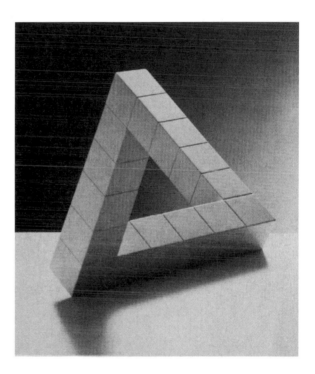

Yet its impossibility is not as absolute as that of a square circle, for example, which can neither be imagined nor drawn. The impossible objects with which we are concerned can, strangely enough, be easily visualized, wherein lies their attraction. They open up a new world and thereby illuminate something of the incredibly complex process that we call

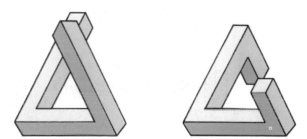

4 Oscar Reutersvärd, Impossible tri-bar

Figure 5

vision. Is an impossible tri-bar *really* impossible? Figure 5 shows how, by separating the arms of such a tri-bar at certain points, we arrive at an object that can be built; it is immediately obvious that we have thereby transformed it into something entirely different.

Sandro del Prete's *Three Candles* (fig. 6) represent a very different category of impossible object to that of the impossible tri-bar. Are there three candles, or just two? If we lower our eyes from the middle flame, we find the candle on which it is burning fades mysteriously into nothing. At the same time, if we raise our eyes from what appears to be the square base of the right-hand candle, we find that its left-hand side vanishes into the background, so that only the right side remains.

A characteristic feature of such impossible objects is that they can only be rendered in black and white; they cannot be coloured in.

Three further drawings by Oscar Reutersvärd are also reproduced on this page (figs. 7-9). There is something positively irritating about such images, in which the figure which initially appears so solid slips away beneath our very eyes. Matter seems to vanish into void.

Ambiguous figures form a different category again. In contrast to impossible objects, which do not exist and which represent nothing, ambiguous figures may suggest more than one three-dimensional reality at once. Thus we can interpret the figure at the centre of Monika Buch's painting (fig. 10) as both a cube projecting outwards and a concave cubic space. It would be perfectly possible to design and build two different three-dimensional models of the picture, one illustrating each interpretation. As we shall see in Chapter 3, every image projected onto the retina of the eye is essentially ambiguous, whether we are looking at a picture or at real objects around us. Fortunately, this rarely causes us problems in everyday life, since our consciousness accepts only those of the many pieces of information provided by the image on the retina which correspond with reality. We only speak of ambiguous figures where two (and sometimes even more) interpreta-

6 Sandro del Prete, "Three candles", pencil drawing

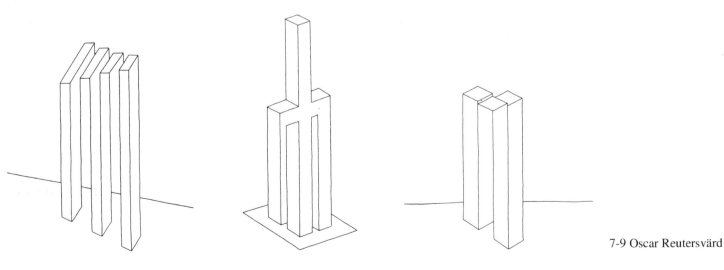

7-9 Oscar Reutersvärd

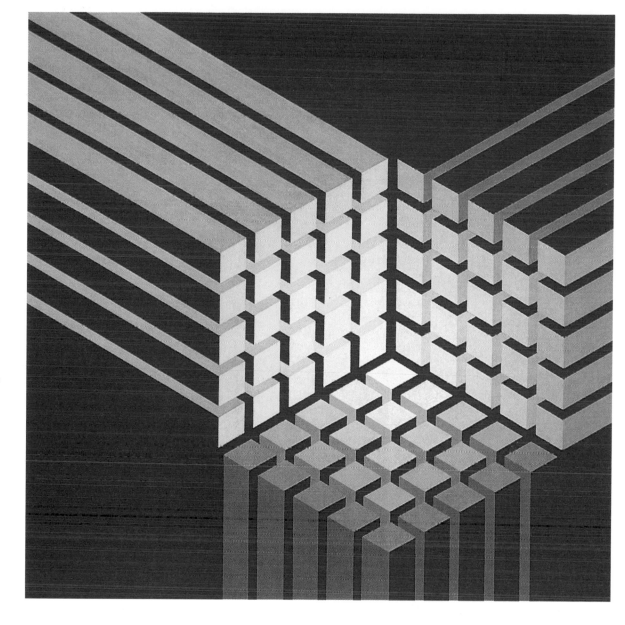

10 Monika Buch, "Illusory cube", acrylic on fibreboard, 60 x 60 cm, 1983. Three large bars, themselves each composed of twenty-five small bars, form a "concave cube". After a few seconds, this suddenly inverts into a convex cube. Before the EYE switches back to the first, concave interpretation, we are able to see how the thinner bars are transformed into transparent streaks, like shafts of coloured light, illuminating the cube from three sides.

tions of one and the same figure are plausible.

The first scientists to make a study of impossible objects and ambiguous figures listed both categories under the heading of "optical illusions". This is somewhat misleading, however, since in this way the unique character of such objects is overlooked. Optical illusions are things which we see but which either do not exist in reality or whose real nature is different. We regularly encounter optical illusions in our daily lives without recognizing them as such, simply because we are constantly making allowances for them. For example, although the moon may appear to follow us as we walk down the street at night, we know full well that it is actually standing still. Similarly, the moon appears much bigger when low on the horizon than it does when high in the sky, but we do not therefore think the moon expands and contracts every night. When I look out of my window down onto the houses below, they appear no larger than the jar on my windowsill, yet I give the phenomenon no second thought. Optical illusions are for the most part an integral aspect of our perceptual expectations.

Certain forms of optical illusion nevertheless possess an unusual character; some are even named after their "inventor" or discoverer. In a painting by Prof. A.J.W.M. Thomassen (fig. 11), we see, amongst other things, the Sander parallelogram (1926; fig. 12). If this particular optical illusion is new to you, take a ruler and measure for yourself the difference between the long AB line and the short BC line! The Fraser illusion (1908; fig. 13) demonstrates the large extent to

11 A.J.W.M. Thomassen, "Anachronistic psychological laboratory", 1975

which the direction of lines is determined by additional factors: although the letters of the word LIFE appear to lie crooked, they in fact stand vertical and parallel. Judging the size of a circle is equally dependent upon the objects surrounding it (Lipps, 1897; fig. 14): the centre circles in the two patterns are both the same size.

12 The Sander illusion

Such optical illusions have been the subject of research for over one hundred and fifty years, and they have much to teach us about the functioning of our sense of sight. The ambiguity of figures was discussed by Necker as early as 1832, although impossible objects only began to attract attention from 1958 on, through the work of Penrose and his son, whose impossible tri-bar also features in Thomassen's painting.

13 The Fraser illusion

In this book we shall be showing, amongst other things, that ambiguous figures and impossible objects are important not simply for the peculiar light which they throw upon the phenomenon of vision, but because their discovery by artists has opened up previously unexplored fields in the history of art.

Figure 14

# 2 Vision as data-processing

Impossible objects and ambiguous figures are not things that can be handled in the literal sense: they arise in our brain. Since the perception process in the case of these figures follows a strange, non-routine pattern, the viewer becomes aware that something is happening inside his head. For a better understanding of the process that we call "vision", it is useful to have an idea of the manner in which our sense of sight (our eyes and our brain) processes light stimuli into meaningful information.

Suspensory ligament of lens

Sinus venosus sclerae (canal of Schlemm)

Lens

Iris

Cornea

Anterior chamber

Posterior chamber

Ciliary body and ciliary muscle

Anterior chamber angle

Conjunctiva

Ciliary part of retina

Ora serrata

Tendon of lateral rectus muscle

Tendon of medial rectus muscle

Visual part of retina

Vitreous body

Choroid

Hyaloid canal

Suprachoroidal space

Sclera

Lamina scribosa of sclera

Bulbar fascia (Tenon's capsule)

Optic nerve

Fovea centralis

Central artery and vein of retina

External sheath of optic nerve

Subarachnoid space

1 Anatomy of the eyeball

# The eye as optical instrument

Rods and cones —

MLE

Outer plexiform layer —

—

Inner plexiform layer —

Ganglion cell layer —

Optic nerve fibres

HC

AC

CM

LB

2 Cross-section of the retina

The eye (p. 11, fig. 1) works like a camera. The lens projects a reversed, reduced image of the outside world onto the retina – a network of photosensitive cells, lying opposite the pupil, which occupies more than half the interior of the eyeball. As an optical instrument, it has long been recognized as a small miracle. Whereas a camera is focused by moving the lens either closer to or away from the photosensitive layer, in the eye it is the refractive power of the lens itself which is adjusted during accommodation (adaptation

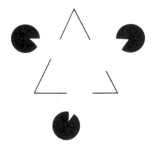

to a specific distance). The shape of the eye lens is modified by means of the ciliary muscle: when the muscle contracts, the lens becomes rounder, whereby a focused image of nearby objects is cast onto the retina. The aperture of the human eye, too, can be adjusted just as in a camera. The pupil serves as the lens opening, which is widened or narrowed by the radial muscles which give the iris encircling the pupil its characteristic colour. As our eyes shift to the field we wish to focus upon, focal distance and pupil size are adjusted instantaneously and "fully automatically".

The structure of the retina (fig. 2), the photosensitive layer inside the eye, is complex. The optic nerve (together with the blood vessels) leads off from the back wall of the eye; there are no photosensitive cells at this point, which is known as the blind spot. The nerve fibres ramify and end in a succession of three different types of cell, which face away from the incoming light. Extensions leading from the third and innermost cell layer contain molecules which temporarily alter their structure as the light received is being processed, and which thereby emit an electrical impulse. The cells are called rods and cones after the shape of their extensions. The cones are colour-sensitive, whereas the rods are not; their photosensitivity, on the other hand, is far greater than that of the cones. One eye contains approximately one hundred million rods and six million cones, distributed unevenly across the retina. Exactly opposite the pupil lies the so-called yellow spot (fig. 3), which contains only cones in a particularly dense concentration. When we wish to see something in focus, we arrange for the image to fall on this yellow spot. There are many interconnections between the cells of the retina, and the electrical impulses from the one hundred million or so photosensitive cells are sent to the brain by just a million separate nerve fibres. The eye can thus be somewhat superficially described as a camera or television camera loaded with photosensitive film.

3 Eye with yellow spot

4 Kanizsa figure

# From impulse to information

5 Illustration from Descartes' "Le traité de l'homme", 1664

But how do we actually see? Until recently, the question was barely addressed. The best anyone could do for an answer was merely the following: within the brain there is an area which specializes in vision; it is here that the retinal image is composed, albeit in brain cells. The more light that falls on a retinal cell, the more intense is the activity of its corresponding brain cell, so that the activity of the brain cells in our visual centre corresponds to the distribution of light upon the retina. In short, the process starts with an image on our retina and ends up with a matching picture on a small "screen" made up of brain cells. But this naturally still does not explain vision; it simply shifts the problem to a deeper level. For who is supposed to view this inner image? The situation is aptly illustrated in Figure 5, taken from Descartes' *Le traité de l'homme*. Here, all the nerve fibres end in the pituitary gland, which Descartes saw as the seat of the soul, and it is this which views the inner image. But the question still remains: how does this "viewing" actually proceed?

Figure 6

The notion of a mini-viewer inside the brain is not merely insufficient to explain vision, but ignores three activities which are manifestly performed by the visual system itself. Looking at a figure by Kanizsa (fig. 4), for example, we see a triangle with three circle segments at its corners. This triangle is not present on the retina, however; it is an invention of the visual system! It is almost impossible to look at Figure 6 without seeing a continuous succession of different circular patterns, all jostling for dominance; it is as if

7 Brush drawing from the "Mustard Seed Garden Manual of Painting", 1679-1701

we were directly experiencing inner visual activity. Many people find their visual system thrown into utter confusion by the Dallenbach figure (next page, fig. 8), as they seek to interpret its black and white patches in a meaningful way. (To spare you this torment, Figure 10 (p. 16) offers an interpretation which your visual system will accept once and for all.) By contrast, you will have no trouble in reconstructing the few strokes of ink of Figure 7 into two people in conversation.

An entirely different method of seeing is illustrated by the investigations carried out by Werner Reichardt from Tübingen, for example, who spent fourteen years studying the visual flight-control system of the housefly, for which he was awarded the Heineken Prize in 1985. Like many other insects, the fly has compound eyes composed

of many hundreds of individual rodlets and each forming its own photosensitive element. The flight-control system of the fly appears to be based on five independent sub-systems, or subroutines, which work rapidly (reacting approximately ten times faster than in humans) and efficiently. Its landing system, for example, operates as follows. When the fly's field of vision "explodes" (because a surface looms nearby), the fly banks towards its centre with a view to landing. If this centre lies above it, the fly automatically inverts to land upside down. As soon as its legs touch the surface, its "engine" is cut off. Once flying in a given direction, the fly extracts only two items of information from its field of vision: the point at which a moving patch of a specific size (which must match the size of a fly at a distance of 10 centimetres) is located within the visual field, and the direction and speed of this patch as it travels across the visual field. Processing of this data prompts automatic corrections to the flight path. It is extremely unlikely that the fly has a clear picture of the world around it. It sees neither surfaces nor objects; visual input is processed in such a way that the appropriate signals are transmitted directly to its motor system. Thus visual input is translated not into

an image of an image, but into a form which allows the fly to react to its environment in an adequate manner. The same can also be said of an infinitely more complex system, such as the human being.

There are a number of reasons why scientists have long been kept from addressing the fundamental question of how man sees. There seemed to be so many other visual phenomena to explain first: the complex structure of the retina, colour vision, contrast phenomena, afterimages, etc. Contrary to expectations, however, findings in these areas still failed to shed light on the primary problem. Even more significant was the lack of any new overall concept or framework within which visual phenomena could be ordered. The relative narrowness of the conventional field of enquiry can be deduced from an excellent manual on visual perception compiled by T.N. Cornsweet, based on his lectures for first- and second-term students. The author notes in his preface: "I seek to champion (in this book) what I hold to be the fundamental themes underlying the vast field which we loosely describe as visual perception." Examining the contents of his book, however, these "fundamental themes" turn out to be the effect of light on the cones and rods of the reti-

8 Dallenbach figure

na, colour vision, the way in which sensory cells can increase or reduce the extent of their mutual influence, the frequency of the electrical signals transmitted via the sensory cells and facial nerves, and so on. Research in this field is today following entirely new paths, as evidenced by the confusing diversity in the specialist press. Only the expert can form a picture of the "new science of vision" currently emerging. There has been just one attempt to integrate some of its new ideas and findings into traditional thinking on visual perception in a manner accessible to the layman. Yet even here the questions "What is vision?" and "How do we see?" are not made the central focus of discussion.

# From image to data-processing

It was David Marr, from the Artificial Intelligence Laboratory at the Massachusetts Institute of Technology, who made the first, admirable attempt to approach the subject from an entirely new angle in his book *Vision,* published posthumously. At a time which barely seemed ripe for such a discussion, he sought to address the core problem and propose possible solutions. Marr's findings are certainly not definitive and are today open to challenge on many points, but his book nevertheless has the advantages of logic and consistency. At all events, Marr's approach offers us a very useful background against which to plot the positions of impossible objects and ambiguous figures. We shall therefore attempt, in the following pages, to trace a broad outline of Marr's thought.

Marr described the shortcomings of conventional perception theory as follows:

"Trying to understand perception by studying only neurons is like trying to understand bird flight by studying only feathers: It just cannot be done. In order to understand bird flight, we have to understand aerodynamics; only then do the structure of feathers and the different shapes of birds' wings make sense."

In this context, Marr names J.J. Gibson as one of the first to concern himself with meaningful questions of this kind in the field of vision. Gibson's important contribution, according to Marr, was to note "that the important thing about the senses is that they are channels for perception of the real world outside (. . .) He therefore asked the critically important question, How does one obtain constant perceptions in everyday life on the basis of continually changing sensations? This is exactly the right question, showing that Gibson correctly regarded the problem of perception as that of recovering from sensory information 'valid' properties of the external world." And thus we reach the field of information processing.

It is not a question of Marr wishing to ignore other possible explanations of the phenomenon of vision. On the contrary, he expressly emphasizes that vision cannot be explained satisfactorily from one angle alone. Explanations have to be found for everyday experiences which agree with the findings of experimental psychology and the totality of the discoveries made by physiologists and neurologists concerning the anatomy of the nervous system. As regards information processing, the computer scientist would like to know just how such a visual system can be programmed and what the best algorithms are for the job. In short, he asks how vision can be programmed. Only a comprehensive theory can be accepted as a satisfactory explanation of the vision process.

9 The response of two different brain cells to optical stimuli with different directions on the retina.

Marr worked on the problem from 1973 to 1980. Unfortunately, he was unable to finish his work, but he laid the foundation stone for further research into those areas which he was no longer in a position to explore for himself.

# From neurology to the vision machine

The conviction that many human functions were controlled by the cerebral cortex was shared by neurologists from the early nineteenth century onwards. Opinions differed as to whether the individual functions were governed by a clearly-defined part of the cerebral cortex, or whether the brain in its entirety was involved in every function.

A now famous experiment by the French neurologist Pierre Paul Broca led to the general recognition of the specific-location theory. Broca was treating a patient who had been unable to speak for ten years, despite lacking none of his vocal chords. When the man died in 1861, an autopsy revealed that a part of the left side of his brain was deformed. For Broca, it was thus clear that speech was governed by this particular section of the cerebral cortex. His theory was confirmed by subsequent examinations of people suffering brain lesions, and it was eventually possible to map out the centres of the various vital functions on the human brain.

A century later, in the 1950s, D.H. Hubel and T.N. Wiesel began experimenting with the brains of living apes and cats. In the visual centre in the cerebral cortex they discovered nerve cells which are particularly sensitive to horizontal, vertical and diagonal lines in the visual field (p. 15, fig. 9). Their sophisticated microsurgical techniques were subsequently adopted by other scientists.

The cerebral cortex thus houses not only the centres of various functions, but within such a centre, e.g. the visual centre, certain nerve cells which are only activated by the arrival of very specific signals. These are signals issuing from the retina which correlate to well-defined situations in the outside world. It was now assumed that information about various shapes and spatial arrangements lay openly accessible within the visual memory and that the information from the activated nerve cells was compared to this stored information.

This detector theory influenced the direction of research into visual perception in around 1960 – the same direction as that being pursued by scientists concerned with "artificial intelligence". The computerized simulation of the processes of human sight by a so-called "vision machine" was considered one easily attainable goal of such research. But things proved otherwise: it soon became clear that it was virtually impossible to write programmes which were capable of recognizing changing light intensities, shadow effects and surface structure, and of sorting the confusion of complex objects into meaningful patterns. Furthermore, such object recognition processes demanded an unlimited memory capacity, since images of infinite numbers of objects needed to be stored in countless different variations and lighting situations.

No further advances in the field of the visual recognition of a real environment appeared possible. Doubt began to arise whether computer hardware could ever hope to simulate the brain: when compared to the human cerebral cortex, in which each nerve cell has an average of 10,000 connections linking it to other nerve cells, the equivalent computer ratio of just 1:1 seems barely adequate!

10 Solution to the Dallenbach figure (p. 14)

# Elizabeth Warrington's lecture

In 1973 Marr attended a lecture given by the British neurologist Elizabeth Warrington. She discussed how a large number of the patients she had examined with parietal lesions on the right side of their brain were perfectly able to recognize and describe a variety of objects, on condition that the objects were seen in their conventional form. Such patients could identify without difficulty a bucket seen side-on, for example, but were unable to recognize the same bucket seen end-on. Indeed, even when told they were looking down at a bucket from above, they vehemently refused to believe it! Even more surprising was the behaviour of those patients suffering lesions on the left side of the brain. Such patients often had no language and were therefore unable to name the object they saw or state its purpose. They were nevertheless able to convey that they correctly perceived its geometry, irrespective of the angle from which they were seeing it. This prompted Marr to observe: "Warrington's talk suggested two things. First, the representation of the shape of an object is stored in a different place and is therefore a quite different kind of thing from the representation of its use and purpose. And second, vision alone can deliver an internal description of the shape of a viewed object, even when the object was not recognized in the conventional sense of understanding its use and purpose . . . Elizabeth Warrington had put her finger on what was somehow the quintessential fact of human vision – that it tells about shape and space and spatial arrangement."

If this is indeed so, those scientists active in the field of visual perception and artificial intelligence (in as far as they are working on vision machines) will have to exchange the detector theory of Hubel's experiments for an entirely new set of tactics.

# The module theory

A second of Marr's starting-points (and here, too, he looks back in part to Warrington's work) is his conviction that our sense of sight has a modular structure. In computer language, this means that our master programme "Vision" embraces a range of subroutines each of which is entirely independent of the rest and can also operate entirely independently of the rest. A clear example of one such subroutine or module is stereopsis, whereby depth is perceived as a result of each eye being offered a slightly different image. It was formerly generally held that, in order to be able to see in three dimensions, we first recognize viewed images as such and only subsequently decide whether the objects are near or far away. In 1960 Bela Julesz, who was also awarded the Heineken Prize in 1985, was able to demonstrate that spatial perception with two eyes derives solely from the processing of small differences between the two retinal images. It is thus possible to perceive depth even where absolutely no objects are present or even suggested. For his experiments, Julesz devised stereograms

11 Random-dot stereogram by Bela Julesz, and the floating square

made up of randomly-distributed dots (cf. fig. 11). The image seen by the right eye is identical to that seen by the left in all but a central square region, which has been cut out, shifted a little to one side and stuck down again onto the background. The white gap left behind was then filled with a random pattern of dots. If the two images (in which no "representation" can be recognized) are viewed through a stereoscope, the square that was cut out appears to float in front of the

background. Such stereograms contain spatial data which are processed automatically by the visual system. Stereopsis is thus an autonomous module contained within our vision. This module theory proved highly fruitful.

# From the two-dimensional retinal image to the three-dimensional model

Vision is a multi-stage process which transforms two-dimensional representations of the outside world (retinal images) into useful information for the viewer. It starts from a two-dimensional retinal image, which – ignoring colour vision for the time being – records only degrees of light intensity. As the first stage, involving just one module, these

one but several different modules. Marr coins the rather unwieldy notion of "$2\frac{1}{2}$-dimensional" in order to emphasize that we are dealing with spatial information from the angle of the viewer: a $2\frac{1}{2}$-D sketch is thus a representation which still suffers from perspective distortions and which cannot yet be directly compared to actual spatial arrange-

12 During the visual process, the retinal image (left) is translated into a primal sketch in which intensity changes become apparent (right).

degrees of intensity are translated into intensity changes – in other words, into contours, which indicate sudden alterations in light intensity. Marr states precisely which algorithm is thereby involved (expressed mathematically, incidentally, the transformation is a fairly complex one), and how the perception and nerve cells are able to perform this algorithm. The result of this first stage is what Marr calls a "primal sketch", which offers a summary of intensity changes, their mutual relationship, and their distribution across the visual field (fig. 12). This is a significant step, since in the visible world intensity changes frequently correspond to the natural contours of objects. The second stage leads to what Marr calls a "$2\frac{1}{2}$-D sketch". The $2\frac{1}{2}$-D sketch maps the orientation and depth of visible surfaces around the viewer, thereby drawing upon information from not

ments. The drawing of a $2\frac{1}{2}$-D sketch shown here (fig. 13) simply illustrates for our purposes some of the different pieces of information processed in such a sketch; no image of this kind is actually produced inside our brain, however.

So far the visual system has been operating, via a number of modules, autonomously, automatically and independently of data on the outside world stored in the brain. During the final stage of the process, however, it is possible that reference is made to existing information. This last stage delivers a 3-D model: a stable description independent of the angle of the viewer and directly suitable for comparison with the visual information stored in the brain.

According to Marr, the component axes of a shape play a major role in the constitution of the 3-D model. Those to whom this notion is

13 Drawing of a 2½-D sketch – "a viewer-centred representation of the depth and orientation of visible surfaces" (Marr).

visual images stored in the brain only becomes active in the process of the recognition of an object.

It is here that a large gap still yawns in our knowledge. How are these visual images stored? How does the recognition process unfold? How does the comparison between existing images and the 3-D image currently being composed actually proceed? This last point is touched upon by Marr (cf. fig. 16), but a great deal of scientific ground will have to be covered before any more clarity or certainty is gained.

Although we ourselves are unconscious of the various phases in which visual information is processed, a number of clearly-demonstrable parallels exist between these phases and the different ways in which, over the course of history, we have rendered our impressions of space on a two-dimensional surface.

Thus the Pointillists emphasize the contourless retinal image, while line drawings correspond to the stage of the primal sketch. A Cubist painting might be compared to the processing of visual data in preparation for the final 3-D model, although this was undoubtedly not the intention of the original artist.

unfamiliar may find it a little far-fetched, but there is indeed some evidence which seems to support it. First, many objects from our environment (in particular animals and plants) can be portrayed quite effectively in simple pipe-cleaner models. The fact that we are still able to recognize them lies in our identification of the reproduction of their natural axes (fig. 14).

Secondly, this theory offers a plausible explanation for the fact that we are able to visually dismantle an object into its various parts. This faculty is reflected in our language, which gives different names to each part. Thus, in describing the human body, designations such as "body", "arm" and "finger" indicate a differentiation according to component axes (cf. fig. 15).

The theory thirdly accords with our ability to generalize and at the same time differentiate between shapes. We generalize by grouping together objects with the same main axes, whereas we differentiate by analyzing their subsidiary axes, such as the boughs of a tree. Marr gives the algorithms with which the 3-D model is calculated from the 2½-D model; this, too, is a largely autonomous process. Marr himself notes that these algorithms only work where clear axes are present. In the case of a crumpled piece of paper, for example, possible axes may be hard to identify, and will offer an algorithm almost no point of application.

The link between the 3-D model and the

14 Simple animal models can be identified from their component axes.

# Man and computer

In his comprehensive approach to the subject, Marr sought to show how we can understand the process of vision without having to call upon knowledge which is already available in the brain.

He thereby opened up a new avenue for researchers of visual perception. His ideas can be used to steer a more efficient course towards the realization of a vision machine.

When Marr was writing his book, he must have been aware of the effort which his readers would be required to exert if they were to follow his new ideas and their implications. This can be sensed throughout the

work and surfaces most forcibly in the last chapter, "In Defense of the Approach". It is a polemic "justification" lasting a good 25 pages in which he seizes one last opportunity to argue his cause. In this chapter he holds a conversation with an imaginary sceptic, who attacks Marr with arguments such as the following:

"I'm still unhappy about this tying-together process and the idea that from all that wealth of detail all you have left is a description. It sounds too cerebral somehow . . . As we move closer to saying the brain is a computer, I must say I do get more and more fearful about the meaning of human values."

Marr offers an intriguing reply: "Well, to say the brain is a computer is correct but misleading. It's really a highly specialized information-processing device – or rather, a whole lot of them. Viewing our brains as information-processing devices is not demeaning and does not negate human values. If anything, it tends to support them and may in the end help us to understand what from an information-processing view human values actually are, why they have selective value, and how they are knitted into the capacity for social mores and organization with which our genes have endowed us."

15 The model axis (left) breaks down into component axes (right).

16 New shape descriptions are related to stored shapes in a comparison which moves from the general (above) to the particular (below).

# 3 Ambiguous figures

The exterior world conveys itself to the human individual largely via the sense of sight, which comprises the eyes, the optic nerves, and the visual centre in the brain. For the sake of brevity, in the following chapters we shall refer to the sense of sight simply as the EYE. (Where eye appears in the usual, lower case, only the optical instrument is intended.)

As discussed in the preceding chapter, the vision process begins with a picture of the environment projected onto the retina via the lens. The information on the retina is highly complex. For our purposes, two categories may be distinguished: image information, based on *pictographic* elements which reproduce the objects present, and spatial information, composed of *stereographic* elements which reproduce the spatial relationships between these objects.

These two types of element generally appear together, as a simple example will illustrate. In the drawing of two fishermen on the banks of a canal (fig. 1), the *pictographic* elements show us two human figures and a ditch or trench. The *stereographic* elements tell us the following: one figure is bigger than the other and partially obscures it; the figures are part dark, part light; two shadows fall behind the dark parts; the borders of the canal converge.

The EYE processes both the pictographic and the stereographic elements into one meaningful interpretation. In our normal environment this usually poses no difficulties, and the entire process takes place within a fraction of a second. But occasionally there is a hiccup and the process comes to a stand-

still; only then do we become conscious of the functioning of our EYE.

Perhaps you have also experienced an incident similar to one that occurred to me. Lying in bed one day, looking at the objects on my bedside table, I noticed something which struck me as completely foreign: a small frame with a metallic gleam on its left side only. I knew for a fact that I possessed no such frame, so one couldn't be standing there. I didn't move, but continued to look at it patiently, hoping to penetrate the mystery. Suddenly I recognized my lighter on the left, standing upright, and on the right a glass, partially obscured by a postcard. This made a lot more sense, and I subsequently found it quite hard to recreate in my mind's eye my original impression of a frame.

Figure 1

There are other instances when the EYE offers us two (and in some cases even more) equally valid interpretations of a particular object configuration. It should be noted, however, that such interpretations derive not from our own mental reflection upon what we are seeing, but directly from the EYE itself. We become aware of an ambiguity because we see first one interpretation, then another, and then, a few seconds later, the first again, and so on. We are dealing here with a process which we ourselves can neither control nor stop, since it takes place automatically. In such cases we speak of ambiguous retinal images and – where these are triggered by a pictorial figure – of ambiguous figures. Their ambiguity can be *pictographic* or *stereographic* in nature. Although this book is primarily concerned with stereographic (spatial) ambiguities, I would not wish to deprive the reader of some of the particularly entertaining ambiguities which can arise in the pictographic field. For this reason, and to help clarify the distinction between the two fields, I have included a number of examples below.

## Pictographic ambiguity

Almost everyone will have come across the phenomenon of pictographic ambiguity, especially in the form of "Freudian" pictures. A particularly good example is *My wife and my mother-in-law* (fig. 2), published in 1915 by the cartoonist W.E. Hill, which offers a finely-balanced choice of interpretations by omitting all extraneous details. See whom you recognize first – it can be a hard task even for psychologists! A few years later, Jack Botwinick produced a pendant picture, *My husband and my father-in-law* (fig. 3). Many such images have been invented over the years; the Eskimo-Indian (fig. 4) and Duck-Rabbit (fig. 5) are particularly well-known.

There are also ambiguous figures whose interpretation depends upon the angle from which they are seen. An extreme example in this case is the comic strip series by Gustave Verbeek which appeared in the *New York Herald* from 1903 to 1905.

Each instalment must first be read and viewed normally, and then the whole thing turned upside down. Figure 6 shows Little Lady Lovekins being picked up by Rock, the giant bird; viewed upside down, the picture shows a large fish upsetting old man Muffaroo's canoe with its tail. Famous, too, are the "double images" in which the significance and function of object and background continuously alternate. In a first glance at Sandro del Prete's *The window opposite* (fig. 7), you will probably see no more than a vase of flowers, a wine glass, and a pair of stockings hanging out to dry.

2 W.E. Hill, "My wife and my mother-in-law"

## Stereographic ambiguity

The images on our retina are two-dimensional. An important function of the EYE is to reconstruct three-dimensional reality from these two-dimensional images.

When we look through two eyes, the two images which fall upon our retina contain slight differences; an independent EYE programme uses these differences to calculate – with a high degree of accuracy up to a distance of fifty metres – the spatial relationships between objects and ourselves, which suggests to us a direct impression of space. But even the retinal image of one eye alone contains sufficient data with which to produce a reliable picture of three-dimensional reality. The reduction of three-dimensionality to two-dimensionality involves a fundamental ambiguity, however, as can be illustrated in a simple example. The line AB in Fig. 8a (p. 24) can be interpreted by the EYE in a number of ways. It can be seen, e.g., as a line of ink on the page of this book, or as a straight line in space, whereby we cannot tell whether A or B is nearer. As soon as we provide the EYE with a little more information, e.g. by incorporating the straight line AB into

the drawing of a cube, the positions of A and B in space are established. In Fig. 8b, A appears nearer than B, and B lower than A; in Fig. 8c these relationships are reversed. In Fig. 8d the same straight line AB runs horizontally from the foreground way back to the horizon!

A cube in which the twelve edges alone are drawn as lines (p. 24, fig. 9) is called a Necker cube after L.A. Necker, the German professor of mineralogy, the first person to study stereographic ambiguity from the scientific perspective.

3 Jack Botwinick, "My husband and my father-in-law"

4 Eskimo-Indian

5 Duck-Rabbit

6 Gustave Verbeek, cartoon from his *Upsidedown* series

7 Sandro del Prete, "The window opposite", pencil drawing

## The Necker cube

On 24 May 1832 Professor Necker wrote a letter to Sir David Brewster, whom he had recently visited in London. The second half of the letter was devoted to what has since become famous as the Necker cube. The letter is important not just because it was the first time that a man of science had described the phenomenon of optical inversion, but also because it captures something of the astonishment of its author. It also sheds light on a typical feature of scientific practice of the

times, whereby it was not yet common to work with a number of different test participants, nor to employ specially-built apparatus. Rather, the researcher made his own observations and attempted, often with very basic means, to see beyond appearances, in the hope of arriving at a conclusion within the framework of his own knowledge.

"In the case of the object to which I would like to draw your attention, we are dealing with a perceptual phenomenon in the field of

optics, a phenomenon which I have observed many times when studying pictures of crystalline shapes. I am referring here to a sudden and involuntary change in the apparent position of a crystal or other three-dimensional body reproduced on a two-dimensional surface. What I mean can be more simply explained with the help of the attached illustrations. The rhombus AX is drawn in such a way that A is nearest to the viewer and X furthest away. ACBD thus represents the frontal plane, with XDC a lateral plane behind it. If you study this figure for a while, however, you will observe that the apparent position of the rhombus sometimes changes, whereby X appears to be nearest and A furthest away and plane ACBD moves behind plane XDC, giving the whole body an entirely different orientation.

For a long time I remained uncertain as to the explanation of this random and involuntary change, which I regularly encountered in various forms in books on crystallography. The only thing I was able to detect was an unusual sensation in the eye at the moment of change. To me this indicated an optical effect, and not just (as I had first thought) a mental one. Later, after thorough analysis, it seemed to me that the phenomenon was linked to the focal setting of the eye. When the point of focus on the retina (i.e. the yellow spot) is directed at A, for example, this corner is seen in sharper focus than the others. This naturally implies its being nearer and at the front, while other corners seen less clearly give the impression of lying further back.

The 'switch' occurred when the point of focus was shifted to X. Once I had discovered this solution, I was able to find three separate proofs of its correctness. First, I was able to see the object in the orientation of my choice, an orientation which I could change at will simply by shifting my focus between points A and X.

Secondly, when I concentrated on A and saw the rhombus in the correct position with A in the foreground, and then, without moving my eyes or the figure, slowly moved a concave lens between my eye and the figure from the bottom of the figure to the top, the switch took place as soon as the figure be-

8a    8b    8c    8d    Figure 8

came visible through the lens. It thereby assumed the orientation in which X appeared furthest to the front. And that solely because X had replaced A at the point of focus, without any spatial adjustment of the latter.

Finally, when I looked at the figure through a hole, punched in a card with a needle, in such a way that either A or X could not be seen, the orientation of the body was determined by the corner that was visible, whereby this corner was always the nearest. It is then impossible to see it in any other way, and thus no switch takes place.

What I have said of the corners is also true of the sides: the planes to which the line of sight or the yellow spot of the retina are directed are always seen as lying in the foreground. It is thus clear to me that this small and at first sight so puzzling phenomenon is based on the law of focus.

You will no doubt be able to draw many conclusions from the observations described here which I, in my ignorance, am unable to predict. You may use these observations according to your own discretion."

Many who have made the same experiment since Necker have come to the conclusion that this switching occurs spontaneously and independently of the point of focus. Nevertheless, Necker's original assumption – that the phenomenon occurs in conjunction with the processing of the retinal image in the brain – was correct. In the Necker cube, the

9 A Necker parallelepiped

Figure 10

Figure 11

Figure 12

EYE cannot determine whether one point (or plane) is closer or further away than another. Figure 10 shows the Necker cube, with its solid ABCD-A'B'C'D' lines, between two others illustrating its two possible interpretations. When we look at the Necker cube, we see first the figure in the centre, then the one on the right, followed shortly afterwards by the one on the left – and so on. This switching from "A-is-nearer-than-A'" to "A-is-further-away-than-A'" we call perceptual inversion: the cube in the centre is thus the inverse representation of the cube on the right, and vice versa.

However, this alternation in the relative distances of ABCD and A'B'C'D' to the viewer is not what strikes us most forcibly. Most conspicuous of all is the fact that both cubes have quite different orientations, just as Necker emphasized in his letter. Thus AD and A'D' appear to intersect, although in the drawing they in fact lie parallel. We might describe the phenomenon of perceptual inversion more precisely as follows: all lines have the same orientation in the retinal image, but as soon as the interpretation switches to the inverse figure, all lines (in space) appear to change their orientation.

Such changes of orientation can prove highly surprising, as we shall see. Perceptual inversion in the upper pair of dice in Figure 11 has been encouraged by the choice of angle at which the dice are shown. The drawings were based on two photographs of the same configuration of dice, but taken from different angles. The left-hand die was placed against a wall, and squares of the same size as its sides were marked out on the wall and ground. The lower drawing makes the completely different orientations of the dice more than clear.

The angle at which a cube is shown also determines the angle through which its sides will project after inversion. In the left-hand pair of dice in Figure 12, this angle is only small; in the right-hand pair (corresponding to the upper drawing in Figure 11), it reaches a maximum.

## Concave and convex

Although the Necker cube suggests two different geometric forms, the terms "concave" and "convex" can be applied to neither; we can always see both the inside and the outside of the cube at once. The situation changes when we omit from our drawing three planes

13 Monika Buch, "Intersecting bars", acrylic on fibreboard, 60 x 60 cm, 1983. The impression of intersecting bars is reinforced here by the fact that the bars appear grouped at a slight angle to each other within the pictorial plane. The tautness of the composition is emphasized by the regular arrangement of the twenty-four small rhombic planes forming the ends of the bars.

which meet at or near the centre of the cube, as in dice reproduced above. We now obtain a figure which again suggests two inverse spatial bodies, but of a different nature: one convex, in which we see only the *outside* of the cube, and one concave, whereby we perceive only three of the planes *inside* the cube. Most people recognize the convex form immediately, but have difficulty seeing the concave form unless suitable subsidiary lines are added.

In his lithograph *Concave and convex* (fig. 14), Maurits Escher demonstrated how the viewer can be forced, by specific geometrical means, to interpret the left half of a picture as convex and the right half as concave; the transition between the two halves is thereby particularly interesting. At first sight, the building appears symmetrical: the left half is more or less the mirror image of the right, and the transition in the middle is not abrupt, but gradual and natural. And yet, as we cross the centre, we find ourselves plunging into something even worse than a bottomless abyss: everything is quite literally turned inside out. Upper side becomes underside, front becomes back. Alone in resisting this inversion are the human figures, lizards and flowerpots; these we continue to identify with palpable realities which are unknown to us in "inside-out" form. Yet they, too, must pay the toll for crossing over onto the other side: they must inhabit a world in which their topsy-turvy relationship to their surroundings is enough to make the viewer dizzy. Take the man climbing the ladder in the bottom left-hand corner: he is about to reach a landing in front of a small temple. He may

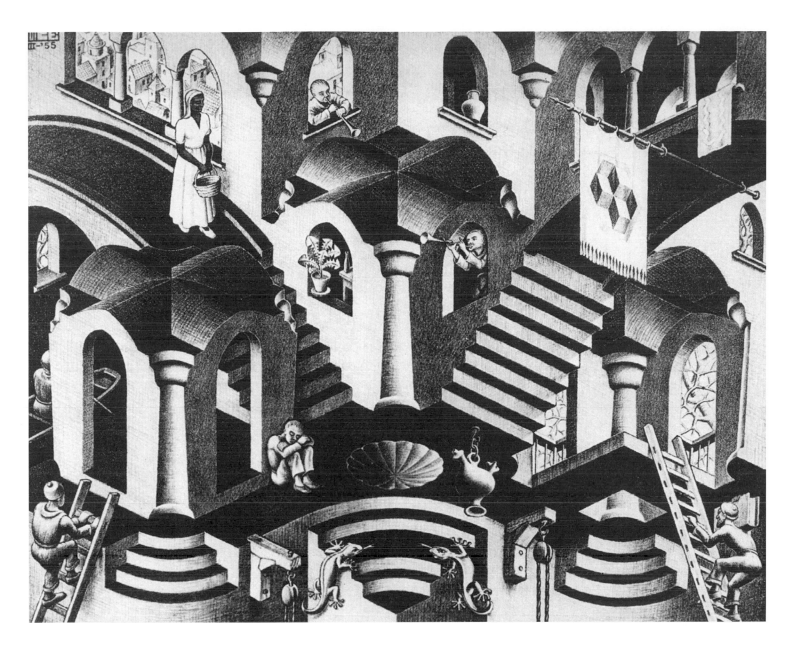

14 M.C. Escher, "Concave and convex", lithograph, 27.5 x 33.5 cm, 1955. "Can you imagine, I spent more than a whole month brooding over this picture constantly, because my initial drafts were all far too difficult to make head or tail of." (M.C. Escher)

wonder why the scalloped basin in the centre is empty. Then he might try to mount the steps on the right. And now the dilemma is upon him: what he took to be a flight of stairs is in fact the underside of an arch. He will suddenly find that the landing, once solid ground beneath his feet, has become a ceiling, to which he is strangely glued in defiance of all the laws of gravity. The woman with the basket will find the same happening to her if she descends the stairs and crosses the centre. If she stays on the left hand side of the picture, however, she will be safe.

Most visually discomforting of all, perhaps, are the two trumpet-players located one on each side of the vertical centre line. The upper, left-hand player is looking out of a window over the groin-vaulted roof of a small temple. From his position he could feasibly climb out (or in?), drop onto the roof and jump down onto the landing. Any music played by the trumpeter lower down on the right, on the other hand, will float up to a vault above his head. This player had better dismiss any thoughts of climbing out of his window, for below him is nothing but a void. In his half of the picture, the "landing" has been inverted and lies out of sight beneath him. The emblem on the banner in the top right-hand corner of the picture neatly summarizes the content of the composition.

In allowing our eye to travel slowly from the left of the picture to the right, it is also possible to see the right-hand vault as a flight of steps – in which case the banner appears totally implausible . . . But let me leave you to explore for yourself the many other confounding dimensions of this intriguing print!

# Common inversion illusions

15 Photograph of the moon (left) and the same photograph printed upside down (right).

We frequently experience geometric ambiguity in our retinal images even where this is not intended by the original picture viewed. Studying a photograph of the moon, for example, we find after a while that the craters transform themselves into raised hillocks, despite the fact that we know them to be craters. In nature, whether an image is interpreted as "concave" or "convex" is strongly influenced by the fall of the light. Where the light comes from the left, the left-hand crater wall will have a bright exterior and a dark interior.

If we study a photograph of the moon, we assume a certain angle of light in order to recognize its craters as such. If, next to this first moon photograph, we then place the same photograph turned upside down (fig. 15), the light conditions assumed in the first will be applied to our reading of the second, whereby it is very difficult to resist an "inverted" interpretation: almost all the crater depressions in the first photograph are now read as hilly elevations in the second.

The same phenomenon can sometimes be observed simply by turning a drawing or a normal photograph upside down. This is illustrated here in the examples of a postcard of a Belgian village (fig. 16) and a detail from a picture by Escher (fig. 17), both printed upside down here.

Even utterly normal everyday objects can suddenly assume an ambiguous dimension, particularly when we see them in silhouette or almost in silhouette.

16 Postcard of a Belgian village, printed upside down.

17 Detail from M.C. Escher's "Town in southern Italy", 1929, printed upside down.

## Mach's illusory movements

A phenomenon can be observed when looking at a three-dimensional reality which does not occur in the case of two-dimensional reproductions. This can be demonstrated by means of a simple and entertaining experiment. Take a rectangular piece of paper measuring approximately 7 x 4 cm and fold it in half lengthways. Then open it out again into a V-shape (fig. 18), and stand it upright with the fold pointing away from you. Now look at it with just *one* eye. After a few seconds, the vertical paper inverts into the form

Figure 18

20 Photograph of the small sheet-metal staircase given to M.C. Escher by Prof. Schouten. This model was the inspiration behind Escher's lithograph "Concave and convex". In drawing form it has long been known as Schröder's steps.

19 Paolo Barreto's Holocube

of a long, horizontal roof. If you now turn your head to the left, to the right, up, and down, you will observe the "roof" appearing to pivot against the background. Two things are striking: first, this pivoting movement occurs contrary to our expectations; secondly, the inverse form remains stable as long as the movement continues. (The experiment can naturally also be made with the paper placed horizontally with the fold pointing upwards; the inverse form is then vertical.)

We can devise many models to demonstrate this illusory movement. Paolo Barreto thought up a simple but highly effective inversion model in his *Holocube* (fig. 19), a composition of three concave cubes. The figure's inverse (convex) form is, however, much more stable than its actual concave geometric form; viewed at some distance, therefore, it appears as three convex cubes which, if we turn our head, seem to float strangely in space. This phenomenon, first described by Ernst Mach, also occurs spontaneously in concave images. We see such images as convex because the concave form strikes us as improbable (figs. 20 and 21). When we move, the inverse image follows us. This is particularly surprising when the image in question is the cast of another face!

21 Two photographs of a concave picture by Sandro del Prete. The EYE nevertheless prefers a convex interpretation.

22 Monika Buch,
"Thiéry's figure II",
acrylic on fibreboard,
60 x 60 cm, 1983. The
vertical strips composing
the picture are extended
to fill the entire surface.

# Pseudoscopy

In connection with his picture *Concave and convex,* Escher confided to me that although he was able to see many objects inverted with one eye, he had never managed to do so with a cat. During this same period I introduced him to the phenomenon of pseudoscopy, in which this kind of "inside-out" vision is forced upon the EYE. We can make our program for three-dimensional vision run the wrong way round by offering the left eye an image destined for the right eye, and vice versa. The same effect can be achieved, somewhat more simply, with the use of two prisms showing both eyes a mirror image. Escher was most enthusiastic about these prisms; for a long time he carried them about

with him everywhere, in order to view three-dimensional objects of all kinds in their pseudoscopic form. As he wrote to me: "Your prisms are basically a simple means of experiencing the same sort of inversion that I was trying to achieve in my picture *Concave and convex.* The small, white, sheet-metal staircase given to me by the mathematician Professor Schouten, and which gave rise to the picture *Concave and convex,* inverts as soon as you look at it through the prisms. I have mounted them between two pieces of cardboard, held together with elastic bands. They make a handy pair of 'binoculars'. I took them on a walk with me and entertained myself e.g. by looking at some leaves which

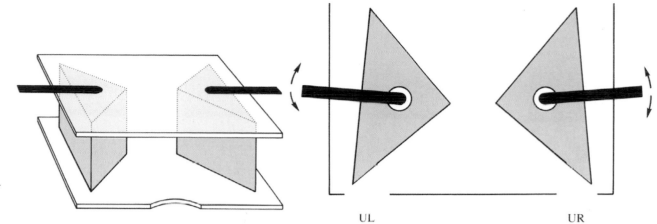

23 and 24 Perspective drawing and top view of a prism pseudoscope

UL                    UR

had fallen into a pond, and which I could suddenly turn on their heads: a 'water level' with water on top and air below, without a drop falling 'down'! The normal interchange of left and right is interesting, too. If you watch your feet moving, and try to extend your right one, it is the left foot which appears to move."

With a little care and patience, you can use Figures 23 and 24 to build your own pseudoscope, allowing you to experience illusory movements on a larger scale.

# Thiéry's figure

25 Invertible illustration by
Mitsumasa Anno. Several houses share a common roof and represent a variant of Thiéry's figure.

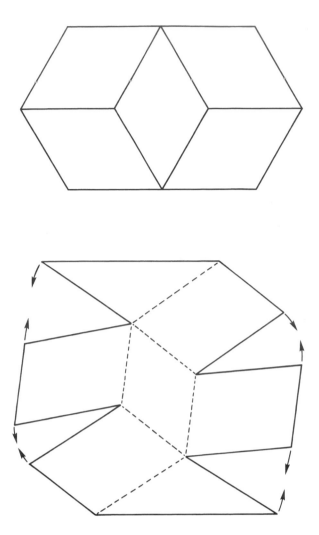

In 1895 Armand Thiéry published a detailed article on his investigations into a specific area of optical illusions. It is here that we find the first mention of the figure that now bears his name, and which has since been employed in countless variations by the artists of Op Art. The most famous such variant consists of five rhombuses with angles of 60 and 120 degrees (fig. 26). This appears to most people as a highly ambiguous figure, in which two cubes continuously and alternately assert either their concave or convex form. Thiéry was careful to conduct all his experiments under the same conditions and employed several test participants "in order to make the observations more reliable". He still fell short of the methods of modern statistics, however, since he failed to specify the arithmetical mean of his observation results, and furthermore chose his test participants for their specialist knowledge in related fields, such as experimental psychology, applied drawing, aesthetics etc. – precisely what a modern-day researcher would avoid! Thiéry writes: "All perspective drawings re-

flect a specific position adopted by the eye of the artist and the viewer. Depending on the extent to which we clarify this position, different drawings can be variously interpreted. Figure (27) is an illustration of a prism seen from below, Figure (28) a prism seen from above. But these drawings become ambiguous when the two figures are combined so that the two prisms share a common face (fig. 29). When read from right to left, the figure represents a folding screen seen from above."

Strangely, Thiéry does not mention the second interpretation, but emphasizes that the figure bears similarities to Schröder's steps (a drawing of the same steps which Prof. Schouten gave to Escher), and observes: "Here too, therefore, there exist two possible interpretations." He goes on to conclude that we may see the figure both as the prism of Figure 27 and as the prism of Figure 28, each with an extension.

It is a less well-known fact that the symmetrical Thiéry figure (fig. 26) can also be perceived as an entirely unambiguous figure. Professor J.B. Deregowski once brought me a wooden block having precisely such a form. For those who have seen such an object, Thiéry's figure ceases to be ambiguous. If you trace the figure's "construction plan" (fig. 30) onto another piece of paper, cut it out and make it up, you will see immediately how it works. Viewing your paper model from above, you will see the Thiéry figure; it will then be difficult for you ever again to see it as ambiguous. The EYE prefers simple solutions!

When presented with geometrically ambiguous figures, the EYE spontaneously and alternately offers us two spatial solutions. Something is either concave or convex; we are either looking up at the underside or down onto the top of a surface . . . The obvious question here is whether it is possible to confront the EYE with a situation in which this alternate "either/or" becomes a simultaneous "both/and". This would produce an impossible object, since two interpretations cannot both be correct at the same time. In Chapter 4 we shall be meeting figures in which this extraordinary situation indeed arises.

26 Thiéry's figure

30 "Construction plan" of Thiéry's figure

Figures 27, 28, 29

# 4 Impossible objects

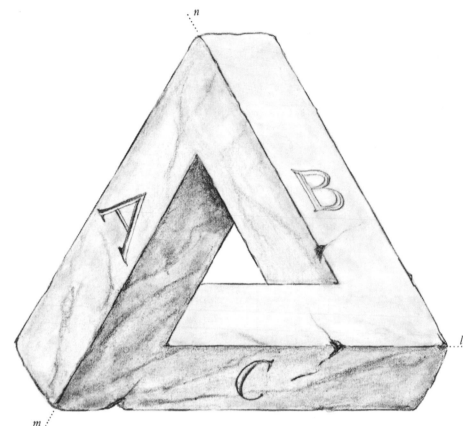

Figure 1

This is an impossible tri-bar. It is not the illustration of a spatial object, for such an object cannot exist. Yet our EYE accepts both this fact and the object without further ado. We may subsequently come up with a variety of logical arguments – how C, for example, lies in a horizontal plane, while A moves towards us and B away from us, and how, if A and B are constantly moving away from each other, they cannot possibly meet at the top as they apparently do. We might point out that the tri-bar forms a closed triangle, all three sides are perpendicular to each other, and the sum of their internal angles thus totals 270 degrees – which is impossible. As a third line of attack, we might enlist the aid of a principle of stereometry, namely that three non-parallel planes always meet at a single point. In Figure 1, however, we see that:

– dark-grey plane C meets white plane B; the line of intersection is *l*;

– dark-grey plane C meets light-grey plane A; the line of intersection is *m*;

– white plane B meets light-grey plane A; the line of intersection is *n*;

– lines of intersection *l*, *m* and *n* intersect at three different points.

The figure in question thus demonstrably fails to satisfy the stereometric stipulation that three non-parallel planes (here A, B and C) should meet at a single point.

To recap: however simple or complex our subsequent reasoning, the EYE signals such internal contradictions without the slightest explanation.

The impossible tri-bar is paradoxical in several respects. The eye takes no more than a split second to transmit the message: "This is a closed object composed of three bars." This is followed a moment later by: "This object cannot in fact exist . . . " The third message might read: " . . . and so the first impression was incorrect." In theory the figure should dissolve into a set of lines bearing no meaningful relationship to each other and no longer organized into the shape of a tri-bar. But this does not happen; instead, the EYE signals afresh: "It is an object, a tri-bar." In short, the conclusion is that it is an object *and* it is not an object – and herein lies the first paradox. *Both* interpretations are argued with equal conviction, as if the EYE were leaving the final verdict to some higher authority.

A second paradoxical feature of the impossible tri-bar emerges from the reasoning surrounding its construction. If bar A moves towards us and bar B moves away from us, yet they still meet, the corner that they form must lie in two places at once, one near the viewer and one further away. (The same naturally applies to the other two corners, since the object remains identical in shape even if we turn it so that a different corner is pointing upwards.)

2  Bruno Ernst, photograph of an impossible tri-bar, 1985

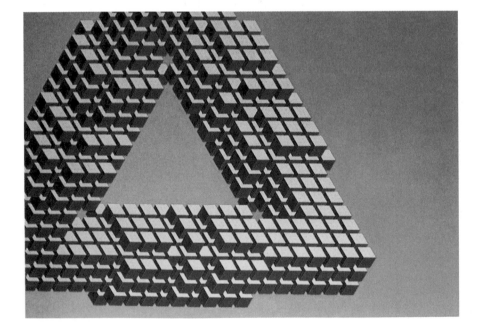

3  Gerard Traarbach,
"Perfect timing", oil on
canvas, 100 x 140 cm,
1985, printed in reverse

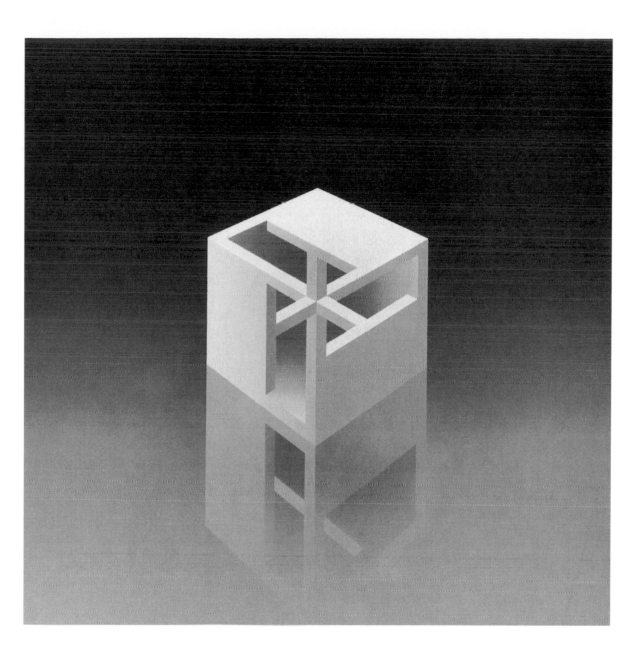

4 Dirk Huizer, "Cube",
irisated screenprint,
48 x 48 cm, 1984

# The reality of impossible objects

One of the most perplexing questions asked of impossible objects concerns their reality: do they exist or not? The drawing of the tri-bar naturally exists; of that there can be no doubt. At the same time, however, there can also be no doubt that the three-dimensional form presented to us by the EYE does not exist as such in the outside world. For this reason we have chosen to speak of impossible *objects* rather than impossible *figures* (as they have more commonly become known in the English language). This would seem a satisfactory means of resolving the dilemma. And yet when we examine, for example, the impossible tri-bar

more closely, its spatial reality continues to force itself upon us.

Confronted by the individual parts in disassembled form (fig. 6), it is almost impossible not to believe that simply bolting together the bars and cubes will produce the desired tri-bar.

Figure 3 will have a special appeal for crystallographers. The object appears to be slowly growing; the cubes slot themselves into the existing crystalline grid, and there is no irregularity.

The photograph (fig. 2) is real, although the tri-bar – an arrangement of cigar boxes photographed from a certain angle – is not. It

is a visual joke which I devised for Roger Penrose, co-author of the first article on the impossible tri-bar (cf. p. 72).

Figure 5 shows a tri-bar made up of numbered blocks measuring 1 x 1 x 1 dm. Simply by counting the blocks, we can work out that the figure has a volume of 12 dm$^3$ and a surface area of 48 dm$^2$.

In a similar way, we can calculate the distance travelled by e.g. a ladybird walking its way round the tri-bar (fig. 7). The mid-point of each bar is numbered and the direction of travel is indicated by arrows. The surface of the tri-bar thereby appears to consist of a long, uninterrupted track; the ladybird must complete four circuits before arriving back at its starting-point.

You might be starting to suspect the impossible tri-bar of harbouring some "secret" on its invisible side. But a transparent view of the impossible tri-bar can be drawn without difficulty (fig. 8). Here, all four neighbouring side planes are visible. The object thereby loses none of its reality.

Let us pose the question once more: what reality does the impossible tri-bar, which can be interpreted and manipulated in so many ways, ultimately have? We should remember that the EYE processes the retinal image of an impossible object just as it would the retinal image of a chair or a house. The result is a "spatial image". In this stage there is no difference between an impossible tri-bar and an ordinary chair. The impossible tri-bar thus exists in the depths of our brain, and indeed at exactly the same level as all the other objects we see surrounding us. The EYE's refusal to affirm its three-dimensional viability in the outside world in no way lessens the fact of the presence of the impossible tri-bar inside our head.

In Chapter 1 we met a type of impossible object whose substance appeared to vanish into nothing. In his pencil drawing of a *Passenger train* (p. 38, fig. 11), Fons de Vogelaere subtly works this same type into the reinforced corner pillar at the left of the picture. If we follow the pillar down from top to bottom or cover the lower section of the picture up to the tracks, we see a pillar supported by four buttresses (of which only two are visible). Seen from below, however, the same pillar

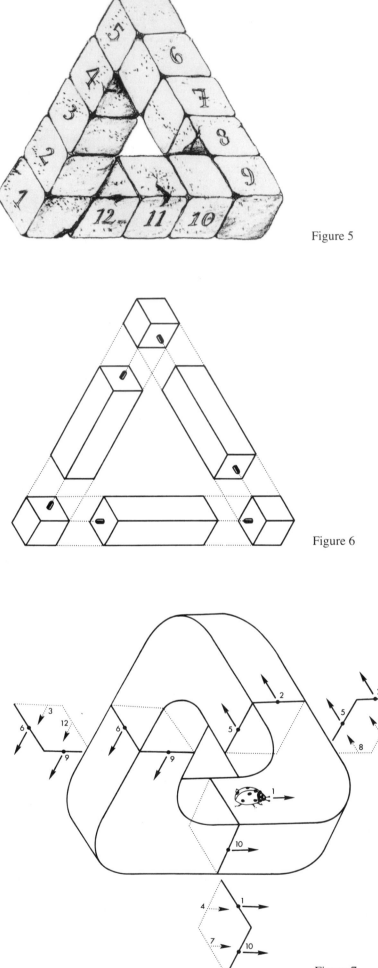

Figure 5

Figure 6

Figure 7

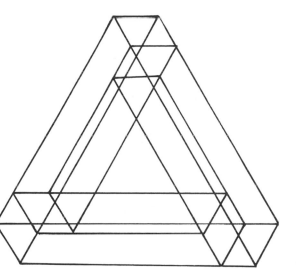

Figure 8

reveals a relatively wide gap through which the train can pass. Solid blocks of stone are thus simultaneously . . . thin air!

This type of object is easy enough to categorize, but proves particularly complex when we come to analyze it. Researchers such as Broydrick Thro have shown that the very description of the phenomenon leads to contradictions. The conflict is one of boundaries. The EYE first calculates contours (outlines) and, from these, shapes which are bounded. Confusion arises when, as in Figure 11, these contours serve a dual purpose.

The same situation arises in Figure 9 (itself an impossible object). In this figure, contour line *l* manifests itself both as the boundary

of volume A and as the boundary of volume B. It is not the boundary of both simultaneously, however. If our eyes fall first upon the upper half of the figure, *l* is perceived as the boundary of A and remains so until A opens out and is no longer a volume. At this point the EYE offers a second interpretation of *l*, namely that it is the boundary of B. If we follow the line back up to its start, our new conclusion will in turn be replaced by the first.

If this were its only ambiguity, we might be tempted to speak of a pictographically ambiguous figure. But it is in fact complicated by additional factors, such as the phenomenon of the figure vanishing into the background, and in particular the spatial notion of the figure formed by the EYE. In this connection you might like to take another look at Figures 7, 8 and 9 in Chapter 1.

Since these types of figure always manifest themselves as strongly spatial entities, we can provisionally number them as impossible objects and describe them – albeit not explain them – in the following general terms: the EYE calculates from these objects two different three-dimensional forms which are mutually exclusive and yet simultaneously present. Thus, for example, something can be seen in Figure 11 which seems to represent a solid pillar. At second glance, however, it appears as an opening, a spacious gap through which, as shown in the picture, a train can pass.

# The impossible object as paradox

At the beginning of this chapter we met the impossible object as a three-dimensional paradox, i.e. as an image whose stereographic elements contradict each other. Before examining this paradox in greater depth, we should consider whether there is such a thing as a pictographic paradox. And indeed there is: think of mermaids, of sphinxes, of the fabulous beasts so often depicted in the art of the Middle Ages and early Renaissance. But it is not the EYE which is offended by such pictographic equations as woman + fish = mermaid; rather, it is our knowledge (in this case, of biology), accord-

ing to which such a combination is unacceptable. Only where spatial data in the retinal image are mutually conflicting is the "automatic" processing carried out by the EYE brought to a halt. The EYE is not prepared for the processing of such strangely structured material, and we witness the result as a new visual experience.

We can divide the spatial information contained in the retinal image (when looking through one eye only) into two classes, natural and cultural. The first class, which is also found in pictures, contains information over which the human cultural environment exer-

Figure 9

cises no influence. Such truths of "unspoilt nature", if you will, include the following:

– objects of the same size appear smaller, the further away they are. This is the basic principle of the linear perspective which has played a central role in art since Renaissance times;

– an object which partially obscures another object is nearer than that other object;

– where two objects or parts of objects are organically connected, both are equidistant from us;

– objects relatively far away from us will generally appear less distinct and will reveal a blue haze from an aerial perspective;

– the side of an object facing a source of light is brighter than the opposite side, and shadows point away from the source of light. In a cultural environment, two further factors play an important role in our assessment of space. We humans have created a living environment dominated by right angles. Our architecture, our furniture and many of our utensils are essentially constructed of rectangular cuboids. One might even say that we have compressed our world into a rectangular system of coordinates, into a world of straight lines, level planes and right angles. Our second, cultural class of spatial information is thus rigid and clear:

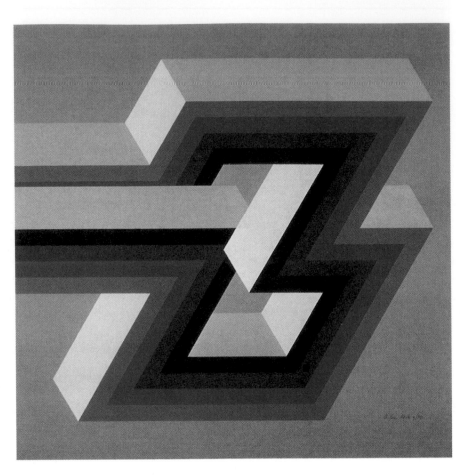

– a plane is a flat plane and continues as such until other details inform us that its continuity has been interrupted;

– corners at which three planes meet determine three main directions, in which connec-

10 Arthur Stibbe, "In front and behind", acrylic on cardboard, 50 x 50 cm, 1986

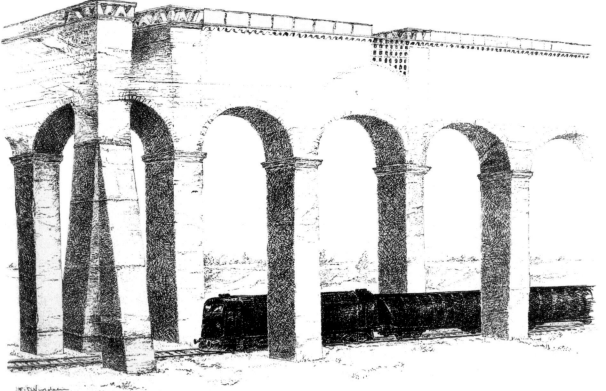

11 Fons de Vogelaere, "Passenger train", pencil drawing, 80 x 98 cm, 1984

12 Oscar Reutersvärd, "Perspective japonaise n° 274 dda", coloured ink drawing, 74 x 54 cm

tion certain zig-zag lines can indicate an extension upwards or downwards.

In our context, the distinction between a natural and a cultural environment is a useful one. Our sense of sight developed in a natural environment, and yet it has the astonishing ability to process, smoothly and accurately, spatial information from the cultural category.

Impossible objects (or at least a large proportion of them) exist thanks to the presence of mutually contradictory spatial statements. In Jos de Mey's *Double-guarded gateway to the wintery Arcadia* (p. 43, fig. 20), for example, the flat plane forming the upper section of the wall seems to disperse lower down into several different planes at varying distances from the viewer. This conflicts with the notion of the continuity of the plane. An impression of varying distances is similarly suggested by the overlapping of certain parts of Arthur Stibbe's *In front and behind* (fig. 10), something again officially prohibited by the rule of the continuity of the flat plane. In a watercolour by Frans Erens (p. 42, fig. 19), its perspective reduction in size in-

13a Harry Turner, from the series "Parado: terns", mixed media, 1973-78

13b Harry Turner, "Corner", mixed media, 1978

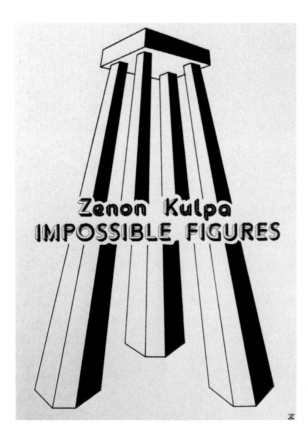

14 Zenon Kulpa, "Impossible figures", ink/paper, 30 x 21 cm, 1980

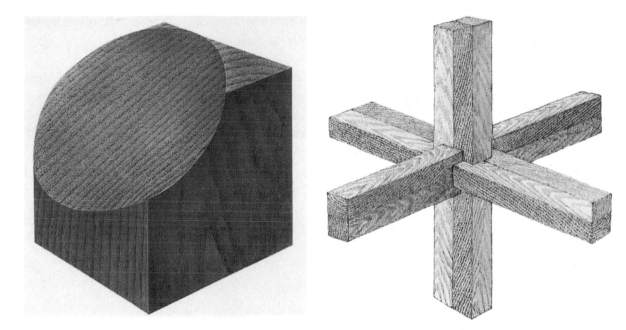

15 Mitsumasa Anno, "A section of a cube"

16 Mitsumasa Anno, "A slightly difficult interlocking wood puzzle"

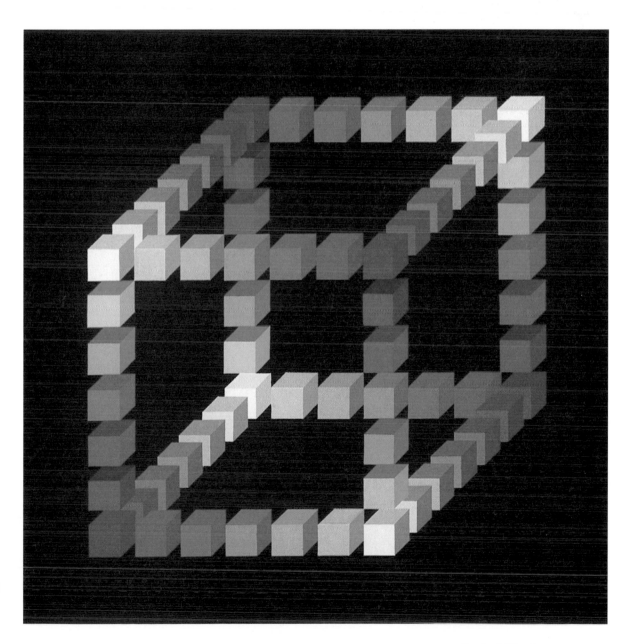

17 Monika Buch, "Cube in blue", acrylic on wood, 80 x 80 cm, 1976

dicates that the plank is running horizontally into the background, yet it is attached to the post in such a way that it must be vertical. In the case of *The five bearers* by Fons de Vogelaere (fig. 21), we are struck by a number of stereographic paradoxes. Although the drawing is entirely free of paradoxical overlaps, it contains a number of paradoxical connections. The way in which the central figure is joined to the ceiling is particularly interesting. The five load-bearing figures link the ceiling and parapet in so many paradoxical ways that the EYE is sent on a restless search for a point from which best to assess them.

You may be thinking that, with the aid of every possible type of stereographic element which can occur in a picture, it would be relatively simple to compile a systematic overview of impossible objects:

– those containing perspective elements which are in mutual conflict;

– those in which perspective elements are in conflict with spatial information stated by an overlapping of forms;

– . . . and so on.

We soon realize, however, that we can find no existing examples for many such conflicts, and at the same time that some impossible objects are difficult to fit into such a system. Such categorization might nevertheless enable us to recognize a number of still unknown types of impossible object.

18 Tamás Farcas, "Crystal", irisated print, 40 x 29 cm, 1980

19 Frans Erens, watercolour, 1985

# Definitions

Let us conclude this chapter by attempting to give at least a working definition of impossible objects.

In my first publications on Escher's pictures of impossible objects, which appeared around 1960, I arrived at the following formulation: a possible object can always be construed as a projection, a representation of a three-dimensional object. In the case of impossible objects, however, no three-dimensional object exists whose representation is a projection; in this sense we may call an impossible object an illusory representation.

This definition is both incomplete and incorrect (a point we shall return to in Chapter 7), because it refers only to the mathematical side of impossible objects.

Zenon Kulpa offers the following definition: the image of an impossible object is a two-dimensional figure which creates the impression of being a three-dimensional object, whereby this figure cannot exist as we spatially interpret it; thus, any attempt to construct it will lead to (spatial) contradictions which are clearly visible to the viewer.

Kulpa's last observation suggests one practical way of judging whether an object is impossible or not: just try building it yourself. You will soon see – perhaps even before you start – if it won't work.

20  Jos de Mey, "Double-guarded gateway to the wintery Arcadia", acrylic on canvas, 60 x 70 cm, 1983

21  Fons de Vogelaere, "The five bearers", pencil drawing, 80 x 98 cm, 1985

I myself would prefer a definition which emphasizes that the EYE comes away from the impossible object with two contradictory conclusions: it is true and at the same time not true. I would like such a definition to embrace the reason for these mutually conflicting conclusions, and furthermore to make clear the fact that impossibility is not a mathematical property of the figure, but a property of its interpretation by the viewer.

22 Shigeo Fukuda, "Images of illusion", screenprint, 102 x 73 cm, 1984

On this basis I propose the following definition:

An impossible object possesses a two-dimensional representation which the EYE interprets as a three-dimensional object, whereby the EYE simultaneously determines that it is impossible for this object to be three-dimensional since the spatial information contained within the figure is self-contradictory.

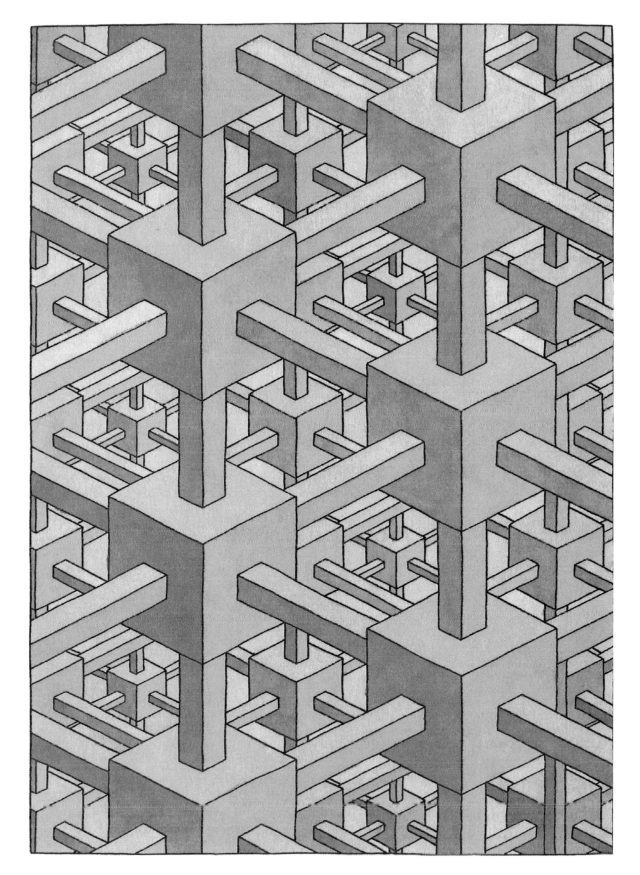

23 Oscar Reutersvärd, "Cubic organization of space", coloured ink drawing, 29 x 20.6 cm. In reality this space is not filled, since the larger cubes are at no point linked to the smaller ones behind.

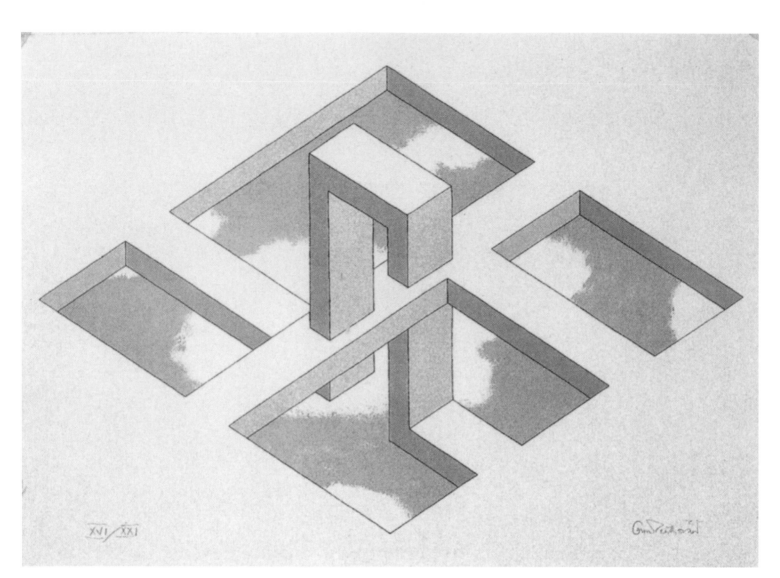

24  Oscar Reutersvärd, "Impossible four-bar with crossbars"

25  Bruno Ernst,
"Mixed illusions",
photograph, 1985

# 5 A gallery of impossible objects

In 1985, while Zenon Kulpa was working on an article on the categorization of impossible objects, *Putting order in the impossible,* I sent him a few new ones. His reaction was: "The more impossible objects are discovered, the harder it becomes to organize them into a rationally useful system."

Kulpa begins by dividing all two-dimensional objects permitting or suggesting a three-dimensional interpretation into four categories:

1. *Possible objects.* These are perceived by the EYE as possible representations of 3-D objects; upon further appraisement, our faculty of reason also judges such objects to be realizable in three dimensions.

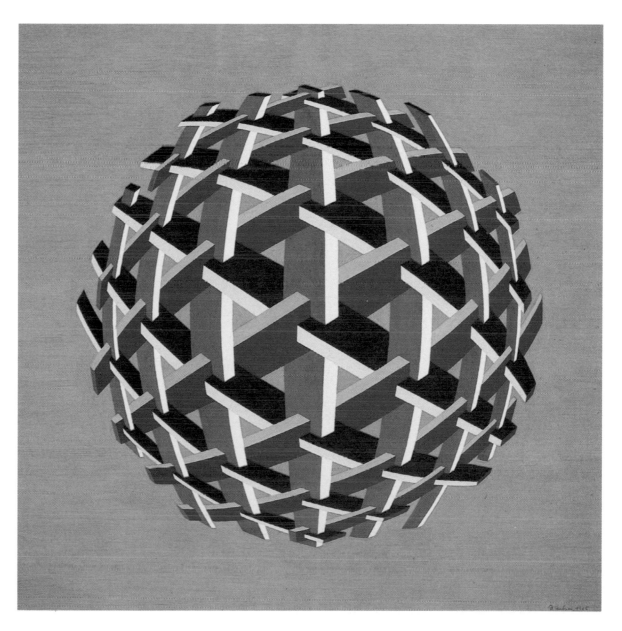

1 Hermann Paulsen, "Magic knot 1", gouache, 75 x 75 cm, 1985. The spatial depth suggested by the cubic structure of this sphere is merely an illusion.

2. *Probable objects.* The EYE calculates a possible and matching 3-D object; upon closer scrutiny, however, it becomes clear that the object cannot be realized in three dimensions. An example is the truncated pyramid shown below (fig. 3). Our EYE tells us immediately that this is a truncated pyramid, although it can be easily demonstrated why such an object is impossible: its three planes, when continued upwards, do not meet at a common apex.

Even after recognizing the rational truth of the situation, however, we cannot persuade our EYE to see something impossible, and for this reason the pyramid cannot be called an impossible object; if you refer back to my definition at the end of the previous chapter, you will see that it must be the EYE which decides whether an object – however impossible in reality – should indeed be assigned to the category of "impossible objects".

3. *Improbable objects.* The EYE's initial reaction is – impossible! But as soon as the possibility of spatial realization proffers itself from another angle, the EYE reacts by constructing an acceptable result. This is the case, for example, with the small block shown in Figure 4. If we tell our EYE that a small section has been cut out of the edge at a slant, it will accept this information and resume normal operation, particularly if we can also show it a three-dimensional model of this "impossible" block.

4. *Impossible objects.* The EYE immediately identifies the spatial contradictions inherent in the figure; these are only later confirmed by rational assessment. Both the EYE and the reason judge the object to be impossible. In this case it is a true impossible object.

These thoughts lead us to the question: is there any kind of objective yardstick which we can apply to tell us whether an object is impossible? Various experiments have been carried out in an attempt to establish, on a purely mathematical basis, criteria which might allow impossible objects to be defined and categorized. It is no surprise that they failed. For here, too, the EYE plays a dominant role – and the mechanisms of the EYE, developed over the course of evolution in order to guarantee the greatest possible

chances of survival, by no means operate along simple mathematical lines.

By acquainting ourselves more thoroughly with the "decision-making processes" of the

2 Oscar Reutersvärd, "Perspective japonaise n° 274 badhk", coloured ink drawing, 75 x 55 cm

Figure 3

Figure 4

EYE, we will be in a better position to dis- cuss the topic with others. Let us therefore try the following useful exercise:

Imagine a horizontal plane S slicing through an object, as in the case of the impossible triangle shown in Figure 6a. Cover the half of the object below the line with a piece of paper, and then draw the cross-section of the upper half of the figure at S. Now cover the top half of the object, and draw the cross-sec- tion of its lower half at S. If your sketches differ in any way, you are dealing with an impossible object. In such cases, the EYE has clearly composed an object from parts which are mutually exclusive as soon as they are combined.

In order to demonstrate the usefulness of this method as a means of detecting non-match-

Figures 6a/b

ing – and hence impossible – cross-sections, a few more examples are included here: Ernst's two-bar (fig. 6b), a normal four-bar (fig. 6c), an impossible cube (fig. 6d) and an impossible tuning fork (fig. 6e). The method proves less successful in the case of *probable* objects; if you apply the experiment to the truncated pyramid of Figure 3, for example, you will obtain corresponding cross-sections!

Meanwhile, we have still come no closer to creating specific categories of "real" impossible objects. Zenon Kulpa reaches no conclusions; he is obliged to make do with overlapping categories compiled ad hoc from a jumbled mixture of criteria. Only the categories "Multi-plane" and "Objects with parallel bars" offer useful subdivisions.

We, too, will be avoiding specific classifications in this chapter. We shall offer no more than a very incomplete overview, in which our grouping of objects makes no claim to be definitive. Our aim thereby is simply to trace a clear and logical path through our subject.

Figures 6c-e

## Apparent filling of space with impossible tri-bars

At first sight, Reutersvärd's composition on p. 45 bears a number of similarities to Escher's *Cubic division of space* from the year 1952. But Reutersvärd's work in fact represents a network of impossible tri-bars in which the large cubes hang like a curtain in the foreground, unconnected to the cubes in the second row.

These may thus be seen as a second curtain behind the first, followed in turn by a third curtain of even smaller cubes. Hermann Paulsen uses closed, curving tri-bars (p. 47, fig. 1) to suggest the filling of a spherical volume. The reduction in size of the impossible tri-bars towards the edge of the circle is cleverly achieved!

## Overlapping planes

We have already observed that the spatial contradictions within an impossible tri-bar can be traced back to a fundamental principle of stereometry, namely that three non-parallel planes intersect at a single point. In the drawing by Oscar Reutersvärd (p. 48, fig. 2) we see three such planes appearing to form a corner of a rectangular volume. But if we extend these planes across the opening which interrupts them, we find that they intersect at different points. This inconsistency goes un-

noticed precisely because pieces have been sawn out of the corners of the planes. The opening thereby created is itself an impossible object. The six planes in Huizer's picture (p. 49, fig. 5) pose no problem in themselves. Their spatial arrangement is only rendered impossible by the tri-bar by which three of them are connected. Despite its apparently simple composition, the picture offers an unfathomably mysterious glimpse of illusory space.

# Mono-bars, two-bars, and something in between

7 Bruno Ernst, "Impossible penetrations", 1984

Figure 8

9 Zenon Kulpa, "2½-dimensional beam, or 1=2", 1984

10 Bruno Ernst, "Impossible two-bar"

One might ask whether such a thing as an impossible monobar can exist at all. Figure 8 shows a normal bar at the top, followed by a bar with both sawn-off ends visible and, at the bottom, a bar with neither of its sawn-off ends visible. These last two are naturally impossible, but the EYE is determined to see them as bars with their ends sawn off at a slant; therefore, according to our earlier classification, they are not impossible objects!

In his drawing *Gateway to the fourth dimension,* (p. 52, fig. 12), Sandro del Prete nevertheless finds a way of making such bars into impossible objects by adding a number of spatial details. All four bars run away from us; of all the objects visible in the picture, the figure of the woman is the closest. The bars share another curious characteristic: each plane is simultaneously both horizontal and vertical, depending on the side from which it is seen first. This peculiarity is emphasized by the inscriptions on the bars.

In Figure 7, an otherwise entirely normal bar has been rendered impossible by its setting: it passes between two other bars which in fact allow it no room to do so, since their edges are hermetically sealed along one side.

The object in Figure 9 was invented by Zenon Kulpa. At first glance we seem to see two parallel bars – only to lose the right-hand bar as it melts into the shadow of its neighbour. Perhaps this is best described as an impossible one-and-a-half bar!

In the case of Ernst's impossible two-bar (fig. 10), the middle "rectangle" reveals a dual orientation: it appears vertical at the front and horizontal at the rear. Its interpretation is determined by the spatial information provided in the immediate vicinity of the outer ends of the two-bar.

Sandro del Prete's *Cosmic wheels* (fig. 11) can also be seen as an impossible (curved) two-bar. It bears resemblances to Escher's *Cube with magic bands* (p. 75, fig. 16).

11 Sandro del Prete, "Cosmic wheels", pencil drawing

12 Sandro del Prete, "Gateway to the fourth dimension", pencil drawing

# Impossible rooms

I drew *Fifty Years Impossible Figures* (fig. 13) as a jubilee poster for Oscar Reutersvärd. The opening in the upper corner of the room is impossible, because the three planes (the two walls and the ceiling) do not meet at a single point. Reutersvärd's first impossible object, an impossible tri-bar composed of nine cubes, appears as a heavenly body in the background. When Jos de Mey saw the poster, he drew his own – to my mind, typically "Flemish" – version of the composition as a Christmas card (fig. 14).

"Waar de Ster, van de Wijzen uit het Oosten, bleef stille staan..."

13 Bruno Ernst, poster design, 1984

14 Jos de Mey (after Bruno Ernst), coloured ink drawing, 27 x 19.5 cm, 1985

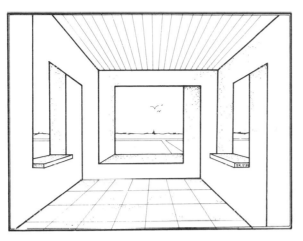 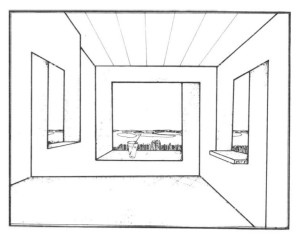

15 and 16 Bruno Ernst,
"Strange rooms"

Reutersvärd's original tri-bar is replaced by a star made up of two interwoven impossible tri-bars, and the picture is shown in centralized rather than false perspective.

The *Strange rooms* of Figures 15 and 16 are again based on the fact that three planes intersect at more than one point. In both pictures this produces side walls which simultaneously face towards us. In Figure 15, moreover, one of the solid walls vanishes into thin air, although the illusion of a room nevertheless remains perfectly convincing.

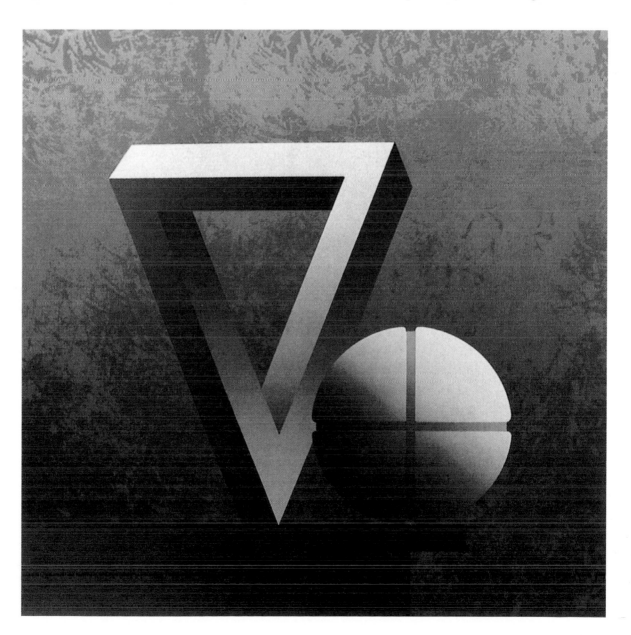

17 Dirk Huizer, "Penrose triangle and imperial orb", irisated screenprint, 45 x 45 cm, 1984

# Tri-bars: alone and in relation
# to their surroundings

An impossible tri-bar can serve as the subject of a picture without further accessories, as can be judged from Dirk Huizer's screenprint (fig. 17).

In Figures 18-20, on the other hand, the environment within which the tri-bar appears plays an important role. Figure 18 shows an impossible tri-bar standing in the hall of my apartment. Reutersvärd promptly responded to this drawing with an interesting variation (fig. 19), in which the tip of the tri-bar is partially obscured by a ceiling support, thereby also altering the line of shadow it casts. In-

spired by this, I then drew Figure 20; I added a few more impossibilities to the room, which had now developed into a museum gallery with impossible objects hanging on its walls. But there were clearly serious difficulties involved in exhibiting a "real impossible tri-bar"!

Figure 21 shows a variation upon the usual impossible tri-bar, in a setting borrowed from a drawing by Macaulay. It now shows the Moon in the year 2034, where the finishing touches are being put to a monument celebrating 100 years of impossible tri-bars.

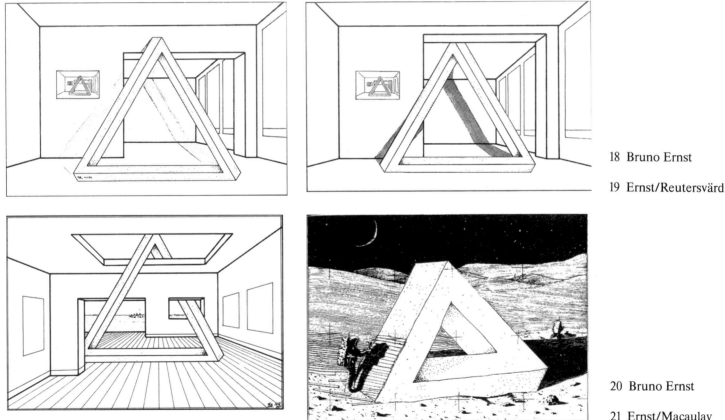

18 Bruno Ernst

19 Ernst/Reutersvärd

20 Bruno Ernst

21 Ernst/Macaulay

# Impossible multi-bars

Figure 22 represents a solid frame which is above and to the left of our viewpoint. From this angle each corner is seen differently, as if one of four distinct corner types which can be numbered 1-4.

The frame as a whole can thus be described

as (1234). By employing these individual corners in different combinations, we can build frames in which the EYE will discover contradictory spatial data. The two drawings to the right of Figure 22 show two impossible four-bars of this type. One has a

corner combination of (4444) and the other, (4141).

Using the same principle, it is not difficult to combine more than four bars into an impossible figure.

It is interesting to note, however, that multi-bars produced in this way are less tantalizing as impossible objects than impossible tri-bars and four-bars. First, the suggestion of right angles in an impossible object, e.g. through a perpendicular combination of bars, gives the EYE a useful reference point from which to determine directions in space, and any contradictions will thereby be made more apparent. The arms of a multi-bar, however, always meet at an angle that is greater than 90°; spatial directions are therefore harder to determine. Secondly, the more bars and lines that there are in a structure, the less its contradictions will strike the eye. Multi-bars, however, are very simple in design. In Figure 23 we see one five-bar (13143), one six-bar (444444), and the curved two-bar (44) which we met earlier in Figure 11.

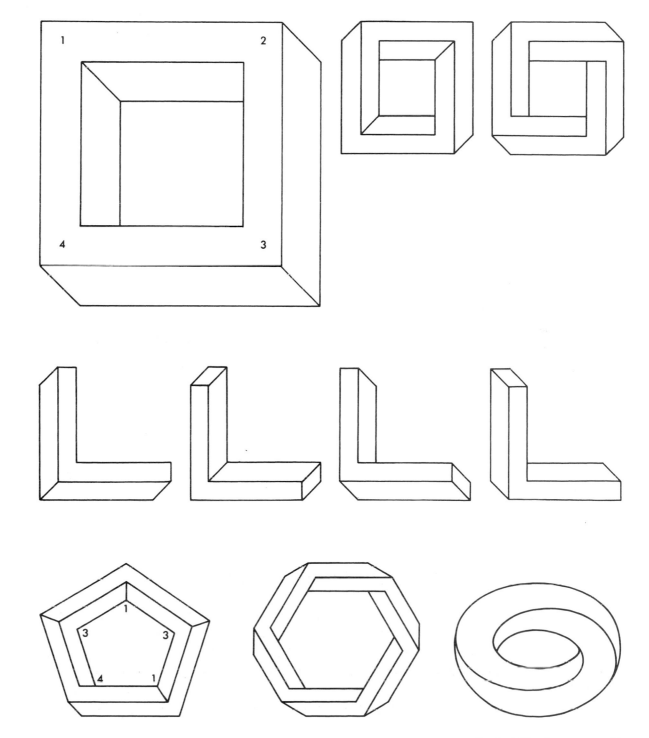

Figure 22

Figure 23

# Four-bars

The four-bar in its classic form is shown in Figure 31. It belongs to the (3441) type, and its building-block composition lends it a particularly realistic character. The surface area and volume can again be calculated: 76 dm$^2$ and 19 dm$^3$. We can experiment with this figure just as with the impossible tri-bar in Chapter 4 (pp. 33-37). Meanwhile, Figure 30 gives you all the parts you need to build an impossible four-bar; you simply have to screw them all together!

The combination of an impossible four-bar with a normal four-armed cross highlights the fact that the top and bottom bars appear perpendicular to one another (fig. 24). Dirk Huizer's impossible stringed instrument (fig. 25) is made up of impossible tri-bars and four-bars, and a normal four-bar.

A four-bar can also serve happily as a megalithic monument (fig. 27); the setting is again borrowed from a drawing by Macaulay.

Everyday objects can further be combined into impossible objects by overlapping them in impossible ways (figs. 26 and 28).

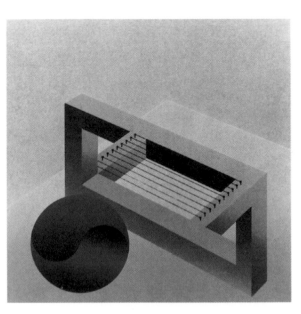

25 Dirk Huizer, "Still life no. 3", irisated screenprint, 44 x 44 cm, 1983

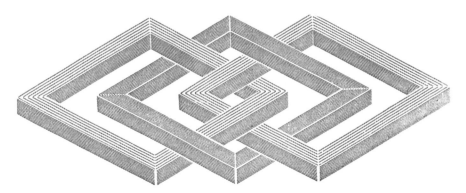

26 Diego Uribe

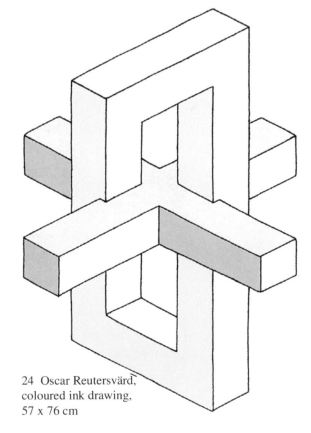

24 Oscar Reutersvärd, coloured ink drawing, 57 x 76 cm

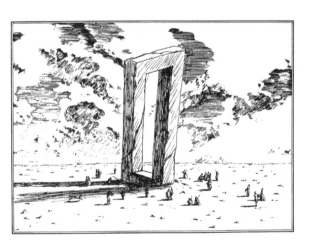

27 Macaulay/Ernst, "Megalithic monument", ink drawing

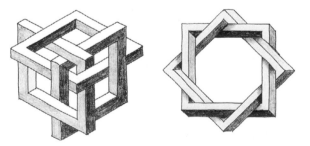

28 Dirk Huizer, small sketches from his correspondence with the author

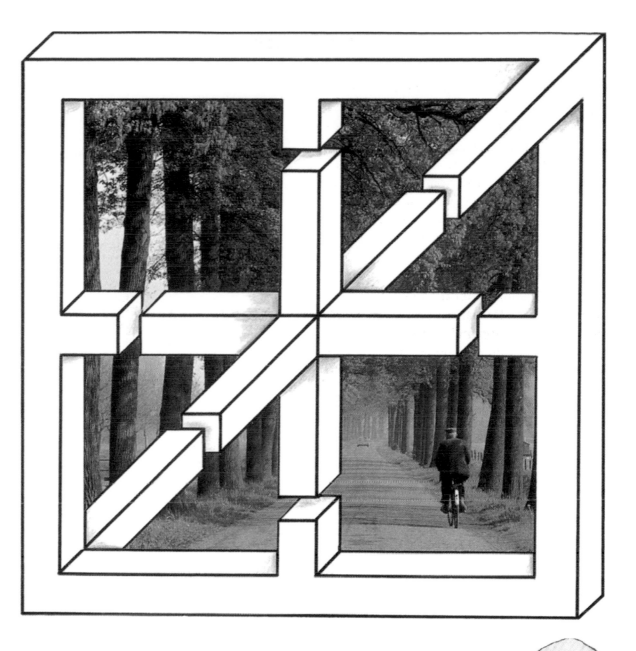

29 Bruno Ernst, collage, 1984

30 Govert Schilling, ink drawing, 1984

31 Bruno Ernst, impossible four-bars

# Multi-bars as jigsaws

Various jigsaws have been designed whose pieces allow the player to make up every possible and impossible type of tri-bar, four-bar, etc. The most obvious method is for the puzzle pieces to illustrate all the possible corner shapes in such a way that one bar of one hexagon always joins onto a bar of another hexagon.

Diego Uribe has designed a much more sophisticated solution, opening up many more possibilities with much less effort. He uses not complete corner shapes, but bar elements instead, which he places along the edges of equilateral triangles. It is possible to make up every possible multi-bar with just thirty-two different triangles (fig. 32), including not only the multi-bars we have already seen, but also figures in which more than two bars meet at one corner, such as in impossible cuboids. There is but one limitation: only perpendicular relationships are possible between the bars within an object. Figure 33 shows you how to combine the pieces into an impossible four-bar, while Figure 34 shows a more complex form in which three bars meet at one corner.

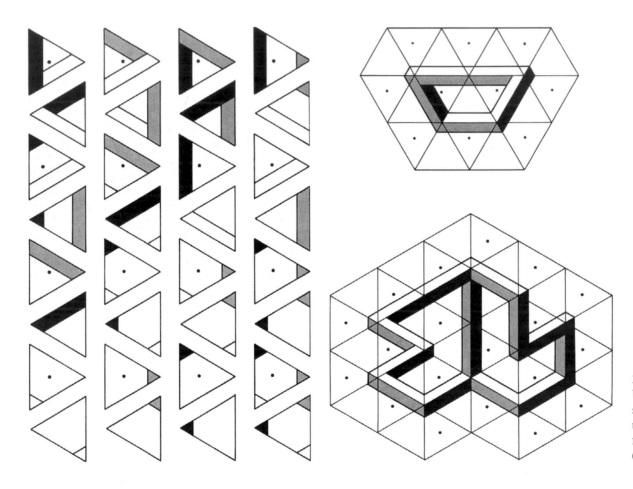

32, 33 and 34 Diego Uribe, design for a jigsaw puzzle; the individual pieces (left) and two figures made from them (right)

# Cuboids

Escher was the first to draw an impossible cuboid (cf. Chapter 6, p. 74). As in the case of multi-bars, a wide range of rather different cuboids can be composed using the corner types of the – normal – original (cf. fig. 35). Figures 36 to 42 show a selection of variations on the theme of impossible cuboids.

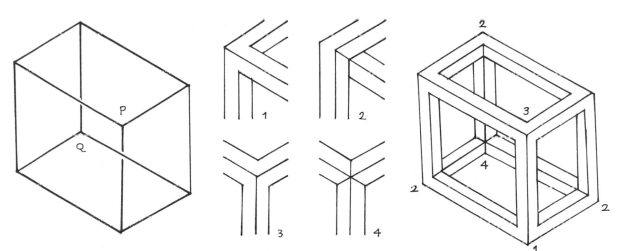

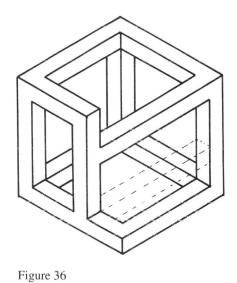

35 The individual corners (centre) of a normal cuboid (right) can be combined into impossible objects (below).

Figure 36

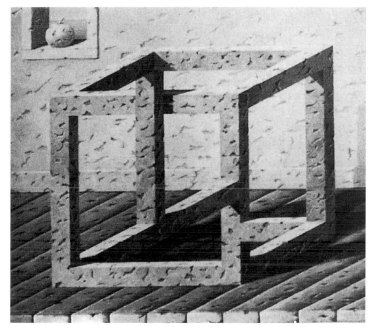

37 Jos de Mey

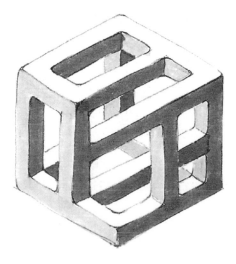

Figure 38

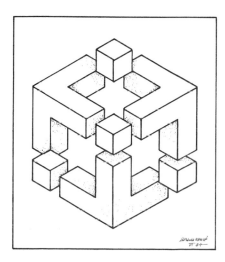

Figure 39

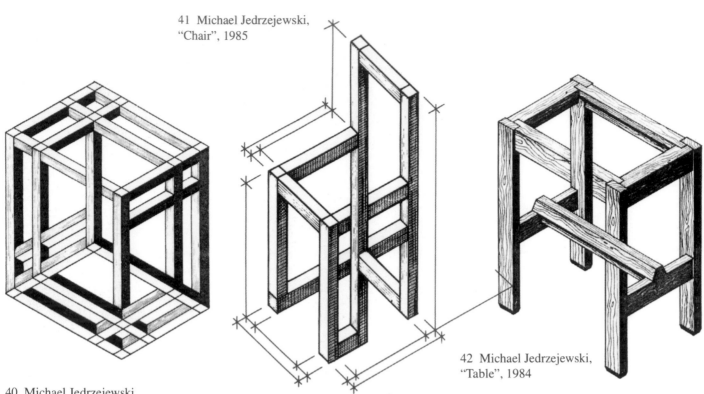

41 Michael Jedrzejewski,
"Chair", 1985

42 Michael Jedrzejewski,
"Table", 1984

40 Michael Jedrzejewski,
"Cube", 1985

# Steps and chessboards

If we walk through the centre of the – in actual fact, impossible – doorway in Figure 43, we remain on the same horizontal plane, standing on a tiled floor. If we look left, however, our path seems to lead up some steps.

the chessboard (fig. 44). If we move from the White Knight via the Castle to the King, we stay on the same level. In moving directly from the White Knight to the King, however, we gain the impression that the King is standing on a higher level than the Knight. In reality everything is flat!

A number of impossibilities have been incorporated into Figure 45, a screenprint by Fred van Houten. Take the ladder, for example: it starts against the wall – and ends beside it. Escher makes similar use of a ladder in his *Belvédère* (Chapter 6, fig. 18).

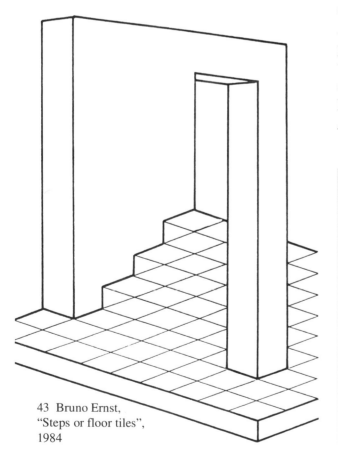

43 Bruno Ernst,
"Steps or floor tiles",
1984

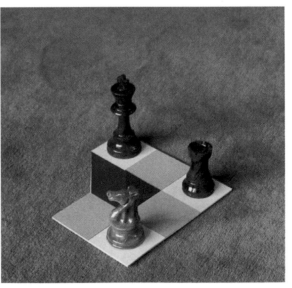

44 Bruno Ernst, "Chessboard I", 1985

45 Fred van Houten,
"Steps", screenprint,
30 x 24 cm, 1984

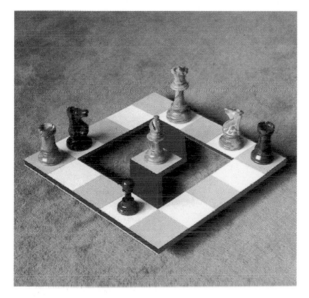

46 Bruno Ernst, "Diagonal", photograph, 1985

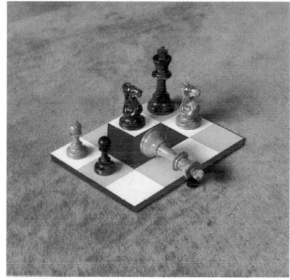

47 Bruno Ernst, "Spiral", photograph, 1985

# Multiple planes

A multiple plane looks like a single, flat plane when viewed from one point in a drawing, and yet appears to consist of two or more planes when seen from another point in the same drawing. This is the oldest type of impossible object; as we shall see in the next chapter, it appears – unintentionally or unconsciously – in works by much earlier artists. Figure 48 demonstrates how a multiple plane can be created. At the top, we see an archway standing on a tiled floor. Consulting the plan of this floor reproduced in the bottom left-hand corner of this page, we see that the left-hand foot of the arch is standing on the black square, and the right-hand foot on the square marked number 2. Let us now redraw the same archway, but making its right-hand side slightly shorter so that it ends on square 3. We have immediately created an impossible object: the seemingly flat front view of the archway contains two base lines, *a* and *b* – and that is impossible. We can continue to shorten the right-hand side until it reaches square 5. The archway has now become part of an impossible four-bar, here achieved by a different method than that described earlier. In the drawing by Jos de Mey (fig. 49), the upper section of the wall forms just a single plane with three diamond-shaped openings. At ground level, however, the same plane multiplies into four walls at varying distances from the viewer, at the same time enclosing a relatively large space, almost as if it were a roofed pergola.

In Figure 50 we see how the side plane of a cube can duplicate itself to make room for ever smaller cubes.

Figure 48

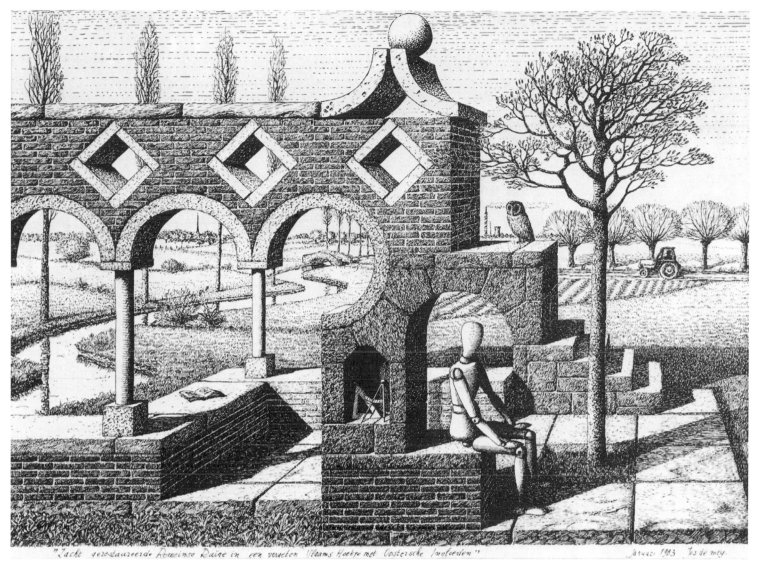

"Zachte gerestaureerde Romeinse Ruine in een vergeten Vlaams Hoekje met Oostersche Invloeden"    Januari 1983  Jos de mey.

49  Jos de Mey, "Carefully-restored Roman ruin in a forgotten Flemish locality with Oriental influences", ink drawing, 30 x 40 cm, 1983

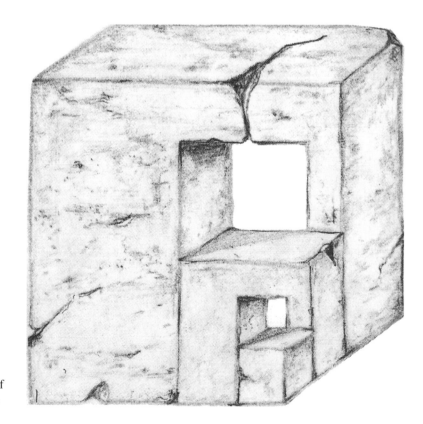

50  Bruno Ernst, "Nest of impossible cubes", 1984

Optical Illusions    63

# Continuous steps

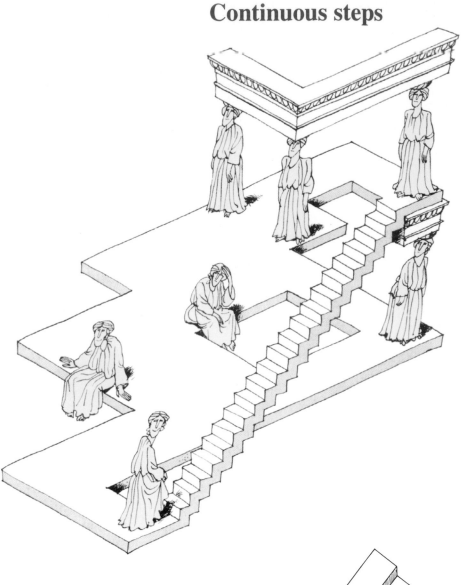

51 Reutersvärd/Ernst, "Caryatids"

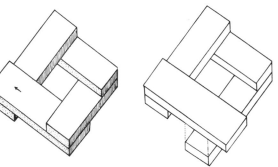

Figure 52

When looking at a flight of steps, we first decide in which direction we wish to follow it. Having chosen our direction, further spatial clues will then enable us to judge whether the stairs lead up or down. The direction of tread thereby plays no role (fig. 53). It is relatively easy to draw a set of steps which, having set off in one direction, rise or fall without end. The origin of the spatial confusion sown by the continuous steps on the left of Figure 52 is unmasked in the drawing of a normal staircase on the right. Figure 51 shows a continuous staircase by Reutersvärd, to which I have added figures emphasizing the impossibility of the situation.

up

down

Figure 53

54 Bruno Ernst, "Negative sound", 1984

# Planes with two orientations

The astonishing nature of this type of plane is illustrated by the following example: the small temple shown in Figure 55 can be mounted from the left in just two steps. Approached from the middle, however, there are three steps to ascend, and no less than five on the right. The steps leading up to the temple are in fact composed of three elongated "rectangles" aligned in two different directions. This has the effect of making the immediate surroundings appear as a vertical plane on the left and a horizontal plane on the right.

This type of plane is not warped, but the EYE calculates its orientation on the basis of details gathered from the immediate setting, and thus in two different ways. Similar planes occur in Reutersvärd's *Layered blocks* (fig. 56).

55 Bruno Ernst, "The wearisome and the easy way to the top", 1984

57 "Stair blocks", after Roger Penrose

56 Oscar Reutersvärd, "Layered blocks"

# Penrose's circular staircase

In 1985 Roger Penrose designed a combination of five impossible cuboids; Figure 57 represents one of its variations. Flights of steps lead from one cube to the next, but if we set off on a circuit standing upright, we will regain our starting-point horizontal! Life returns to normal in a similar arrangement of six cubes, but the strange phenomenon reappears in the case of seven.

# From ambiguous figures to impossible objects

58 Sandro del Prete, "Children looking out of the window", pencil drawing

59 Sandro del Prete, "The inverted chess-board", pencil drawing

A rhombus such as Sandro del Prete's chessboard (fig. 59) is an ambiguous figure: it is a square seen from either above or below. The positioning of its chessmen and ladders creates an impossible "both/and" situation, however, with both "above" and "below" interpretations presented simultaneously and in mutual contradiction. The peculiarity of the situation becomes clear when we move the White Castle square by square "diagonally upwards" along the edge of board.

A similar example of the transformation of an ambiguous figure into an impossible object is seen in Figure 58. Taking the window frame on its own, it can be seen either as a window facing west viewed from above, or as a window facing south viewed from below. Both interpretations are reinforced by secondary spatial clues found in the decoration of the windowsill, the ornamentation over the top of the window and the two separate halves of the window cross. The two incompatible view-points are fused by the figures we see inside the house: we are able to perceive the entire composition at once and both from above and below.

61 Bruno Ernst, "False candles", 1984

60 Oscar Reutersvärd, "Two arrows"

## Boundary conflicts

We offer three examples of a type of impossible object in which matter appears to vanish into thin air, the so-called "devil's fork" type.

The tuning fork in Figure 54 (p. 65) in fact has only one solid arm; the sound waves are therefore shown as if issuing from the sha-dow of this impossible object. Some of the arms of the candlestick in Figure 61 similarly appear not to exist. And it is impossible for Reutersvärd's two arrows (fig. 60) to have four ends. Yet how many bars does it truly contain – two, or three? On no account four!

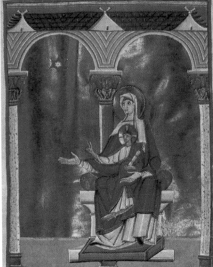

During the search for impossible objects existing prior to 1934, the year in which Oscar Reutersvärd began to concern himself consciously with the subject, it emerged that such objects were chiefly to be found in art of the age before the advent of classical perspective. They were created unconsciously, but always for a specific purpose.

The oldest example known today is found amongst some miniatures from the Pericope of Henry II, compiled before 1025 and now preserved in the Bayerische Staatsbibliothek in Munich. The Madonna and Child shown above left, taken from an Adoration of the Magi, contains a central pillar which ought to end in the foreground. If it did, however, it would obscure our view of the enthroned Virgin. Instead, the top half of the pillar appears in the front pictorial plane, but the bottom half is depicted in the rear, creating an impossible object of the "multiple plane" category.

Another important example is found in the 15th-century fresco of an Annunciation in the Grote Kerk in Breda (above right; cf. also p. 85). Art historian J. Kalf was the first to note something odd about the central pillar. This impossible object seems closely related to the Pericope miniature, both in terms of its character and the reason for its invention.

# 6 Origins and history

The conscious construction of an impossible object is a relatively new phenomenon. In 1934 Oscar Reutersvärd drew the first impossible tri-bar. Escher invented the impossible cube in 1958 and incorporated it into his lithograph, *Belvédère*. The article by Penrose and his son on the impossible tri-bar structure and the continuous flight of steps appeared that same year; Escher took these two figures as the models for his *Waterfall* (1961) and *Ascending and descending*

(1960). We have a relatively clear overview of these more recent developments thanks to information received by the author at first hand.

We shall be seeing in the second part of this chapter, however, that impossible objects, whether created consciously or unconsciously, have existed in art for a considerably longer period. Indeed, the earliest known examples date from as far back as the 11th century.

## Oscar Reutersvärd: the Nestor of impossible objects

Remarkably, Reutersvärd drew his first impossible object quite by chance. Nevertheless, he quickly realized that the figure possessed special, previously undrawn proper-

Opus 1
n° 293 aa

Oscar Reutersvärd jr   1934

1  Oscar Reutersvärd, "Opus 1 n° 293 aa", 1934

ties. He takes up the story in the following excerpts from his own letters on the subject: "At senior school I had Latin and philosophy instead of maths and biology. In our Latin lessons, while the teacher was offering edifying observations on the Romans, virtually every pupil would be doodling in the blank margins of his Latin grammar. I used to try drawing stars with four, five, six, seven or eight points that were as regular as possible. As I was elaborating a six-pointed star with a circle of cubes one day, I discovered that the cubes had formed a strange constellation. Driven by an inexplicable impulse, I added another three cubes to the configuration, in order to make a triangle. I was sharp enough to realise that I had thereby drawn a paradoxical figure. After the class I showed it to one of my schoolmates, Jan Cornell, because he was my friend and was mad on maths. 'I've never seen anything like that before!', he cried. 'You must look it up in a mathematical encyclopaedia right away; you're bound to find something on such extraordinary geometric objects!' I hurried to the Stockholm municipal library, where I sought in vain for examples of objects with the same remarkable characteristics.

Over the next few years I occasionally played with the possibilities of 'cubes in paradoxical combinations', creating the endless staircase and figures of the devil's fork type. My devil's fork was slightly different, by the way, to the figure subsequently published by

Schuster; mine was derived from impossible meanders (p. 81, fig. 29). At the time I called my figures 'illusory bodies'.

In 1958 the same Jan Cornell (now a well-known publisher) gave me an article to read in which the two Penroses introduced a number of impossible objects; it was only then that I realized what I had actually discovered as a boy. Up to that point I had drawn about a hundred impossible objects, but the Penrose article inspired me to begin a thorough exploration of the field. I have drawn a total of approx. 2500 impossible objects between then and now [1986]."

Reutersvärd's account of how he arrived at the endless staircase also sheds light on the way in which his impossible objects arose in the form of related series: "A few days before making the journey from Stockholm to Paris (May 1950), I heard on the radio an interesting programme on Mozart's method of composition. His manner of working was described as 'creative automatism'. Each musical inspiration that he wrote down itself inspired a new idea, and this another, and so on. I felt this was an apt description of the way in which I myself developed impossible objects. I decided to note the time and place of origin on a sequence of impossible objects which I drew during my journey in this 'unconscious', automatic way. It was an arduous experiment, but one that was both interesting and fruitful, and which enabled me to trace the development of increasingly complex figures step by step. I produced fourteen

drawings during the almost 40-hour trip. Strangely enough, I did not realise at the time that the figure was in fact a continuous flight of steps. I only consciously began to address the subject some years later" (cf. figs. 3-5). Writing about Escher, Reutersvärd acknowledged: "I am a very, very great admirer of Escher. I saw one of his impossible objects for the first time in 1961, when Jan Cornell sent

2 Oscar Reutersvärd, "Opus 2B", 1940

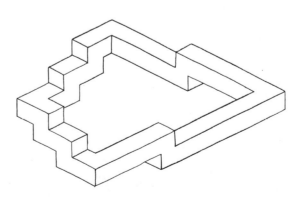

3-5 Oscar Reutersvärd, travelling sketches, 1950

Nr 10

achevé à 7ʰ35 un peu avant Liège

Figure 5

me his *Ascending and descending.* I was very impressed by it, although not so much by the irregularity of the stairs (2 x 15 + 2 x 9).

In 1962 Cornell sent me a reproduction of Escher's *Waterfall,* a remarkable composition in which I particularly admired Escher's treatment of the tri-bar theme. In 1963 and 1964 I wrote Escher two letters, in which I expressed my admiration for his work. He did not reply. I sent him extracts from articles on his work appearing in Swedish newspapers, but again he failed to respond."

# Drawing something truly impossible

6 Stockholm 1934: Oscar Reutersvärd (right) and Jan Cornell (second from left)

At the Escher Congress in March 1985 in Rome, I talked to Roger Penrose about the role which he and his father had played in rediscovering the impossible tri-bar structure and the continuous steps. He seems to have been greatly inspired by Escher's work, although at that time Escher had not yet drawn any impossible objects, and indeed had no idea even of their existence. Penrose tried drawing a truly impossible object for himself. As he explains: "My own interest in impossible objects stems from the year 1954, when, as a research student, I attended the International Congress of Mathematicians in Amsterdam. I knew one of the speakers, and he remarked that I might be interested in an exhibition of works by the Dutch graphic artist M.C. Escher, an exhibition which had deliberately been organized to run parallel to the congress. I went to see it, and I remember that I was absolutely spellbound by his work, which I was seeing for the first time.

On my journey back to England, I determined to make something 'impossible' myself. I experimented with various designs of bars lying behind and in front of each other in different combinations, and finally arrived at the impossible triangle (later known as the impossible tri-bar) which, it seemed to me, represented the impossibility which I sought in its purest form.

Although Escher had many extraordinary things on display in his exhibition, there was nothing which we would today call an impossible object.

7 Oscar Reutersvärd, 1950

I showed my father the above-mentioned triangle at the next possible opportunity. He immediately sketched a number of variants and eventually came up with the drawing of an impossible flight of stairs leading continually downwards (or upwards). We wanted to publish our findings, but had no idea how or where, since we didn't know what field our subject fell into. It then occurred to my father that he knew the editor of the *British Journal of Psychology* and could ask him whether he would print our article. We decided, therefore, that it was a psychological subject, and sent him our short manuscript. It was published in 1958. We acknowledged the catalogue of the Escher exhibition which I had seen in Amsterdam. When the copies appeared, we sent one to Escher as a token of our esteem. At that time none of us knew of the much earlier work by Oscar Reutersvärd, which I only discovered in 1984." The much-

8  Roger Penrose, Rome, 1985 (photo: Bruno Ernst)

discussed article by the two Penroses is reproduced in full below.

# "Impossible Objects: A Special Type of Visual Illusion"

*By L.S. and R. Penrose, University College, London, and Bedford College, London. (Manuscript received 30 November 1956)*

"Two-dimensional drawings can be made to convey the impression of three-dimensional objects. In certain circumstances this fact can be used to induce contradictory perceptual interpretations. Numerous ideas in this field have been exploited by Escher (1954). The present note deals with one special type of figure. Each individual part is acceptable as a representation of an object normally situated in three-dimensional space; and yet, owing to false connexions of the parts, acceptance of the whole figure on this basis leads to the illusory effect of an impossible structure. An elementary example is shown in Fig.[9]. Here is a perspective drawing, each part of which is accepted as representing a three-dimensional rectangular structure. The lines in the drawing are, however, connected in such a manner as to produce an impossibility. As the eye pursues the lines of the figure, sudden changes in the interpretation of distance of the object from the ob-

server are necessary. A more complicated structure, not drawn in perspective, is shown in Fig.[10]. As this object is examined by following its surfaces, reappraisal has to be made very frequently.

Another way of presenting the same type of illusion is to express the impossibility in terms of such a phenomenon as a continually descending or ascending path. The flight of steps drawn in Fig.[11] is an example of this. Each part of the structure is acceptable as representing a flight of steps but the connexions are such that the picture, as a whole, is inconsistent: the steps continually descend in a clockwise direction.

Actual objects suitably designed, viewed from particular angles, can give exactly the same impressions as inconsistent drawings. A photograph of a model of this kind, apparently an impossible staircase, is shown as Fig.[12]. Actually the far right hand step was much nearer to the camera and much higher than the step which appears to be just above it. Illusions with a different purpose, constructed in a somewhat similar manner, have been discussed by Kilpatrick (1952)."

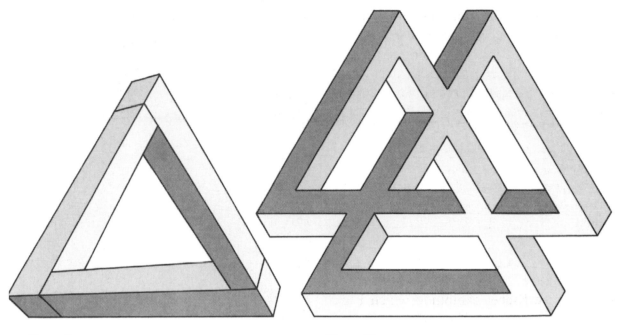

Figure 9

Figure 10

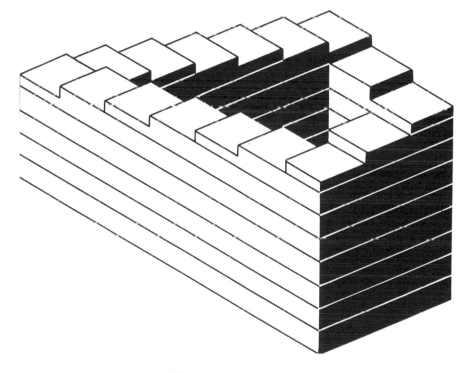

Figure 11

Figure 12

References:
Escher, M.C. (1954): *Catalogus 118;* Stedelijk Museum, Amsterdam.
Kilpatrick, F.P. (1952): "Elementary demonstrations of perceptual phenomena". In *Human Behavior from the Transactional Point of View.* Hanover, N.H.: Institute for Associated Research.

# Escher's impossible cube

When Escher started working on his lithograph *Concave and convex* in 1955, he was already thoroughly acquainted with the ambiguity of the Necker cube; he was looking for a means of combining the constantly alternating orientations of the cube into an object which allowed two mutually exclusive interpretations at once, and was thus impossible. He succeeded most happily in 1957, with his *Cube with magic bands* (fig. 16). The preliminary studies for this picture show that Escher was already relatively adept at handling impossible tri-bars.

One year later, Escher invented an impossible cube in which the Necker cube is no longer ambiguous but has become a "stable" impossible object. He thereby drew upon the discoveries which he had made in the field of impossible connections of bars. His first sketches on the theme do not yet employ impossible overlapping, but in the final form, which he used for the picture *Belvédère,* such overlapping is present. The ingenious structure of this impressive picture (known as the "Phantom House" in its early stages) deserves closer examination.

In Chapter 5 we met the principle according to which large numbers of impossible cuboids can be constructed. The majority – including the version which Escher chose for his *Belvédère* – are positively taxing on the viewer. The EYE tries to make something of them, but its efforts are thwarted by the blatant contradictions built into their geometrical details. Only through the harmonious interplay of such impossible elements with additional perspective information can the picture as a whole reveal the beauty of the impossible cube – and hence the reality and magnificence of the impossible!

Escher was a master of this art. Examining his *Belvédère* (p. 77, fig. 18) more closely, we are struck by the very unobtrusiveness of the impossible cuboid at the centre of the composition; its horizontal planes are long and narrow, while those of its parts having contradictory spatial orientations lie far apart and are even camouflaged. This is not at all the solution we might expect, since it seems

13 M.C. Escher, 1958
(photo: Bruno Ernst)

to obscure the very elements which make the object impossible. Escher takes a further step in this direction by concealing the ceiling behind arcades and the floor behind a balustrade. What remains of the impossible cuboid is shown in Figure 14. Above and below its skeletal framework Escher now builds solid, detailed blocks, with which he both reinforces the reality of the picture as a whole and at the same time accentuates the conflicting orientations of the top and bottom of the cuboid. Thus the upper storey appears to lie at right angles to the one below – an impression

14 Analysis of the structure of Escher's "Belvédère" (cf. fig. 18), lithograph, 42.2 x 29.5 cm, 1958

heightened by the different directions in which the woman on the top floor and the man on the floor below are each gazing. A minimum of four pillars are necessary to connect the top and bottom planes of an impossible cube, whereby only two can be "impossible"; here, Escher uses eight pillars, six of them establishing impossible connections. The ladder leading from the floor to the ceiling represents another such connection, and one whose impossibility is underlined by the two figures climbing its rungs: the lower figure sets off from inside the cuboid, while the upper figure has somehow arrived outside. Escher uses all these manipulations to infuse his picture with a greater degree of impossibility than that initially achieved by concealing contradictory elements. It is clear that he developed the composition with great care, in order to portray the wondrous nature of the impossible cuboid as realistically as possible.

# Escher and Penrose

In a letter to his son Arthur of 24 January 1960, Escher described how the Penrose article first came to his notice. At the time, he was "working on the design of a new picture, which featured a flight of stairs which only ever ascended or descended, depending on how you saw it. Seen in the round, a winding staircase would normally take the shape of a spiral, vanishing into the clouds at the top and into hell at the bottom. Not so with my stairs: they form a closed, circular construction, rather like a snake biting its own tail. And yet they can be drawn in correct per-spective: each step higher (or lower) than the previous one. A number of human figures are following the stairs in two directions. Those on one side toil ever upwards, while those on the other are trapped in a never-ending descent. I discovered the principle in an article which was sent to me, and in which I myself was named as the maker of various 'impossible objects'. But I was not familiar with the continuous steps of which the author had included a clear, if perfunctory, sketch, although I was employing some of his other examples."

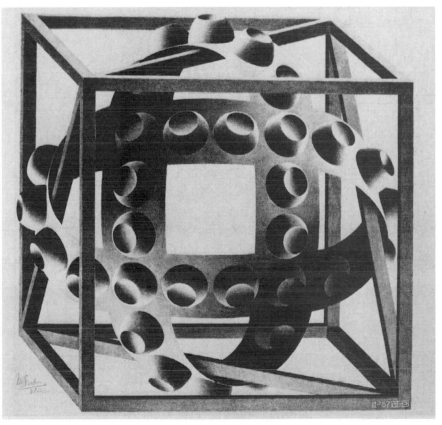

15 M.C. Escher, preliminary study for "Cube with magic bands"

16 M.C. Escher, "Cube with magic bands", lithograph, 30.9 x 30.9 cm, 1957

Fig. I
Belvedere v. M. Escher
Ansicht von Süd-Westen

Norden

Süden

Osten

Westen

Süden

Fig. II
Konstruktions-Schema
Ansicht von Süd-Westen

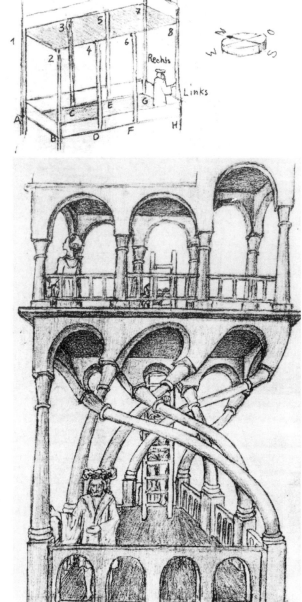

Links
Rechts
Rechts
Links

Rechts

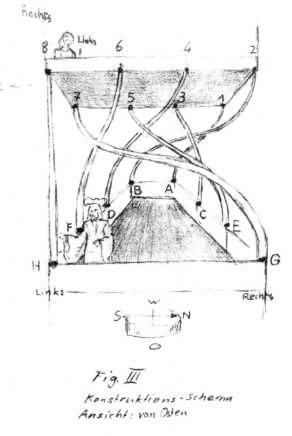

Links

Links
Rechts

Fig. III
Konstruktions-Schema
Ansicht: von Osten

Sandro Del Prete
8. V. 85

Fig. IV

Blick in das Innere von
Belvedere gemäss Eschers
Vorlage

17  Sandro del Prete, pencil drawing, 36.5 x 25.2 cm, 1985. Escher's "Belvédère" may be seen as a coherent construction in which a number of connections are curved.

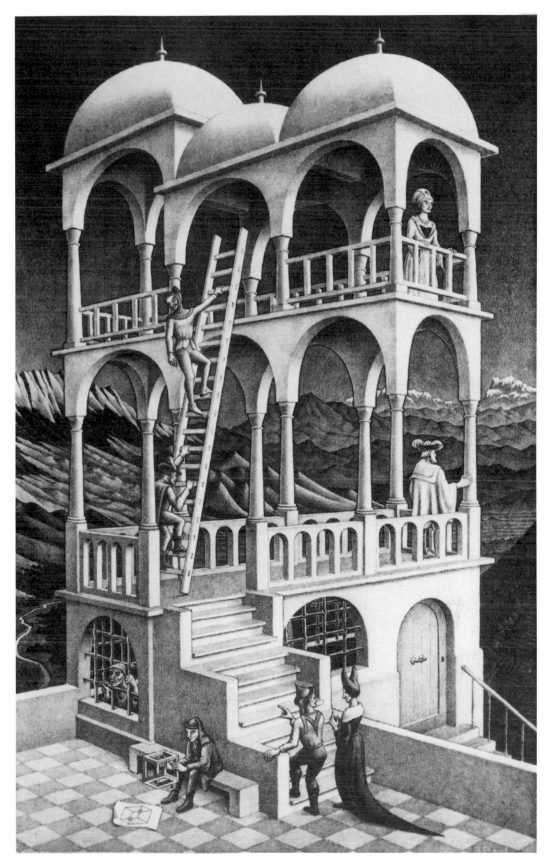

18 M.C. Escher, "Belvédère", lithograph, 46.2 x 29.5 cm, 1958

Escher's work provides no explicit evidence that he knew of the impossible tri-bar prior to reading the Penrose article. Nevertheless, the sketches for *Cube with magic bands* demonstrate that he was indeed preoccupied with similar concerns. But it was the endless stairs which captivated Escher above all else, despite the "perfunctory drawing". He subsequently (18 April 1960) wrote to the two Penroses: "A few months ago, a friend of mine sent me a photocopy of your article . . . Your Figures 3 and 4, the 'continuous flight of steps', were entirely new to me, and I was so taken by the idea that they recently inspired me to produce a new picture, which I would like to send you as a token of my esteem. Should you have published other articles on impossible objects or related topics, or should you know of any such articles, I would be most grateful if you could send me further details." Penrose responded with a letter of thanks and an article on a new type of impossible object. The picture which

Escher had sent was *Ascending and descending* (fig. 21), the least original of Escher's four pictures of impossible objects and no more than a "clothed" version of the Penrose drawing. Escher himself never understood how its impossibility actually arose. In *The Magic Mirror of M.C. Escher,* I offered an analysis of the picture on the basis of Escher's own explanations. Only years later did I realize that *Ascending and descending* as Escher interpreted it was not an impossible object, but rather a distorted figure which could very probably be built in three dimensions, whereas the Penrose stairs are truly impossible.

Escher houses his stairs on top of a building. As he understood it, it would be possible to wind strips of tape in a spiral around the exte-

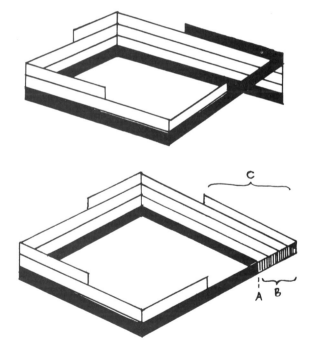

19 (above) and 20 The underlying structure of Escher's "Ascending and descending" can be interpreted in two ways. Escher himself explained it in terms of Fig. 19, which cannot be described as an impossible object. I adopted the same explanation in my book, "The Magic Mirror of M.C. Escher".

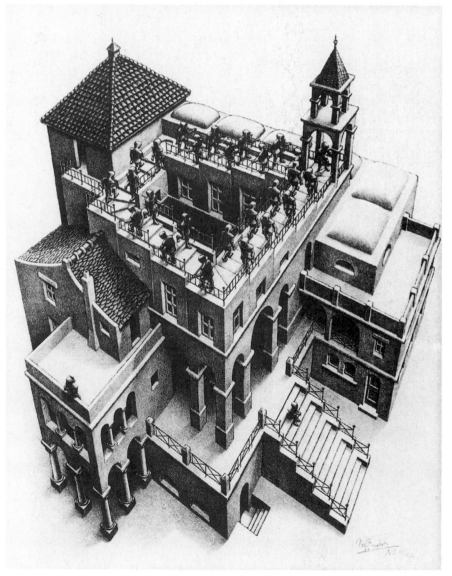

21 M.C. Escher, "Ascending and descending", lithograph, 32.5 x 28.5 cm, 1960

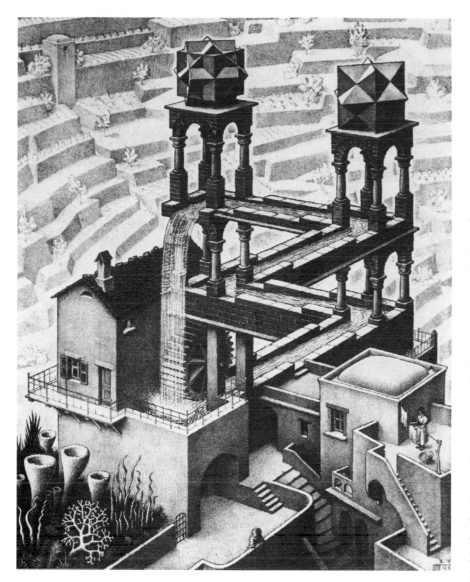

22 M.C. Escher, "Waterfall", lithograph, 38 x 30 cm, 1961

rior of this building. By means of a slight angling, uniformly distributed across every corner and plane, it would then be possible to create the illusion of a continuous flight of steps, as illustrated in Figure 19. At no point is there any gap in the staircase. In Figure 20, on the other hand, all four sides lie horizontal. The hatched strip should end at A, but by adding length B we create an (impossible) connection with strip C: *this* is the impossible object which is discussed in the Penrose article and which, executed as a model, produces a staircase with a gap in it. It is naturally impossible to tell from *Ascending and descending* which of the two methods it employs; what *is* clear, however, is that the difference between the possible and the impossible is very small in such a richly-detailed composition. Escher made true use of Penrose's tri-bar in his *Waterfall* lithograph of 1961 (fig. 22). Through a series of sketches, any one of which could have produced an attractive impossible object, he arrived at a tri-bar in a thoroughly natural-looking setting with highly realistic details. Geometric impossibility is here accentuated by physical impossibility. Escher organizes the whole into a *perpetuum mobile* of the first order: the water in his picture is made to drive a water wheel which is thus able to generate power from nothing!

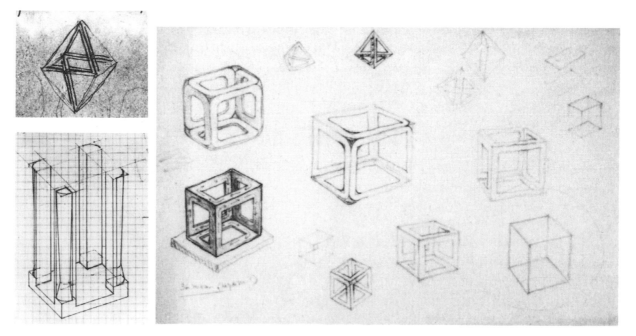

23 M.C. Escher, sketches of impossible objects

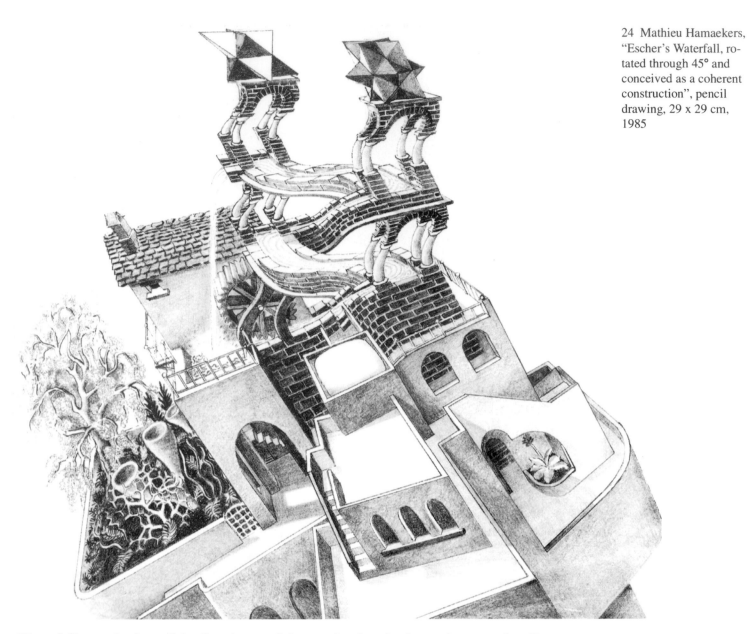

24 Mathieu Hamaekers, "Escher's Waterfall, rotated through 45° and conceived as a coherent construction", pencil drawing, 29 x 29 cm, 1985

*Waterfall* was the last of the four impossible pictures which Escher completed. Having, in his opinion, now successfully depicted the peculiar nature of impossible objects, he returned to the subject to which he was irresistibly drawn and which he considered his personal speciality: the regular filling of planes. Escher was the first to draw an impossible cube; he also knew how to visualize a number of other impossible objects in highly plastic, indeed almost narrative form. Perhaps his chief significance for impossible objects lies in the fact that, through his pictures, they have won greater popularity and international recognition as an enrichment to our visual world.

# The devil's fork

Impossible objects with ambiguous contours, characterized by the fact that they cannot be coloured in (cf. fig. 25), were being created by Oscar Reutersvärd even before 1958. It was not until 1964, however, that attention was drawn to such objects in a short article by D.H. Schuster, dedicated to impossible objects of a type that soon became known as the "devil's fork" (article on page 81).

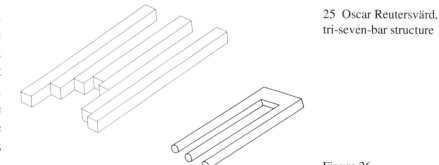

25 Oscar Reutersvärd, tri-seven-bar structure

Figure 26

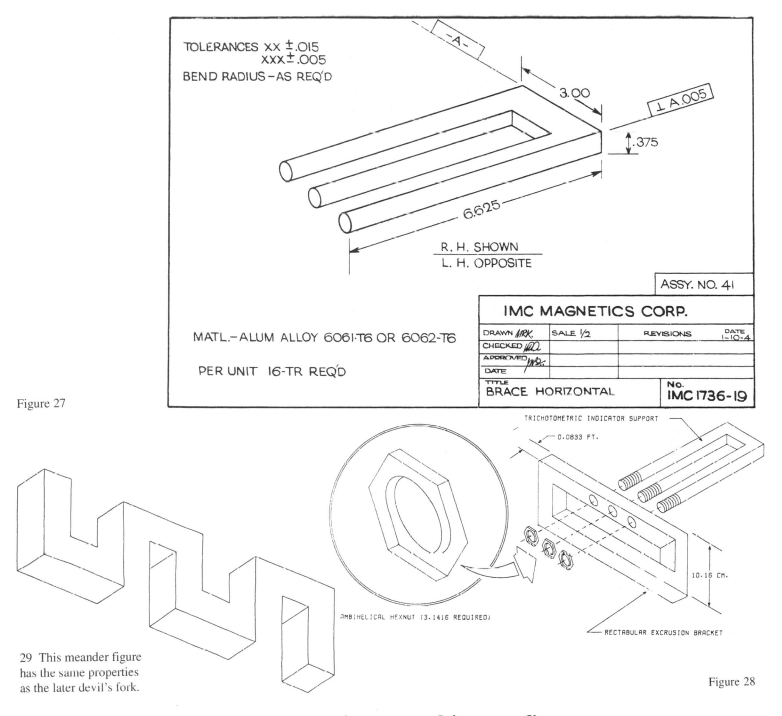

TOLERANCES XX ±.015
         XXX ±.005
BEND RADIUS – AS REQ'D

-A-

3.00

⊥ A .005

.375

6.625

R. H. SHOWN
L. H. OPPOSITE

ASSY. NO. 41

**IMC MAGNETICS CORP.**

| DRAWN MRK. | SALE ½ | REVISIONS | DATE 1-10-4 |
|---|---|---|---|
| CHECKED | | | |
| APPROVED | | | |
| DATE | | | |

TITLE
BRACE HORIZONTAL

No.
IMC 1736-19

MATL.– ALUM ALLOY 6061-T6 OR 6062-T6

PER UNIT 16-TR REQ'D

Figure 27

TRICHOTOMETRIC INDICATOR SUPPORT

0.0833 FT.

10.16 CM.

AMBIHELICAL HEXNUT (3.1416 REQUIRED)

RECTABULAR EXCRUSION BRACKET

29 This meander figure
has the same properties
as the later devil's fork.

Figure 28

# A new ambiguous figure:
# a chain joint/a horizontal brace

"The figure opposite [26], which recently appeared in an *Aviation Week and Space Technology* (80, 1964) advertisement, is shown here because, in my opinion, it is a matter of a new type of ambiguous figure. Unlike other ambiguous drawings and geometric figures – Jastrow's duck-rabbit, Hill's wife-and-mother-in-law, Botwinick's husband-and-father-in-law (a male counterpart to Hill's drawing), the Necker cube, the Schröder stairs and Mach's book – it is the shift in the optical focal point which plays a role in perception and interpretation here. If the observer focuses on the left-hand side of the figure at reading distance, he sees three legs, and the right-hand side remains blurred and fuzzy; if he focuses on the right-hand side, he sees a U-shaped object, like a chain joint/horizontal brace. Only if he looks at the middle or slowly allows his view to pass over the figure does he come to realize that he is looking at an 'impossible object', as impossible as the illusory figures described by Penrose and Penrose and authors referring to them."

Drawings soon appeared of technically realistic variations upon the "devil's fork" theme (figs. 27 and 28). Reutersvärd's thorough understanding of such objects led him to draw more complex structures, such as Figure 25, with three bars made to look like seven, and Figure 29, whose true nature as a "devil's fork" is less easily recognizable.

## Going back in time

Although the history of impossible objects may confidently be said to have started in 1934, some had already appeared before this date. Some were intended as a passing joke, as in the case of Marcel Duchamp; others arose semi-consciously or unconsciously in a desperate attempt to reproduce stereographic elements in a satisfactory manner. These latter were formerly taken as perspective imperfections; today, however, we can appreciate them from an entirely new angle.

In 1916/17 Marcel Duchamp turned an advertisement for Sapolin, a well-known paint manufacturer, into a homage to his friend Apollinaire by omitting and adding various letters (fig. 30). He also transformed part of the bed frame, by means of a few strokes of white paint, into a – not entirely convincing – impossible tri-bar and four-bar structure. Duchamp himself never pursued this line any further. To find another example, we must travel back 150 years in time.

30 Marcel Duchamp, "Apolinère enameled"; corrected ready-made, 1916-17, Philadelphia Museum of Art

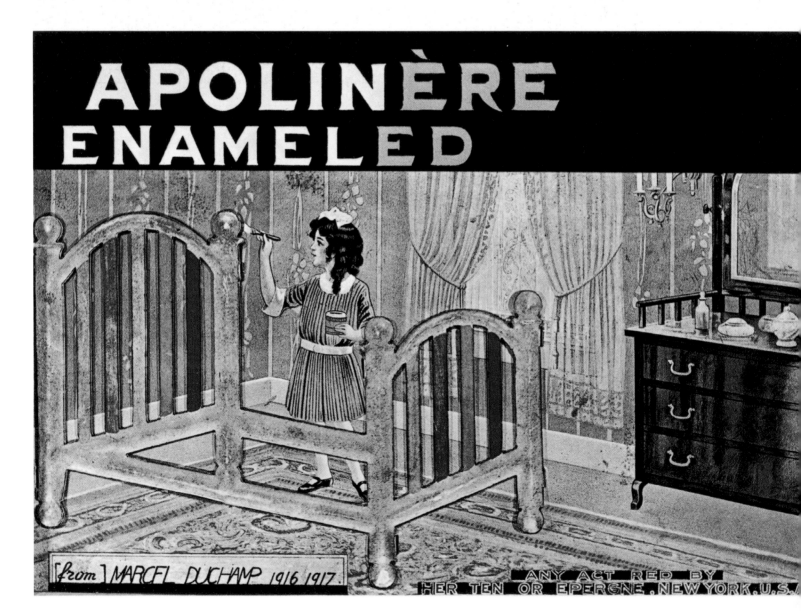

31 Giovanni Battista Piranesi, "Carceri, Plate XIV", revised edition, 1760

## Piranesi's fourteenth prison

Giovanni Battista Piranesi (1720-78) was born in Venice. Although destined by his background and training for the architectural profession, in practice he was considerably more active as an etcher and engraver. He published over thirty books on architecture, chiefly polemic works, illustrated with hundreds of drawings of architecture in the neoclassical style. His vast oeuvre commands little interest today. One exception, however, is his series of *Carceri* – bizarre, fantastical and mysterious drawings of prison dungeons. *Invenzioni capricci di carceri,* a set of fourteen plates, first appeared in 1745 as the third part of his extensive publications. He subsequently revised all the plates, added two more and republished them in 1760 under the title *Carceri d'invenzione (Imaginary Prisons).*

Although fantastical depictions of prisons were not uncommon in those days, Piranesi's pictures stand out for the personal, original and powerful nature of their expression.

They show increasingly unreal, often impossible rooms in a style which goes beyond neoclassicism.

In *Carceri XIV,* Piranesi employed the contrast of multiple flat planes as one of the many means with which he consciously sought to create unusual, impossible spaces, without realising, however, that he had thereby achieved an entirely new manner of spatial contradiction.

A great deal has been written about his engravings and several authors have discussed the perspective impossibilities they contain. Some have even seen them as an application of non-Euclidean geometry, and Prof. J.H. van den Berg made them the basis of an important part of his "Metabletica of Matter."

These pictures have little to do with non-Euclidean geometry, however. Although consciously striving after spaces which were difficult, if not impossible, to analyse, Piranesi was nevertheless dependent upon contemporary conventions of suggesting three-

Whoever makes a DESIGN, without the Knowledge of PERSPECTIVE, will be liable to such Absurdities as are shewn in this Frontispiece.

32  Analysis of Piranesi's "Carceri, Plate XIV"

dimensional space on a two-dimensional surface. He achieved his goal by deliberately including unclear and even contradictory spatial details. He thereby entered the territory of impossible objects, of which a number of examples can be identified in his *Carceri*. The most obvious is found in the above-mentioned fourteenth engraving, reproduced here in the revised version of 1760 (fig. 31). A long wall featuring three pointed arches starts from the left and runs across and beyond the centre of the picture. At point B (cf. fig. 32) a section of this wall moves forward, whereby the lower half of the wall projects much further into the foreground than the section above. A multiple plane is thus created. Piranesi reinforces this effect by adding a flight of steps (C), which runs parallel to the wall and yet disappears behind it. I have illustrated these main features as accurately as possible, albeit diagrammatically, in Figure 32, through which the impossible object becomes instantly and clearly recognizable.

33  William Hogarth, "False Perspective", engraving, 1754

## Hogarth's "false" perspective

Another picture which arose at about the same time, although very different in nature, is equally significant with respect to impossible objects.

The English painter and engraver William Hogarth (1697-1764) is famed as the leading moralist amongst the English painters of the eighteenth century, a reputation which makes us frequently forget that he also executed a number of excellent paintings in the style of the Italian masters of his day. *False perspective,* a copper engraving from the year 1754

84     Optical Illusions

(fig. 33), would surely make him the "father of impossible objects", were it not for the fact that the very purpose of the composition was to demonstrate the types of mistake made by incompetent draughtsmen. As he makes clear in his caption: "Whoever makes a DESIGN without the Knowledge of PERSPECTIVE will be liable to such Absurdities as are shewn in this Frontispiece." Here, too, his moralizing tendencies – albeit not aimed, in this case, at the most popular sins of the day – come clearly to the fore.

The angler in the right-hand foreground is standing on a tiled ground whose incorrect vanishing-point makes it look like a vertical wall; this has nothing to do with impossible objects. Behind the angler, the boards of the shed wall compose a flat plane which combines two orientations at once (cf. Chapter 5). A sign hangs overhead from a braced pole, but the spatial configuration this suggests is contradicted by the fact that the pole and the brace are attached to two clearly separate buildings. The sign itself is partially obscured by trees which other spatial pointers place much further away. A woman leaning out of the window in the top right-hand corner is lighting a tramp's pipe with her candle. And yet the tramp is standing on a hill at least a hundred yards from her house . . .

The other "absurdities" we shall let rest. You

34 Pieter Breughel, detail from "The Magpie on the Gallows", Hessisches Landesmuseum, Darmstadt

will perhaps have noticed that Hogarth at no point uses a precisely definable impossible object. Nevertheless, in composing his loose-knit impossible pictures, he employs the same spatial contradictions that we encounter in self-contained constructions of true impossible objects.

# The Mural in Breda

In Breughel's *The Magpie on the Gallows* (1568; fig. 34), we see a clearly recognizable impossible four-bar. It would not surprise me to learn that the artist had quite consciously depicted something that is entirely out of the ordinary. In trying to make sense of the picture's strange spatiality, we are initially tempted to see the gallows in terms of warped beams. But if we attempt to draw a beam warped in this way, we do not obtain the same result as Breughel. Here, again, we seem to be dealing with a chance but conscious discovery.

It is inevitable that our current preoccupation with impossible objects should make us want to see such objects in historical works, however out of the question this may be. In some

cases, nevertheless, the exercise is justified – as in the mural in St. Mary's church, or Grote Kerk, in Breda. Here, the testimony of an innocent witness from the period before 1934 lends credibility to the search for impossible objects from the past.

In 1902, a mural measuring 2.7 x 2.5 metres was discovered beneath the plaster in Breda's Grote Kerk. Remarkably well preserved, it shows an Annunciation from the hand of a fifteenth-century artist (cf. colour reproduction on p. 68). The scene is framed by two arches, supported by three pillars. The two outer pillars lie in the foreground, whereas the central pillar ends behind a table towards the back of the room. The result is a flat wall residing in both the front and rear pictorial

planes. The first art historian to write about the painting took note of this curious feature, describing it as "a perspectively-misplaced red pillar". However, the artist knew precisely why he was committing this supposed error: he clearly did not wish the scene to be cut in two by the pillar. (We know of other, similarly organized Annunciations, incidentally, in which the central pillar ends in the foreground.)

The colour reproduction on page 68 indicates the very poor condition of the mural today.

# Circumstances favouring unintentional impossible objects

Man first began recording his visual impressions in pictorial form a very long time ago. Of course, all pictorial representations are by definition incomplete and selective, but during that initial (yet nevertheless lengthy) phase, only pictographic elements were reproduced. As objects began to be depicted in greater detail, however, so stereographic elements were added: human figures became three-dimensional, as did their immediate surroundings.

As the striving for a more accurate portrayal of space grew increasingly intense, so artists discovered countless tricks and ploys with which to present a synopsis of perceived spatialities on a two-dimensional surface. This same progression can be traced in every culture in which representation has developed into "art", and in some cases it has led to the flowering of identical artistic ideals: Greece in the 5th century and Italy around 1425 both arrived at a centralized perspective, for example, while an axonometric perspective was preferred e.g. in Japan. We can expect to find unintentional impossible objects wherever an almost self-contained system of rep-

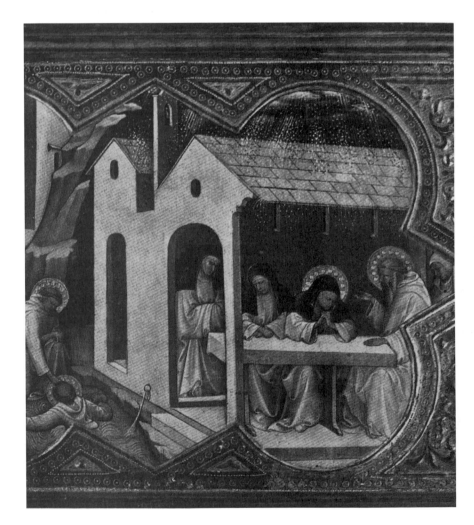

35  Lorenzo Monaco, detail from the predella of the "Coronation of the Virgin", 1413, Uffizi, Florence

36  Pietro Lorenzetti, altarpiece, first half of the 14th century, Uffizi, Florence

resenting space has been established. Such systems enable artists to reproduce spatial relationships with a high degree of accuracy; where they fail, this sometimes emerges in the form of spatial contradictions within the picture. Figures 35 and 36 show two works, one by Lorenzo Monaco and the other by Pietro Lorenzetti, dating from the period prior to the invention of centralized perspective. Both artists have managed to establish a spatially coherent floor, but neither has succeeded in incorporating the ceiling without ambiguity. In both cases, what is clearly an interior rear wall in the lower half of the picture appears at the top both to lie much further away and to project forward – almost as if it were an exterior wall. The human figures thereby seem to sit both inside and outside the building at once. An even older painting from Ochrid (fig. 37) conceals a spatial contradiction in its portrayal of Mary's throne. The baldachin at the top is spatially coherent and is correctly related to the foot of the throne by the pillar on the left. This is not the case with the right-hand pillar: the artist has clearly shied away from overlapping the figure of Mary, and a spatial contradiction has arisen. The oldest impossible object currently known to us is a miniature from the 11th century (cf. p. 68).

# Impossible objects as a sign of cultural change

Centralized perspective, together with the form of perception which accompanies it, represents a binding rule governing the representation of space which we cannot simply abandon without a second thought. We have lived with its maxims for five and a half centuries and judge all representations according to perspective criteria.

Around 1900 a number of new trends began to emerge within the arts. Of the many characteristics distinguishing these movements, one of the most striking was the rejection of traditional spatial representation. One relatively well-defined movement which subsequently emerged, and which became known as Op (or Optical) Art, concerned itself with optical effects and examined the particular way in which our brain processes information. The fact that Op Art is generally dismissed as a passing phenomenon in the history of art reflects first and foremost the selectivity of those writing about art, many of whom have failed to recognize the fact that Op Art is based on the workings of our awareness of living. Op Art has nevertheless become a widely-acknowledged concept within the applied arts and the world of advertising.

While impossible objects demonstrate points of contact with Op Art, it is well possible that they attract interest for more profound reasons. There is no suggestion of any rejection of the laws of spatial representation; on the contrary, impossible objects not only accept and on occasion infringe such laws, but indeed exploit them to create a taut spatiality. The future will show whether the widening interest in impossible objects is indeed more than merely a short-lived artistic experiment. Even today, however, it can be argued that we are concerned here not just with an artistic statement, but rather with a fundamental revision of Western thinking and experience. In 1934 the time was not yet ripe for the work of Oscar Reutersvärd; barely 25 years later, Escher's images captivated broad sections of the public. Escher's style of drawing was comfortably conventional, and thus it was not his manner of expression which attracted such widespread interest, but his sensational subject matter: the exploration of the functioning of our brain. Impossible objects are not the exclusive property of art, however, nor do they belong primarily to the world of mathematical science. Impossible objects can be created amateurishly and inexpertly, and yet still exert a fascination even for those with no head for geometrical formulae. They radiate an aura of self-revelation which directly appeals to a newly-acquired human sensibility. Impossible objects are a sign of this cultural change.

# Misunderstandings surrounding impossible objects

Science has many theories which also appeal strongly to a lay public – the "black holes" which have captured the general imagination in our own times are a case in point. Einstein's theory of relativity, the fourth dimension, and non-Euclidean geometry similarly remain very popular. Unfortunately, what remains after the simplifications of third-hand popularization does little justice to the precisely-localized scientific content of the original theory. Some authors have thus been prompted to link the phenomenon of "impossible objects" to scientific concepts shrouded in mystery.

In his – highly recommendable – introduction to Reutersvärd's second book, *Omöjliga figurer i färg,* Carlo Bresti examines in detail attempts to create four-dimensional figures. He thereby arrives at the conclusion that, in this respect, impossible objects represent a breakthrough in art: "As the twentieth century's flight from three-dimensionality has long since taken us down a one-way street to the regions of two-dimensionality, so the art of the next century will flee in the opposite direction, into the realm of the fourth dimension, where continuous steps and triangles with angles totalling 270 degrees will be common accessories."

This has no foundation: even if we incorporate the fourth dimension, a continuous flight of stairs still remains an impossible object, while even in the fourth dimension the angles of a triangle total precisely 180 degrees.

The search for a four-dimensional equivalent of an impossible object is nevertheless valid. Indeed, Roger Penrose began looking in 1976, but published nothing on his results. Scott E. Kim (who corresponded with Penrose on the subject) produced an article in 1978 in which he gave a detailed description of an impossible four-dimensional tri-bar, together with instructions on how to reproduce it in three dimensions. Although this "four-dimensional drawing" (drawing in the fourth dimension involves a reproduction in three dimensions!) perhaps means little without the detailed accompanying description of how it arose, we have here reproduced an il-

37 Annunciation, Byzantine icon, early 14th century, National Museum, Ochrid

it (fig. 38). We are also currently waiting for the *Continually ascending staircase in four dimensions* promised in the same article.

We have already noted that Professor J.H. van den Berg sought to establish parallels between Piranesi's *Carceri* and non-Euclidean geometry. Reutersvärd does the same when writing about his own impossible objects.

Non-Euclidean geometry was similarly one of the topics which arose in the course of my correspondence with the Belgian artist Mathieu Hamaekers. In connection with his superb models of impossible objects, constructed out of curved, twisted bars (cf. Chapter 7), he wrote: "The methods I have developed are based on the geometries of Riemann and Lobachevski. It would be possible to give every culture its own aesthetic, because non-Euclidean modelling offers an infinite number of possibilities. It is important that each culture should be able to express its individuality even in the twenty-first century. This same modelling can also be a compromise between the organic and the mathematical."

While most of us have a vague notion of the fourth dimension, the precepts of non-Euclidean geometry demand closer examination.

Euclid based his geometric system on five axioms (propositions which, although undemonstrated, are accepted as self-evident). Axioms are an indispensable condition of any system of logic, for each proof must be built either upon the preceding proof or upon a proposition (premise) — in this case, Euclid's axioms. Axioms must be used sparingly, in order that something which might have been proved by preceding axioms should not itself be made an axiom.

The fifth Euclidean axiom occupies a special position. It can be formulated as follows: "Through a point P, which does not lie on a given line *l*, it is possible to draw, in the plane in which both *l* and P lie, a single line which runs parallel to *l*."

Up until the first quarter of the last century, leading mathematicians were more or less convinced that the fifth axiom could be proved with the help of the other axioms, although every attempt in this direction failed. In 1829, Lobachevski showed that dropping the fifth Euclidean axiom resulted in an entirely different geometry. He replaced the fifth axiom by the thesis that an infinite number of lines can be drawn through P which run parallel to line 1. However much this axiom may appear to contradict our everyday experience, it was nevertheless possible to deduce from it a geometry without inner contradictions. A quarter of a century later, Riemann appeared on the scene with a geometry in which Euclid's fifth axiom was replaced by the postulate that no single line can be drawn through a point P outside the line 1 which is parallel to line 1.

In elaborating these geometries further, we find that their fifth axioms each have different consequences. Thus in Euclid's geometry, the sum of the angles of a triangle is always 180 degrees. In Lobachevski's geometry, the angles of a triangle always total less than 180 degrees, while Riemann's geometry produces triangles whose angles always total more than 180 degrees. We must emphasize, however, that all this has little or nothing to do with impossible objects, nor

Figure 38

with their spatial realization in the form of models. For while their geometrical models can be described precisely in Euclidean terms, the impossible objects themselves defy definition even in non-Euclidean geometries. They continue to owe their fascination and "possibility" – their reality, in other words – to the manner in which our visual system functions.

In the field of logic, too, attempts have been made to establish a connection between impossible objects and paradoxes. If we take the term "paradox" in its broadest sense, we can speak without hesitation of logical and visual paradoxes. In this case, impossible objects surely fall into the category of visual paradoxes.

Concentrating upon the structure of a logical (perhaps even linguistic) paradox, however, will certainly not lead to a better understanding of impossible objects. M.J. Cresswell has attempted to define impossible objects using the categories of logic. Although an interesting approach, it casts no new light on their nature. From the literature upon which he draws, moreover, it is clear that he had little opportunity to orientate himself within the fields of the functioning of the visual system and research into impossible objects. In his conclusion, he simply expresses the hope that new light may be shed on the problems from the point of view of logic and semantics, and by none other than ... impossible objects!

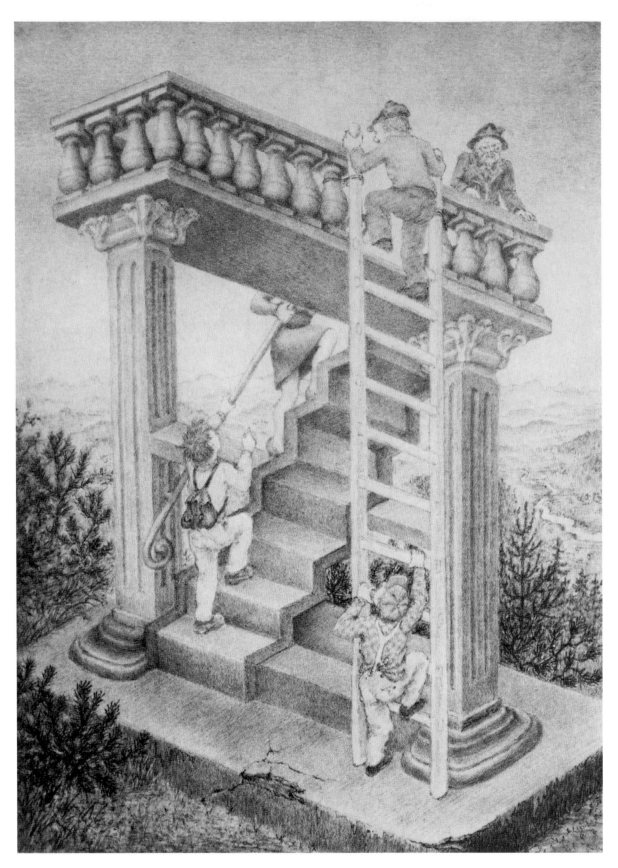

39  Sandro del Prete, "Winding staircase up to Belvédère II", pencil drawing

# 7 Models

Of course it is impossible to build a real-life, three-dimensional model of an impossible object; if you could, it wouldn't be one!

When we talk of a model of an impossible object, we mean a three-dimensional object which can be made to look like an impossible object if viewed or photographed from a certain angle. Such a model, incidentally, bears no similarity to the impossible object which is perceived by the EYE. Figure 1 shows a photograph of an impossible four-bar in which the true nature of the model is revealed by a mirror. It is patently clear that no similarity exists between the object and the image in the mirror.

As the first impossible objects became known, people lost no time in trying to make models of them. One of the first such models, very popular in its day, was the *Crazy crate,* a model of Escher's impossible cube produced by American opthalmologist Cochran out of two separate pieces.

For almost every impossible object we can invent a number of different models. Figure 2 demonstrates how we continue to see one and the same triangle, ABC, however differently oriented its lines in space. The lines themselves can assume all sorts of different forms and be broken or curved – projected onto our retina, they always supply the same image.

If we take bars instead of lines and trim their ends appropriately, the EYE perceives their spatial arrangement as an impossible tri-bar.

1 Bruno Ernst, photograph of an impossible four-bar and its reflection in the mirror.

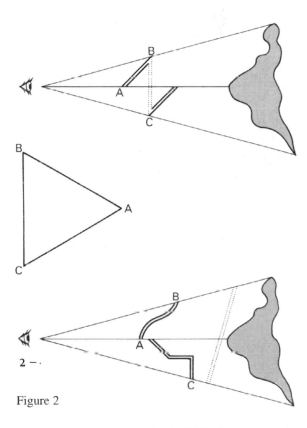

Figure 2

# The Ames transformation

The way in which three-dimensional constructions acquire, through their projection onto the retina, a spatial coherence which does not accord with their actual spatial arrangement we shall call the "Ames transformation", and the result the "Ames image". Every model of an impossible object produces, by means of the Ames transformation, an Ames image in the form of an impossible object, although this naturally does not mean that all Ames images are impossible objects.

The majority of models are very obvious and hence less interesting. It is possible to apply certain stipulations to the Ames arrangement, however, to make it more challenging. We may thus insist that it should be as simple as possible, for example, or that it should form a closed figure, or that the arrangement itself should have an attractive geometric form, etc.

The following illustrations offer a selection of models; explanatory notes are provided in the accompanying captions.

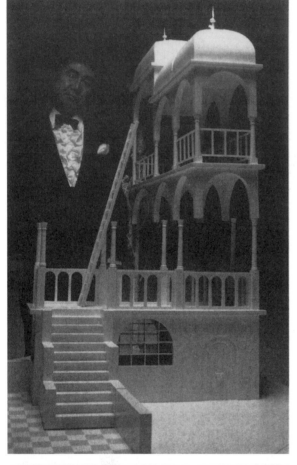

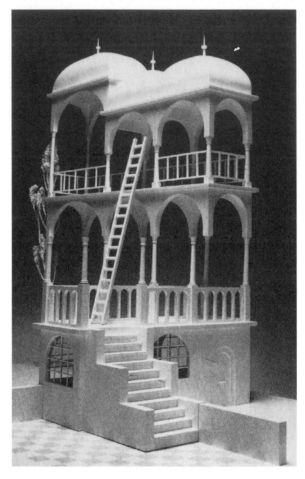

3 Shigeo Fukuda, models of Escher's Belvédère

4 Mathieu Hamaekers pictured with an impossible cuboid; the model contains a number of curved bars.

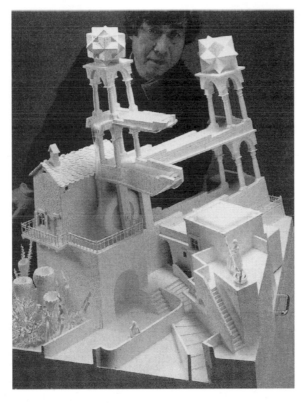

5 Shigeo Fukuda, model of Escher's "Waterfall", photographed from an angle revealing the gaps in the model.

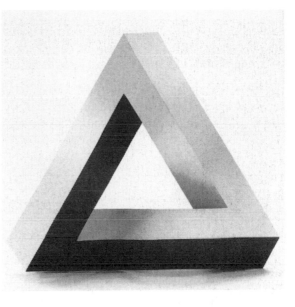

6 Mathieu Hamackers, model of an impossible tri-bar; front view

7 The same model rotated through 45°

8 The same model rotated through 90°

# Bibliography

Further reading on impossible objects and ambiguous figures:

B. d'Amore, *F. Grignani, Pitture, Sperimentali e Graphic Design,* Commune di Reggio Emilia, 1979

M. Anno, *Strange Pictures,* Tokyo: Fukuikan Shoten, 1968; French edition: *Jeux de constructions,* L'école des loisirs, Paris, 1970

M. Anno, *The Unique World of Mitsumasa Anno: Selected Illustrations 1969-1977,* Kodansha Ltd., Tokyo, 1977

F. Attneave, "Multistability in perception", *Scientific American,* vol. 225, no. 6, 1971, pp. 62-71 and December 1971, pp. 91-99

T.O. Binford, "Inferring surfaces from images", *Artificial Intelligence,* vol. 17, no. 1, pp. 205-244

I. Chakravarty, "A generalized line and junction labeling scheme with applications to scene analysis", IEEE *Trans. on Pattern Analysis and Machine Intelligence,* vol. PAMI-I, no. 2, 1979, pp. 202-205

*Challenge to Geometry – Oscar Reutersvärd, Zenon Kulpa – Impossible figures,* Art Museum of Lodz, Lodz 1984, exhibition catalogue

M.B. Clowes, "On seeing things", *Artificial Intelligence,* vol. 2, no. 3, 1971, pp. 79 -116

M.B. Clowes, "Scene analysis and picture grammars", in: F. Nake and A. Rosenfeld, eds., *Graphic Languages (Proc. IFIP Working Conf. on Graphic Languages,* Vancouver, 1972), Amsterdam 1972, pp. 70-82; also in: *Machine Perception of Patterns and Pictures,* Institute of Physics, London and Bristol, 1972, pp. 243-256

T.M. Cowan, "The theory of braids and the analysis of impossible figures", *Journal of Mathematical Psychology,* vol. 11, no. 3, 1974, pp. 190-212

T.M. Cowan, "Supplementary report: braids, side segments, and impossible figures", *Journal of Mathematical Psychology,* 1977, 16, pp. 254-260

T.M. Cowan, "Organizing the properties of impossible figures", *Perception,* vol. 6, no. 1, 1977, pp. 41-56

T.M. Cowan and R. Pringle, "An investigation of the cues responsible for figure impossibility", *Journal of Experimental Psychology; Human perception and performance,* vol. 4, no. 1, 1978, pp. 112-120

K. Critchlow, *Order in Space,* The Viking Press Inc., New York, 1970

S.W. Draper, "The Penrose triangle and a family of related figures", *Perception,* vol. 7, 1978, pp. 283-296

S.W. Draper, "The use of gradient and dual space in line drawing interpretation", *Artificial Intelligence,* vol. 17, no. 1, 1981, pp. 461-508

B. Ernst, *The Magic Mirror of M.C. Escher,* Tarquin Publications, Norfolk, 1985

B. Ernst, *Adventures with Impossible Figures,* Tarquin Publications, Norfolk, 1986

G. Falk, "Interpretation of imperfect line-data as a 3-D scene", *Artificial Intelligence,* vol. 3, no. 2, 1972, pp. 101-144

C. French, "Computer art – a load of quasi-spherical objects?" PAGE (*Computer Arts Society quarterly*), no. 44, 1980, pp. 1-12

M. Gardner, "Of optical illusions from figures that are undecidable to hot dogs that float", *Scientific American,* 222, 1970, pp. 124-127

R.L. Gregory, "Visual Illusions", *Scientific American,* November 1968, pp. 48-58

R.L. Gregory, "The confounded eye", in: R.L. Gregory and E.H. Gombrich, eds., *Illusion in Nature and Art,* Duckworth, London/Scribners, New York, 1973, pp. 49-95

J. Guiraud and P. Lison, *Systematique des figures reversibles,* Gestetner, Brussels, 1976

A. Guzman, *Computer recognition of three-dimensional objects in a visual scene,* MIT Artificial Intelligence Laboratory, Cambridge (MA), 1968

A. Guzman, "Decomposition of a visual scene into three-dimensional bodies", AFIPS *Proc. of FJCC,* vol. 33, Thompson Book, New York, 1968, pp. 291-304; also in: A. Gresselli (ed.), *Automatic interpretation and classification of images,* Academic Press, New York, 1969, pp. 243-276

W.F. Harris, "Perceptual singularities in impossible pictures represent screw dislocations", *South African Journal of Science,* 1973, 69, pp. 10-13

J. Hochberg and V. Brooks, "The psychophysics of form: reversible – perspective drawings of spatial objects", *American Journal of Psychology,* vol. 73, 1960, pp. 227-254

D.A. Huffman, "Impossible objects as nonsense sentences", in: B. Melzer and D. Michie (eds.), *Machine Intelligence* 6, Edinburgh University Press, 1971, pp. 295-323

D.A. Huffman, "A duality concept for the analysis of polyhedral scenes" in: E.W. Elcock and D. Michie (eds.), *Machine Intelligence* 8, Ellis Horwood, Chichester/Halsted, New York, 1977, pp. 475-492

D.A. Huffman, "Realizable configurations of lines in pictures of polyhedra", in: E.W. Elcock and D. Michie, eds., *Machine Intelligence* 8, Ellis Horwood, Chichester/Halsted, New York, 1977, pp. 493-509

D.A. Huffman, "Surface curvature and applications of the dual representation", in: A.R. Hanson and E.M. Riseman (eds.), *Computer Vision Systems,* Academic, New York, 1978, pp. 213-222

W.G. Hyzer, "Plenty of chances to go astray in photographic interpretation", *Photo Methods for Industry,* January 1970, pp. 20-24

T. Kanade, "A theory of Origami world", *Artificial Intelligence,* vol. 13, no. 3, 1980, pp. 279-311

T. Kanade, "Recovery of the three-dimensional shape of an object from a single view", *Artificial Intelligence*, vol. 17, no. 1, 1981, pp. 409-460

Z. Kulpa, "Oscar Reutersvärd's exploration of impossible lands", in *150 Omöjliga figurer – Oscar Reutersvärd*, Malmö Museum, Malmö, 1981, exhibition catalogue

Z. Kulpa, "Are impossible figures possible?", *Signal Processing*, vol. 5, no. 3, 1983, pp. 201-220

Z. Kulpa, "Putting order in the impossible", in: E. Térouanne (ed.), *Proc. 16th Meeting of the European Mathematical Psychology Group, (Montpellier, 8-11 Sept. 1985)*, Université Paul Valéry, Montpellier, 1985, pp. 127-144

A.K. Mackworth, "Interpreting pictures of polyhedral scenes", *Artificial Intelligence*, vol. 4, 1973, pp. 121-137, vol. 4, 1977, pp. 54-86

A.K. Mackworth, "Model-driven interpretation in intelligent vision systems", *Perception*, vol. 5, 1976, pp. 349-370

A.K. Mackworth, "How to see a simple world: an exegesis of some computer programs for scene analysis", in: E.W. Elcock and D. Michic (eds.), *Machine Intelligence* 8, Ellis Horwood, Chichester/Halsted, New York, 1977, pp. 510-537

R. Nevatia, *Machine Perception*, Prentice-Hall, Englewood Cliffs NJ, 1982

B. Raphael, *The thinking computer – Mind inside matter*, W.H. Freeman, San Francisco, 1976

O. Reutersvärd, *Omöjliga figurer*, Bokförlaget Doxa AB, Bodafors, 1982; Dutch edition: *Onmogelijke figuren*, Meulenhoff/Landshoff, Amsterdam 1983

L.G. Roberts, "Machine perception of three-dimensional solids", in: J.T. Tippet et al. (eds.), *Optical and Electro-optical Information Processing*, MIT Press, Cambridge (MA), 1965, pp. 159-197

J.O. Robinson and J.A. Wilson, "The impossible colonnade and other variations of a well-known figure", *British Journal of Psychology*, vol. 64, no. 3, 1973, pp. 363-365

P.V. Sankar, "A vertex coding scheme for interpreting ambiguous trihedral solids", *Computer Graphics and Image Processing*, vol. 6, 1977, pp. 61-89

R. Shapira and H. Freeman, "A cyclic-order property of bodies with three-face vertices", IEEE *Trans. on Computers*, vol. C-26, no. 10, 1977, pp. 1035-1039

K. Sugihara, "Dictionary-guided scene analysis based on depth information", in: *Report on Pattern Information Processing Systems* No. 13, Electrotechnical Laboratory, Tokyo, 1977

K. Sugihara, "Picture language for skeletal polyhedra", *Computer Graphics and Image Processing*, vol. 8, 1978, pp. 382-405

K. Sugihara, "Studies on mathematical structures of line drawings of polyhedra and their applications to scene analysis", *Res. Electrotech. Lab.*, no. 800, 1979

K. Sugihara, "Classification of impossible objects", *Perception*, vol. 11, 1982, pp. 65-74

K. Sugihara, "Mathematical structures of line drawings of polyhedrons – toward man-machine communication by means of line drawings", IEEE *Trans. on Pattern Analysis and Machine Intelligence*, vol. PAMI – 4, no. 5, 1982, pp. 458-469

K. Sugihara, *An algebraic approach to shape-from-image problems,* Res. Note RNS 83-01, Dept. of Information Science, Faculty of Engineering, Nagoya University, 1983

E. Térouanne, "Impossible figures and interpretations of polyhedral figures", *Journal of Mathematical Psychology*, vol. 27, 1983, pp. 370-405

E. Térouanne, "On a class of 'impossible' figures: a new language for a new analysis", *Journal of Mathematical Psychology*, vol. 22, no. 1, 1983, pp. 24-47

E.B. Thro, "Distinguishing two classes of impossible objects", *Perception*, vol. 12, no. 6, 1983, pp. 733-751

V. Vasarely and M. Joray, *Vasarely*, Editions du Griffon, 1971

D. Waltz, "Understanding line drawings of scenes with shadows", in: P. H. Winston (ed.), *The Psychology of Computer Vision*, McGraw Hill, New York, 1975, pp. 19-91

W. Whiteley, "Realizability of polyhedra", in: *Structural Topology*, vol. 1, University of Montreal Press, Montreal, 1979, pp. 46-58

P.H. Winston (ed.), *The Psychology of Computer Vision*, McGraw-Hill, New York 1975

A.W. Young and J.B. Deregowski, "Learning to see impossible", *Perception*, vol. 10, 1981, pp. 91-105

J.M. Yturralde, "Ambiguous structures", in: D.W. Brisson (ed.), *Hypergraphics – Visualizing Complex Relationships in Art, Science and Technology*, Westview Press, Boulder (CO), 1978, pp. 177-185

Impossible objects are phenomena which cannot exist but which we can see all the same. They captivate the imagination and tantalize the viewer with their mysterious fascination. They illuminate something of the remarkable process of vision, as our brain is forced to accept a situation of visual conflict which it never encounters in the outside world. Amongst the first to concern themselves with impossible objects were Oscar Reutersvärd and M.C. Escher.

When Bruno Ernst – the pseudonym of J.A.F. Rijk – began preparing an exhibition of the work of these artists in 1983, it emerged that many other artists all over the world had also discovered impossible and ambiguous objects as a source of inspiration. The publication of more than one hundred articles since 1970 is incontrovertible evidence of the close attention which the subject has attracted amongst theoreticians, too. This interest prompted the author to undertake an exhaustive study of the field, in the course of which he encountered no less than fifty artists working with impossible objects. The results of his investigations are found in this book, in which Bruno Ernst guides the reader, with the aid of numerous examples and illustrations, through the wonderful world of optical illusions and visual realities.

The Dutch author Bruno Ernst has closely followed the development of the works of M.C. Escher from 1956 onwards, and has published his observations in, amongst others, *The Magic Mirror of M.C. Escher* and *Leven en werk van M.C. Escher*.

# M.C. Escher®

## The Graphic Work

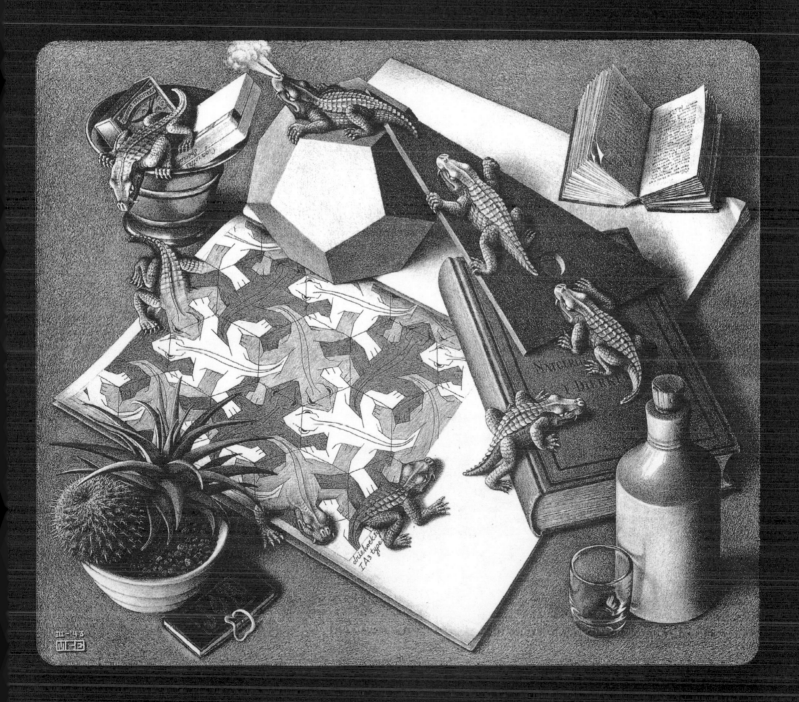

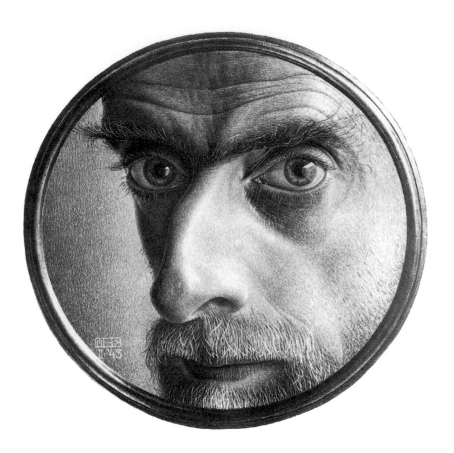

Front cover:
Reptiles, 1943
Lithograph, 33.5 x 38.5 cm

Illustration page 2:
Detail from: Self-portrait, 1943
Lithographic crayon
Diameter about 18 cm

EVERGREEN is an imprint of Benedikt Taschen Verlag GmbH

© 1992 Benedikt Taschen Verlag GmbH
Hohenzollernring 53, D-50672 Köln
© 1989 for all M. C. Escher reproductions:
Cordon Art – Baarn – Holland
English translation: John E. Brigham
This title was published in 1959 by
Koninklijke Erven J. J. Tijl N. V.,
Zwolle, under the title
M. C. Escher »Grafiek en Tekeningen«.

Printed in Germany
ISBN 3-8228-9634-9

# Contents

**Eight heads**, woodcut stamped print, 1922.
This is the first regular division of a plane surface carried
out by the artist when he was a pupil of the School of
Architecture and Decorative Arts in Haarlem. It indicates
at what an early stage he felt drawn to rhythmic repetition.
In the original wood-block eight heads were cut, four
female and four male. Space can be filled to infinity with
contiguous prints.

# Introduction

Anyone who applies himself, from his early youth, to the practice of graphic techniques may well reach a stage at which he begins to hold as his highest ideal the complete mastery of his craft. Excellence of craftsmanship takes up all his time and so completely absorbs his thoughts that he will even make his choice of subject subordinate to his desire to explore some particular facet of technique. True enough, there is tremendous satisfaction to be derived from the acquisition of artistic skill and the achievement of a thorough understanding of the properties of the material to hand, and in learning with true purposefulness and control to use the tools which one has available — above all, one's own two hands!

I myself passed many years in this state of self-delusion. But then there came a moment when it seemed as though scales fell from my eyes. I discovered that technical mastery was no longer my sole aim, for I became gripped by another desire, the existence of which I had never suspected. Ideas came into my mind quite unrelated to graphic art, notions which so fascinated me that I longed to communicate them to other people. This could not be achieved through words, for these thoughts were not literary ones, but mental images of a kind that can only be made comprehensible to others by presenting them as visual images. Suddenly the method by which the image was to be presented became less important than it used to be. One does not of course study graphic art for so many years to no avail; not only had the craft become second nature to me, it had also become essential to continue using some technique of reproduction so that I could communicate simultaneously to a large number of my fellow men that which I was aiming at.

If I compare the way in which a graphic sheet from my technique period came into being with that of a print expressing a particular train of thought, then I realize that they are almost poles apart. What often happened in the past was that I would pick out from a pile of sketches one which it seemed to me might be suitable for reproduction by means of some technique that was interesting me at that moment in time. But now it is from amongst those techniques, which I have to some degree mastered, that I choose the one which lends itself more than any other, to the expression of the particular idea that has taken hold of my mind.

Nowadays the growth of a graphic image can be divided into two sharply defined phases. The process begins with the search for a visual form such as will interpret as clearly as possible one's train of thought. Usually a long time elapses before I decide that I have got it clear in my mind. Yet a mental image is something completely different from a visual image, and however much one exerts oneself, one can never manage to capture the fullness of that perfection which hovers in the mind and which one thinks of, quite falsely, as something that is "seen". After a long series of attempts, at last — when I am just about at the end of my resources — I manage to cast my lovely dream in the defective visual mould of a detailed conceptual sketch.

Regular division of a plane nr. 99, VIII 1954

After this, to my great relief, there dawns the second phase, that is the making of the graphic print; for now the spirit can take its rest while the work is taken over by the hands.

In 1922, when I left the School of Architecture and Ornamental Design in Haarlem, having learnt graphic techniques from S. Jessurun de Mesquita, I was very much under the influence of this teacher, whose strong personality certainly left its mark on the majority of his pupils. At that period the woodcut (that is to say the cutting with gouges in a side-grained block of wood, usually pear) was more in vogue with graphic artists than is the case today. I inherited from my teacher his predilection for side-grained wood, and one of the reasons for my ever-lasting gratitude to him stems from the fact that he taught me how to handle this material. During the first seven years of my time in Italy, I used nothing else. It lends itself, better than the costly end-grained wood, to large-sized figures. In my youthful recklessness I have gouged away at enormous pieces of pearwood, not short of three feet in length and perhaps two feet wide. It was not until 1929 that I made my first lithograph, and then in 1931 I tried my hand for the first time at wood-engraving, that is to say engraving with burins on an end-grain block. Yet even today the woodcut remains for me an essential medium. Whenever one needs a greater degree of tinting or colouring in order to communicate one's ideas, and for this reason has to produce more than one block, the woodcut offers many advantages over wood-engraving, and there have been many paints in recent years that I could not have produced had I not gained a thorough knowledge of the advantages of side-grained wood. In making a colourprint I have often combined both of these raised relief techniques, using end-grain for details in black, and side-grain for the colours.

The period during which I devoted such enthusiasm to my research into the characteristics of graphic materials and during which I came to realize the limitations that one must impose on oneself when dealing with them, lasted from 1922 until about 1935. During that time a large number of prints came into being (about 70 woodcuts and engravings and some 40 lithographs). The greater

Regular division of a plane with two congruent motifs

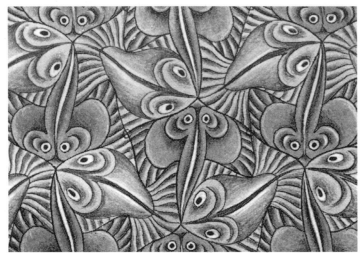
Regular division of a plane with two different motifs

number of these have little or no value now, because they were for the most part merely practice exercises: at least that is how they appear to me now.

The fact that, from 1938 onwards, I concentrated more on the interpretation of personal ideas was primarily the result of my departure from Italy. In Switzerland, Belgium and Holland where I successively established myself, I found the outward appearance of landscape and architecture less striking than that which is particularly to be seen in the southern part of Italy. Thus I felt compelled to withdraw from the more or less direct and true-to-life illustrating of my surroundings. No doubt this circumstance was to a high degree responsible for bringing my inner visions into being.

On one further occasion did my interest in the craft take the upper hand again. This was in 1946 when I first made the acquaintance of the old and highly respectable black art technique of the mezzotint, whose velvety dark grey and black shades so attracted me that I devoted a great deal of time to the mastery of this copper-plate intaglio, a process that has today fallen almost entirely into disuse. But before long it became clear that this was going to be too great a test of my patience. It claims far too much time and effort from anyone who, rightly or wrongly, feels he has no time to lose. Up to the present I have, in all, produced no more than seven mezzotints, the last one being in 1951.

I have never practised any other type of intaglio. From the moment of my discovery, I have deliberately left etching and copper-plate engraving to one side. The reason for this can probably be traced to the fact that I find it preferable to delineate my figures by means of tone-contrast, rather than by linear contour. The thin black line on a white background, which is characteristic of etching and copper-engraving, would only be of use as a component part of a shaded area, but it is not adequate for this purpose. Moreover, with intaglio, one is much more tied to white as a starting point than is the case with raised relief and planography. The drawing of a narrow white line on a dark surface, for which raised relief methods are eminently suitable, is practically impossible with intaglio, while on the other hand, a thin black line on a white background can be satisfactorily achieved, albeit as a rather painstaking operation, in woodcuts and wood-engravings.

Apart from prints 1 to 5, all the numbered reproductions in this book were made with a view to communicating a specific line of thought. The ideas that are basic to them often bear witness to my amazement and wonder at the laws of nature which operate in the world around us. He who wonders discovers that this is in itself a wonder. By keenly confronting the enigmas that surround us, and by considering and analyzing the observations that I had made, I ended up in the domain of mathematics. Although I am absolutely innocent of training or knowledge in the exact sciences, I often seem to have more in common with mathematicians than with my fellow artists.

On reading over what I wrote at the beginning of this introduction, about the particular representational character of my prints, I feel it may be rather illogical to devote so many words to it, not only here but beside each separate reproduction as well. It is a fact, however, that most people find it easier to arrive at an understanding of an image by the round-about method of letter symbols than by the direct route. So it is with a view to meeting this need that I myself have written the text. I am well aware that I have done this very inadequately, but I could not leave it to anyone else, for — and here is yet another reason for my astonishment — no matter how objective or how impersonal the majority of my subjects appear to me, so far as I have been able to discover, few, if any, of my fellow-men seem to react in the same way to all that they see around them.

M. C. Escher

# Classification and description
# of the numbered reproductions

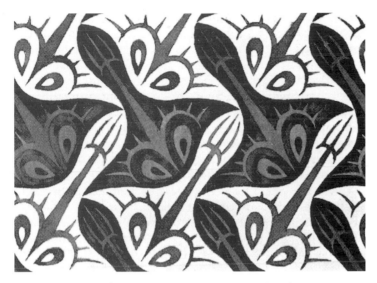

Regular division of a plane with two symmetrical and congruent motifs

## I. Early prints 1-7

The seven prints in this group, selected from a large number which were made before 1937, display no unity as far as their subject matter is concerned. They are all representations of observed reality. Even no. 7 (Dream), although pure fantasy, consists of elements which, taken separately, are realistically conceived.

**1. Tower of Babel,** woodcut, 1928, 62 x 38.5 cm
On the assumption that the period of language confusion coincided with the emergence of different races, some of the building workers are white and others black. The work is at a standstill because they are no longer able to understand each other. Seeing that the climax of the drama takes place at the summit of the tower which is under construction, the building has been shown from above, as though from a bird's eye view. This called for a very sharply receding perspective. It was not until twenty years later that this problem was thoroughly thought out. (see 63, Another World et seq).

**2. Castrovalva,** lithograph, 1930, 53 x 42 cm
A mountainous landscape in the Abruzzi.

**3. Palm,** wood-engraving printed from two blocks, 1933, 39.5 x 29.5 cm

**4. Portrait of the engineer G.A. Escher,** father of the artist, in his 92nd year, lithograph, 1935, 26.5 x 21 cm

In the case of the portraiture of someone with strongly asymetrical features, a great deal of the likeness is lost in the print, for this is the mirror image of the original work. In this instance a contraprint was made; that is to say, while the ink of the first print was still wet on the paper, this was printed on to a second sheet, thereby annulling the mirror image. The ''proof'' brings out the signature that he himself wrote on the stone with lithographic chalk and which is now to be seen, doubly mirrored, back in its original form.

**5. Fluorescent sea,** lithograph, 1933, 33 x 24.5 cm

**6. St. Peter, Rome,** wood-engraving, 1935, 24 x 32 cm
The convergence of the vertical lines towards the nadir suggests the height of the building in which the viewer finds himself, together with the feeling of vertigo that takes hold of him when he looks down.

**7. Dream,** woodcut, 1935, 32 x 24 cm
Is the bishop dreaming about a praying locust, or is the whole conception a dream of the artist?

---

## II. The regular division of a plane 8-35

This is the richest source of inspiration that I have ever struck; nor has it yet dried up. The symmetry drawings on the foregoing and following pages show how a surface can be regularly divided into, or filled up with, similar-shaped figures which are contiguous to one another, without leaving any open spaces.
The Moors were past masters of this. They decorated walls and floors, particularly in the Alhambra in Spain, by placing congruent, multi-coloured pieces of majolica together without leaving any spaces between. What a pity it is that Islam did not permit them to make ''graven images''. They always restricted themselves, in their massed tiles, to designs of an abstract geometrical type. Not one single Moorish artist, to the best of my knowledge, ever made so bold (or maybe the idea never occurred to him) as to use concrete, recognizable, naturistically conceived figures of fish, birds, reptiles or human beings as elements in their surface

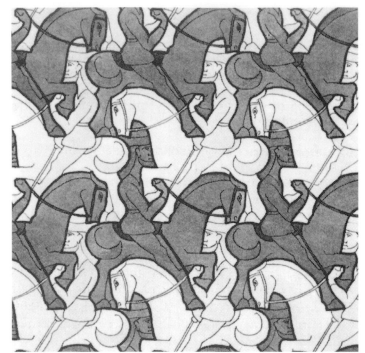

Symmetry drawing A

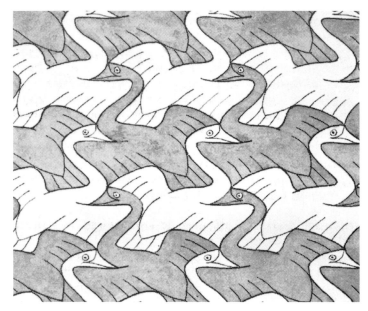

Symmetry drawing B

Symmetry drawing C

coverage. This restriction is all the more unacceptable to me in that the recognizability of the components of my own designs is the reason for my unfailing interest in this sphere.

### a. Glide Reflexion 8-9-10

Anyone who wishes to achieve symmetry on a flat surface must take account of three fundamental principles of crystallography: repeated shifting (translation); turning about axes (rotation) and gliding mirror image (reflexion). It would be an exaggeration to attempt to discuss all three of them in this short treatise, but seeing that glide reflexion is definitely displayed in three of my prints, I must pay special attention to it.

**8. Swans,** wood-engraving, 1956, 20 x 32 cm
The swans in this example of glide reflexion are flying round in a closed circuit formed like a recumbent figure eight. In order to pass over to its mirror image, each bird has got to raise itself up like a flat biscuit sprinkled with sugar on one side and spread with chocolate on the other. In the middle, where the white and black streams cross, they fill up each other's open spaces. So a completely square surface pattern is created. (See also symmetry drawing B.)

**9. Horsemen,** woodcut printed from three blocks, 1946, 24 x 45 cm
In order to indicate that the light-shaded horsemen are the mirror images of the dark-shaded ones, a circular band is portrayed on which a procession of horsemen moves forward. One can imagine it to be a length of material, with a pattern woven into it, the warp and woof being of different colours. The dark knights on the light background thereby change colour on the reverse side of the band. In the middle both front and back have become enmeshed, and now it appears that light and dark horsemen together fill up the space completely. (See also symmetry drawing A.)

**10. Two intersecting planes,** woodcut printed from three blocks, 1952, 22 x 32 cm
Two thin, flat rectangular boards intersect each other at a slight angle. Holes have been sawn in each board leaving openings shaped like fishes and birds. The holes in one board can be filled up by the remaining parts of the other board. The jigsaw pieces of the one are mirror images of those in the other (see also symmetry drawing C).

### b. The function of figures as a background 11-14

Our eyes are accustomed to fixing upon a specific object. The moment this happens everything round about becomes reduced to background.

**11. Day and night,** woodcut printed from two blocks, 1938, 39 x 68 cm
Grey rectangular fields develop upwards into silhouettes of white and black birds; the black ones are flying towards the left and the white ones towards the right, in two opposing formations. To the left of the picture the white birds flow together and merge to form a daylight sky and landscape. To the right the black birds melt together into night. The day and night landscapes are mirror images of

each other, united by means of the grey fields out of which, once again, the birds emerge.

**12. Sun and moon,** woodcut printed from four blocks, 1948, 25 x 27.5 cm
The subject of this coloured woodcut is once again the contrast between day and night. But in this instance the two notions are not, as in print 11, pictured as next to each other but in the same place — though not simultaneous, being separated by a leap of the mind. It is day-time when there is a sun shining in the centre, where the sun is shooting out yellow and red rays. Against this background stand out fourteen dark blue birds. As soon as one divests them of their function as objects and regards them as background, then there appear fourteen light coloured birds against a night sky, with a crescent moon in the centre and with stars, planets and a comet.

**13. Sky and water I,** woodcut, 1938, 44 x 44 cm
In the horizontal central strip there are birds and fish equivalent to each other. We associate flying with sky, and so for each of the black birds the sky in which it is flying is formed by the four white fish which encircle it. Similarly swimming makes us think of water, and therefore the four black birds that surround a fish become the water in which it swims.

**14. Sky and water II,** woodcut, 1938, 62 x 40.5 cm
Similar in subject to that in no. 13 (Sky and Water 1), except that the birds and fishes are to be seen here in direct as well as in mirror image.

**c. Development of form and contrast 15-16-17**

**15. Liberation,** lithograph, 1955, 43.5 x 20 cm
On the uniformly grey surface of a strip of paper that is being unrolled, a simultaneous development in form and contrast is taking place. Triangles, at first scarcely visible, change into more complicated figures, whilst the colour contrast between them increases. In the middle they are transformed into white and black birds, and from there fly off into the world as independent creatures. And so the strip of paper on which they were drawn disappears.

**16. Development I,** woodcut, 1937, 44 x 44 cm
Scarcely visible grey squares at the edges evolve in form and contrast towards the centre. Their growth is completed in the middle. An unsatisfactory feature of this kind of inward-directed unfolding is that there is so little space left for the freedom of movement of the most greatly developed figures: two white and two black reptiles.

**17. Verbum,** lithograph, 1942, 33 x 38.5 cm
An evolution working from the centre outwards, thus the opposite way round to the previous print, offers more space at the edges for the fully grown figures. The central word ''Verbum'' recalls the biblical story of creation. Out of a misty grey there loom triangular primeval figures which, by the time they reach the edges of the hexagon, have developed into birds, fishes and frogs, each in its own element: air, water and earth. Each kind is pictured by day and by night, and the creatures merge into each other as they move forward along the outline of the hexagon, in a clockwise direction.

**d. Infinity of number 18-27**

If all component parts are equal in size, it is impossible to represent more than a fragment of a regular plane-filling. If one wishes to illustrate an infinite number then one must have recourse to a gradual reduction in the size of the figures, until one reaches — at any rate theoretically — the limit of infinite smallness.

**18. Sphere surface with fishes,** woodcut printed from two blocks, 1958, diameter 32 cm
The previous print demonstrated a return motion towards the starting point. There now follow variations on that theme, with two cores, a starting point and an end point between which the chains of figures move. Here, as a first example, is a sphere with two poles and a network of longitudinal and latitudinal circles. Swimming spirally outwards from the one visible pole, there come alternate rows of white and black fishes. They attain their greatest size on reaching the equator and thereafter they become smaller and disappear into the other, invisible, pole on the far side of the sphere.

**19. Path of life II,** woodcut printed from two blocks, 1958, 37 x 37 cm
Here, too, the point of infinite smallness is in the centre. This time an attempt has been made to eliminate the unsatisfactory feature of an illogical limit. The area is filled with white and grey fish-shaped figures whose longitudinal axes are accentuated by black lines. Out from the central point come four series of white fish (rays) swimming head to tail in a spiral motion. The four largest specimens, which close off the square surface, change direction and colour; their white tails still belong to the centrifugal movement, but their grey heads are already turning inwards and so form part of the grey series which are moving back towards the centre.

**20. Smaller and smaller,** wood-engraving printed from four blocks, 1956, 38 x 38 cm
The area of each of the reptile-shaped elements of this pattern is regularly and continuously halved in the direction of the centre, where theoretically both infinite smallness of size and infinite greatness of number are reached. However, in practice, the wood-engraver soon comes to the end of his ability to carry on. He is dependent on four factors: 1. the quality of his wood-block, 2. the sharpness of the instrument that he is using, 3. the steadiness of his hand and, 4. his optical ability (good eyesight, plenty of light and a powerful magnifying lens). In this particular case, the halving of the figures is carried through ad absurdum. The smallest animal still possessing a head, a tail and four legs is about 2 millimetres in length. From the point of view of composition, this work is only partially satisfactory. In spite of the central limit, it remains only a fragment, because the outer edge of the pattern has been arbitrarily fixed. So a complete composition has not been achieved.

**21. Whirlpools,** wood-engraving printed from two blocks, 1957, 45 x 23.5 cm
Closely related to the foregoing picture, there is here displayed a flat surface with two visible cores. These are bound together by two white S-shaped spirals, drawn through the bodily axes of, once again, fish swimming

head to tail. But in this case they move forward in opposite directions. The upper core is the starting point for the dark-coloured series, the component members of which attain their greatest size in the middle of the picture. From then on, they come within the sphere of influence of the lower core, towards which they keep on swirling until they disappear within it. The other, light-coloured, line makes the same sort of journey but in the opposite direction. As a matter of special printing technique, I would point out that only one wood-block is used for both colours, these having been printed one after the other on the same sheet of paper, and turned 180 degrees in reflection to each other. The two prints fill up each other's open spaces.

**22. Circle limit I,** woodcut, 1958, diameter 42 cm
So far four examples have been shown with points as limits of infinite smallness. A diminution in the size of the figures progressing in the opposite direction, i.e. from within outwards, leads to more satisfying results. The limit is no longer a point, but a line which borders the whole complex and gives it a logical boundary. In this way one creates, as it were, a universe, a geometrical enclosure. If the progressive reduction in size radiates in all directions at an equal rate, then the limit becomes a circle. In the example in question (chronologically the first of the three which have been included in this book), the arrangement of the component parts still leaves much to be desired. All the lines, once again accentuated by the bodily axes, consist of alternating pairs of fish, two white ones head to head and two black ones whose tails touch. So there is no continuity here, no direction of forward movement, nor is there any unity of colour in each line.

**23. Square limit,** woodcut printed from two blocks, 1964, 34 x 34 cm
Design number 20 (Smaller and smaller) showed a pattern composed of elements continuously reduced by half as they move in the direction of the centre. A similar system of halving was adapted here, but this time moving from within outwards. The limit of the infinitely small shapes is reached on the straight sides of the square.

**24. Circle limit III,** woodcut printed from five blocks, 1959, diameter 41.5 cm
Here, the failings of the previous work are as far as possible remedied. White curved lines cut across each other and divide one another into sections, each of which equals the length of a fish. They mark the routes along which series of fish move forward, from the infinitely small, through the greatest size, to infinitely small. Each series comprises fish of only one colour. It is necessary to have at least four colours so as to get the lines of fish to contrast with each other. It is worth mentioning, from the point of view of printing technique, that five wood-blocks were made, one for the black lines and four for the colours. Each block has the shape of a right-angled segment and so has to be printed four times over in order to fill the circle. Therefore a complete copy of this print requires 4 x 5 = 20 impressions.

**25. Circle limit IV,** (Heaven and Hell), woodcut printed from two blocks, 1960, diameter 41.5 cm
Here, too, we have the components diminishing in size as they move outwards. The six largest (three white angels and three black devils) are arranged about the centre and

radiate from it. The disc is divided into six sections in which, turn and turn about, the angels on a black background and then the devils on a white one, gain the upper hand. In this way, heaven and hell change place six times. In the intermediate, "earthly" stages, they are equivalent.

**26. Fishes and scales,** woodcut, 1959, 38 x 38 cm
The final example in this group brings in two different sorts of mutation, carried out at one and the same time, that is to say both shape and size. The double process completes itself twice over. In the upper part of the print, from right to left, scales grow into fish that keep on increasing in size. In the lower half the same thing happens, but from left to right.

**27. Butterflies,** wood-engraving, 1950, 28 x 26 cm
Working downwards from the top to the centre, the white area is divided up by black contours of increasing thickness which take on ever larger butterfly shapes; these continue to develop.

### e. Story pictures 28-33

The chief characteristic of the six following prints is the transition from flat to spatial and vice versa. We think in terms of an interplay between the stiff, crystallized two-dimensional figures of a regular pattern and the individual freedom of three-dimensional creatures capable of moving about in space without hindrance. On the one hand, the members of planes of collectivity come to life in space; on the other, the free individuals sink back and lose themselves in the community. A row of identical spatial beings such as those to be found in the prints of this group often emerges to be treated as a single individual in motion. This is a static method of illustrating a dynamic fact. A few prints from each group, such as 11 (Day and night), 15 (Liberation) and 17 (Verbum) might also be counted in this category, were it not for the fact that their chief characteristic differs from that of the ones we have just been considering.

**28. Reptiles,** lithograph, 1943, 33.5 x 38.5 cm
The life cycle of a little alligator. Amid all kinds of objects, a drawing book lies open, and the drawing on view is a mosaic of reptilian figures in three contrasting shades. Evidently one of them has tired of lying flat and rigid amongst his fellows, so he puts one plastic-looking leg over the edge of the book, wrenches himself free and launches out into real life. He climbs up the back of a book on zoology and works his laborious way up the slippery slope of a set square to the highest point of his existence. Then after a quick snort, tired but fulfilled, he goes downhill again, via an ashtray, to the level surface, to that flat drawing paper, and meekly rejoins his erstwhile friends, taking up once more his function as an element of surface division.

N.B. The little book of Job has nothing to do with the Bible, but contains Belgian cigarette papers.

**29. Cycle,** lithograph, 1938, 47.5 x 28 cm
At the top right-hand corner a jolly young lad comes popping out of his house. As he rushes downstairs he loses his special quality and takes his place in a pattern of flat, grey, white and black fellow-shapes. Towards the left and

upwards these become simplified into lozenges. The dimension of depth is achieved by the combination of three diamonds which give the impression of a cube. The cube is joined on to the house from which the boy emerges. The floor of a terrace is laid with the same familiar pattern of diamond-shaped tiles. The hilly landscape at the top is intended to display the utmost three-dimensional realism, while the periodic pattern at the lower part of the picture shows the greatest possible amount of two-dimensional restriction of freedom.

**30. Encounter,** lithograph, 1944, 34 x 46.5 cm
Out from the grey surface of a back wall there develops a complicated pattern of white and black figures of little men. And since men who desire to live need at least a floor to walk on, a floor has been designed for them, with a circular gap in the middle so that as much as possible can still be seen of the back wall. In this way they are forced, not only to walk in a ring, but also to meet each other in the foreground: a white optimist and a black pessimist shaking hands with one another.

**31. Magic mirror,** lithograph, 1946, 28 x 44.5 cm
On a tiled floor there stands a vertical reflecting screen out of which a fabulous animal is born. Bit by bit it emerges, until a complete beast walks away to the right. His mirror image sets off towards the left, but he seems fairly substantial, for behind the reflecting screen he appears in quite a realistic guise. First of all they walk in a row, then two by two, and finally both streams meet up four abreast. At the same time they lose their plasticity. Like pieces of a jigsaw puzzle they slide into one another, fill up each other's interstices and fade into the floor on which the mirror stands.

**32. Metamorphose,** woodcut printed from twenty-nine blocks, 1939-40 and 1967-68, 19.5 x 700 cm
A long series of changing shapes. Out of the word ''Metamorphose'' placed vertically and horizontally on the level surface, with the letters O and M (= Greek E) as points of intersection, there emerges a mosaic of white and black squares that changes into a carpet of flowers and leaves on which two bees have settled. Thereupon the flowers and leaves change back into squares again, only to be transformed once more, this time into animal shapes. To use musical terminology, we are dealing here with four-four time.

Now the rhythm changes; a third shade is added to the white and black and the measure changes to three-four time. Each figure becomes simplified and the pattern which at first was composed of squares now consists of hexagons. Then follows an association of ideas; hexagons make one think of the cells in a honeycomb, and so in every cell there appears a bee larva. The fully grown larvae turn into bees which fly off into space. But they are not vouchsafed a long life of freedom, for soon their black silhouettes join together to form a background for white fish. As these also fuse together, the interstices seem to take on the form of black birds. Similar transformations of background objects now appear several times: dark birds... light-coloured boats... dark fish... light horses... dark birds. These become simplified into a pattern of equilateral triangles which serve for a short while as a canvas on which winged letters are depicted but then

quickly turn once more into black bird shapes. Small grey birds begin to appear in the white background and then gain in size until their contours equal those of their fellows. Such areas of white that still remain take on the form of a third variety of bird so that there are now three different kinds, each with its own specific form and colour, filling the surface completely. Now for another simplification: each bird turns into a lozenge. Just as in print number 29 (Cycle), this is an opportunity to pass over to the three-dimensional, as three diamond shapes suggest a cube. The blocks give rise to a city on the sea-shore. The tower standing in the water is at the same time a piece in a game of chess; the board for this game, with its light and dark squares, leads back once more to the letters of the word ''Metamorphose''.

**33. Predestination,** lithograph, 1951, 29 x 42 cm
An aggressive, voracious fish and a shy and vulnerable bird are the actors in this drama: such contrasting traits of character lead inevitably to the denouement. A regular pattern floats like a ribbon in space. Lower down, in the middle, this picture strip is made up of fish and birds, but by a substitution of figures, only birds remain on the left side and fish on the right. Out from these gradually fading extremities, one representative of each sort breaks loose — a black, devilish fish and a white bird, all innocence, but sad to say irrevocably doomed to destruction. The fate of each is played out in the foreground.

**f. Irregular filling of plane surfaces 34-35**

The next two prints consist of figures that do not in any way repeat themselves in similar form. So they do not really belong to group II; nevertheless they were added to it because they do in fact have their surfaces filled up, with no spaces left empty.

What is more, they could never have been produced without years of training in regular surface-filling. The recognizability of their components as natural objects plays a more important role. The only reason for their existence is one's enjoyment of this difficult game, without any ulterior motive.

**34. Mosaic I,** mezzotint, 1951, 14.5 x 20 cm
Regularity of construction can be recognized in this rectangular mosaic in that, both as regards height and breadth, three light and three dark figures alternate like the squares on a chessboard. With the exception of the shapes round the edge, every white one is surrounded by four black ones and every black by four white. The sum total can immediately be ascertained: 36 pieces, 18 white and 18 black.

**35. Mosaic II,** lithograph, 1957, 32 x 37 cm
In this case the only regularity to be noted is the rectangularity of the complete surface. There are but few of the inner figures bordered by four adjacent ones. The direct environment of the frog consists of two figures; the guitar is hemmed in by three, the cock by five and the ostrich (if that is what it really is) by six. The sum total can only be arrived at by careful counting.

## III. Unlimited spaces 36-37-38

**36. Depth,** wood-engraving printed from three blocks, 1955, 32 x 23 cm
Here, too, space is divided up cubically. Each fish is found at the intersection of three lines of fish, all of which cross each other at right-angles.

**37. Cubic space division,** lithograph, 1952, 27 x 26.5 cm
Intersecting each other at right angles, girders divide each other into equal lengths, each forming the edge of a cube. In this way space is filled to infinity with cubes of the same size.

**38. Three intersecting planes,** woodcut printed from two blocks, 1954, 32.5 x 37.5 cm
Three planes intersect each other at right angles. They are indicated by square tiles with the same number of square gaps between them. Each plane recedes in perspective to a vanishing point and the three vanishing points coincide with the points of an equilateral triangle.

---

## IV. Spatial Rings and Spirals 39-46

**39. Knots,** woodcut printed from three blocks, 1965, 43 x 32 cm
Three unbroken knots are displayed here; that is to say a simple knot has been tied three times over in a cord, the ends of which run into each other. The perpendicular cross-section of each knot is different. In the top right hand example the profile is round, as in a sausage; the top left one is cruciform, with two flat bands intersecting each other at right angles; below is a square, hollow pipe with gaps through which the inside can be seen. If we start at any arbitrary point and follow a flat wall with the eye, then it appears that we have to make four rounds before we come back to our point of departure. So the pipe does not consist of four separate strips, but of one which runs through the knot four times. The knot shown at the top right-hand corner is in principle every bit as interesting, but it remains undiscussed here, as the draughtsman hopes to devote a more detailed print to it in the future.

**40. Moebius band II,** woodcut, printed from three blocks, 1963, 45 x 20 cm
An endless ring-shaped band usually has two distinct surfaces, one inside and one outside. Yet on this strip nine red ants crawl after each other and travel the front side as well as the reverse side. Therefore the strip has only one surface.

**41. Concentric rinds,** wood-engraving, 1953, 24 x 24 cm
Four spherical concentric rinds are illuminated by a central source of light. Each rind consists of a network of nine large circles which divide the surface of the sphere into forty-eight similar shaped spherical triangles.

**42. Spirals,** wood-engraving printed from two blocks, 1953, 27 x 33.5 cm
Four spiralling strips come together to form a curved

casing which, as a narrowing torus, returns to the place where it began, penetrates within itself and starts on its second round.

**43. Sphere spirals,** woodcut printed from four blocks, 1958, diameter 32cm
Here, just as in no. 18, a sphere is shown with a network of longitudinal and latitudinal circles. Four spirals twist their way around the spherical surface, infinitely small at the poles and broadest at the equator. Half of its yellow exterior is visible. Through open lanes in its side the red interior can be followed to the opposite pole.

**44. Moebius band I,** wood-engraving printed from four blocks, 1961, 24 x 26 cm
An endless band has been cut through, down its whole length. The two sections have been drawn apart from each other a little, so that a clear space divides them all the way round. Thus the band ought to fall apart into two unattached rings, and yet apparently it consists of one single strip, made up of three fish, each biting the tail of the one in front. They go round twice before regaining their point of departure.

**45. Rind,** wood-engraving printed from four blocks, 1955, 34.5 x 23.5 cm
Like the spirally shaped peel of a fruit and like a hollow, fragmented sculpture, the image of a woman floats through space. The sense of depth is enhanced by a bank of clouds which diminishes towards the horizon.

**46. Bond of union,** lithograph, 1956, 26 x 34 cm
Two spirals merge and portray, on the left, the head of a woman and, on the right, that of a man. As an endless band, their foreheads intertwined, they form a double unity. The suggestion of space is magnified by spheres which float in front of, within and behind the hollow images.

---

## V. Mirror images 47-54

### a. Reflections in water 47-48-49

**47. Rippled surface,** lino cut printed from two blocks, 1950, 26 x 32 cm
Two raindrops fall into a pond and, with the concentric, expanding ripples that they cause, disturb the still reflexion of a tree with the moon behind it. The rings shown in perspective afford the only means whereby the receding surface of the water is indicated.

**48. Puddle,** woodcut printed from three blocks, 1952, 24 x 32 cm
The cloudless evening sky is reflected in a puddle which a recent shower has left in a woodland path. The tracks of two motor cars, two bicycles and two pedestrians are impressed in the foggy ground.

**49. Three worlds,** lithograph, 1955, 36 x 25 cm
This picture of a woodland pond is made up of three elements: the autumn leaves which show the receding surface of the water, the reflexion of three trees in the

background and, in the foreground, the fish seen through the clear water.

## b. Sphere reflexions 50-54

**50. Still life with reflecting globe,** lithograph, 1934, 28.5 x 32.5 cm
The same reflecting globe as the one shown in no. 51 (Hand with Reflecting Globe), but in this case viewed sideways on, like a bottle with a neck.

**51. Hand with reflecting globe,** lithograph, 1935, 32 x 21.5 cm
A reflecting globe rests in the artist's hand. In this mirror he can have a much more complete view of his surroundings than by direct observation, for nearly the whole of the area around him — four walls, the floor and ceiling of his room — are compressed, albeit distorted, within this little disc. His head, or to be more precise, the point between his eyes, comes in the absolute centre. Whichever way he turns he remains at the centre. The ego is the unshakable core of his world.

**52. Three spheres II,** lithograph, 1946, 26 x 47 cm
Three spheres, of equal size but different in aspect, are placed next to each other on a shiny table. The one on the left is made of glass and filled with water, so it is transparent but also reflects. It magnifies the structure of the table top on which it rests and at the same time mirrors a window. The right-hand sphere, with its matt surface, presents a light side and dark side more clearly than the other two. The attributes of the middle one are the same as those described in connection with no. 51; the whole of the surrounding area is reflected in it. Furthermore it achieves, in two different ways, a triple unity, for not only does it reflect its companions to left and right, but all three of them are shown in the drawing on which the artist is working.

**53. Dewdrop,** mezzotint, 1948, 18 x 24.5 cm
This leaf from a succulent plant was in fact about 1 inch in length. On it lies a dewdrop which shows a reflection of a window and yet at the same time serves as a lens which magnifies the structure of the leaf-veins. Quaintly shaped air-pockets, shining white, are trapped between the leaf and the dewdrop.

**54. Eye,** mezzotint, 1946, 15 x 20 cm
Here the artist has drawn his eye, greatly enlarged, in a concave shaving mirror. The pupil reflects the one who watches us all.

## VI. Inversion 55-56

It was stated in connection with print no. 29 that a combination of three diamond-shapes can make a cube. Yet it still remains an open question as to whether we are looking at this cube from within or without. The mental reversal, this inward or outward turning, this inversion of a shape, is the game that is played in the two following prints.

**55. Cube with magic ribbons,** lithograph, 1957, 31 x 31 cm
Two endless circular bands, fused together in four places, are curved around the diagonals of a cube. Each strip has a row of button-like protuberances. If we follow one of these series with the eye, then these nodules surreptitiously change from convex to concave.

**56. Concave and convex,** lithograph, 1955, 28 x 33.5 cm
Three little houses stand near one another, each under a crossvaulted roof. We have an exterior view of the left-hand house, an interior view of the right-hand one and an either exterior view or interior view of the one in the middle, according to choice. There are several similar inversions illustrated in this print; let us describe one of them. Two boys are to be seen, playing a flute. The one on the left is looking down through a window on to the roof of the middle house; if he were to climb out of the window he could stand on this roof. And then if he were to jump down in front of it he would land up one storey lower, on the dark-coloured floor before the house. And yet the right-hand flautist who regards that same cross-vault as a roof curving above his head, will find, if he wants to climb out of his window, that there is no floor for him to land on, only a fathomless abyss.

## VII. Polyhedrons 57-62

**57. Double planetoid,** wood-engraving, printed from four blocks, 1949, diameter 37.5 cm
Two regular tetrahedrons, piercing each other, float through space as a planetoid. The light-coloured one is inhabited by human beings who have completely transformed their region into a complex of houses, bridges and roads. The darker tetrahedron has remained in its natural state, with rocks, on which plants and prehistoric animals live. The two bodies fit together to make a whole but they have no knowledge of each other.

**58. Tetrahedral planetoid,** woodcut printed from two blocks, 1954, 43 x 43 cm
This little planet inhabited by humans has the shape of a regular tetrahedron and is encircled by a spherical atmosphere. Two of the four triangular surfaces, with which this body is faced, are visible. The edges which separate them divide the picture into two. All the vertical lines: the walls, houses, trees and people, point in the direction of the core of the body — its centre of gravity — and all the horizontal surfaces, gardens, roads, stretches of water in pools and canals, are parts of a spherical crust.

**59. Order and chaos,** lithograph, 1950, 28 x 28 cm
A stellar dodecahedron is placed in the centre and is enclosed in a translucent sphere like a soap bubble. This symbol of order and beauty reflects the chaos in the shape of a heterogeneous collection of all sorts of useless, broken and crumpled objects.

**60. Gravitation,** lithograph, coloured by hand, 1952, 30 x 30 cm
Here once again is a stellar dodecahedron, encased in

twelve flat, five-pointed stars. On each of these platforms lives a tailless monster with a long neck and four legs. He sits there with his lump caught beneath a flat-side pyramid, each wall of which has an opening, and through this opening the creature sticks his head and legs. But the pointed extremity of one animal's dwelling platform is at the same time the wall of one of his fellow-sufferer's prisons. All these triangular protrusions function both as floors and as walls; so it comes about that this print, the last in the series of polyhedrons, serves also as a transition to the relativity group.

**61. Stars,** wood-engraving, 1948, 32 x 26 cm
Single, double and triple regular bodies float like stars through space. In the midst of them is a system of three regular octahedrons, indicated by their edges only. Two chameleons have been chosen as denizens of this framework, because they are able to cling by their legs and tails to the beams of their cage as it swirls through space.

**62. Flat worms,** lithograph, 1959, 34 x 41.5 cm
Bricks are usually rectangular, because in that way they are most suitable for building the vertical walls of our houses. But anyone who has anything to do with the stacking of stones of a non-cubic type will be well aware of other possibilities. For instance, one can make use of tetrahedrons alternating with octahedrons. Such are the basic shapes which are used to raise the building illustrated here. They are not practicable for human beings to build with, because they make neither vertical walls nor horizontal floors. However, when this building is filled with water, flat worms can swim in it.

---

## VIII. Relativities 63-67

The underlying idea in the following pictures is basically this: before photography was invented, perspective was always closely linked with horizon. Yet even at the time of the Renaissance it was known that not only do the horizontal lines of a building meet at a point on the horizon (the famous "vanishing point"), but also the vertical lines meet downwards at the nadir and upwards at the zenith. This is obvious with old ceiling-paintings which have vertical perspective receding lines, such as pillars. But now that photography is part of our everyday lives, we really have come to understand vertical perspective. We have only to point our lens at the top or at the bottom of a building to realize that architectural draughtsmen are simply taking the easy way out when they indicate everything that stands vertically, in their perspective projections, with parallel lines. In the following prints the vanishing point has several different functions at one and the same time. Sometimes it is situated on the horizon, the nadir and the zenith all at once.

**63. Another world II,** wood-engraving printed from three blocks, 1947, 31.5 x 26 cm
The interior of a cube-shaped building. Openings in the five visible walls give views of three different landscapes. Through the topmost pair one looks down, almost vertically, onto the ground; the middle two are at eye-level

and show the horizon, while through the bottom pair one looks straight up to the stars.

Each plane of the building, which unites nadir, horizon and zenith, has a threefold function. For instance, the rear plane in the centre serves as a wall in relation to the horizon, a floor in connection with the view through the top opening and a ceiling so far as the view to towards the starry sky is concerned.

**64. High and low,** lithograph, 1947, 50.5 x 20.5 cm
In this print the same picture is presented twice over, but viewed from two different points. The upper half shows the view that an observer would get if he were about three storeys up; the lower half is the scene that would confront him if he were standing at ground level. If he should take his eyes off the latter and look upwards, then he would see the tiled floor on which he is standing, repeated as a ceiling in the centre of the composition. Yet this acts as a floor for the upper scene. At the very top, this tiled floor repeats itself once again, purely as a ceiling.

**65. Curl-up,** lithograph, 1951, 17 x 23.5 cm
The imaginary creature here portrayed and fully described goes into action in the following print.

**66. House of stairs,** lithograph, 1951, 47 x 24 cm
Now comes a further development of the concept of relativity that was displayed in the foregoing prints. A playful element is introduced, one which came up for discussion in connection with the regular dividing-up of surfaces, in other words glide reflexion. Roughly the whole of the top half of the print is the mirror image of the bottom half. The topmost flight of steps, down which a curl-up is crawling from left to right, is reflected twice over, once in the middle and then again in the lower part. On the stairs in the top right-hand corner, in the same way as is also shown in number 67, the distinction between ascending and descending is eliminated, for two rows of animals are moving side by side, yet one row is going up and the other down.

**67. Relativity,** lithograph, 1953, 28 x 29 cm
Here we have three forces of gravity working perpendicularly to one another. Three earth-planes cut across each other at right angles, and human beings are living on each of them.

It is impossible for the inhabitants of different worlds to walk or sit or stand on the same floor, because they have differing conceptions of what is horizontal and what is vertical. Yet they may well share the use of the same staircase. On the top staircase illustrated here, two people are moving side by side and in the same direction, and yet one of them is going downstairs and the other upstairs. Contact between them is out of the question because they live in different worlds and therefore can have no knowledge of each other's existence.

---

## IX. Conflict between the flat and the spatial 68-73

Our three-dimensional space is the only true reality that

we know. The two-dimensional is every bit as fictitious as the four-dimensional, for nothing is flat, not even the most finely polished mirror. And yet we stick to the convention that a wall or a piece of paper is flat, and curiously enough, we still go on, as we have done since time immemorial, producing illusions of space on just such plane surfaces as those. Surely it is a bit absurd to draw a few lines and then claim: "This is a house". This odd situation is the theme of the next live pictures.

**68. Three spheres I,** wood-engraving, 1945, 28 x 17 cm
At the top of this print the spatial nature of a globe is brought out as strongly as possible. Yet it is not a globe at all, merely the projection of one on a piece of paper which could be cut out as a disc. In the middle, just such a paper disc is illustrated, but folded in two halves, one part vertical and the other horizontal, with the top sphere resting on this latter. At the bottom another such disc is shown, but unfolded this time, and seen in perspective as a circular table top.

**69. Drawing hands,** lithograph, 1948, 28.5 x 34 cm
A piece of paper is fixed to a base with drawing pins. A right hand is busy sketching a shirt-cuff upon this drawing paper. At this point its work is incomplete, but a little further to the right it has already drawn a left hand emerging from a sleeve in such detail that this hand has come right up out of the flat surface, and in its turn it is sketching the cuff from which the right hand is emerging, as though it were a living member.

**70. Balcony,** lithograph, 1945, 30 x 23.5 cm
The spatial nature of these houses is a fiction. The two-dimensional nature of the paper on which it is drawn is not disturbed — unless we give it a bang from behind. But the bulge that can be seen in the centre is an illusion too, for the paper stays flat.
All that has been achieved is an expansion, a quadruple magnification in the centre.

**71. Doric columns,** wood-engraving printed from three blocks, 1945, 32 x 24 cm
The lower part of the left-hand column suggests a heavy three-dimensional stone object, and yet it is nothing more than a bit of ink on a piece of paper. So is turns out to be a flat strip of paper which, having been folded three times, has got itself jammed between the ceiling and the capital of the right-hand column. But the same thing applies to the right-hand column itself; from above it resembles a ribbon lying flat on the floor with the left-hand column resting upon it.

**72. Print gallery,** lithograph, 1956, 32 x 32 cm
As a variation on the theme of the print Balcony, namely, magnification towards the centre, we have here an expansion which curves around the empty centre in a clockwise direction. We come in through a door on the lower right to an exhibition gallery where there are prints on stands and walls. First of all we pass a visitor with his hands behind his back and then, in the lower left-hand corner, a young man who is already four times as big. Even his head has expanded in relation to his hand. He is looking at the last print in a series on the wall and glancing at its details, the boat, the water and the houses in the background. Then

his eye moves further on from left to right, to the ever expanding blocks of houses. A woman looks down through her open window onto the sloping roof which covers the exhibition gallery; and this brings us back to where we started our circuit. The boy sees all these things as two dimensional details of the print that he is studying. If his eye explores the surface further then he sees himself as a part of the print.

**73. Dragon,** wood-engraving, 1952, 32 x 24 cm
However much this dragon tries to be spatial, he remains completely flat. Two incisions are made in the paper on which he is printed. Then it is folded in such a way as to leave two square openings. But this dragon is an obstinate beast, and in spite of his two dimensions he persists in assuming that he has three; so he sticks his head through one of the holes and his tail through the other.

---

## X. Impossible buildings 74-75-76

**74. Belvedere,** lithograph, 1958, 46 x 29.5 cm
In the lower left foreground there lies a piece of paper on which the edges of a cube are drawn. Two small circles mark the places where edges cross each other. Which edge comes at the front and which at the back? In a three-dimensional world simultaneous front and back is an impossibility and so cannot be illustrated. Yet it is quite possible to draw an object which displays a different reality when looked at from above and from below. The lad sitting on the bench has got just such a cube-like absurdity in his hands. He gazes thoughtfully at this incomprehensible object and seems oblivious to the fact that the belvedere behind him has been built in the same impossible style. On the floor of the lower platform, that is to say indoors, stands a ladder which two people are busy climbing. But as soon as they arrive a floor higher they are back in the open air and have to re-enter the building. Is it any wonder that nobody in this company can be bothered about the fate of the prisoner in the dungeon who sticks his head through the bars and bemoans his fate?

**75. Ascending and descending,** lithograph, 1960, 38 x 28.5 cm
The endless stairs which are the main motif of this picture were taken from an article by L.S. and R. Penrose in the February, 1958, issue of the British Journal of Psychology. A rectangular inner courtyard is bounded by a building that is roofed in by a never-ending stairway. The inhabitants of these living-quarters would appear to be monks, adherents of some unknown sect. Perhaps it is their ritual duty to climb those stairs for a few hours each day. It would seem that when they get tired they are allowed to turn about and go downstairs instead of up. Yet both directions, though not without meaning, are equally useless. Two recalcitrant individuals refuse, for the time being, to take any part in this exercise. They have no use for it at all, but no doubt sooner or later they will be brought to see the error of their nonconformity.

**76. Waterfall,** lithograph, 1961, 38 x 30 cm

In the same article in the British Journal of Psychology as was mentioned in connection with the foregoing print, R. Penrose publishes the perspective drawing of a triangle. A copy of this is reproduced here.

It is composed of square beams which rest upon each other at right-angles. If we follow the various parts of this construction one by one we are unable to discover any mistake in it. Yet it is an impossible whole because changes suddenly occur in the interpretation of distance between our eye and the object.

This impossible triangle is fitted three times over into the picture. Falling water keeps a millwheel in motion and subsequently flows along a sloping channel between two towers, zigzagging down to the point where the waterfall begins again. The miller simply needs to add a bucketful of water from time to time, in order to compensate for loss through evaporation. The two towers are the same height and yet the one on the right is a storey lower than the one on the left.

Maurits Cornelis Escher, born in Leeuwarden, 17 June 1898, received his first instruction in drawing at the secondary school in Arnhem, by F. W. van der Haagen, who helped him to develop his graphic aptitude by teaching him the technique of the linoleum cut. From 1919 to 1922 he studied at the School of Architecture and Ornamental Design in Haarlem, where he was instructed in graphic techniques by S. Jesserun de Mesquita, whose strong personality greatly influenced Escher's further development as a graphic artist. In 1922 he went to Italy and settled in Rome in 1924. During his ten-year stay in Italy he made many study tours, visiting Abruzzia, the Amalfi coast, Calabria, Sicily, Corsica and Spain. In 1934 he left Italy, spent two years in Switzerland and five years in Brussels before settling in Baarn (Holland) in 1941, where he died on 27 March 1972, at the age of 73 years.

1.
Toren van Babel
Tower of Babel

2.
Castrovalva

3.
Palm
Palm

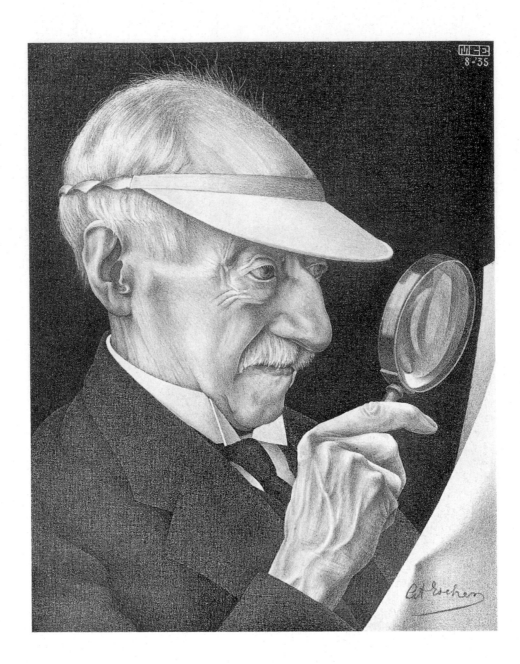

4.
G. A. Escher

5.
Lichtende zee
Fluorescent sea

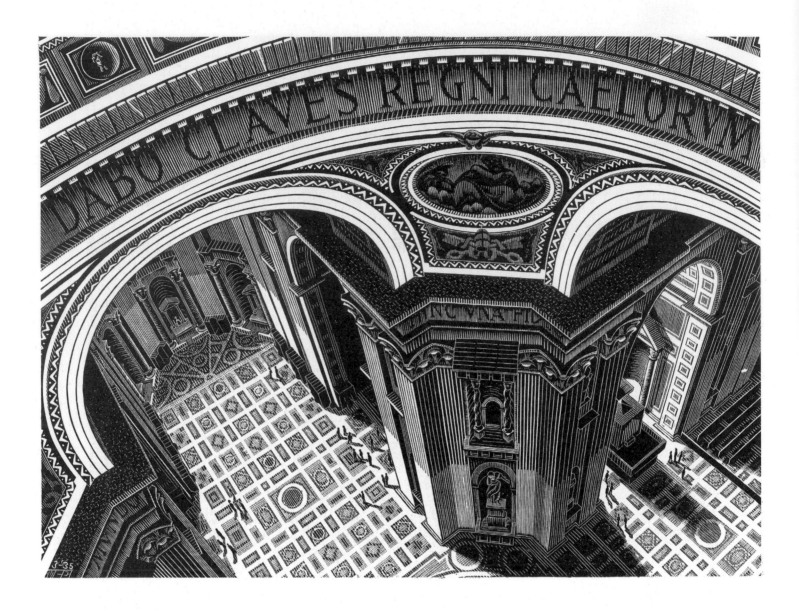

6.
St. Pieter, Rome
St. Peter, Rome

7.
Droom
Dream

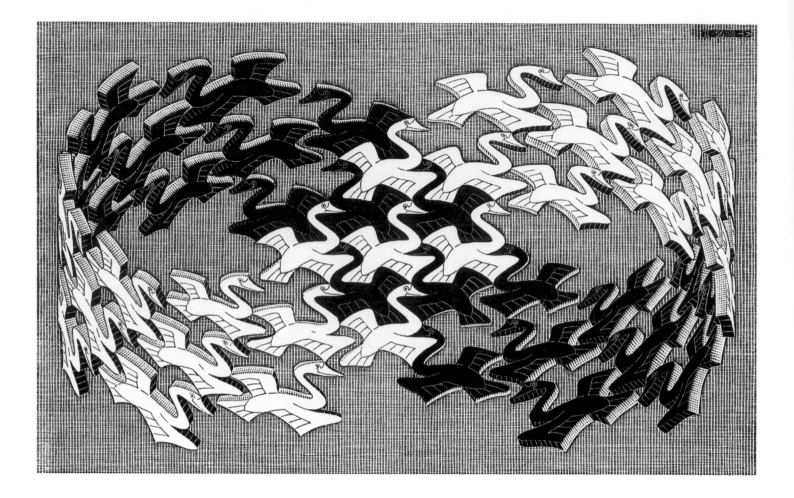

8.
Zwanen
Swans

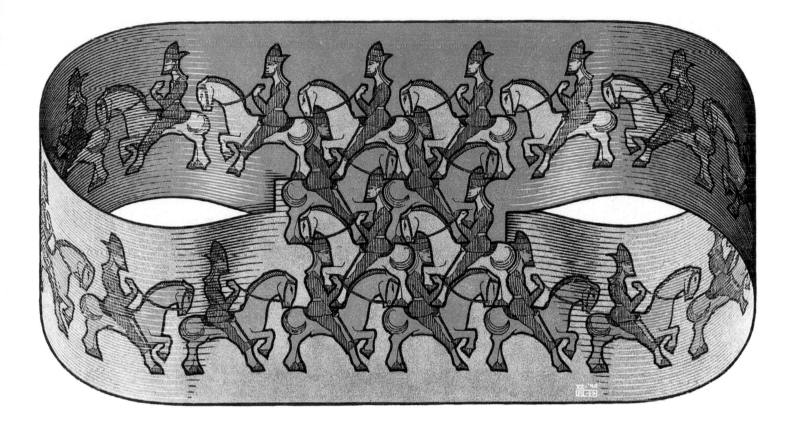

9.
Ruiter
Horsemen

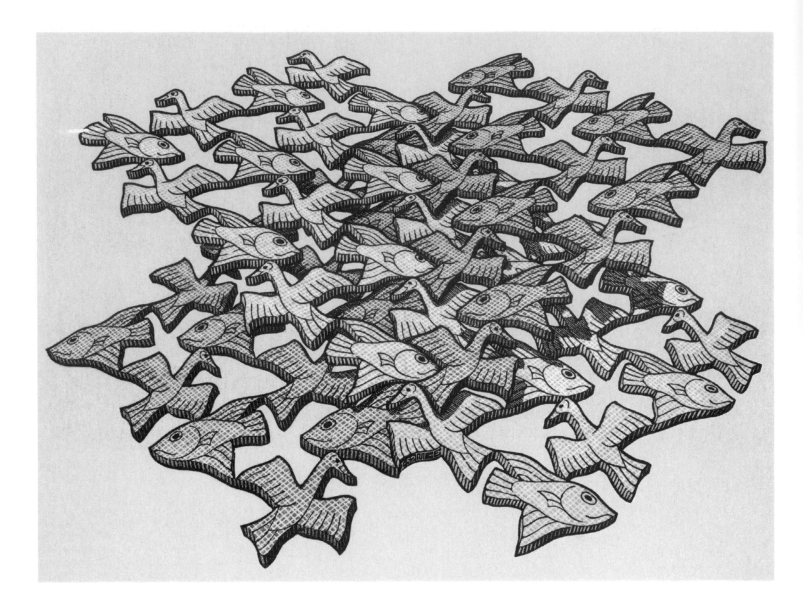

10.
Twee snijdende vlakken
Two intersecting planes

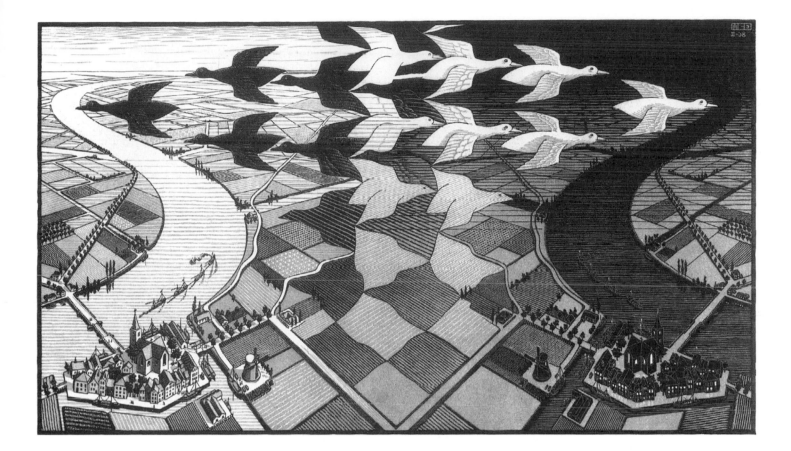

11.
Dag en nacht
Day and night

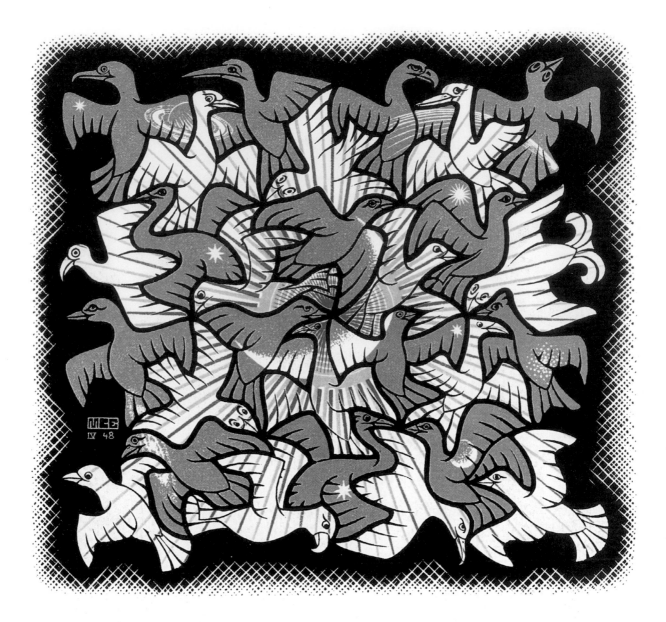

12.
Zon en maan
Sun and moon

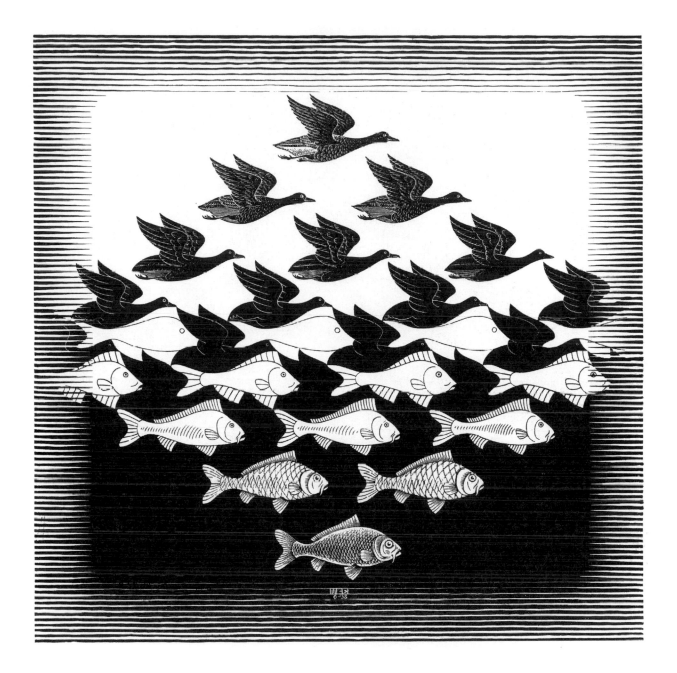

13.
Lucht en water I
Sky and water I

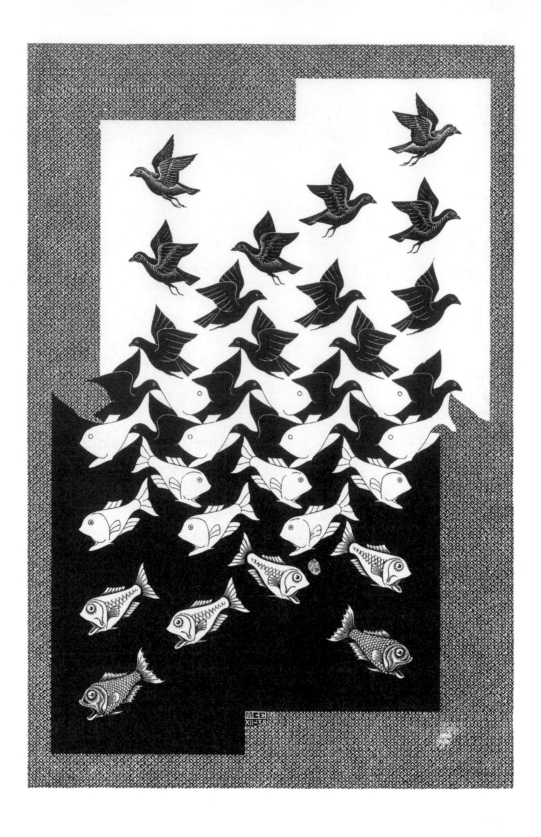

14.
Lucht en water II
Sky and water II

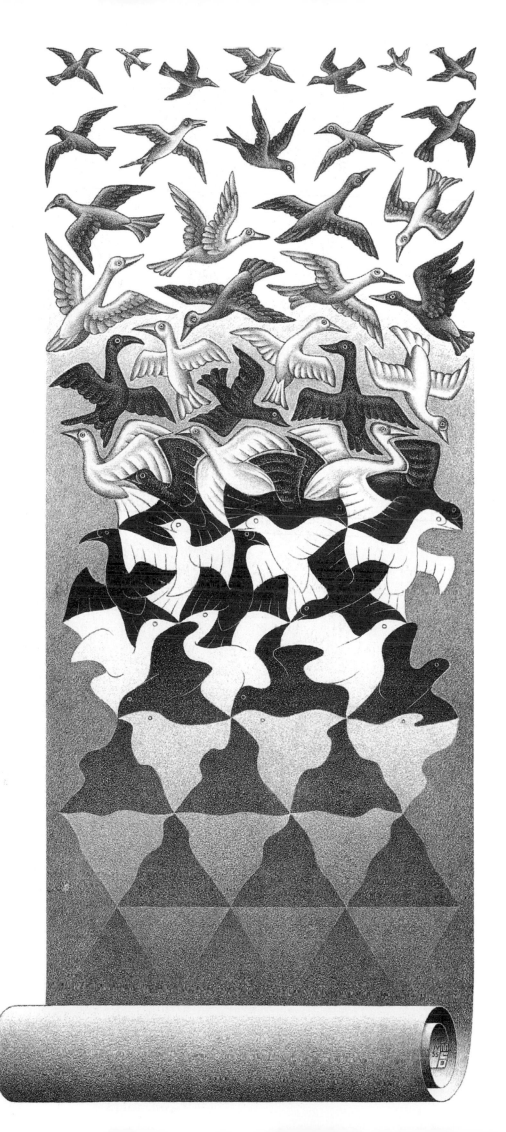

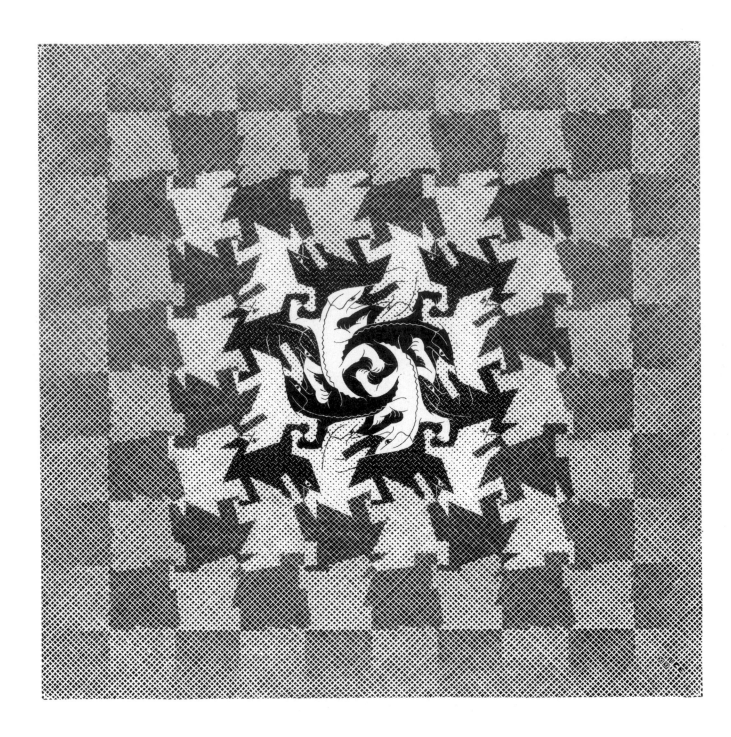

16.
Ontwikkeling I
Development I

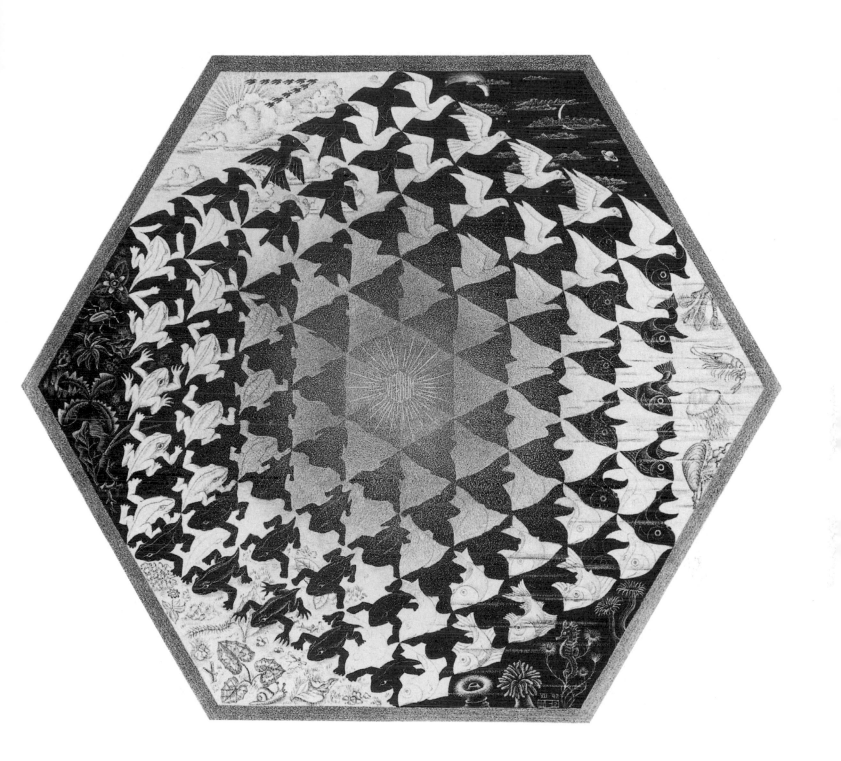

17.
Verbum

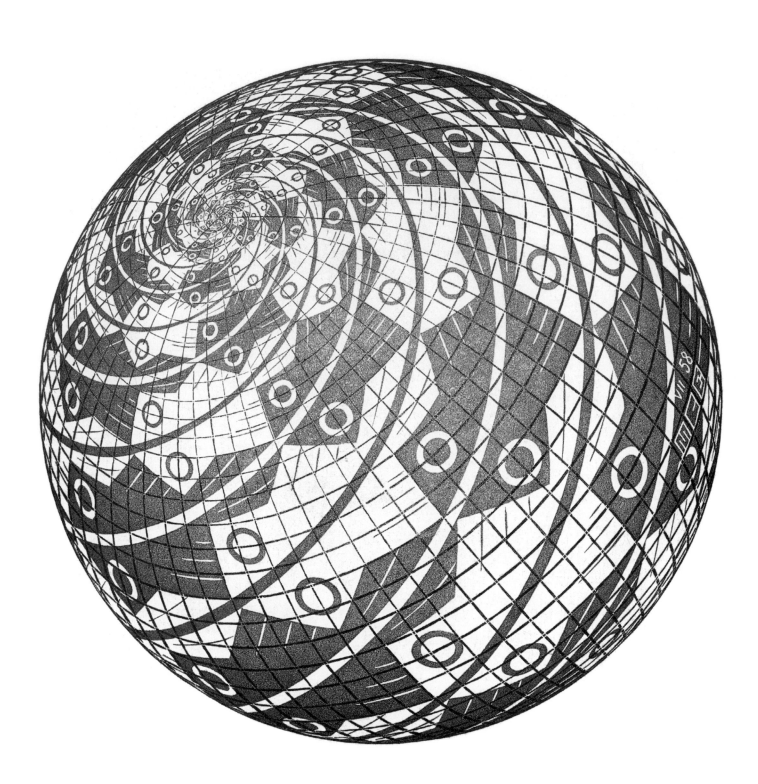

18.
Boloppervlak met vissen
Sphere surface with fishes

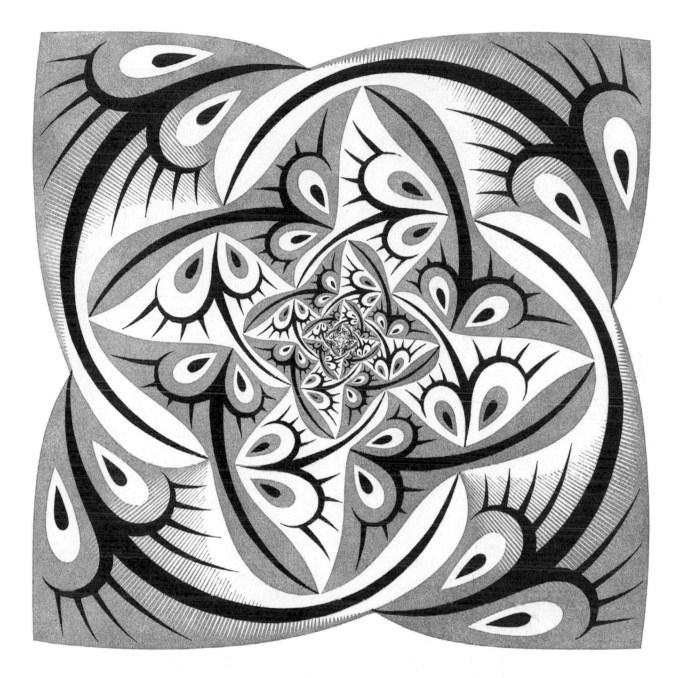

19.
Lovonsweg II
Path of life II

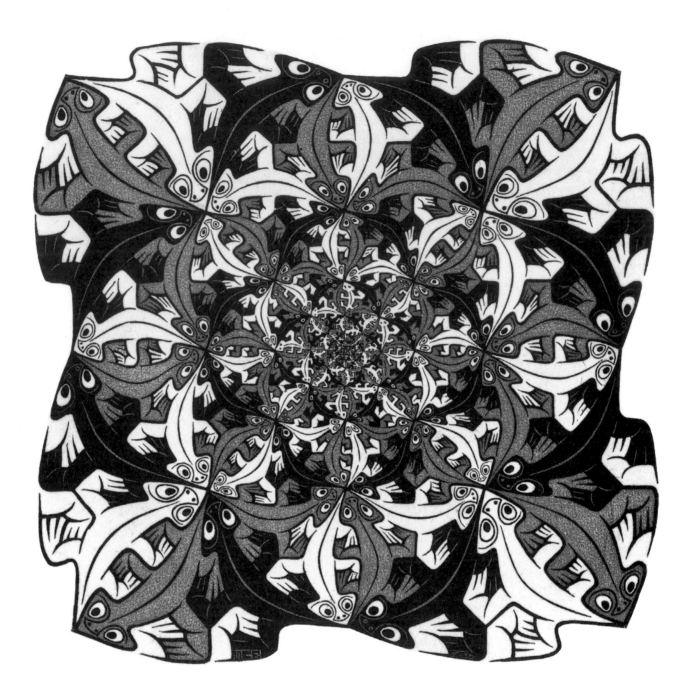

20.
Kleiner en kleiner
Smaller and smaller

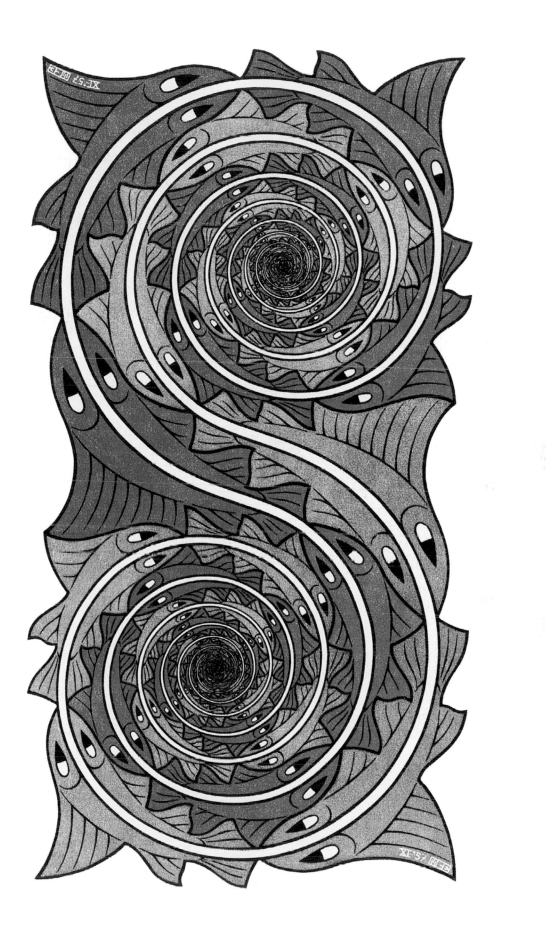

21.
Draaikolken
Whirlpools

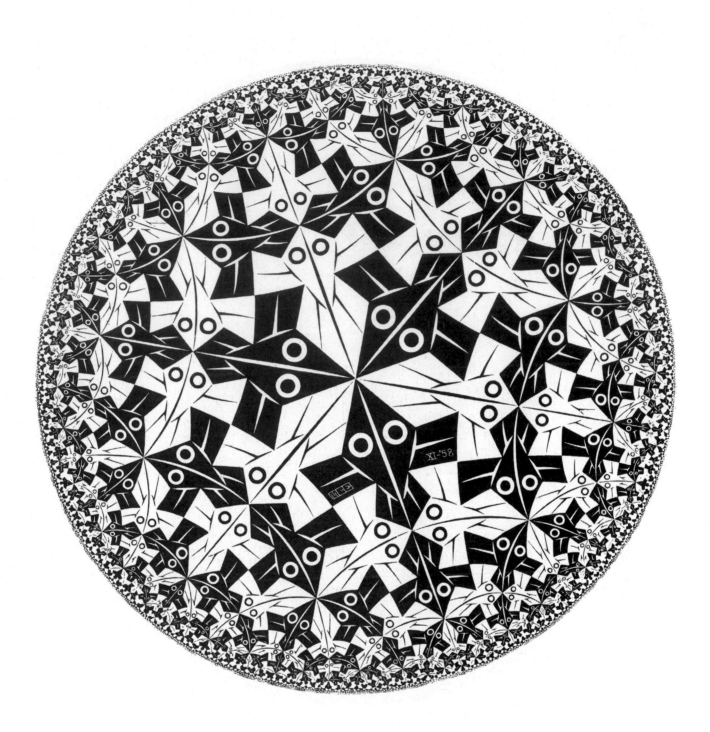

22.
Cirkellimiet I
Circle limit I

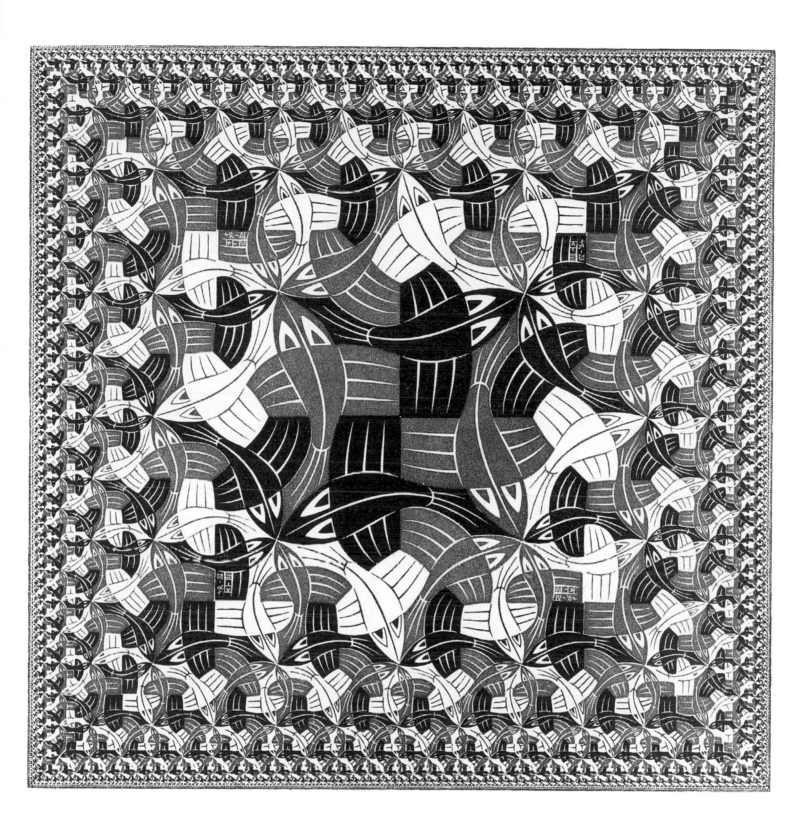

23.
Vierkantlimiet
Square limit

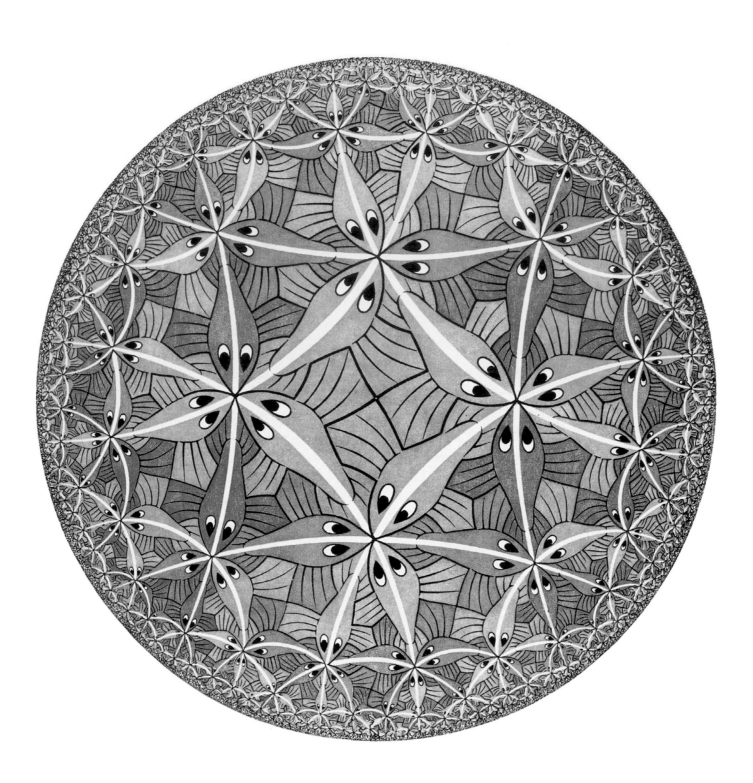

24.
Cirkkellimiet III
Circle limit III

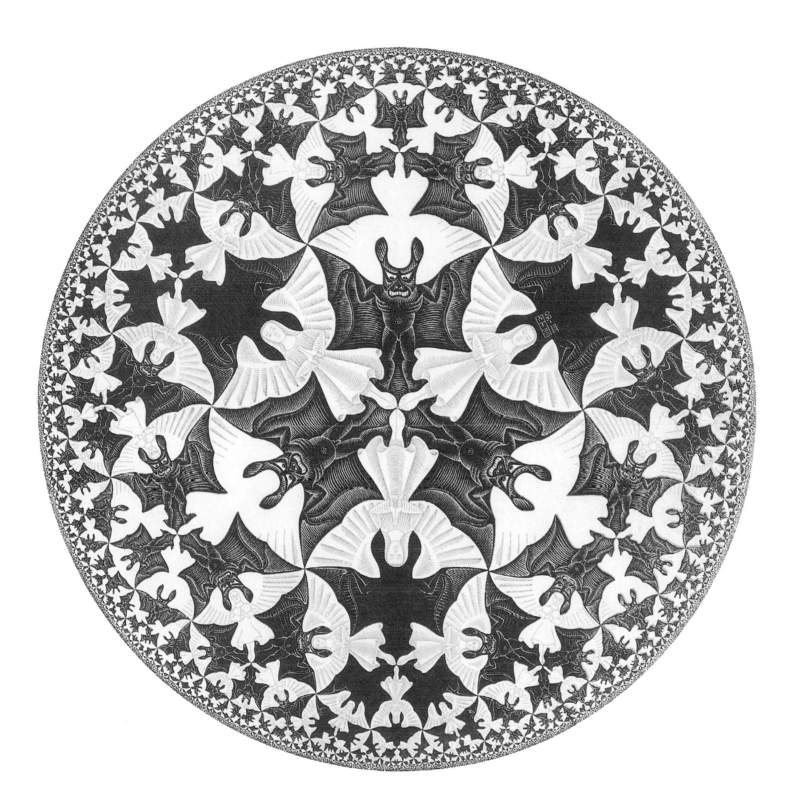

25.
Cirkellimiet IV
Circle limit IV

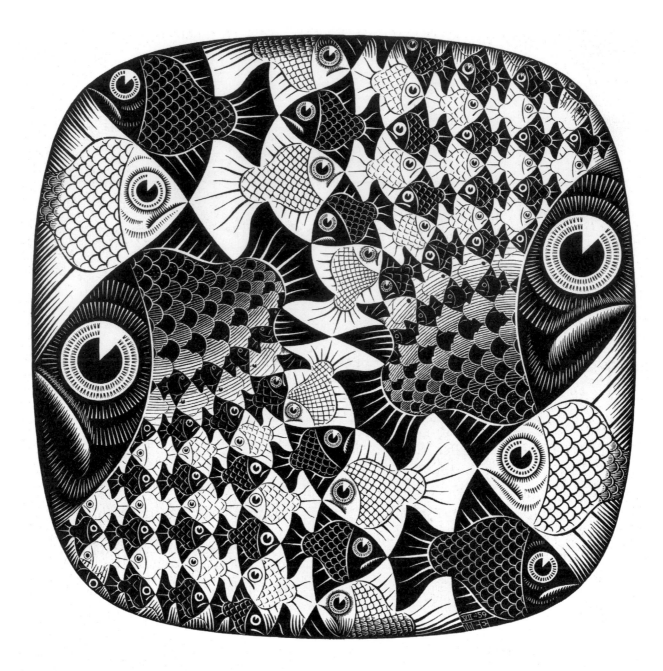

26.
Vissen en schubben
Fishes and scales

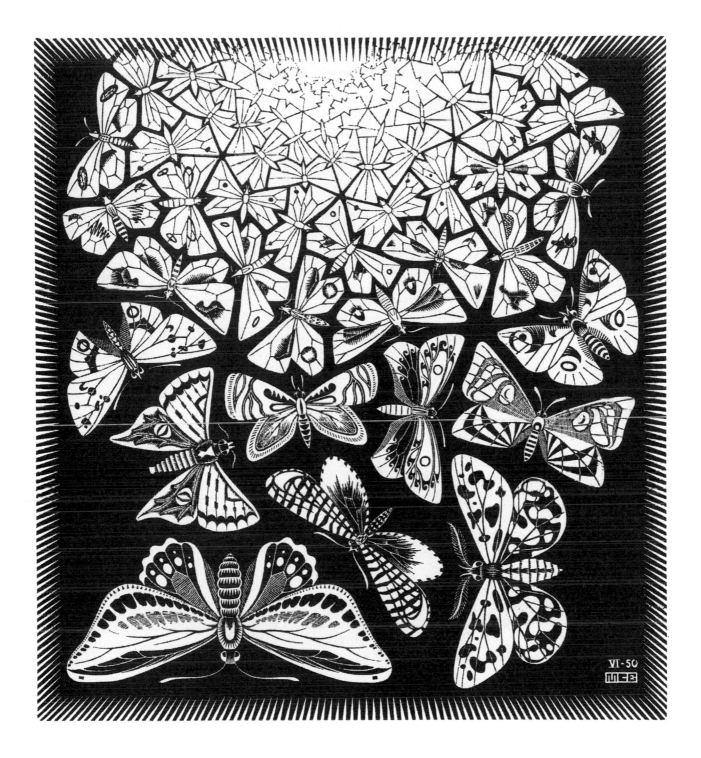

27.
Vlinders
Butterflies

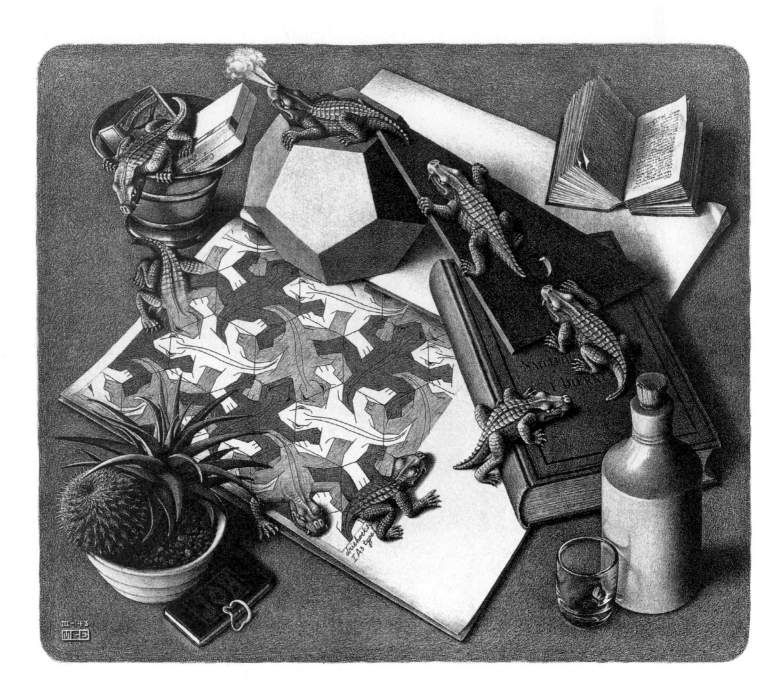

28.
Reptielen
Reptiles

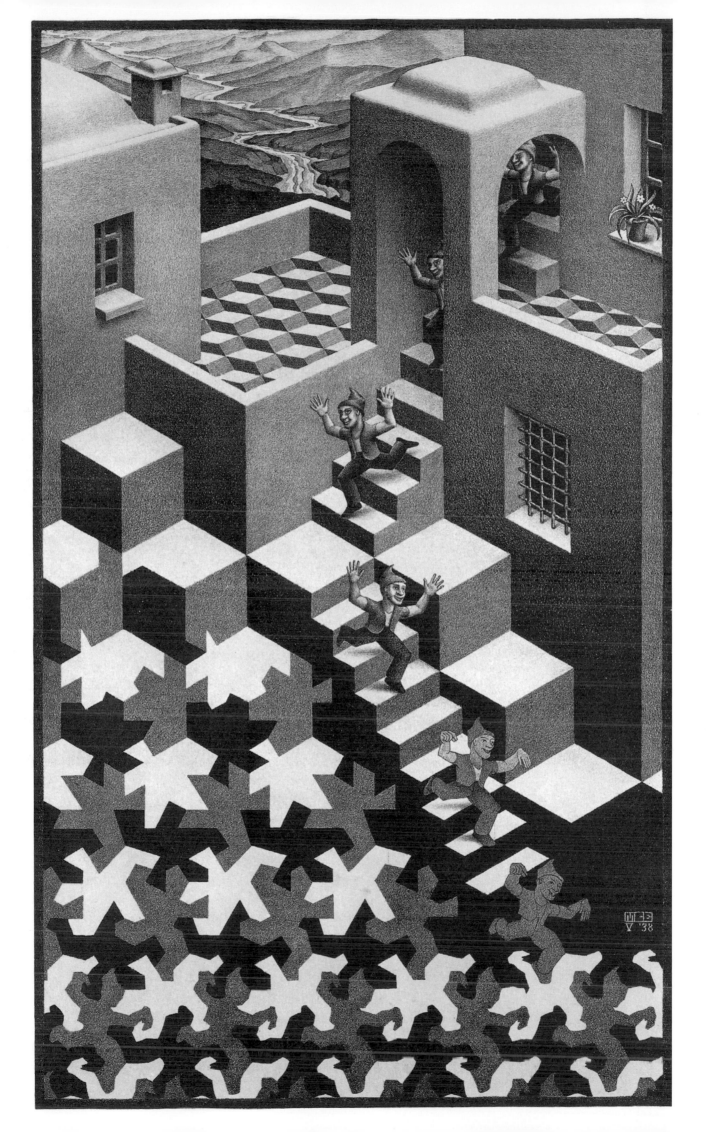

29.
Kringloop
Cycle

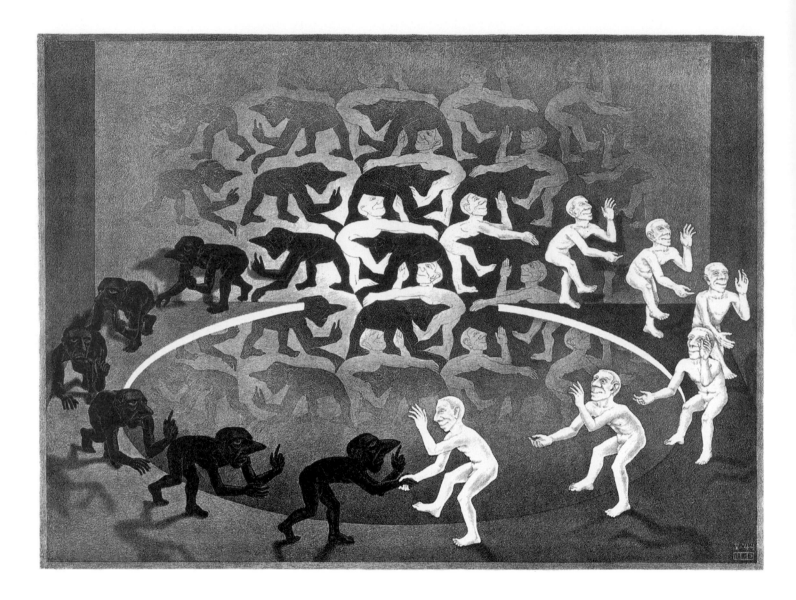

30.
Ontmoeting
Encounter

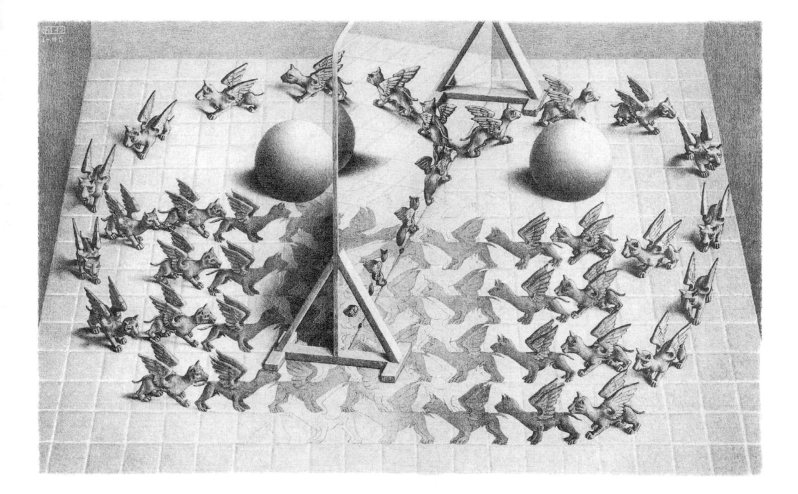

31.
Toverspiegel
Magic mirror

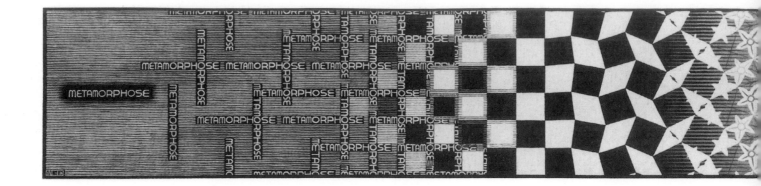

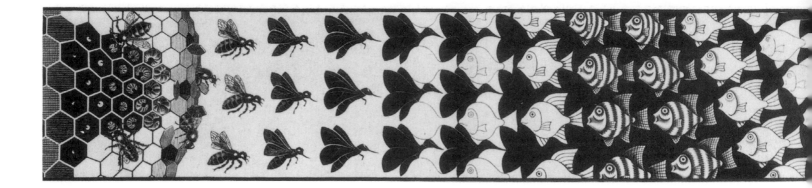

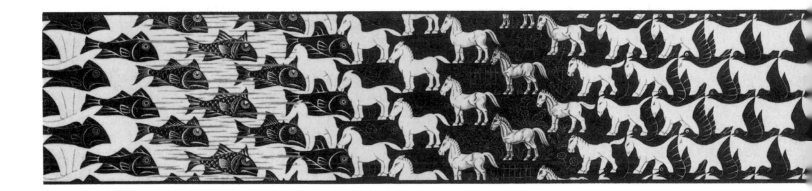

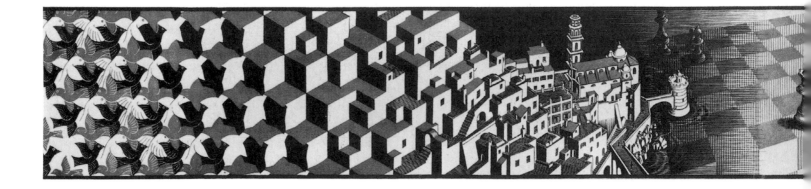

32.
Metamorphose
Metamorphose

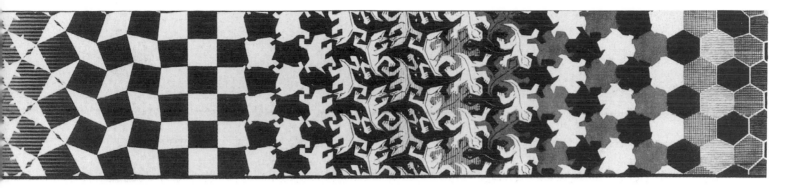

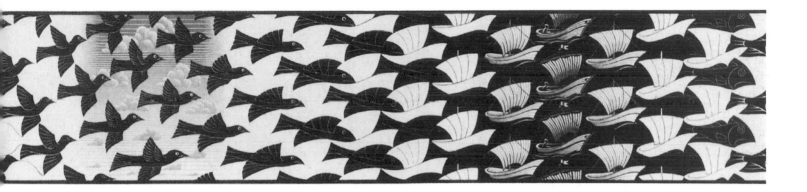

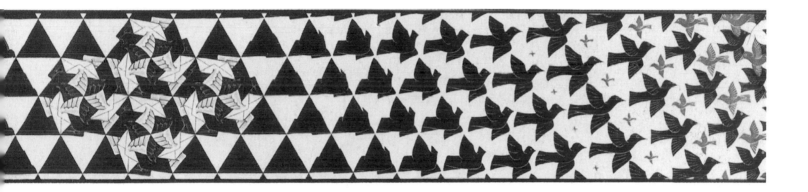

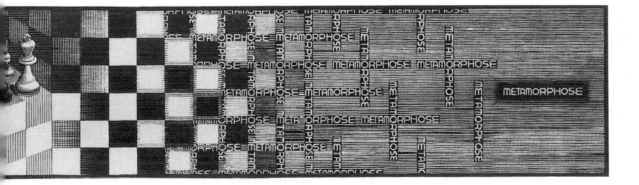

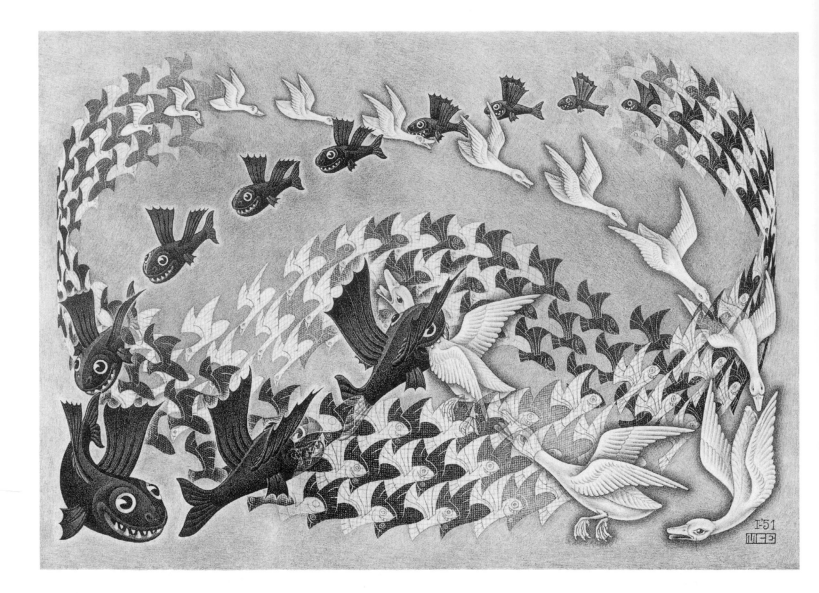

33.
Predestinatie
Predestination

34.
Vlakvulling I
Mosaic I

35.
Vlakvulling II
Mosaic II

36.
Diepte
Depth

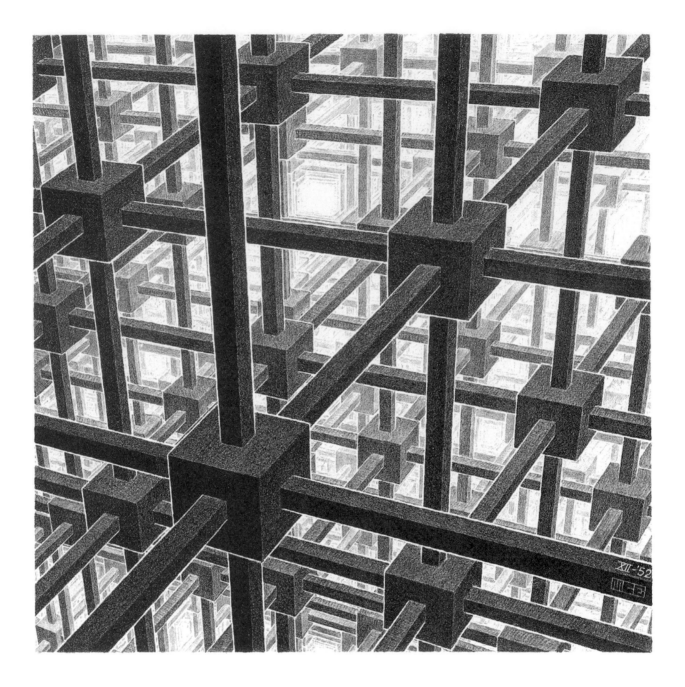

37.
Kubische ruimteverdeling
Cubic space division

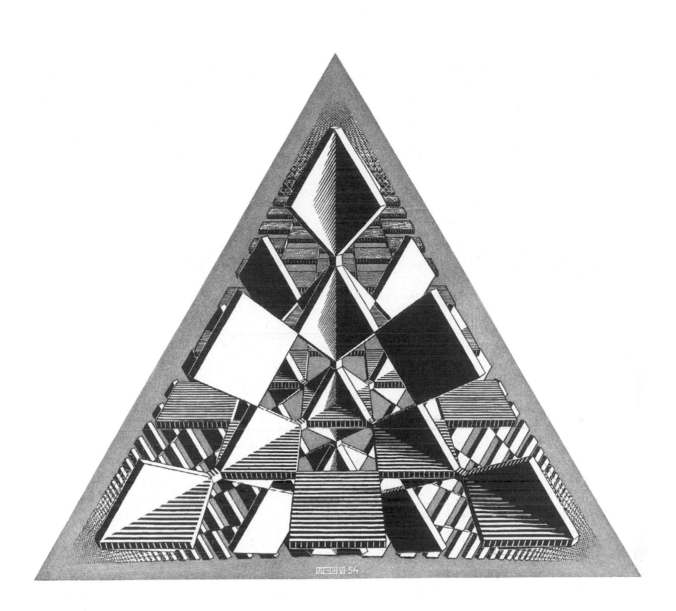

38.
Drie snijdende vlakken
Three intersecting planes

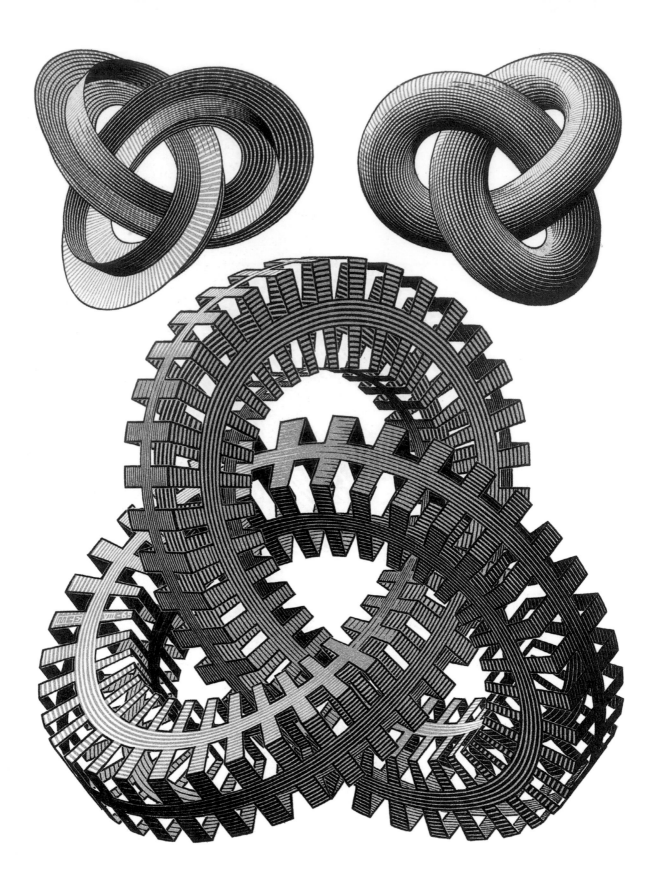

39.
Knopen
Knots

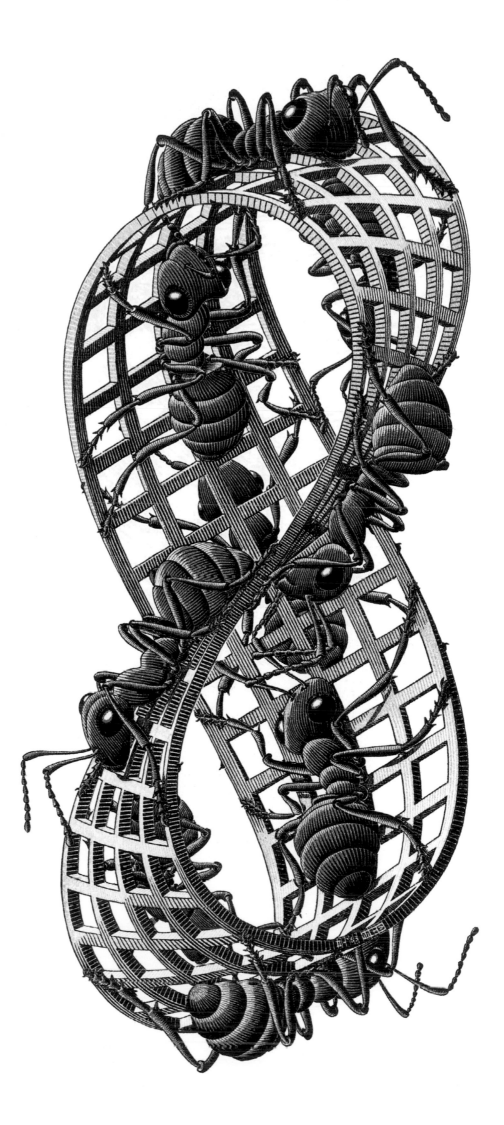

40.
Band van Möbius II
Moebius band II

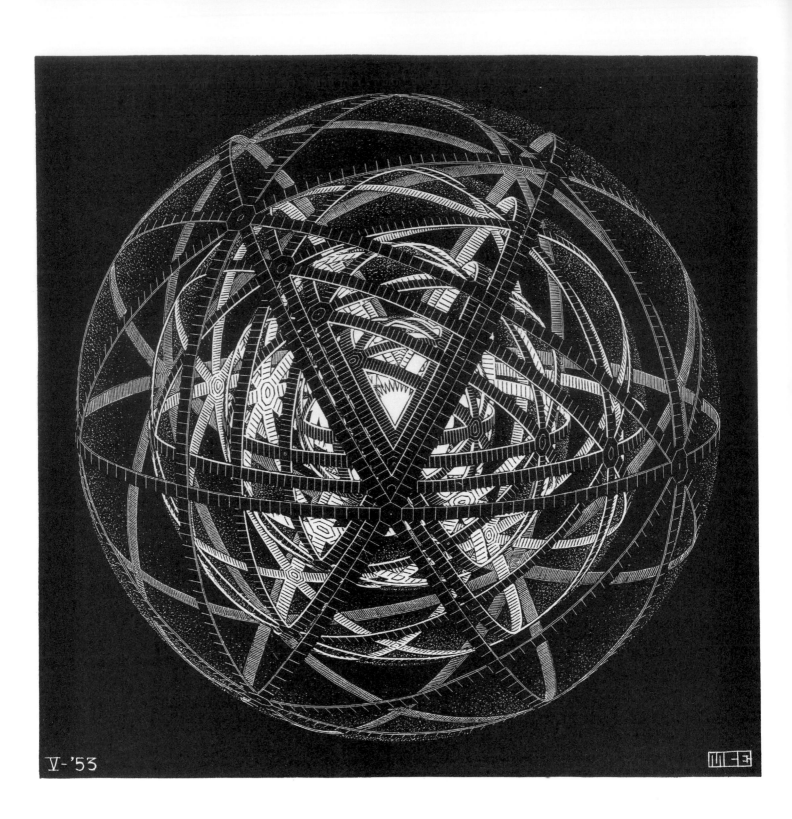

V-'53

41.
Concentrische schillen
Concentric rinds

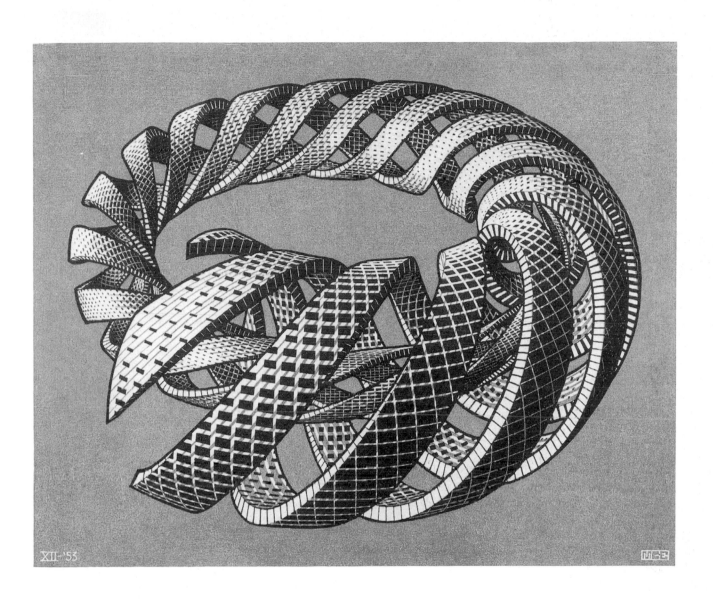

42.
Spiralen
Spirals

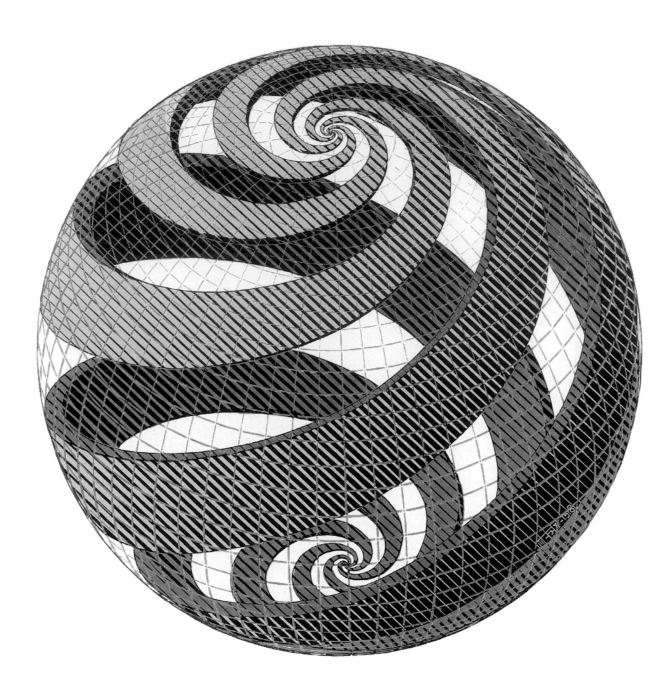

43.
Bolspiralen
Sphere spirals

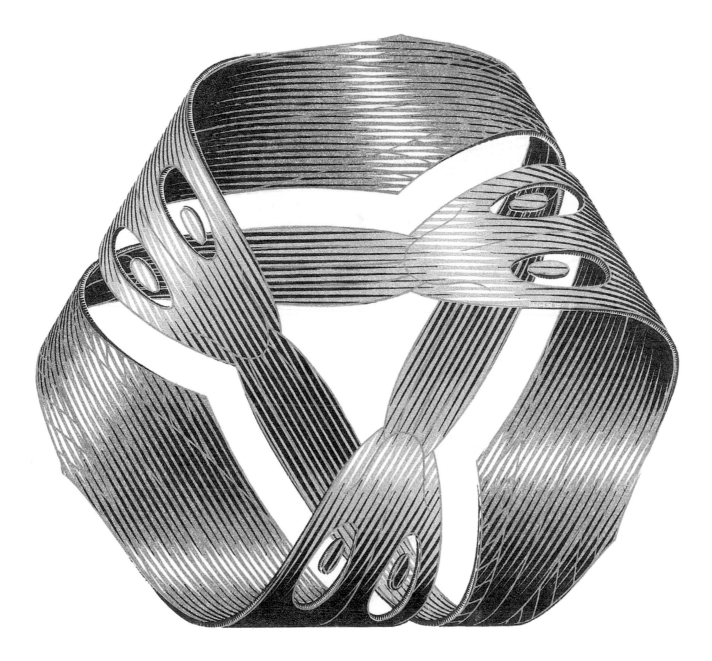

44.
Band van Möbius I
Moebius band I

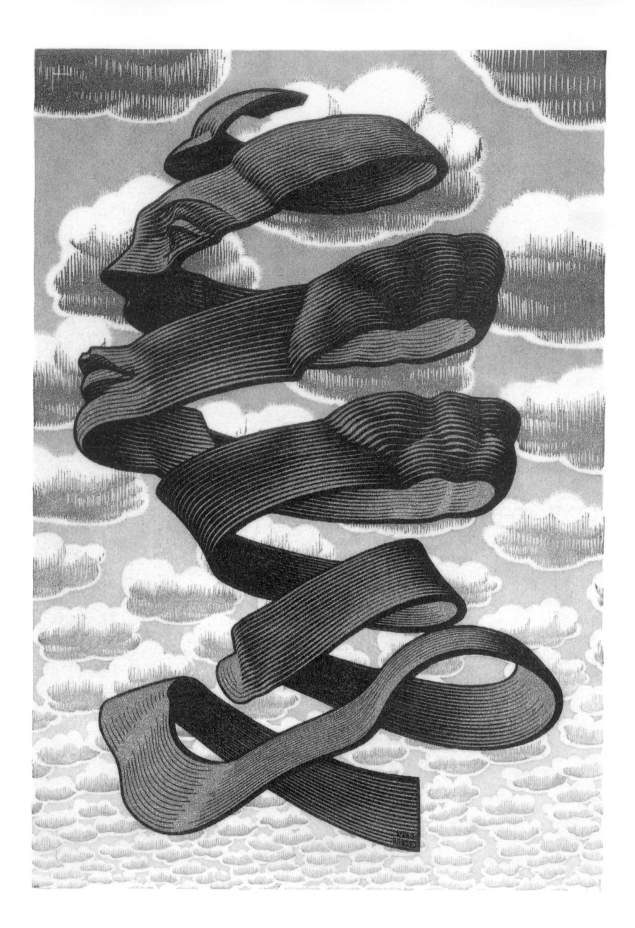

45.
Omhulsel
Rind

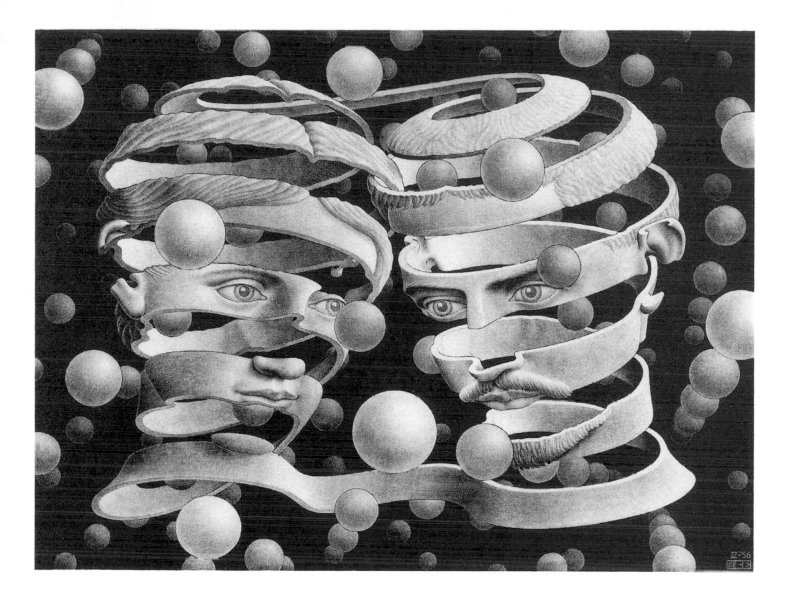

46.
Band
Bond of union

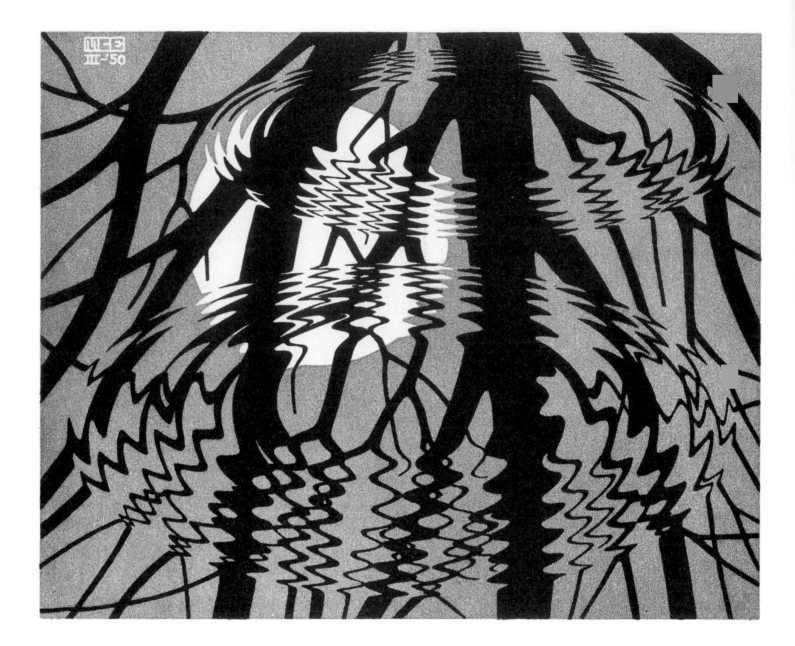

47.
Rimpeling
Rippled surface

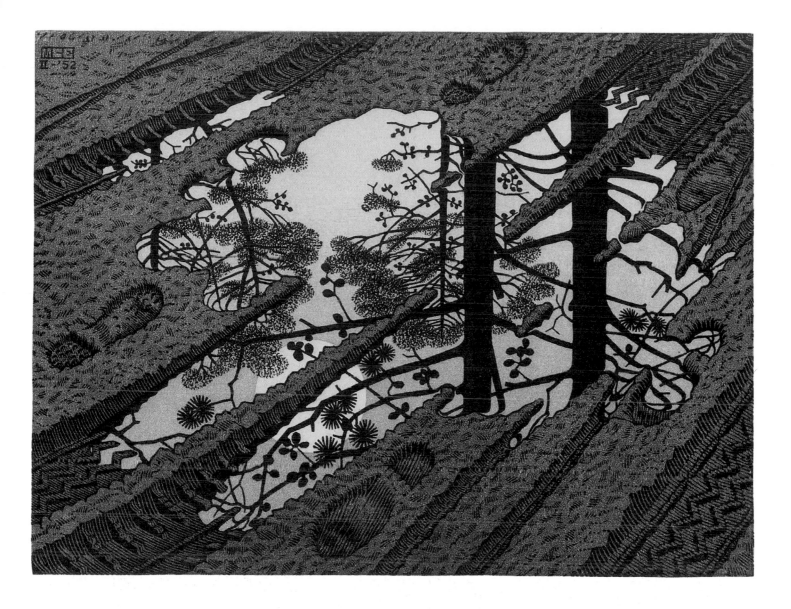

48.
Modderplas
Puddle

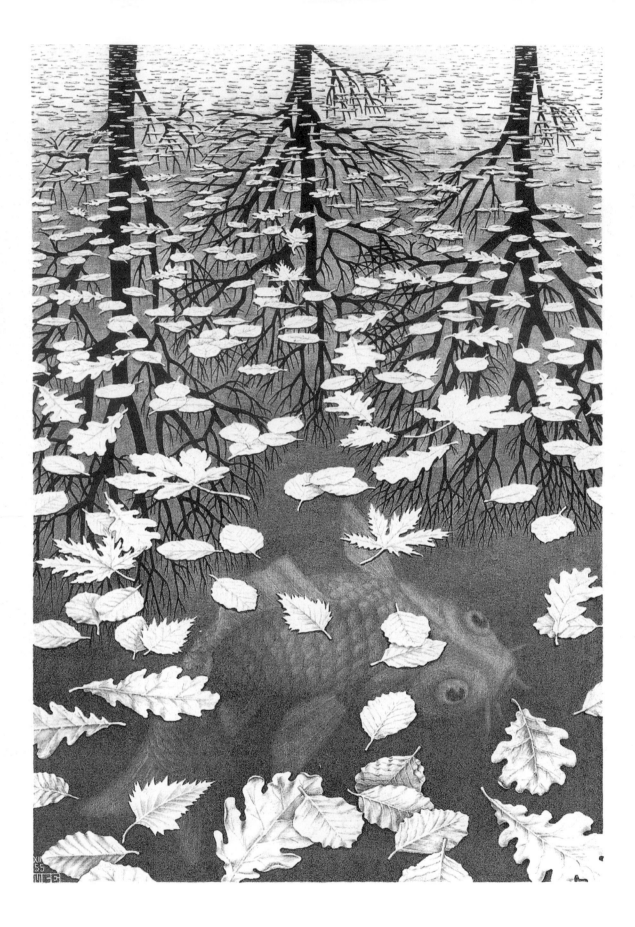

49.
Drie werelden
Three worlds

50.
Stilleven met bolspiegel
Still life with reflecting globe

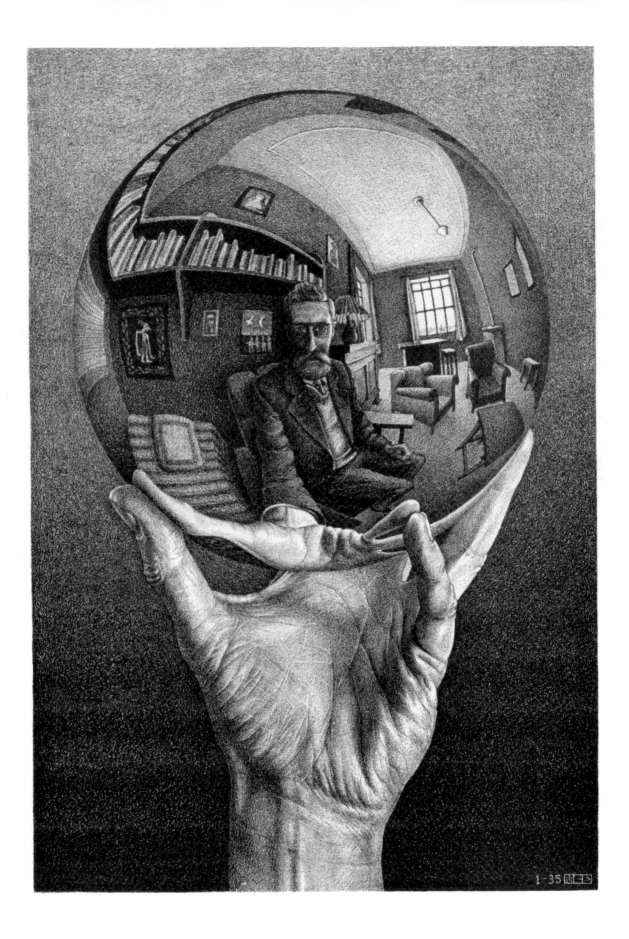

51.
Hand met spiegelende bol
Hand with reflecting globe

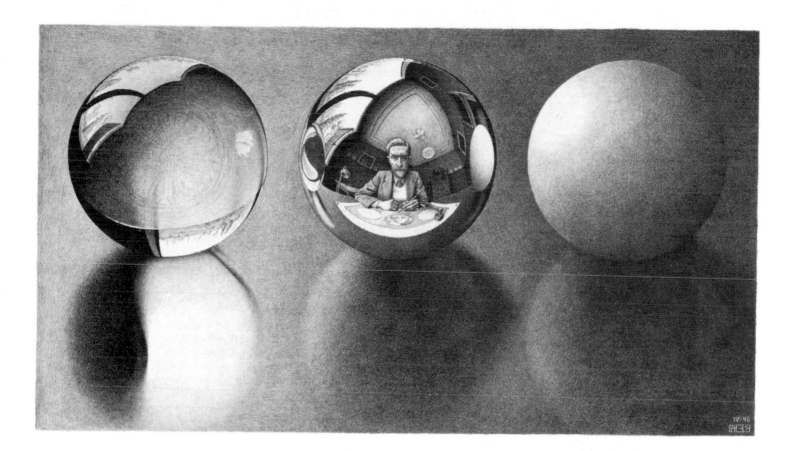

52.
Drie bollen II
Three spheres II

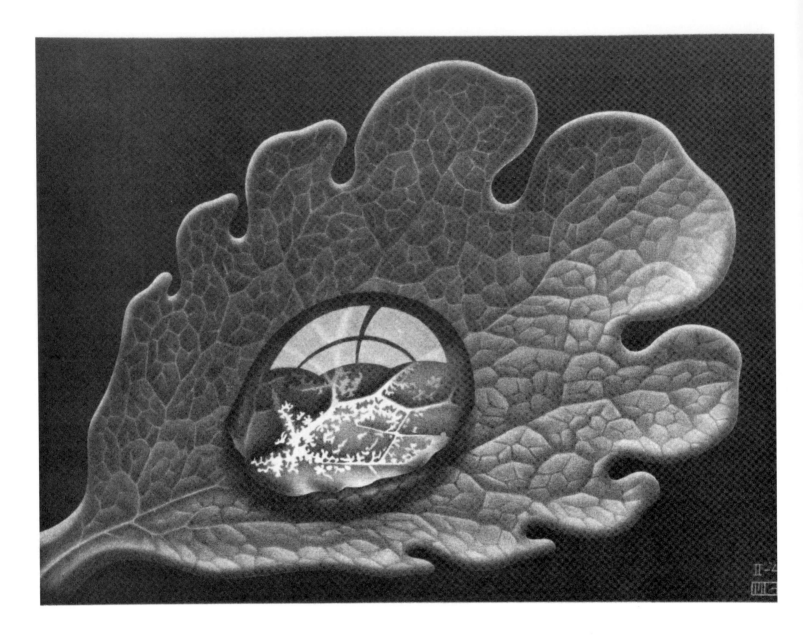

53.
Dauwdruppel
Dewdrop

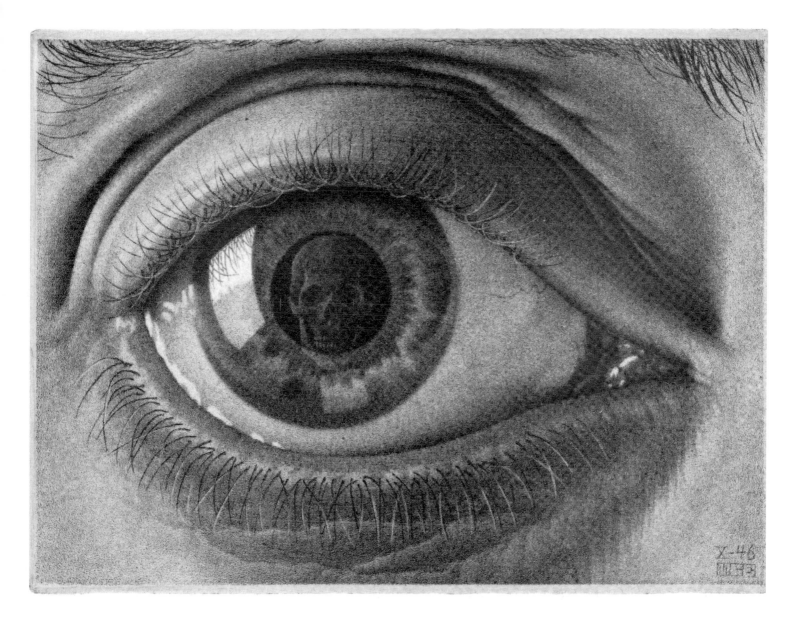

54.
Oog
Eye

55.
Kubus met banden
Cube with magic ribbons

56.
Hol en bol
Concave and convex

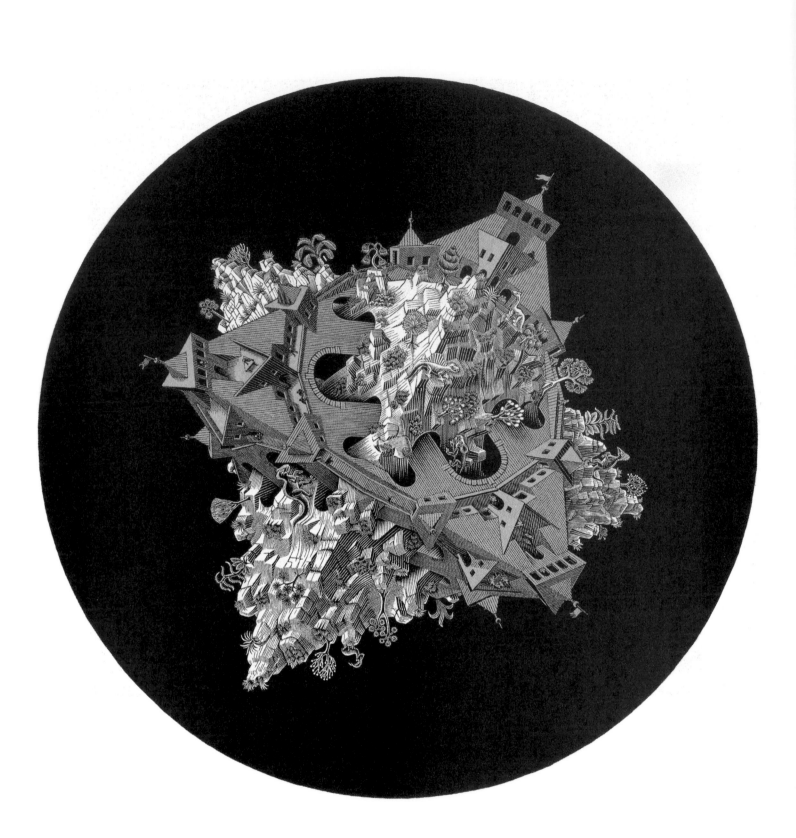

57.
Dubbele planetoïde
Double planetoid

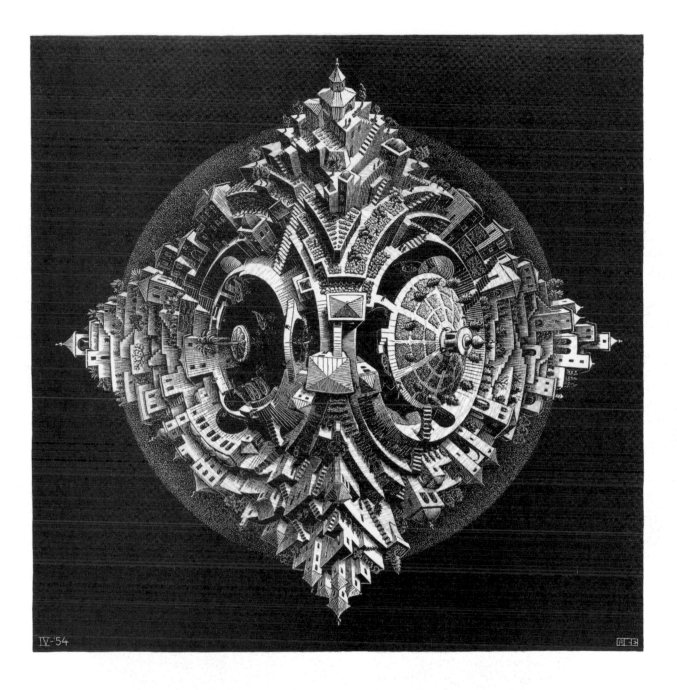

IV-'54

58.
Viervlak-planetoïde
Tetrahedral planetoid

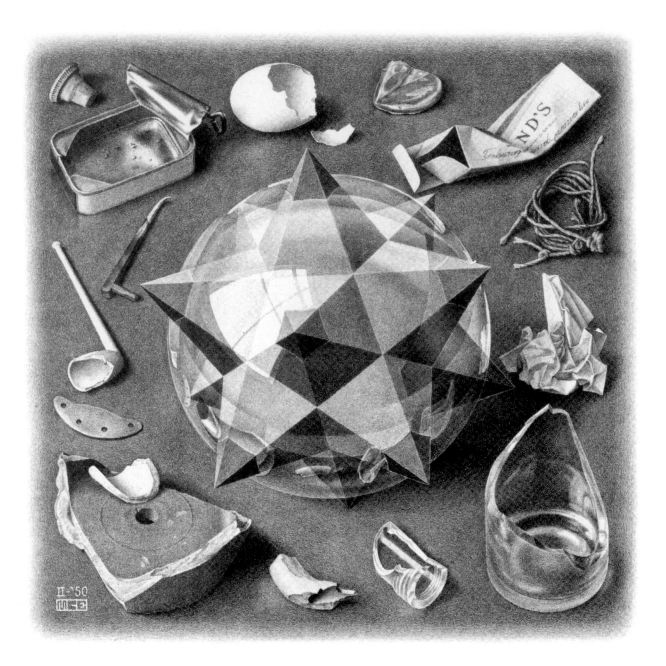

59.
Tegenstelling
Order and chaos

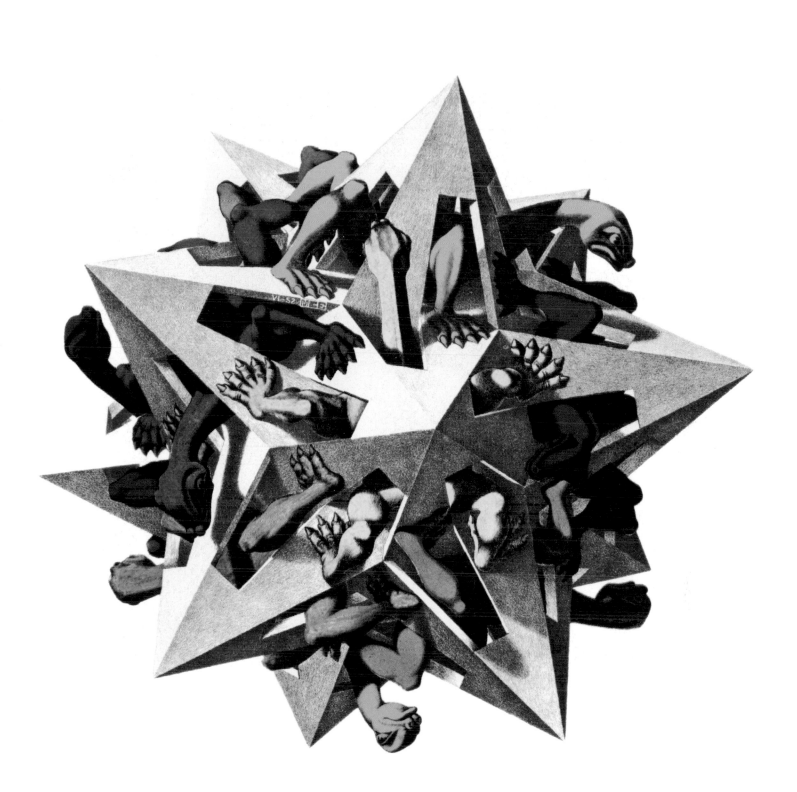

60.
Zwaartekracht
Gravitation

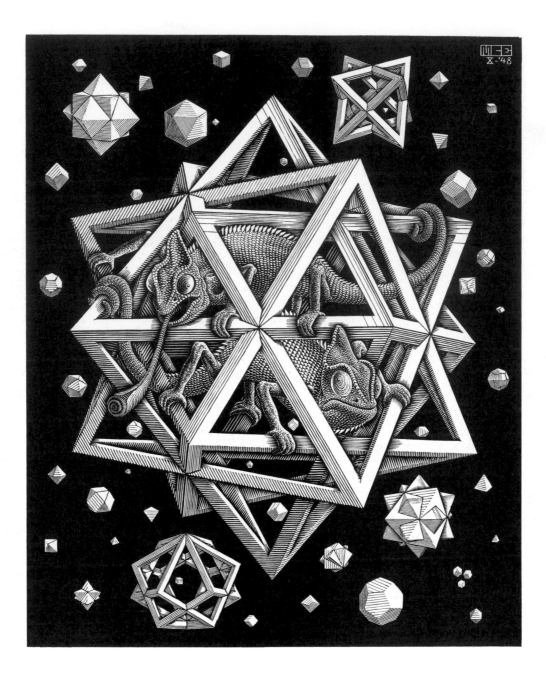

61.
Sterren
Stars

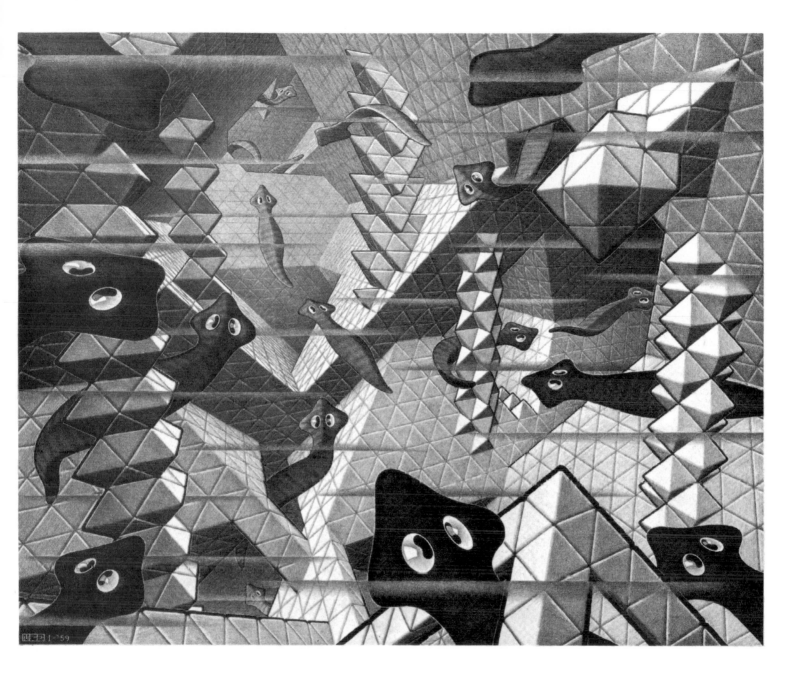

62.
Plalwormen
Flat worms

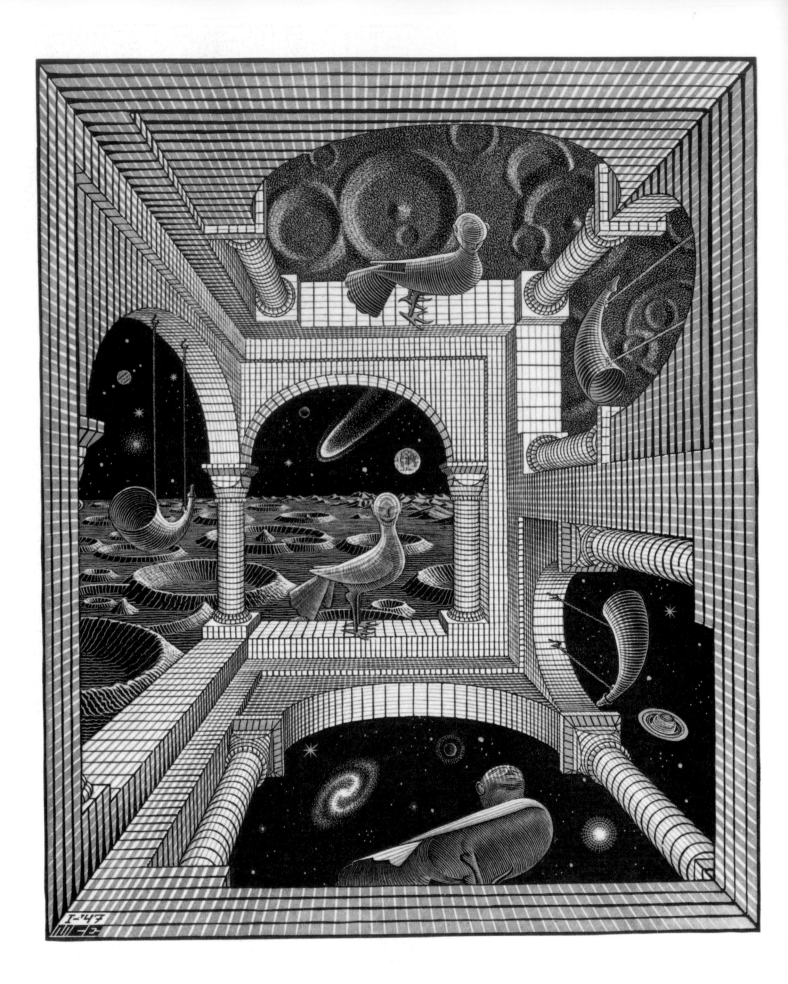

63.
Andere wereld II
Another world II

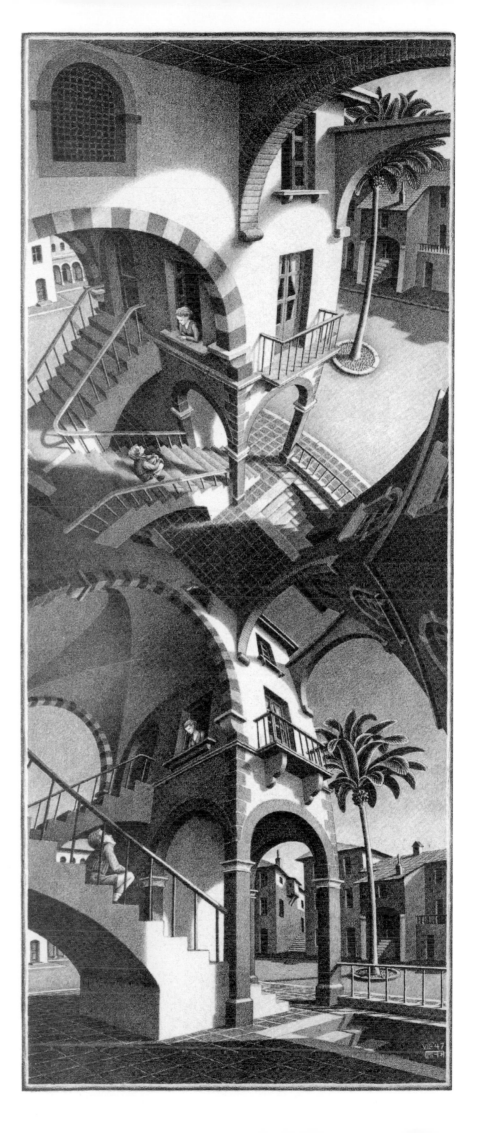

64.
Boven en onder
High and low

De Pedalternorotandomovens centroculatus articulosus ontstond, (generatio spontanea!) uit onbevredigdheid over het in de natuur ontbreken van wielvormige, levende schepselen met het vermogen zich rollend voort te bewegen. Het hierbij afgebeelde diertje, in de volksmond genaamd „wentelteefje" of „rolpens", tracht dus in een diepgevoelde behoefte te voorzien. Biologische bijzonderheden zijn nog schaars: is het een zoogdier, een reptiel, of een insekt? Het heeft een langgerekt, uit verhoornde geledingen gevormd lichaam en drie paren poten, waarvan de uiteinden gelijkenis vertonen met de menselijke voet. In het midden van de dikke, ronde kop, die voorzien is van een sterk gebogen papagaaiensnavel, bevinden zich de bolvormige ogen, die, op stelen geplaatst, ter weerszijden van de kop ver uitsteken. In gestrekte positie kan het dier zich, traag en bedachtzaam, door middel van zijn zes poten, voort bewegen over een willekeurig substraat (het kan eventueel steile trappen opklimmen of afdalen, door struikgewas heendringen of over rotsblokken klauteren). Zodra het echter een lange weg moet afleggen

en daartoe een betrekkelijk vlakke baan tot zijn beschikking heeft, drukt het zijn kop op de grond en rolt zich bliksemsnel op, waarbij het zich afduwt met zijn poten voor zoveel deze dan nog de grond raken. In opgerolde toestand vertoont het de gedaante van een discus-schijf, waarvan de centrale as gevormd wordt door de ogen-op-stelen. Door zich beurtelings af te zetten met één van zijn drie paren poten, kan het een grote snelheid bereiken. Ook trekt het naar believen tijdens het rollen (b.v. bij het afdalen van een helling, of om zijn vaart uit te lopen) de poten in en gaat „freewheelende" verder. Wanneer het er aanleiding toe heeft, kan het op twee wijzen weer in wandel-positie overgaan: ten eerste abrupt, door zijn lichaam plotseling te strekken, maar dan ligt het op zijn rug, met zijn poten in de lucht en ten tweede door geleidelijke snelheidsvermindering (remming met de poten) en langzame achterwaartse ontrolling in stilstaande toestand.

XI-'51

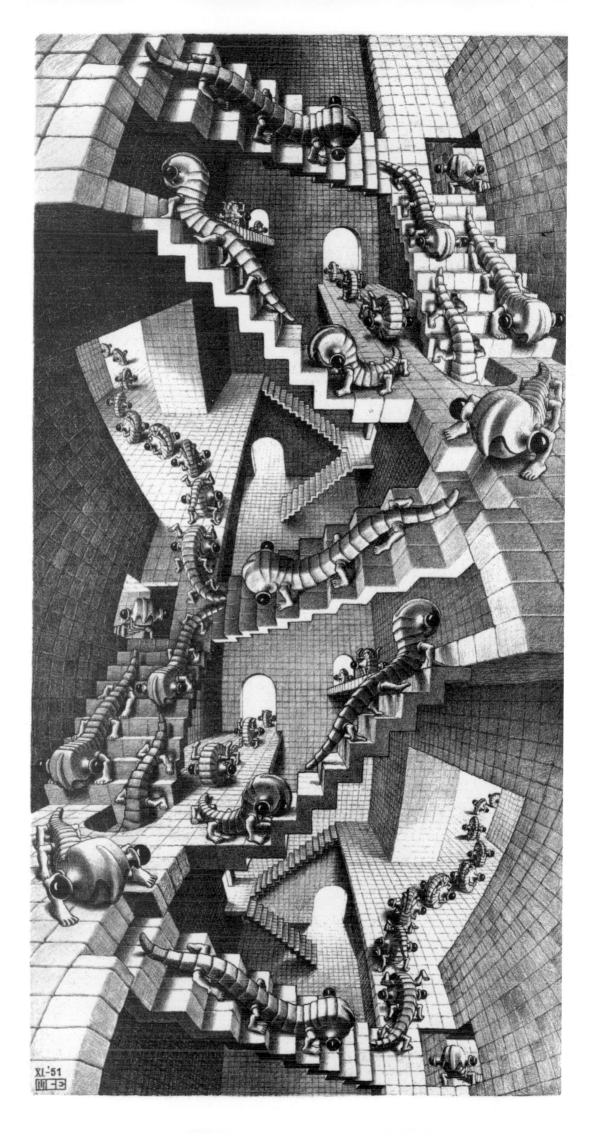

66.
Truppeluis
House of stairs

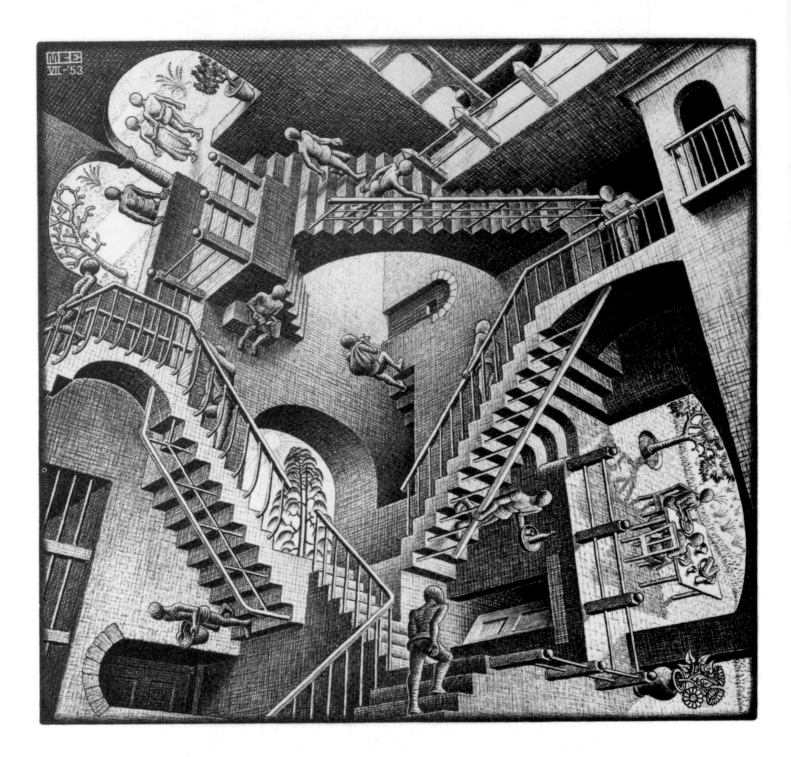

67.
Relativiteit
Relativity

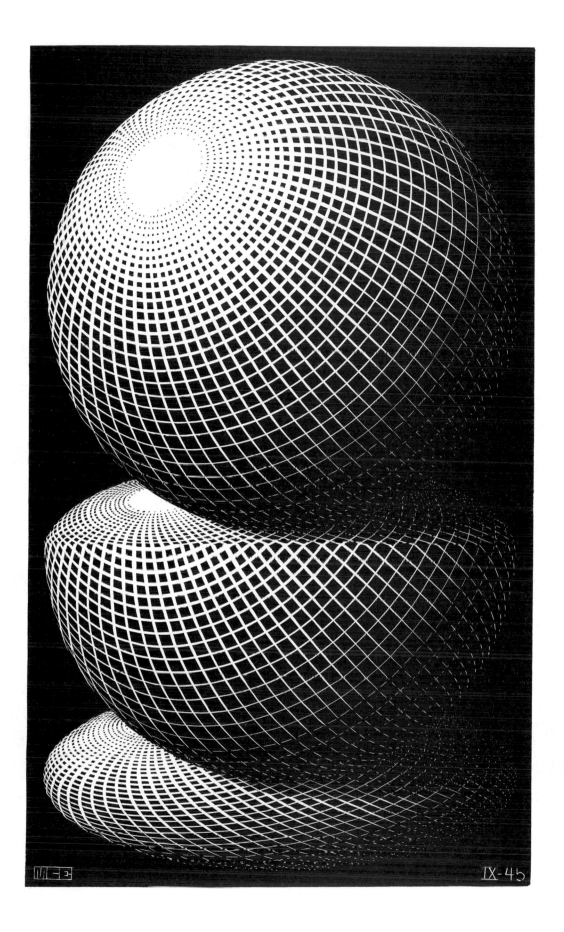

68.
Drie bollen I
Three spheres I

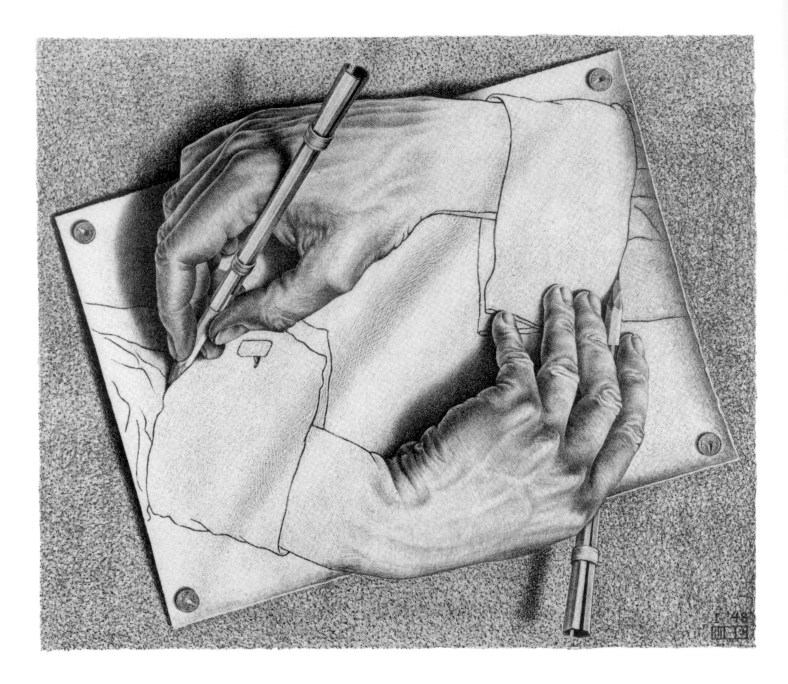

69.
Tekenen
Drawing hands

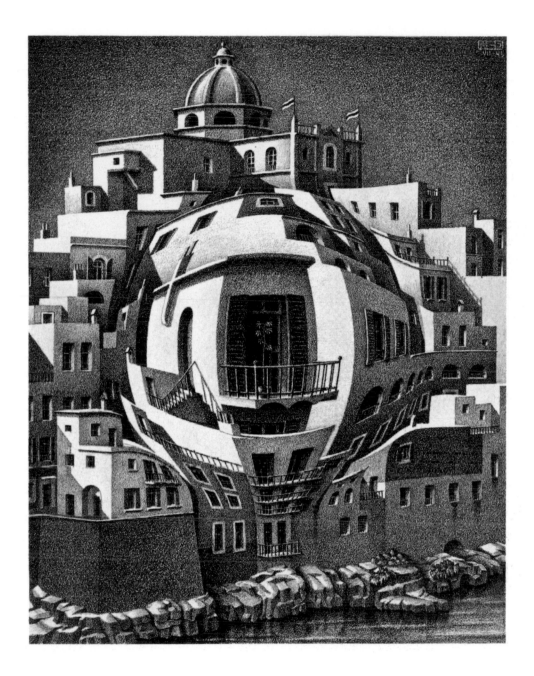

70.
Balkon
Balcony

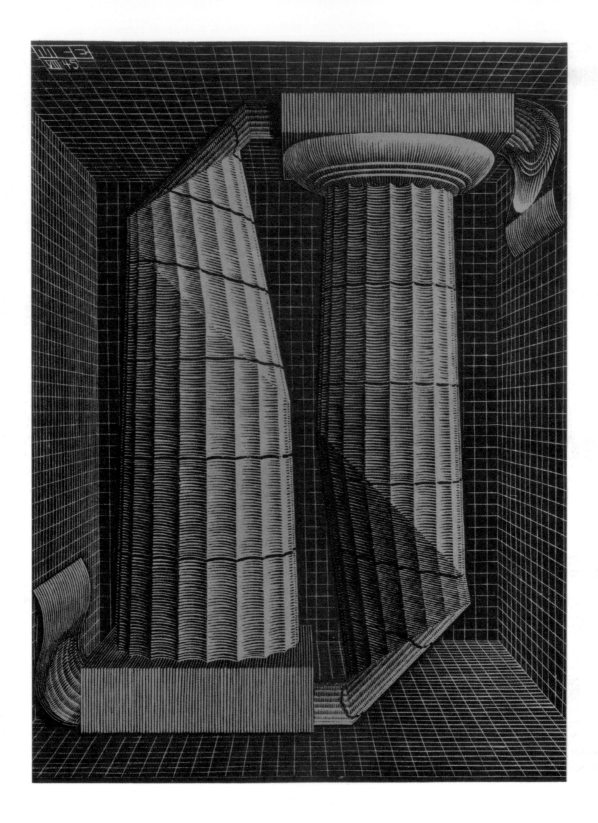

71.
Dorische zuilen
Doric columns

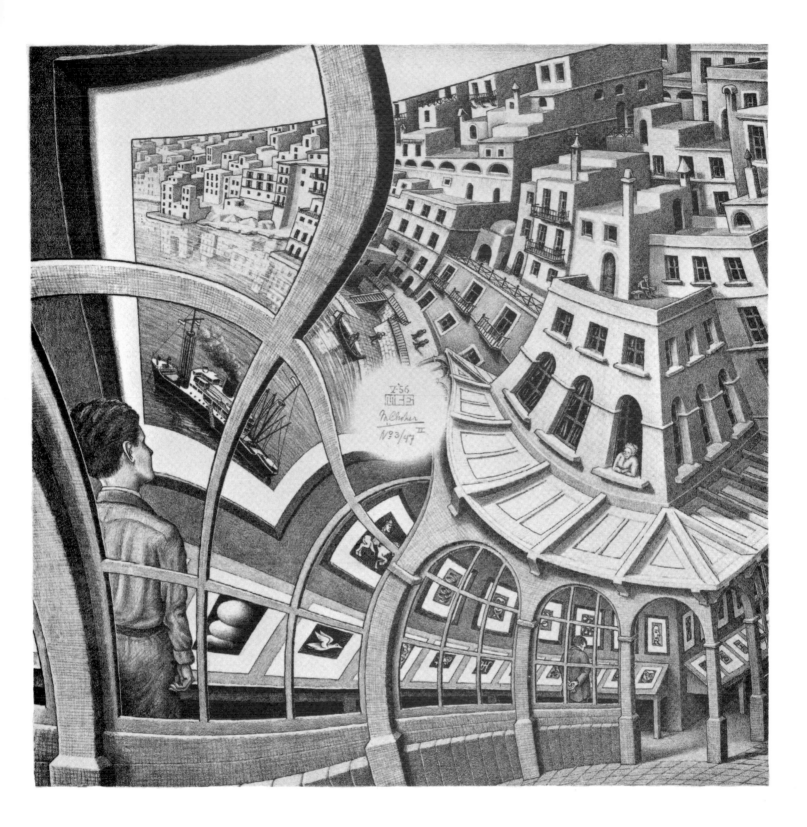

72.
Prententoonstelling
Print gallery

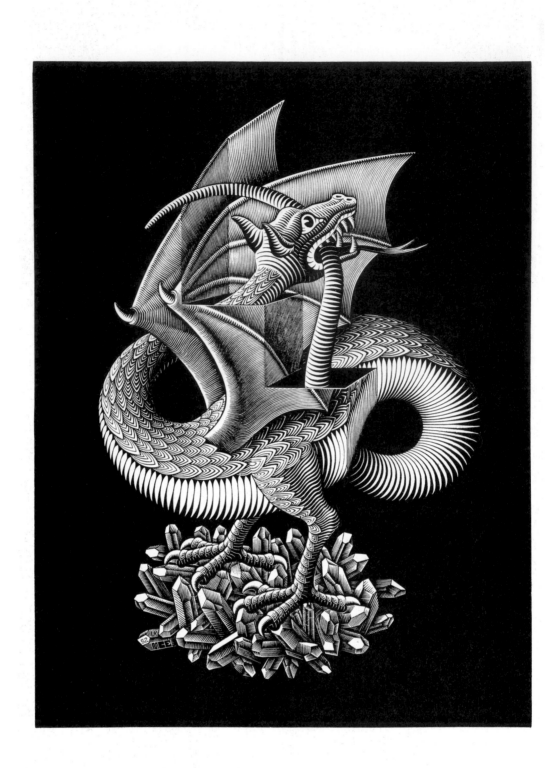

73.
Draak
Dragon

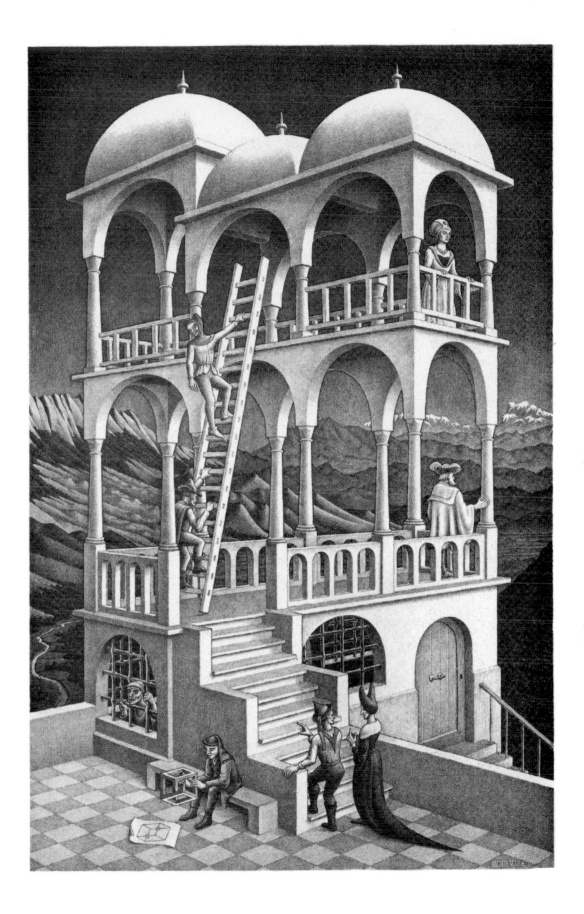

74.
Belvedere

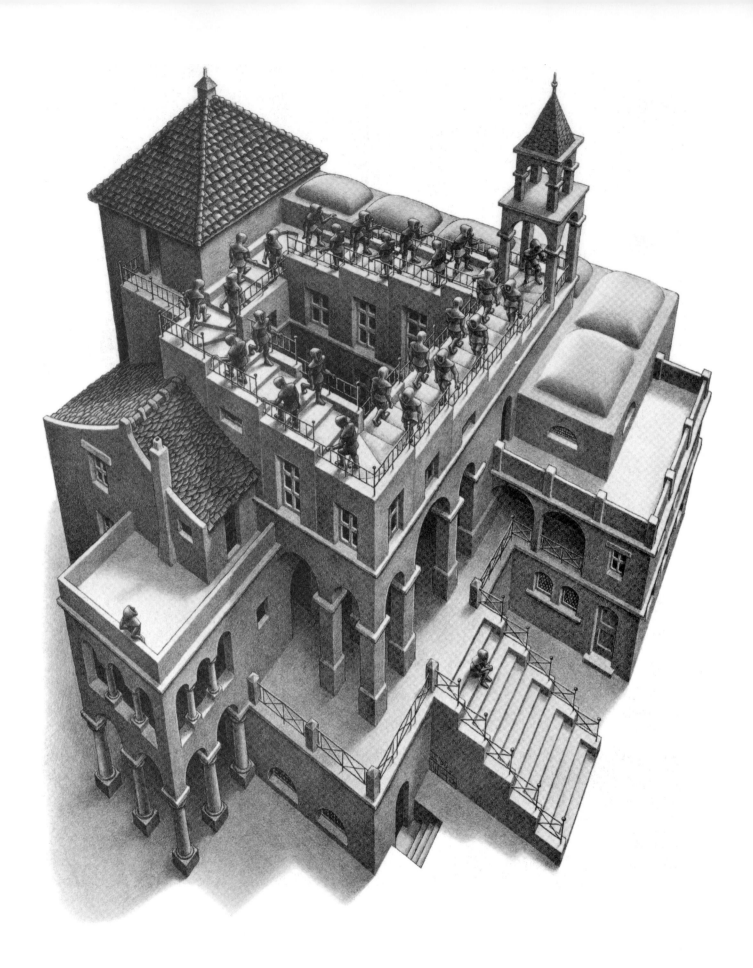

75.
Klimmen en dalen
Ascending and descending

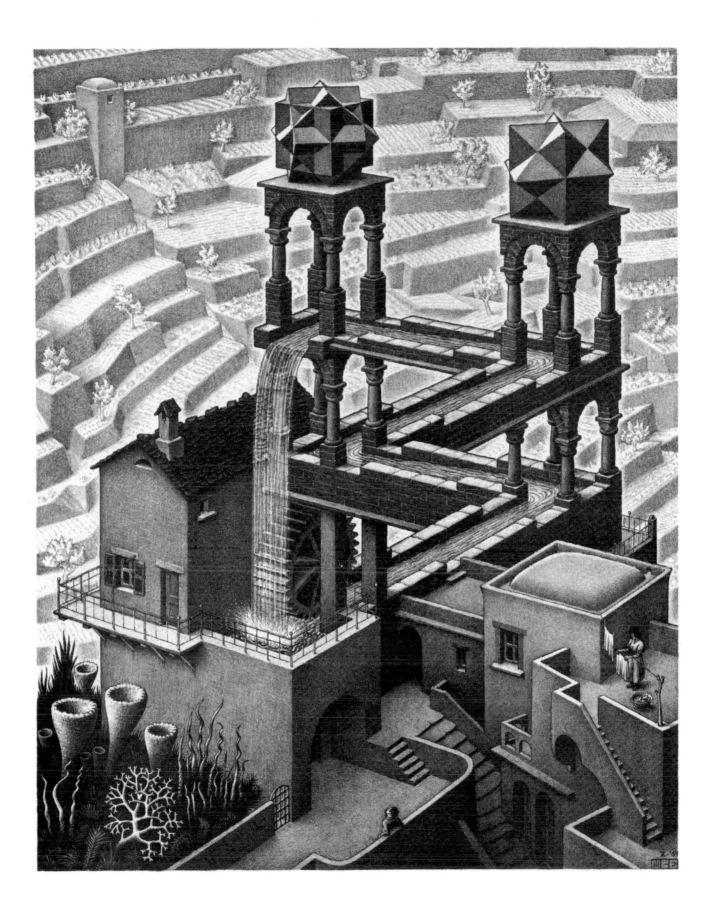

76.
Waterval
Waterfall

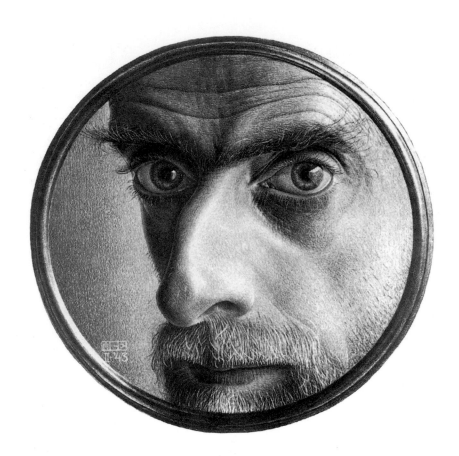